Gojko Subotić

THE SACRED LAND
ART OF KOSOVO

Drawings by
Nikola Dudić, Dragomir Todorović

Colour photographs by
Jovan Stojković, Branimir Strugar

The Monacelli Press

Front jacket illustration
The church of the Annunciation
Gračanica monastery

Back jacket illustration
The Virgin of the Deesis
Patriarchate of Peć, church of the Holy Apostles

Editorial consultant
Aleksandar V. Stefanović

With the cooperation of
Milorad Medić, Bojan Miljković,
Dragan Vojvodić

Translated by
Vida Janković, Radmila Popović

Edited by
Ellen Elias-Bursać

Maps of the Balkans and Kosovo by
Cesare Sacconaghi (Gallarate)

Illustrations credits
B. Strugar: 10, 15, 17, 23, 24, 28, 44, 52-57, 63, 76;
PLATES 1, 9, 11, 14, 15, 18, 19, 27, 28, 30, 32-35, 58-60, 62, 66, 67, 74, 75, 78-80.
J. Stojković: 9, 16, 18, 33, 39, 40, 73, 77, 78, 85, 86, 89, 100, 102, 103;
PLATES 2-8, 12, 13, 16, 17, 20-26, 29, 31, 32, 35-57, 61, 63, 68-73, 76, 77, 81, 82, 84-87.
D. Tasić: 11, 14, 30, 36-39, 41-43, 59, 60, 62, 78-82, 84.
V. Korać: 7, 8.
O. Kandić: 3, 4, 6.
M. Čanak Medić: 12, 13, 29, 51, 64, 68-73.
S. Nenadović: 19-22, 25-27, 31, 88, 93, 84, 98, 99.
N. Dudić: 50, 66, 67, 91, 92, 95-97.
S. Ćurčić: 33-35.
Dj. Bošković: 45-49.
D. Todorović: 61, 75.
M. Orlić: 58

First published in the United States of America in 1998 by
The Monacelli Press, Inc.
10 East 92nd Street, New York, New York 10128.

Copyright © 1997 Editoriale Jaca Book SpA, Milano
English edition copyright © 1997 The Monacelli Press, Inc.

Library of Congress Catalog Card Number: 97-77006
ISBN: 1-58093-006-9

Printed and bound in Italy

Table of contents

Introduction

The large province of Kosovo in the south of Serbia, rich in fertile plains and silver ore mingled with gold, is no less rich in cultural monuments, churches built in the Middle Ages by rulers and church dignitaries, noblemen, clergy and monks, and – as an old notice has it – by "the impoverished and the middling poor".

Over time, Kosovo has encompassed several regions which were historically and geographically, though not administratively, distinct.[1] At the end of the war (1945), in a new subdivision of the country, an autonomous province within Serbia which covered the same surface area was given the official name *Kosovo and Metohija*[2], which applied to two naturally distinct units, stretches of plains and the slopes of nearby mountains separated by low hillocks and saddles. A watershed divides the rivers which flow into the Black, Aegean and Adriatic seas. Its position has determined the significance of Kosovo in the center of the Balkan peninsula: at the intersection of major roads running from several directions, heading seaward. This was the "Zeta route" – the valley of the Drim River towards Skadar – the shortest connection, via Prizren, along which ran most of the traffic between the interior of the Balkans and the Adriatic Coast.

From a historical perspective, the heart of the Province's territory is Kosovo Field. Because of the fateful events which occurred there this place became deeply embedded in the Serbian consciousness and was invested early with special significance. Notes taken by one Bishop Martin Segonus in the second half of the 15th century have recently come to light. Travelling toward Skoplje, he wrote that the field was roughly 70 miles long and "renowned for battles between different nations". He certainly must have had in mind the famous clash of the Serbian forces gathered around Prince Lazar and the Turkish army under the command of Sultan Murad I himself – a battle in which both rulers lost their lives on 15 June 1389. The battle had far-reaching consequences for the future of the Balkan states, despite the fact that the first news to reach the West reported a great success for the Christian warriors. At a later date the field of Kosovo – as prelate Segonus coming from Novo Brdo knew only too well – was again a theatre of war. In the autumn of 1448, the Turks crushed Hungarian military leader John Hunyadi in command of an anti-Turkish alliance, and several years later, in 1455, the Turks took possession of these lands for many years to come.

Kosovo had become integrated within the borders of the Serbian state as early as the end of the 12th century, during the reign of its founder Grand *župan* Stefan Nemanja. However, no monuments of art dating from the first decades of new rule have survived. Neither do remains of

Byzantine structures reveal much about ecclesiastical centers from the previous age. A somewhat fuller picture is offered by archeological excavations of older fortresses that long defended these eastern frontiers of the Empire.

A considerable impetus to the spiritual and artistic life was provided by the foundation of the independent Serbian Archbishopric with its seat in the monastery of Žiča (1219). Its first head, St. Sava, Nemanja's youngest son, established bishoprics whose network relied on the tradition of the Byzantine ecclesiastical administration with the centers in ancient Ulpiana and Prizren. In connection with this, artistic activity can be simultaneously followed from the twenties of the 13th century in the cathedrals which were built or restored, but also in the modest dwellings of monks. In broad terms, the development of art in Kosovo depended on the position that this rich region held in the life of the country. It therefore saw its greatest rise in the period when rulers lived in its towns, and Serbian spiritual leaders held court in Peć, hitherto a remote estate of the Archbishopric. The very transfer of the spiritual throne from Žiča, after its demolition in an enemy attack, is with good reason brought into connection with the proximity of the king's court, in which the head of the church was invested with a major role and duties.

In the entire art history of medieval Serbia, the sacred buildings of Kosovo, with their number and character represent the most significant part of the heritage from its age of prosperity in the second half of the 14th century. Broad prospects were opened to art at that time, with new ideas and styles arriving from Byzantium. They did not, however, exclude the traditional presence of western artistic forms that reached the interior of the country from the other side of the coast via the towns on the Adriatic Coast.

Both the social position and financial resources of those who commissioned the building were directly manifested in its appearance. In size and ornamentation, opulence of material and aesthetic conceptions, rulers' endowments differed from the more modest churches built by archbishops using less opulent materials in their seat in Peć, the interior of which was adorned by frescoes interpreting in a sublime manner the specific ideas and culture of monastic life. Even greater was the difference between edifices of the highest representatives of secular and spiritual authority and the endowments of lower feudal lords, in particular modest village churches or simple caves arranged for the prayers of anchorites.

Because the church held a special position within the Serbian state, the influences exerted by the cultures of the East and the West, with the Greek and the Latin and their respective religious and literary traditions, were felt more acutely in the life of the Kosovo region than they were elsewhere. Nevertheless, the spread of Byzantine literacy played a decisive role, and with it various genres of domestic theological literature, which evolved until the 10th century.

On the other hand, there were stylistically heterogenous forms exisiting in parallel, intertwined in architecture and sculpture, occasionally producing startling symbioses. Coexisting for years in a mutual tolerance which might surprise the uninformed, artists, regardless of their own religious affiliation and artistic training, respected the character of the other existing denominations and fulfilled in a solicitous manner their cultural requirements to the last. A telling instance of religious breadth is the fact that King Stefan Dečanski (1322-1331), recollecting years spent in asylum in the monastery of Christ the Pantocrator in Constantinople, decided to devote a large mausoleum church in the monastery of Dečani to the same patron, but entrusted its construction to Franciscan Vitto, a member of the Friars Minor of Kotor.

These coordinates can be comprehended fully only with a broader insight into the economic and social life of medieval Serbia. Its economy was considerably boosted by the exploitation of mineral resources on the territory of Kopaonik and Novo Brdo in particular, dating to the early 14th century. Mining was introduced to Serbia by a group of Silesians who were assimilated over time, but retained technical terms for their work and kept the Catholic faith. This religion was also shared by numerous merchants and lessees from Dubrovnik, Kotor and elsewhere, who had their colonies in mining settlements and marketplaces, and raised churches there. Rich coastal

archives offer a wealth of data on the travels through Kosovo or permanent sojourns there by people from the coastal area, dubbed *Latins* by the people of Kosovo because of their religion. High office and assignments of significance at the Serbian royal court were entrusted to members of patrician families from the coastal region, primarily from Kotor. Versed in all manner of jobs, these men were most frequently in charge of the royal purse. Their names are encountered in the West, whither, as they were acquainted with circumstances there, they travelled to conduct negotiations, often delicate and long, especially when the possibility of union was being discussed at the papal court.[3] Initiatives of this kind came from both sides and, most of them, interestingly, in the first half of the 14th century. The permanent association of the country with the tradition of Orthodoxy, however, at whose great center, Mt Athos, Stefan Nemanja built the monastery of Hilandar for the monks of his "blood"[4], was never seriously called into question by such ideas.

When Milutin conquered lands to the south and married Princess Simonis, daughter of Andronikos II in 1298, Serbia's connections with the political and social life of Byzantium, its institutions and customs grew closer yet. At the same time spiritual ties were strengthend, particularly with Mount Athos, where ideas and the monastic life provided a special school to eminent prelates, men of letters and translators. Artists, summoned to work for rulers and ecclesiastical dignitaries, came to Mt. Athos from conquered Byzantine provinces and the larger cities, primarily Thessalonica.

Although by the close of the 13th century the territories to the south of Skoplje were within the Serbian state, the courts of King Milutin were located in Kosovo, in a lowland region. These rather small towns whose names were noted at the end of the ruler's charters, have disappeared nearly without a trace, while to the north of them remained Priština, an unfortified town in which Stefan Dušan (1331-1355) subsequently sojourned on several occasions. His successful military campaigns emboldened Dušan to proclaim himself Emperor of the Serbs and Greeks (1346). He expanded the state to the shores of the Aegean and Ionean seas, so that by the middle of the century its borders encompassed, apart from Macedonia, all of Epirus, Thessaly and Albania (except for Dyrrachium).

Dušan stayed in Prizren quite often. Prizren was a town whose character revealed, more than others, the economic advantages of its position at the crossroads of important caravan routes. Fairs were held there four times a year; merchants from coastal towns, Kotor and Dubrovnik in particular, but also Venice, Genoa, etc., arrived from various directions, some settling permanently. Crafts and trades, particularly the production of textiles, especially silk (the silkworm was cultivated locally), were organized into guilds headed by protomasters. King, and future Emperor, Dušan, also resided in this thriving town because he was having the monastery of the Holy Archangels raised in its vicinity, in the Bistrica Valley. Within the monastery confines was a large church in which he wished to be buried. This, however, was not the first edifice of its kind in Kosovo. Before it, kings Uroš II Milutin and Stefan Dečanski had built mausolea – the churches of St. Stephen in Banjska and Christ the Pantocrator in Dečani. These churches and the complex of the Patriarchate of Peć with the Holy Apostles in its core – the resting place of the highest church dignitaries as early as the second half of the 13th century – left a distinctive mark on the architecture of the region as a whole. It was as if the example set by heads of church had inspired the Serbian kings to build monumental buildings of outstanding character where they were to rest in peace, in their new administrative center. Dušan did the same. This region signified, in a special way, his parent country, though he pushed the borders far southward in the first years of his reign, thereby stripping the territory of present-day Kosovo of its key geographical position.

Kosovo was homeland to a number of distinguished feudal families (the Musićes, the Brankovićes, the Lazarevićes) who continued to hold their estates, as the legacy of their ancestors, for many years. Nevertheless, the fertile soil and the ore-rich lands were largely in the possession

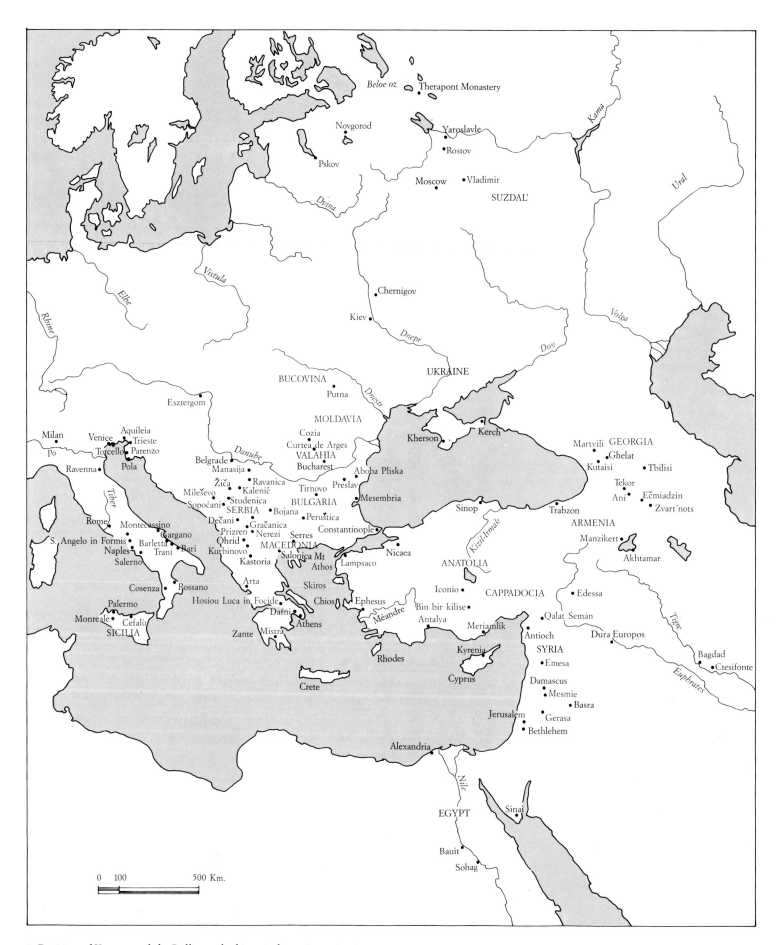

1. Position of Kosovo and the Balkans, the historical crossing-point in
the Mediterranean of the Latin, Byzantine and Slavonic worlds.

of the rulers themselves. The endowment charters of the monasteries of Banjska, Dečani and the Holy Archangels that have survived, attest to the fact that the sovereigns granted them enormous estates in the plains surrounded by wooded mountains, along with villages and summer pastures, thus permanently providing for the subsistance of their monastic communities. The lands of other monasteries, especially those of the Patriarchate of Peć, being added to this, it can be claimed that most of the territory of present-day Kosovo was taken by church estates. It is therefore not unusual that vast regions to the west were called Metohija, after a term of Greek origin used locally to denote monastery estates which were not immediately adjacent to the monastery (τα μετοχια).

On some of these *metochs*, as can be seen from the example of the estate of the Žiča – a monastery where the Patriarchate of Peć was to expand later on – the number of churches grew due to the monks' obligation to attend religious services. There are hundreds of village churches which are now in ruins, others the only remaining trace of which is in written sources or a surviving name – and these buildings, past and present, testify to the presence of a large population, its infrastructure and religious life for many centuries throughout Kosovo and Metohija. Along with the monasteries, town churches, and those of feudal lords, places of prayer in caves and graveyards, these places of worship comprise a dense network of shrines for which this region is often called the *Holy Land*. The survey of monuments at the end of the book, presented in a selective, well-documented account, sets forth only the most basic facts assembled in the field or taken from sources.

A survey of the architectural heritage including a broader overview of monuments would certainly offer a more complete picture of artistic activity, but would not provide a fuller understanding of its nature. The analysis has been therefore restricted only to the monuments which most thoroughly represent artistic ideas and realizations, starting from the simplest anchoritic cave-dwellings with places for worship, and going on to buildings raised by kings and archbishops.

Most of the survey is, nevertheless, dedicated to larger structures in which artists could express their ideas in monumental dimensions and in a most complex mode. A view, therefore, of artistic creativity within the boundaries of present-day Kosovo offers a profusion of ideas and forms. We should not, however, lose sight of the fact that early Serbian art, despite its strict compliance with the fundamental principles of the Eastern Christian church, did not adhere closely to a particular tradition or mimic established forms. Rather it was responsive to the vital styles it met with in the workshops of master craftsmen in Byzantine towns and the Adriatic coast, freely seeking for solutions suited to the views and needs of the Serbian environment.

The narrative sources which recount preparations a ruler made to endow a church for himself first draw attention to his consultations with immediate associates, frequently outlining the reasons influencing the selection of a certain patron-saint, and explaining the personal wishes of the founder as to the building's appearance. Especially interesting are the passages regarding the king's attachment to the Christian sacred buildings he wished to emulate. Writers of *Lives* were not always precise in their descriptions, so sources of other kinds and analogies with sacred buildings in other places have enabled scholars to extrapolate the essential ideas motivating the person who commissioned the project, regarding the character of the building and its decoration. Descriptions confirm that on these issues the rulers relied on spiritual advisers, the most prominent of whom in the first half of the 14th century was Danilo II (1325-1337). The final appearance of each church was decided in consultation with artists who set out their proposals in accordance with their experience and the practice fostered in the region where they came from. These certainly gave each building a particular flavor, especially in the sculptural articulation of the whole and in façade ornamentation. In that sense, the rulers in Kosovo, as was the case earlier in Raška in the Ibar valley, gladly embraced western architectural patterns, adapting them – primarily in the design of the dome and the spatial components in which the services were carried

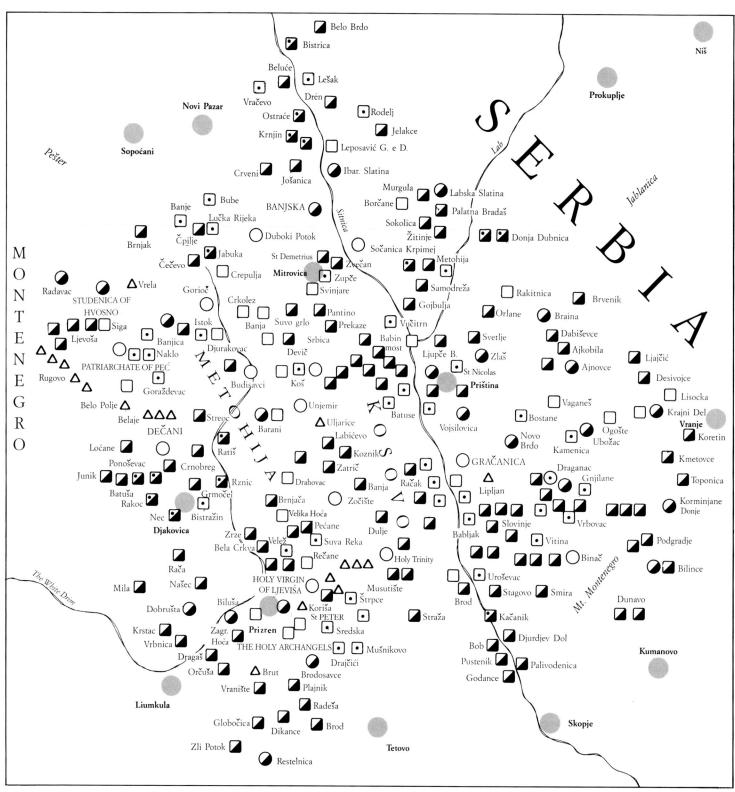

2. Main monuments and sanctuaries of Kosovo and Metohija—the Diocese of Ras-Prizren—from the Middle Ages to Modern Times. (Based on the map by Jovan Cvijić, The Balkan Peninsula.)

Monuments and sanctuaries predating 1459

○ existing monasteries

◑ ruins of monasteries

▢ existing churches

◩ ruins of churches

△ hermitages

Monuments and sanctuaries built from 1459 on

⊙ existing monasteries

▣ existing churches

◪ ruins of churches

12

primarily in the design of the dome and the spatial components in which the services were carried out – to the Orthodox ritual.

The strict artistic concepts of the Serbian clergy found more consistent expression in wall and icon painting. Western artistic experience and iconography of the western world were far less likely to penetrated their closed system. The character of sacred paintings and their meaning in the tenor of the views of the Eastern Church is discernable in small shrines with abbreviated iconographic content, while in the spacious interiors of larger buildings, where surfaces serve an overlay of meanings and functions, one can find developed, thematically connected sequences of compositions with manifold messages, frequently comprehensible only to those versed in theology. Intricate concepts translated into visual language had a long tradition in the art of the Byzantine sphere, and in medieval Serbia, its significant segment, this was best evidenced in the Kosovo churches. The frescoes were the work of both local and foreign masters, and their learned advisers. Their contribution is most tangible in the wealth of historical depiction and the individual portraits of Serbian rulers, noblemen, church dignitaries and monks. Special among them are portraits of the members of the house of Nemanjić in the form of a family tree – an exuberant vine with foliage interwoven with their images like the Tree of Jesse. These compositions appeared for the first time in Kosovo where three of four such representations have survived.

The fortunate circumstance that a number of large monastic buildings still stand well preserved, can be explained by the fact that advanced building techniques were employed to raise them. They were invariably sturdier structures than other buildings of the period. Furthermore, they were maintained and restored with greater care – the Patriarchate of Peć being a most telling instance – both in the decades when the spiritual life was declining after the fall of Serbia (1459), and after the restoration of the Patriarchate of Peć (1557) which prolonged the existence of the Serbian church and creative activity in its fold until the time of the Great Migration of Christians into northern regions across the Sava and the Danube (1690).

This tangible distinction between the well-preserved churches on the one hand, carefully built in stone, and the ruins of fortified towns on the other, once housing the royal court which were constructed using rather more modest materials, moved an anonymous poet to praise the devotion of rulers who spent their riches on endowed churches[5] rather than on palaces in the poem "Where did the treasure of Czar Nemanja vanish?". Milutin, as we have said, resided in smaller fortresses and adjacent towns; no ruins have, to date, been discovered which would suggest that he led a lavish lifestyle.

The descriptions provided here are not consistent in proportion to each building's size and the opulence of its icons and frescoes. Whole chapters could be devoted to single extensive cycles, as in the case of churches like Dečani, but such a focus would go beyond the scope of this volume. Here we intend to depict, by means of a specific selection, the nature of creative activity in Kosovo, primarily its monumental aspects – architecture, sculpture and fresco. In time, the appearance of church interiors altered: they were lavishly embellished with candelabra and choroses, icons on the altar screens and proskynetaria, gold and silver vessels, vestements of priests, curtains, epitaphioi and other fabrics, most frequently embroidered with gold and silver, and then analogia in wood-carving and intarsia, thrones and other church furnishings. A part of these objects is now held in collections whose existence is only noted here. Preservation of a building, in most cases its frescoes, over centuries of Turkish rule, is sketched in broad outline. An occasional illustration or incidental reference will nevertheless conjure for the reader the former opulence of the interior, best evoked in the ambience of the church of Christ the Pantocrator in Dečani.

Countless Kosovo shrines are in ruins or they have vanished serving as sacrificial offerings toward the perservation of the larger buildings which have survived all subsequent turmoils. These enduring monuments in the lands known as Serbia sacra are the result of the far-seeing

need of the autonomous Christian state and church to master the transience of human destiny with a sense of permanence. Referring in specific to the artistic and spiritual heritage of Kosovo, André Malraux, author of *The Metamorphosis of Gods* said: "Culture, when it is the most precious possession, is never the past".[6]

Notes

[1] "Not a single administrative district is known from the period of the medieval Serbian state and early Turkish rule having 'Kosovo' in its name", – S. Cirković, *Srednjovekovna prošlost današnjeg Kosova*, Zbornik radova Filozofskog fakulteta XV 1 (Beograd 1985) 152.

[2] Until the significant changes of the Constitution in 1968.

[3] The bond between the Serbian royal court and the people of Kotor is perhaps best expressed by a famous episode from the time of King Uroš I, 1247, when a conflict broke out between the Archbishoprics of Bar and Dubrovnik. Refusing to recognize the jurisdiction of the Dubrovnik prelate over their territory, the citizens of Bar and their clergy drove away envoys from Dubrovnik (who, in their defence, had made mention of the Pope) with abuses and cries: "Quid est papa? Dominus rex Urosius est noster papa (S. Stanojević, *Borba za samostalnost katoličke crkve u nemanjićkoj državi*, Beograd 1912, 105-106; *Istorija Crne Gore*, II, 1, Titograd 1980, 22-23 (S. Cirković).

[4] The monastery was founded eight centuries ago, in 1198, with the consent of the Emperor Alexios III Angelos (1195-1203), who, in connection with this, issued a chrysobul to St Sava. «Revue des études slaves» LVI (Paris 1984) 466.

[5] The specific term *zadužbina*, or endowed church, denotes in Serbian a building erected *zaduž* (for one's soul).

[6] «Revue des études slaves» LVI (Paris 1984) 466.

The Thirteenth Century:
the Beginnings

The church of St. Peter of Koriša

Followers of the anchoritic life, that "wild flower" of Eastern Christian monasticism, made an early appearance among the Serbs. Their modest dwellings on cliffs of sheer rocks allow one only occasionally to recognize that these were the old abodes of hermits who sought peace in craggy, inaccessible localities and isolation from the world in order to spend their lives in strict ascetic devotion. They lived in natural caves which they roughly fashioned to fit the basic needs of their cult and to protect themselves from inclement weather and attacks of wild beasts. The generally dry wall partitions shutting the entrances to their cells, were destroyed by time, obliterating traces of the hermits' former presence. More visible signs of their lives have been preserved in better protected spots whose occupants were able to reinforce them with better materials and to decorate the prayer areas with wall-paintings. The hermits' survival also depended on longer sojourns in these caves and more careful maintenance of the cells, particulary if one of its founders attained a measure of renown, as well as the disciples who followed in his footsteps.

In the Prizren region, in the rugged surroundings of Koriša, Peter the Hermit won fame in the early decades of the 13th century for his ascetic feats. His simple life of supreme renunciation and prayer was vividly described in the following century by well-known writer Teodosije who had expressly come from Hilandar (on Mt Athos) to see the site of Peter's dwellings and to hear at first hand the legends about him that had been transmitted by his followers. Being familiar with the lives of ascetics, their spiritual moods and hesychastic conceptions which were experiencing a revival on Mt. Athos at precisely that time, Teodosije described in the *Lives of the Saints* and in his *Service*, the spiritual drama of this hermit and the moral temptations that accompanied his seclusion from the world, as well as the rigours of survival.

According to Teodosije, in searching for a sanctuary which would give him the peace he sought, young Peter found himself in the Koriša River canyon in a deserted spot lodged between steep rocks. He settled in one of the barely accessible caves, "facing the wind and the sun". There he lived "frozen by the cold and scorched by the sun's heat"... as if he were bodiless, all the while

3,5

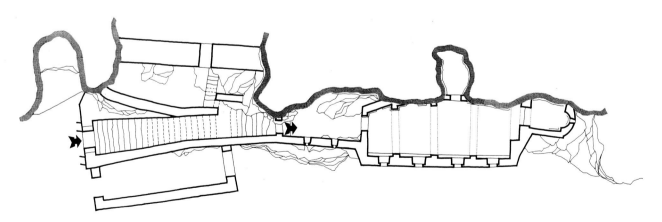

3. St. Peter of Koriša, Hermitage-church with the cave space and monastery structures, ground plan.

gathering wild plants and the bitter heech acorn, if these be called nourishment." There is preserved in this cave an interesting and early part of a wall-painting on the lower layer of uneven rock surfaces dating from the days of the Koriša hermit himself. Where the altar was located on the eastern side there is a depiction of the "Procession of the Hieromonks" under ornamented painted arches. Above them is the Deësis – Christ on his throne with the Holy Virgin and St. John the Baptist drawn in an unusual pose with heads folded in prayer over the chest. In the same row, in the "naos" of the cave, we see the Archangel Michael and the Apostle Peter and, at a lower level, damaged figures of the Warrior-Saints (Demetrios, George, Prokopios, Mercury, Niketas and Blasios) who are also under arches.

Although sources do not record this, the hermit dedicated his prayer area – as seen by the disposition of the drawings – to the Archangel Michael. This celestial herald and executor of divine will on earth, had shrines dedicated to him throughout the Christian world – ranging from cult sites in the East, across southern Italy (Monte Sant Angelo) to Normandy (Mont Saint Michel). All these are on heights and frequently above water from where Michael descended to succour men or to punish them by meting out justice. In a vivid depiction of the struggle waged by the lone Peter against evil powers which had populated the surrounding caves and disturbed him in his spiritual devotions, Teodosije recounts that Peter opposed them by praying and making the sign of the cross. Similarly he was saved from Satan, embodied in the "terrible dragon" by the Archangel Michael himself. For this reason, the Archangel was awarded the spot right next to the "altar space." Behind him, also at the behest of the Koriša hermit, is St. Peter because his name-sake adopted the saint's name when he become a monk in a church dedicated to the Apostle, near his village.

The archaic iconographic elements and the simplified forms of the depictions, lack plasticity but are nonetheless expressive with powerful dark lineaments and rich ornaments recalling the art of earlier times, expressiveness that lasted longer in the regions of the Empire, particularly in Cappadocia, in the largest hermitage in the Byzantine world.

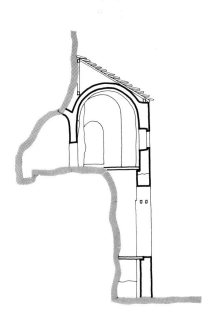

4. Church and cave with the Saint's tomb, section.

5. Monastery grounds, actual look.

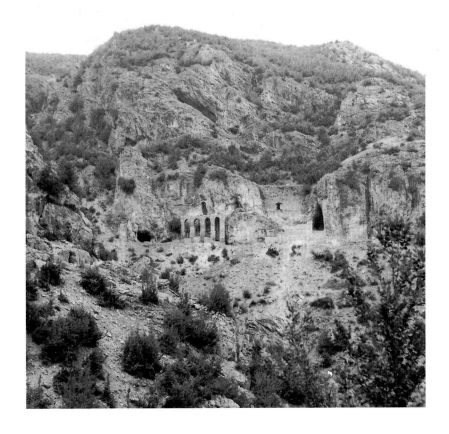

It also characterized the frescoes in the shrines of the Basilian monks in southern Italy and in the rock-hewn churches in Sicily. In a specific way, the wall-paintings of the time of Peter of Koriša, were similar to those in the well-known Prizren Gospel, a rare preserved example of Serbian manuscript illumination originating in this area which itself followed the simple, even rustic language, of linear forms so typical of the older sculptural art developed on the Adriatic coast. However, a number of historical reasons and especially the parallel appearance of Greek and Slavic inscriptions on the frescoes, indicate that the hermit's cell was decorated in the second quarter of the 13th century, undoubtedly after the permanent integration of the Prizren region into the borders of the Serbian state.

As testified to by younger anchorites attracted to Peter by his holy life, the hermit prepared his own tomb. It was located, as investigations have shown, in a cavity in the back of the cave and therefore the Deësis across the whole wall in this part of the cell is of special significance. The depiction of the prayer which the Holy Virgin and John the Baptist address Christ for the salvation of sinners (usually drawn in the central part of the Last Judgment scene) suited its sepulchral character.

The veneration shown to the Koriša hermit during his lifetime was intensified by legends and grew into a cult. A number of caves near the cell were inhabited by ascetics who followed his example, while several decades later a church was built next to the cell on the southern side. In this new space the old hermit's cell acquired the status of a parakklesion. Later documents indicate that Peter's abode was placed under the aegis of the Serbian monastery of Hilandar on Mt. Athos, whose representative in Metohija was Grigorije, an aged hermit. It was his wish for the writer Teodosije to come from the parent brotherhood to celebrate the Koriša hermit in his *Life of the Saint* and in a special liturgical service. This was an act required to introduce new personages into the order of sainthood.

The new structure in Koriša was of a simple oblong shape but its eastern side along the steep rocky incline had to be given very tall supporting pillars connected by arches. This was an isolated instance in early Serbian architecture. It is possible that this unique structure was inspired by the experiences of the Athonite builders who frequently buttressed their edifices above a rocky coast in a similar manner. It may well be that this was the idea of Grigorije who perhaps

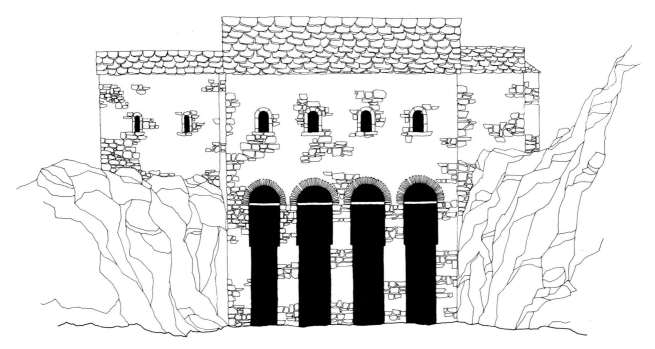

6. Hermitage, reconstruction.

brought the skilled craftsmen from Athos to Koriša for this purpose. Further westward, monastic cells were added which expanded the hermitage but their appearance and all the forms of the church and other structures at the eastern end cannot now be envisaged from the ruins.

The chapel near the cell was also painted with frescoes. The scenes that have been left of the life of Christ and the Virgin (Lazarus' Resurrection, the Annunciation of Anne, the Nativity and the Presentation of the Virgin) reflect the characteristics of the first half of the 14th century.

In spreading the cult of Peter the Hermit, Brother Grigorije built a church to him in the village of Koriša itself. He had it decorated with wall-paintings and supplied it with all necessities including a library. Somewhat later, in 1343, while making ready to start building the large monastery of the Holy Archangels which he ordained as his tomb – also near Prizren – King Stefan Dušan appointed Jakov as its first *hegoumenos*. Jakov was a highly educated and capable person who later become the Metropolitan of Serres. In order to help him carrying out his considerable duties and supervising the construction work, the King granted him St. Peter's church in the village as his seat and gave the aged Grigorije the old shrine of Peter of Koriša as his personal property.

The later lives of the monks in this hermitage following the lofty example if its founder left no significant traces, though a number of shrines were established prior to the fall of the Prizren region to Ottoman rule in 1455. They are known to us today mainly as ruins, as is the cell itself which survived the next two or three centuries. We know from a document written in 1572 that the monks transferred the bones of St. Peter to the Crna Reka Monastery which was hidden from sight and therefore less likely to suffer Ottoman violence.

The church of Studenica of Hvosno

One of the first bishoprics of the Serbian Church was established in Hvosno, the birthplace of the hermit Peter, sometime during the years of his spiritual maturation and search for peace in the Koriša cliffs. Directly prior to this, St. Sava with his reputation as a high-born monk who devoted himself wholly to the spritual life on Mt. Athos received from the Byzantine Emperor and Patriarch in Nicaea, the autocephalous status of the Serbian Church and was himself ordained as its first archbishop in 1219. Sava chose as the see of the Hvosno bishops an old cult center above the village of Studenica. This was an excellent site above a fertile valley across which spread the monastery estates. Here, too, an old custom of the Christian Church was repeated. This was to erect a new structure over partially restored ruins where believers gathered on holy days. It is not unlikely that in the early Byzantine period the seat of the bishopric was also located there. After the collapse of Samuilo's state and the revival of Byzantine authority in 1019, these parts, together with some others, were subordinated to the Ohrid Archbishopric. The deed granted by Basil II makes special mention of Hvosno as a part of the Prizren Bishopric.

Both the older and younger entities in the Hvosno Studenica were largely protected by late classical multi-angled ramparts and outer walls extending along the margins of the flattened slope, the last one above the plain where the Mokra Mountain hillsides end.

In the second half of the 19th century there still were remains of the old complex and its medieval structures ("huge and terrible cliffs"), but these descriptions are not all reliable. It was archaeological excavations which shed new light on their character and interrelations. In the meantime, the stonework – well-cut blocks, parts of the architectural relief and a slab with incised inscriptions – was used by the local population for their needs. As a result they can still be found on houses in the neighbouring villages. Marble pillars and ornamental blocks from the ruins were removed to Peć when a Turkish bath was built. Mainly shallow foundations were discovered in these structures. This indicates that initially there was a three-aisled basilica with a semi-circular apse and narthex. Within the bema, under the consistory table there was also a vaulted premise with steps leading to a reliquary, usually containing a special casket. The western part of the shrine, mostly ruined, has not been clearly delineated. But the eastern part proves that the basilica was built before the middle of the 6th century. The role of the diakonikon was probably taken by the small church of a simple, oblong form on the north side. It seems that it suffered less damage over time and perhaps was restored and served for rituals even before the erection of the episcopal complex within the Serbian Church.

Of special interest are the old underground barrrel-vaulted tombs on both the internal and external sides of the ramparts. They are a kind of sepulchral structure widely built in the Roman Balkans, in which number of built tombs have been preserved, but earlier frequent diggings, as elsewhere, have emptied the site of findings. The limited excavations prevent a full view of the walls with the stronghold. The stronghold in fact had contributed to the safety of this small but imposing unit with its entrance on the northern, most accessible side.

Earlier structures were probably conserved when it was decided to make the locality the centre of one of the bishoprics of the Serbian Church. Some of the later structures therefore relied upon the previous ones. Broad ramparts with expertly laid rows of bricks on top of the medieval stone

provided a sturdy foundation. Basically, by following earlier traces it was possible to retain the entrance on the northern side which was strengthened by other semi-circular towers in place of the ruined ones with their square bases.

The main church dating from the time of St. Sava and dedicated to the Dormition of the Virgin 7 replaced an earlier one with its apse stretching across the previous apse. But its forms did not repeat the character of earlier churches. Its ground plan can only be discerned in the shallow foundations of the old broad basilican space. By its spatial conception it represented the finalized form of the type of edifice usually called the Raška school in the history of Serbian architecture, since the time of Gustave Millet. This referes to a single-nave edifice with a developed altar space, a domed central bay enlarged on the south and north sides with rectangular choirs, and a some-what elongated space and narthex in the west.

It is likely that Žiča Cathedral was the model for Hvosno. It was precisely the former church that by closing the vestibules at the lateral ends of the subdomical area with separate spaces for the prothesis and the diakonikon completed the formation of the blueprint which was to cha-racterize the Raška school edifices of the 13th century.

In Hvosno as well, east of the choirs, it has been possible to recognize the square parts of the bema of which the northern part had a special ritual function. According to the Orthodox rite, sacrificial offerings were prepared in it and preserved after being consecrated.

As in other major architectural "schools" in the East and West, every structure varied the basic ground plans to a degree, observing not only the function of the individual parts but also their interrelationships. A careful comparison between the Hvosno Church of the Virgin and shrines dating from the first half of the 13th century points to similar relations and rhythms between parts and forms, as well as to the differences which were not only the consequence of the work of other master-builders but also of slight shifts in specific sequences in the elaboration of stylistic wholes.

A thorough analysis of the ground plans, especially of the details offering information about the statics and structural requirements of the foundation, can enable us to conjure up the former appearance of the ruined edifice and some of its forms. Thus here, too, only drawings of ideal re-constructions can show us what the probable aspects of these edifices were.

Unfortunately, many invaluable elements were removed from the site with building materials which otherwise could have made it possible to form a more accurate picture of the shapes of the upper parts of the church.

The dome, dominating the central part of the naos with four strong pilasters, stood on doubled 8-10 arches with pendentives that formed a ring-like base for the drum. The apse, whose opening was practically as broad as the entire naos, was externally square, while from the north and south sides it later got the rectangular spaces of the prothesis and diakonikon which were twice as wide as the transept sides.

The elongated feature of the edifice was emphasized but its general appearance was con-siderably altered by subsequent additions. Despite insufficient data for a fuller reconstruction of the whole complex, it is possible to assume what the basic structure looked like. In the spirit of Raška architecture, north and south of the narthex parakklesia were erected with smaller apses, externally less pronounced but of a rectangular shape. They were not directly attached to the narthex but separated from it with rather large walls, unusual for space of this size and function. This can be explained by the need to reinforce statically the upper, taller sections. It is rightly believed that towers also stood in these places, or on the western façade in the earlier architecture. The fact that an outer narthex was added to the western side also confirms this assumption. Its interior was certainly divided by columns while the bays were probably groin-vaulted. By analogy with other churches in which the bishops had their seat, it can be concluded that above the developed western part there regularly were catechumeni, well-known in the architecture of Mt. Athos. According to this biographer, St. Sava himself tried to introduce to his homeland the finest

7. Hvosno church of the Virgin, plan.

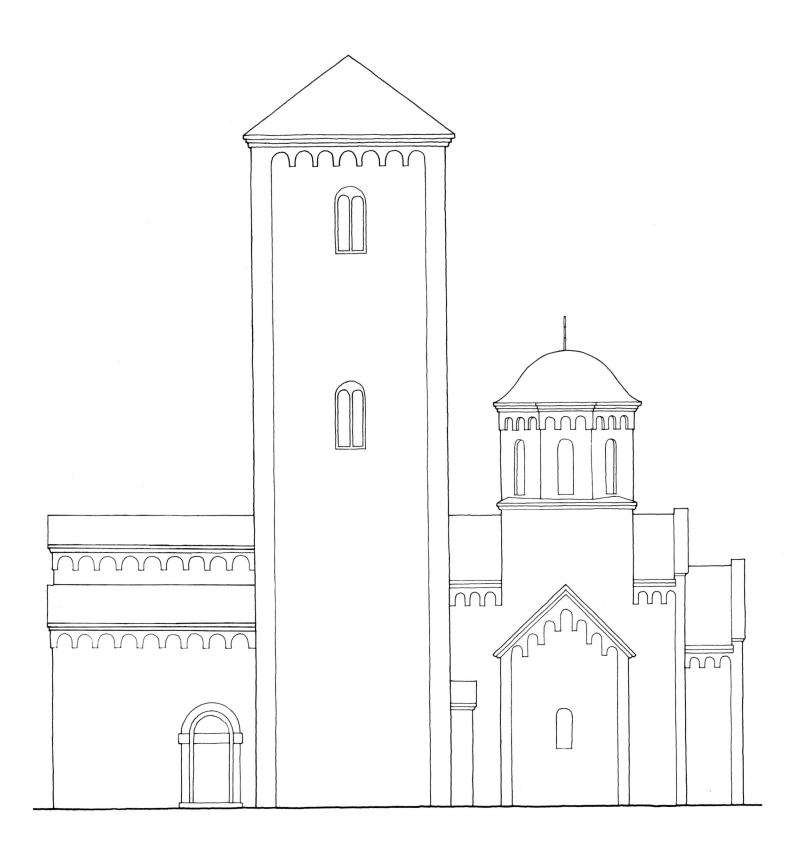

8. *The church, southern side, reconstruction.*

models; we can therefore assume that the catechumeni and the parakklesia built along the lateral sides of the katholika of the large monasteries (the Lavra of St. Athanasius, Iviron and Vatopedi) were built at Sava's initiative in Žiča. They then became a part of the building plans of the Raška builders. In the context of the Hvosno Studenica, it is possible that there were premises above the exonarthex and the parakklesia which would explain the meaning of the narrow "passages" on both side of the porch. Across them it was possible, by means of a staircase, to reach a cat-echumen and the towers from which the bells were rung.

The general similarity to the Saviour's Church in Žiča, including the presence of the outer narthex and towers, leads to the conclusion that the Virgin of Hvosno belongs to the earliest shrines raised following ecclesiastical independence, that in fact it had its origin in the third decade of the 13th century and its exonarthex, parakklesia and towers in the following decade of that century.

The preserved lower parts of the main church, although relatively modest, speak interestingly of the origin of the builders employed to raise it. These sections were made of stone with a façade of *tufa*, a material easily hewn and fashioned into light arched and vaulted structures. The remaining parts exhibit tiers of accurately dressed stone typical of the stone-masonry workshop which produced the Romanesque churches in the Zeta coastal area. The flat pilasters strengthening the façade and the aspect of the altar apse conform to this tradition. On the outside, the square shape characterized a large number of 9th to 12th century shrines in Dioclea and in the Bay of Kotor. To this, one must add relatively simple Romanesque capitals with leafy designs, perhaps a fragment of the church furnishings belonging to the same style. Everything therefore leads to the conclusion that these experienced stone-masons with their feel for proportion came from the Adriatic coast, perhaps from Kotor itself, whence builders had previously come to Serbia. The open circulation between the Adriatic coast and the interior, especially with Kosovo, was intensified even more once these areas found themselves within the borders of the Serbian state.

The interior of the church was covered with frescoes whose fragments indicate that the walls were painted on two separate occasions. The few remaining fragments do not however help us to say more about them.

The monastic complex also contained other buildings. To the south, near the ramparts, another smaller elongated church seems to have been built in the 14th century, while in the northern section we can see a large portion of a fairly spacious rectangular refectory whose end with apse is

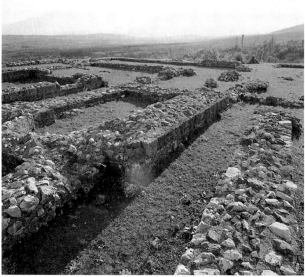

9. *Monastery grounds, airview of remnants.* 10. *Foundations of the Monastery structures.*

in ruins. The refectory was not, interestingly, located at its usual site, west of the narthex from where monks collectively went to their meals. The choice of the site here is probably due to shortage of space.

Even if the ruins could provide a hint of the basic forms of the main structures it would be difficult from the scant written sources to reconstruct the rich history of the monastery and the Hvosno bishopric's see during the several ensuing centuries before this shrine met its end, first damaged by a destructive fire and then abandoned during the Great Migration of 1690. We do know, however, of the lives of several distinguished Hvosno hieromonks, bishops and metropolitans whose tombstones have been preserved. We are also aquianted with their writings, transcription and book-binding activities. Some record of their artistic accomplishments has reached us. Before the second world war by strange coincidence, a large bell was dug up along with precious embroidered and painted cloth that had been hidden by the monks at a time when they had to abandon their dwellings. A large epitaphios, in the Peć Patriarchate today, was the work of an excellent artisan from the early 14th century while the famous writer and painter, Longin, who occasionally stayed in Hvosno prepared a wonderful drawing as a young man to serve as the design for a large aer in 1597. All these are, nonetheless, but pale reflections of the opulent interiors and treasures which were once collected in this episcopal center. Today the past of the monastery can be evoked only by the ambience and treasuries of monasteries which are still standing.

The church of the Holy Virgin of Ljeviša

From Byzantine times, the church organization retained an episcopate in Prizren and the Cathedral in Ljeviša, a present-day densely populated town traversed by the Bistrica River. The old center was renovated at the time, but only for the needs of the new eparchical administration. Its appearance was radically altered only later, at the outset of the 14th century. The broad, three-aisled church with external three-sided apses and a narthex open toward the church interior, was lighted by windows above the lateral naves, while archaeological investigations have shown that the western façade had a porch with lateral low spaces similar to those along the narthex. It is difficult to ascertain the date when the basilica was erected despite many analogous examples in

19

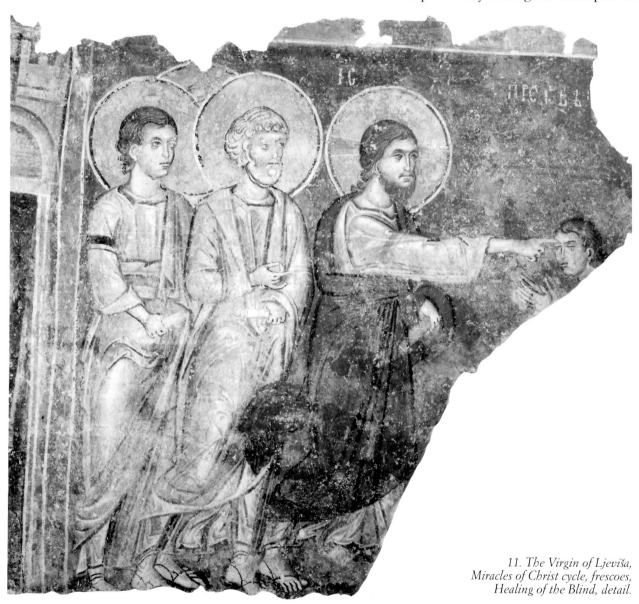

11. The Virgin of Ljeviša,
Miracles of Christ cycle, frescoes,
Healing of the Blind, detail.

the architecture of the Eastern Christian world, because it belonged to a type of much earlier Byzantine traditional structures such as prevailed even after the re-establishement of the Emperor's authority in these regions. A number of marble fragments from the low altar screen typical of the 6th century testify, as in Hvosno, to the existence of an earlier Christian shrine in this locality. In the 11th century the church was, without a doubt, the seat of the Prizren bishops as cited in a document of Basil II's, in which he confirms the rights and defines the extent of the Ohrid Diocese. For their part, the scant but valuable fragments of bas-relief ornamentation carved in the walls were built later, also confirming by their plasticity and style that they belong to the same period.

There are no indications that after 1219 the Cathedral, as part of the Serbian Archbishopric, altered its appearance in any essential way. Conservation excavation has indicated only that the church's lateral aisles – previously covered by a wooden construction – were then placed under a single roof.

The Church of the Virgin of Ljeviša, on the other hand, was soon afterwards enhanced with new wall-paintings, but the remaining fragments exposed when restoration work removed the outer layers, revealed only a small part of the once elaborate frescoes. A fairly well-preserved depiction of the Healing of the Blind and an image of the Saviour from the Wedding at Cana, 11 were a part of Christ's Miracles, painted on the western wall which separated the central nave from the southern aisle. In addition, a rare iconographic image of the Mother of God with Child *PLATE 29* bearing the epithet of "Provider" and holding a bread-basket was uncovered behind a pillar.

The representations here are cheereful, of simplified form and painted in light colors, thus demonstrating that they had already moved away from the expressiveness of the late Comnenan period which lasted longer in some of the areas of the Byzantine stylistic circle. Nonetheless, some of the saints' features and the trembling folds of the draperies indicate that there still prevailed an enduring tradition of the grand, universal style which was gradually transformed in various ways that led to blunting the sharpness of the linear brush strokes and softening the dramatic tensions of the depictions.

The particularities of the older paintwork in Ljeviša were not an isolated phenomenon in Serbia. They were similar to the frescoes in the parakklesion of the St. Nichola's Church in Studenica, and in the diakonikon of the main church of the Morača Monastery. It may therefore be reasonably asserted that they were the work of master-builders belonging to the same work-shop that was active in the second quarter of the 13th century.

The church of the Holy Apostles in Peć

PLATE 1

A structure added to an earlier place of worship near Hvosno at the point where the Bistrica River emerges from its lengthy and picturesque gorge was of far-reaching significance for the overall subsequent life of the Serbian Church. The site itself with its fortification was called "The Gorge," while the numerous caves scattered about on its rugged cliffs, deep and often hardly visible, gave the neighbouring village its name of Peć (cave). Because these grottoes were very early populated by anchorites this locality was placed under the aegis of the Žiča Monastery and together with them, mentioned in the very first deed granted by King Stefan Provovenčani (the "First-Crowned"). Moreover, the entire region was called Metohija (Metochion, in Greek) by token of these monastery estates.

The extensive Žiča holdings and the monastic community were governed by the Archbishop; it was therefore logical that the churches on these estates were built at his behest, often under his direct supervision. The renewal of an earlier single-nave church in the Peć area and the structures added to it are ascribed by Archbishop Nikodim in 1319 to St. Sava himself, who is also mentioned as its founder in an inscription under his somewhat younger portrait inside the church. It may well be that this first Serbian Archbishop was engaged in the raising of a church in the remote locality of Žiča, but there is reason to believe that Sava's successor Arsenije (1233-1263) deserves full credit for the undertaking. The long ceremonious inscription under the Deësis in the altar apse ends in a prayer with his name at the close of it. The interior of the church

PLATE 2

dedicated to the Holy Apostles was painted in the years between 1250 and 1260. The Archbishop himself manifested his ties to this locality by his decision to be buried there. After his death, when it became known that miracles occurred about his tomb, the church was referred to as Arsenije's.

Of the earlier building, dating from the 11th century, the elongated naos was retained, while the remaining parts were expanded on in the Raška architectural mode. Here, too, a dome was

12,13

built over the central space against the gently pointed arches with pendentives whose lower, square area was shaped into a circular base of the drum. The subdomical area was, by custom, enlarged with rectangular choirs while on the eastern side the altar space was extended with a bay that enabled freer circulation. At the same time, a separate prothesis and diakonikon were erected on the north and south sides, both vaulted and ending in semi-circular apses.

The remains of the walls outside the present foundation have not been sufficiently investigated; it may well be that there were parakklesia originally on the lateral sides which were later removed when larger churches were raised on these sites.

PLATE 3

The fairly rough manner of construction here was perhaps a reflection of the modest monastic environment for which the church had been commissioned. However, the forms and construction design of the church demonstrate the builder's skill and assurance. He covered the façade of the building with mortar and, as in Žiča, by emulating the Mt. Athos churches, he painted it in a vivid shade of red. The monastic tradition interpreted this colour as being the blood of the martyrs who perished for the sake of their faith.

Regarded as a part of the Raška architectural school in which every monument – despite its similarity and kinship with other monuments – had specific traits of its own: the Church of the

Holy Apostles had a plan and spatial conception as well as certain forms that corresponded to the ecclesiastical needs of the Eastern Church and belonged to Byzantine tenets. At the same time, however, the specific method of construction revealed elements indicating that the skills and practice of western builders had been mastered and that analogous edifices could be found along the coast and on the opposite shore of the Adriatic Sea.

The interior decorative elements of the Holy Apostles, despite its damaged aspect in its present-day impoverished ambience and the changes that took place in later centuries, still present a fairly rich picture of the spiritual life and sophisticated ideas of the time. The church's iconography and artistic craftsmanship, more than the edifice itself, its size and character, prove that on the estate of the Archbishopric, it had acquired a special place not only within the borders of Žiča, but also throughout the land. Above all, the wall-paintings show that already by Archbishop Arsenije's time the sepulchral character of the church was emphasized by the presence of a sarcophagus in the western part. Moreover, the idea that the church should become the resting place of other Serbian prelates had certainly been widely adopted when Arsenije's successor, the second member of the Nemanjić dynasty, namely, the youngest son of Stefan the First-Crowned, Sava II (1263-1271) was buried there. The dedication of the church to Christ's disciples was undoubtedly inspired by the grand Church of the Holy Apostles in Constantinople, built at the time of Justinian. the Serbs were well aware that the church, with its appearance, reliquaries and other treasures as described by countless pilgrims, was the mausoleum of a number of Byzantine emperors, and especially of the Ecumenical Patriarchs. The dedication was, of course, linked to the missionary calling of the highest ecclesiastical dignitaries in the Orthodox world, so that the choice of patron for the church that was being built, had the same role in Serbia.

The historiography of art has long endeavoured to discover the specific thematic and ico-nographic elements that reflect the spiritual atmosphere of the environment to which a church belonged, as well as to ascertain the immidiate historical circumstances that could have influenced the choice of depiction to be drawn and the ideas they purported to express. In this sense, much attention was earlier paid to Žiča, the first independent see of the Serbian Church. The bulk of its wall-paintings had been damaged and replaced at a later date (1309-1316), but it is assumed that they repeated the earlier themes and disposition of St. Sava's times. The conclusions arrived at also refer to the Peć Church, because it was precisely the cathedral church that they took as their model not only for its construction but also for its decorative elements.

The sepulchral nature of the church was primarily expressed by the monumental painting of the Deësis in the spherical part of the broad apse, clearly visible above the low altar screen. The church-goers knew that the prayer to the enthroned Christ offered by the Virgin and St. John Prodromos referred mainly to the dignitaries buried there. But the believers were themselves comforted by their faith in salvation and by the knowledge that grace would be granted them on Judgment Day, the depiction of which on the walls showed the same personages in iconographic form as defenders of the human race.

In the lower part of the church, as was customary from the end of the 12th century onward, there is depicted the Service of the Hierarchs together with a series of the most prominent repre-sentatives of Christian teachings, holding scrolls with excerpts from liturgical prayers. It is note-worthy that this prosession ends with the figures of St. Sava of Serbia, the already deceased and widely venerated founder of the autocephalus Serbian Church. Even earlier custom allowed that eminent prelates of local churches could be portrayed in the altar space, while from the 11th cen-tury onward they appeared not only as a part of the autocephalous archbishopric, as in Ohrid and Cyprus, but also in a series of other bishoprics, principally in the Greek ones. It was natural for the image of St. Sava to have first appeared in the Church of the Holy Apostles in Peć as it was most closely linked to the very heart ot the Serbian Church. Possibly about the same time an artist of less expressive power repeated Sava's image in the prothesis, representing him as officiating

PLATES 13-15

15-16

14

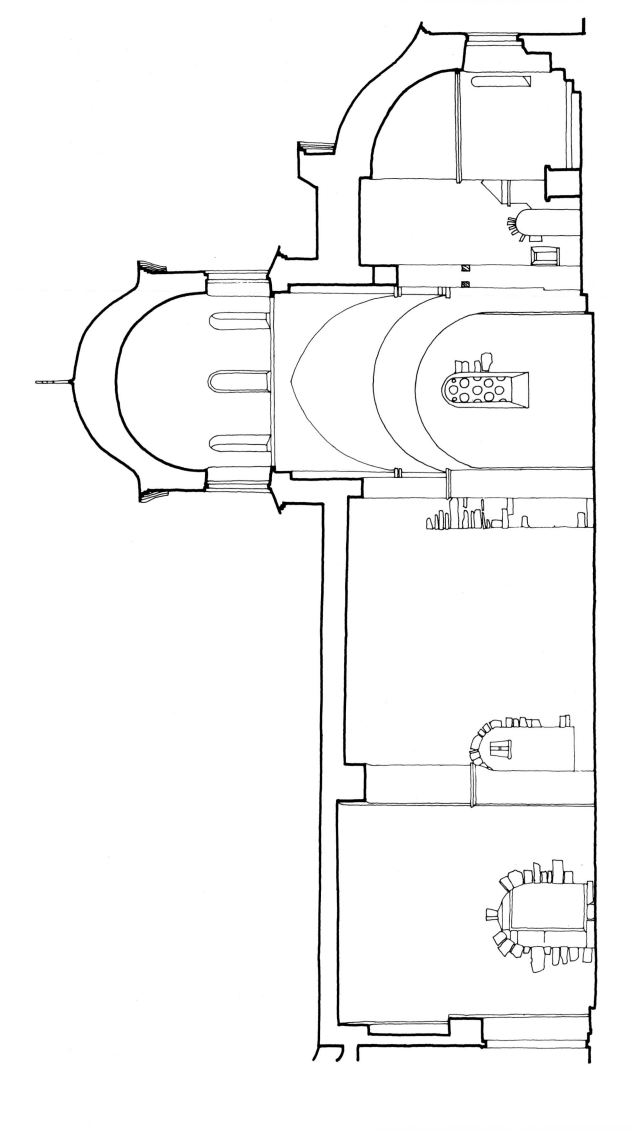

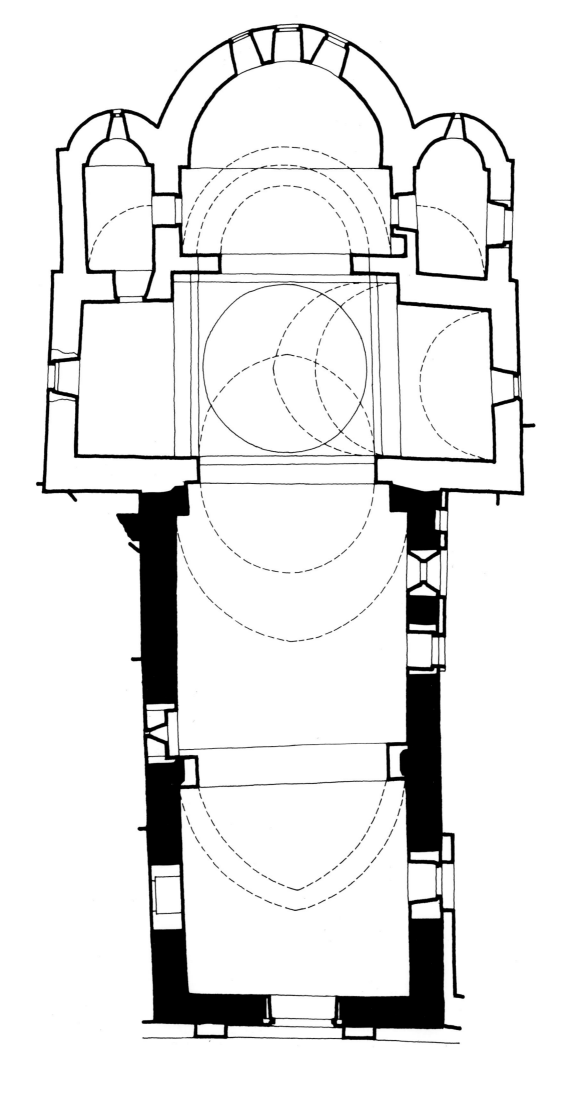

12-13. *Patriarchate of Peć, Holy Apostles, section and plan.*

PLATES 18,19

together with his successor Arsenije, but without the other holy fathers to whom this act should have been a priority honour.

The frescoes in the cupola and subdomical area express a complex and unique notion: on the broad circular surface painted in ochre tones conjuring up the light enhanced with gleams of the gold leaf in the painting, Christ seems to ascend towards the dark azure of the sky, leaving behind him the disciples with the Virgin and the Archangels disposed between the windows of the tympanum. As usual, on the pendentives below them the Evangelists are shown as engaged in writing the Saviour's life. Between them are the figures of Christ in Mandylion and Keramidion. But on the divided surfaces formed by the substructure of the dome, a number of episodes are illustrated in a special layout which totally differs from that depicted in other cycles. On the western side is the Sending Out of the Apostles; on the southern side is the Resurrection of Lazarus and the Doubting Thomas, while on the northern side is the Last Supper and the Descent of the Holy Spirit. In this unusual disposition, the paintings on the eastern surface, probably of the Annunciation, are no longer visible. The reasons for this manner of linking scenes from various thematic entities have been sought in the statements made by Archbishop Nikodim (1317-1325). In the Preface to his translation of the Jerusalem Typikon from Greek, done in 1319, the head of the Serbian Church notes that St. Sava built the church in Peć modelling it on the famous and sacred Jerusalemn edifice visited by Sava in his journey through Palestine. This refers to the church in Zion and the monastery of St. Sabbas the Consecrated. This connection should not be interpreted as meaning that the shape of the models was emulated, but that their significance was invoked. Of the episodes to be painted in the central part of the church, three were chosen from the upper part of the Zion church: the Last Supper, the Doubting Thomas and the Descent of the Holy Spirit.

The supposition that it was precisely the Zion church that served as a model for the Serbian sees in Peć and Žiča, becomes more convincing if we bear in mind that up to the 12th century, Zion, too, had been dedicated to the Holy Apostles and that Christ, before the Ascension, sent his disciples out to preach the new faith from that very church. The iconography of the Peć church, closely connected with Serbian Church leaders, was directly concordant with the scene recalling their apostolic role. Finally, in view of its significance, the church in Zion was called "The Mother of all Churches" and therefore this appellation was conferred in Serbia on the cathedrals in Žiča and later in Peć.

By being arranged along church's walls whose surfaces were not always suitable for complex compositions, biblical scenes were adapted to the space available, but not always in a harmonious relationship in the architectural framework. Their simple depiction with an orthogonal projection of the ambience and its forms belong mainly to the tradition of earlier artwork. A new period in the development of the so-called monumental 13th century style portrayed mature and powerful plastic forms. The pictures are dominated by figures interpreting events in darkly resonant colors with surfaces lit by sudden rays of light and faces with gleaming eyes and finely modulated brighter tones. The surprising facial expressiveness is barely supported by the ancillary elements as, for instance, in the Ascension episode which is a veritable masterpiece but has only frail tree-trunks in the background. The highest achievement of these artists – analyses indicate that a number of hands were at work here – are testified to by the individual portraits and group figures deftly accompanied by seemingly neutral yet tastefully coloured surfaces and interiors. The scenes of the Doubting Thomas and the Resurrection of Lazarus are examples of such a pictorial language, though an archaic one, due to the exaggerated size of Christ's figure which nonetheless is successfully adapted to the requirements of the available space. The former scene is depicted with firm symmetry under a gently pointed arch, and the latter on an irregular segment of the vaulted field. Both evince an exciting rhythm in which the elements of the richly narrated stories are arrayed.

Certain figures of the Apostles, especially the younger ones, evoke reminiscenses of the Hellenistic legacy, so discernible in the radiance and gentle sensuality of the figures that could not have been seen in the works of an older, severer spirit. It was as if the artisans glanced back to the earlier works and directly copied their delineations, their plasticity and color harmonies. This was not a new phenomenon: Byzantine art always relied on classical models, sometimes in waves felt powerfully during specific epochs, creating unique paraphrases leading to a distinct style. Broadly speaking, the Peć artwork was not isolated in this sense but it came at the outset of a period in Serbia that reached its fullest expression in the more recent Sopoćani church.

It is not easy to fathom the environment in which the Peć artisans were trained nor the traditions they followed. It must assuredly have been a matter of the involvment of some larger centres where a broad artistic culture could be attained and where there were monuments and collections of old manuscripts that preserved the traditional artistic accomplishments and transmitted them to subsequent generations.

During the ensuing decade, the Archbishopric's Metochion in Peć enjoyed a calmer existence than the Žiča centre which was threatened a number of times and which finally suffered from hostile incursions from the north. This was why the remains of Archbishop Joanikije (1279-1286) were transferred to the Holy Apostles. At the same time, valuable objects which were a temptation to attackers were also removed for safe-keeping. It was recorded that the governor of Vidin, John Šišman, descended to "The Gorge" itself (1291-1292) with the intention of seizing the treasures of the Church of the Saviour. It was under this name that historical sources referred to the Church of the Saviour's Ascension in Žiča. But the same appellation was later also given to the Peć church together with the role it had acquired in the last decade of the 13th century. For after the calamity that had befallen Žiča, the Serbian Archbishops temporarily moved to Peć. In recent times, it has justly been observed that this move did not simply mean transferring the see of the Archbishopric, but also taking over some of its functions. Žiča continued to be regarded as the centre of the Serbian Church whose prelates occasionally sojourned there in later centuries as well. Neverthless, the ecclesiastical administration gradually shifted southwards where, in the following period, the residences of the Serbian kings were frequently located.

Parallel with these developments, the anchorites continued their peaceful lives in their nearby cave abodes. At the time of the Archbishop Jakob (1286-1292), two Greek monks left a Dečani

14. St. Sava, altar zone, fresco, detail.

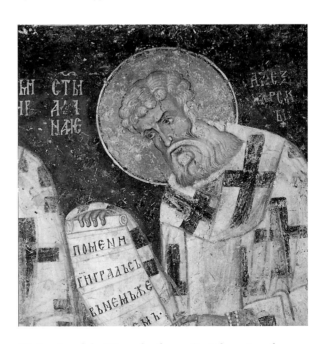

15. Service of the Hierarchs, fresco, St. Athanasius of Alexandria, detail.

cell for Kotrulica, doubtlessly one of the caves in the Bistrica river Gorge of Peć. Their cave was
"enclosed" with walls for their needs. Like other hermits, they spent most of their time in
isolation and only on Sundays descended to the Church of the Holy Apostles for prayers and
communion.

Today one can still see a number of these hermits' caves on the left side of the river. As in
Koriša, the Peć dwellings were enclosed with walls that have been preserved in many places,
some of them several metres high. Here, likewise, in places set aside for religious activities, traces
of frescoes are still visible. These rough-hewn abodes were usually inter-connected by steps
carved into the rock or else made of wood which also covered the light roofs and the narrow
passages. Incised supports that carried the wooden beams can still be seen on all sides. However,
some of the cells could be reached only by rope ladders, while heavy loads had to be raised by
pulleys.

Thus these modest dwellings whose living conditions were made even more arduous by rain
and snow, and their accessibility most hazardous, were neverthless islands of intensive intellectual
activity. The renowned writer and subsequent Patriarch, Jefrem, between 1355 and 1371 wrote
most of his canons and 170 stychiria in such a cell, where the scribes did not enjoy any better
conditions. Thus, there are no grounds for the generally held belief that the scriptoria were
housed in spacious, specially built premises. Examples from the Meteore in Thessaly likewise
confirm the fact that those cells, clinging to the cliffs like nests, also produced exeptional works in
the fields of transcription and illumination.

The sudden assaults from the north were a concrete reason why the site of the Church of
the Holy Apostles had to be protected by a fortification. Like other monasteries in similar
locations, attacks on the monastery and church coming from the heights above them, had to be

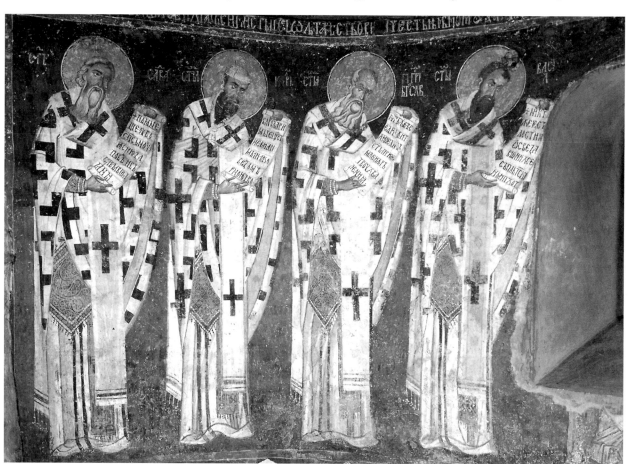

16. Service of the Hierarchs, fresco, 1260 ca.

withstood. Ramparts were therefore built up on a steep incline forming a stronghold of a triangular base. From its highest point, one can still clearly see the lower portions of the formerly stalwart tower.

18

The frescoes in the western part of the Church of the Holy Apostles were painted during the closing years of a century that brought about certain changes. These were probably the work of Archbishop Jevstatije II (1292-1309). We learn from his biography that he had earlier been engaged in restoring the burned church in Žiča. In Peć, it was necessary to undertake the first indispensable renovative work in the interior of the church where complex divine services had to be held with the participation of a numerous clergy.

At present we do not know what all the wall-painings were like, since the original frescoes in one part of the subdomical area were replaced by later ones. But the faithful entering the church were welcomed here by impressive scenes on walls that had in the past been better illuminated. In PLATE 4 two of the highest zones of the church, along the broad, vaulted western wall, the episodes of the Sufferings of Christ and above the entrance, the figures of SS Constantine and Helena, are portrayed while on the left and right sides, we can see the large busts of St. Nicholas and the Virgin. In the lowest zone where, judging by the fragments, there were the portraits of the members of the dynasty, the only remaining figures are those of Kings Stefan the First-Crowned and Uroš I. Both PLATES 5, 6 are clothed in monastic vestements and both are named Symeon, a name they assumed after retiring from the throne in order to emulate the venerated founder of their family. These latter portraits no longer belong to the traditional donor composition in the form of a procession headed by Symeon Nemanja and approaching Christ or the Virgin to receive their Grace. Nor are they characterized by earlier assiduously delineated facial features. These scenes were done by painters who favoured robust shapes while eschewing delicate modelling and creating artwork of totally different configuration. Their spirituality was best expressed in the dynamic scenes of Christ's Sufferings drawn in a continuous sequence with emotional gestures in a setting of intricate architectural tracery. Among the Serbs, this was the first "new wave" monument, usually referred to as the Palaeologian style in Byzantine art. Somewhat prior to the Peć frescoes, the distinct new traits were manifested in 1294-95 by masters Michael Astrapas and his assistant Eutychios in their first famous monument, the Virgin Peribleptos in Ohrid. These accomplished artists, schooled in

17. The Gorge of the Bistrica overlooking Peć, hermits' caves.

18. Upper part of the fortress and ramparts that protected the Monastery at Peć.

Thessalonica where other members of the Astrapas family also participated in the city's intellectual and artistic life, worked together long afterwards, predominatnly in Serbia. It has not been proven that they made additions to the frescoes in the Church of the Holy Apostles, but this could have been done by one of their assistants or by artisans with a similar training background. Parallel to them, other painters traversed the same developmental path, altered the church programmes and iconography and, in particular, the artistic expression. Members of the old Constantinople studios whose monuments are less known today, also had a large share in effecting these changes. The Protaton frescoes in the large three-aisled church in Karyes on Mt. Athos are essentially similar to those in the church of the Holy Apostles, although they exhibit a greater measure of refinement and softer modelling. The two monuments, however, display a greater degree of refinement and the softness of modulation. They did not conserve the signatures of the artists nor any other inscriptions relating to the patrons of the church or the dates of their painted creations. It is only the Athonite tradition that has long and insistently been attributing the frescoes of its main church to well-known artist Manuel Panselinos. Those frescoes could have originated around the year 1300, as did those in the Church of the Holy Apostles. The subsequent development of this style, it will be seen, can be followed in the somewhat later churches in Kosovo itself.

The Fourteenth Century: Perseverance and Flourishing

The church of the Holy Virgin of Ljeviša

The Prizren bishop Sava – subsequent Archbishop Sava III – endeavored to restore his cathedral church in the 14th century. The old basilica was no longer used significantly, in the physical sense, except for the lower parts of the walls and the interior piers; its spatial plan and exterior therefore acquired a totally different appearance. This time, the Raška tradition was abandoned with its domed single-nave church, the choir transept and the parakklesia. The broad central nave of the former cathedral was divided by a double row of piers forming a cross-in-square in the style of Byzantine architecture. This notion suggested a more complex interior easily perceived from the outside: the branches of the central and transversal nave were taller than the other parts of the edifice, while a cupola was built at their intersection on a square base. Counter-balance to the dome was achieved by four much smaller cupolas placed toward the ends.

Deftly adapting the lower parts of the cathedral, the experienced builder formed a kind of de-ambulatorium from the lateral aisles and narthex such as were also known to urban and mo-nasterial Byzantine builders in various forms. The new entity, therefore, represented a specific, essentially five-aisled edifice with a cross and five cupolas in its central area. This structure, retaining the dimensions of the old basilica, resulted in its elongation, unusual for architecture of this type with added cupolas at a distance from the central one. Its interior divided by piers into a number of segments acquired an exciting rhythm, increased by the mysterious play of shadows and depths resulting from scant sources of light. Of exceptional interest is the exonarthex with its open ground-floor, also lying on the foundations of the old portico, while on the upper floor are two closed areas of the parakklesion with a raised bell tower. There are numerous instances in the cathedrals of the Raška school of external narthexes added on with one or two lateral or frontal towers, but in Prizren these parts were built at the same time and comprised an integral structure. The bell-tower itself with a wide arched passage on the ground floor and a large two-light mullioned window on the upper level emerges through the body of the exonarthex to rise, with its free upper section, high above the church's dome. Open on all sides so that the entire town could hear the church-bells, its light-weight construction and transparency as well as sturdy proportions embrace the ceremonial western side of the complex. Today, however, like so many other monumental façades it is obscured by a network of narrow streets of the thickly populated quarter "on the Ljeviša," as this part of the town was known in the Middle Ages.

The variety of the construction elements used in rebuilding the Prizren cathedral can readily be noted in its interior arches adequately following the nature of the available space. But the real wealth of forms and architectural texture is most obvious in the façades, till then unknown to Serbian architecture. In keeping with Byzantine building methods, the façade was made of blocks of warm-toned *tufa* with bricks of different shapes and shades and broad sculptural clasps, altogether creating rich surfaces and warm color blends. The façade itself is highly diverse with its apertures, lunettes and archivolts, shallow pillasters and niches. Some of them, especially elements of the arches, were made exclusively of bricks in multiform sequences and free motifs without regular repetitions, ranging from decoratively disposed elements to a series of delicate

ornaments formed, for instance, by the stylized patterns of wavesets or incised cross-like small vessels.

25-27

This manner of elaborating the Ljeviša façade was a novelty for the Serbs and meant that the earlier, simple broad wall surfaces had been abandoned, but more than that, it was the most representative expression of a long and carefully nurtured practice which had produced major works throughout Byzantium. As was often the case in both earlier and more recent history, examples similar to these Serbian structures in Serbia are preserved in Thessalonica. Still, immediate influences on the skillful builders who restored the Church of the Virgin in Prizren would to all appearances have to be sought in the workshops of Epirus. From there, particularly in the 13th century, builders fanned out over a broad area; their techniques could be recognized in places which, after the Serbian penetration into the northern regions of Byzantium, lay within its borders.

Two inscriptions on the external side of the altar apse are testimony to the building of the church and those people associated with it. Done in a rare form of full, clear lettering as was the custom of the time, the inscriptions were pressed into soft clay, which was fired and built into the 24 wall as an ornamental band. The higher, shorter inscription mentions Prizren Bishop Sava whose share in the restoration work is recalled by other bricks (five of which have survived) and which simply note the bishop's name without hierarchical titles. The lower, longer text cites, in a first- 27 person statement by the founder of the church, King Milutin himself, that he "maintained the Church of the Virgin of Ljeviša" from the very moment of its foundation. At the end of the inscription stands the year 1306-7, probably indicating the date of the building of the eastern section rather than the completion of the entire church.

After reconciling with Byzantium and marrying Princess Simonis, the daughter of the Emperor Andronikos II, King Milutin was at the threshold of large-scale undertakings which lasted the duration of his reign (1281-1321). Before that, he had built a new church on the site of an old katholikon dating from the time of St. Sava and St. Symeon Nemanja, without a doubt the most significant of the early Athonite shrines to survive. This was followed by raising and restoring churches and monasteries in his own country, marking a new era in the history of Serbian architecture (St. Niketas near Skoplje, St. Joachim and Anna in Studenica, Staro Nagoričino and St. Prochoros Pčinski near Kumanovo). Banjska and Gračanica were in Kosovo, in addition to the Virgin of Ljeviša. A most active benefactor at home who enjoyed the support of his prelates at a time of internal rifts, Milutin gained renown by also building shrines and donating churches to large centers abroad. He built a church and a hospital at the Petras Monastery in Constantinople where the sick were cared for by physicians surrounded by famous medical codices. Milutin built his palace and the Church of St. Nicholas in Thessalonica, while within the Chilandar Metochion he erected the church of St. George. In Palestine he assisted in the restoration of shrines which included the monastery of St. Sabbas the Consecrated near Jerusalem, inhabited by Serbian monks.

Generally speaking, the restoration of the Ljeviša church was an articulation of new circumstances and close ties between the Serbian ruler and Byzantine social and artistic life. In this context a new spirit suddenly dominated architecture, especially sacral architecture, which did not exclude western building traditions. The latter were also in evidence during the subsuquent decades, particularly in Kosovo and, naturally, in its westernmost parts. A skillful master mason undoubtedly from the coastal area recorded his share in the work on the Virgin of Ljeviša at the entrance to the church from the outer narthex. Being entirely in the tradition of the Byzantine style, the church did not have the monumental Romanesque portal which was typical of the Raška school, (an open porch, vivid detail and a bell-tower imposing its solemn character on the front). The stone-cutter, therefore, applied his western-type skill to the execution of the stone doorposts and architrave. A curling design emerges from the dragon's mouth at one end, hovers over all the

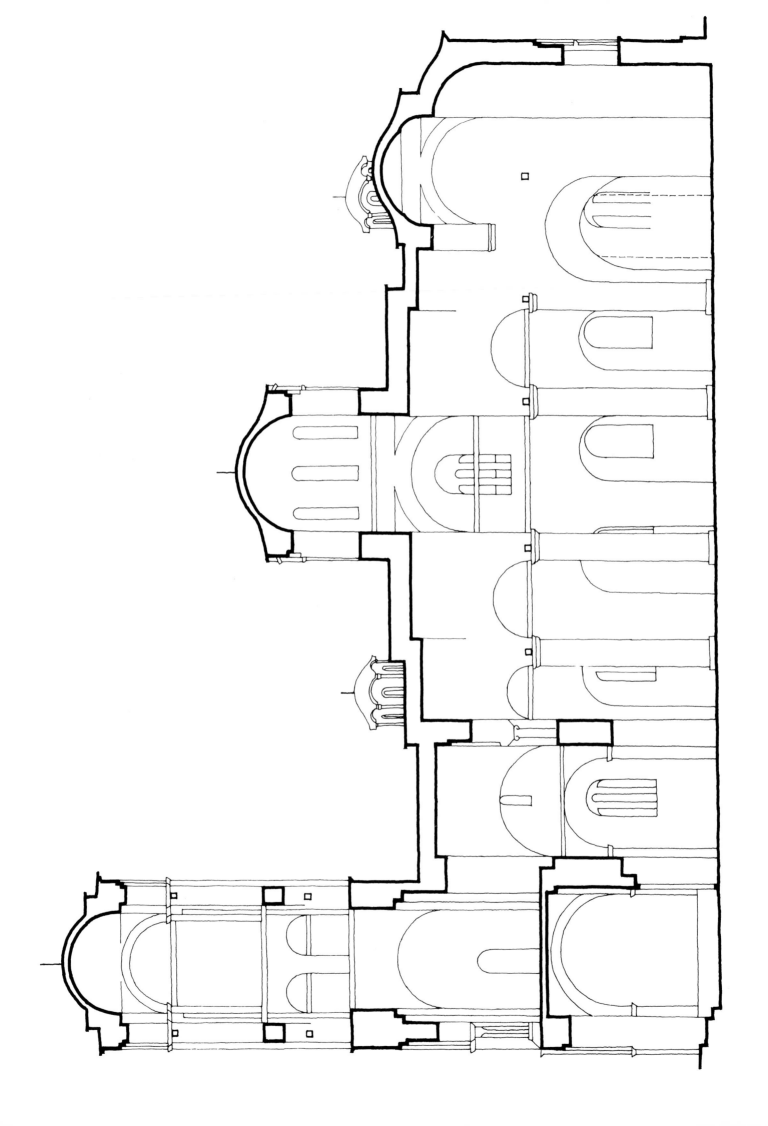

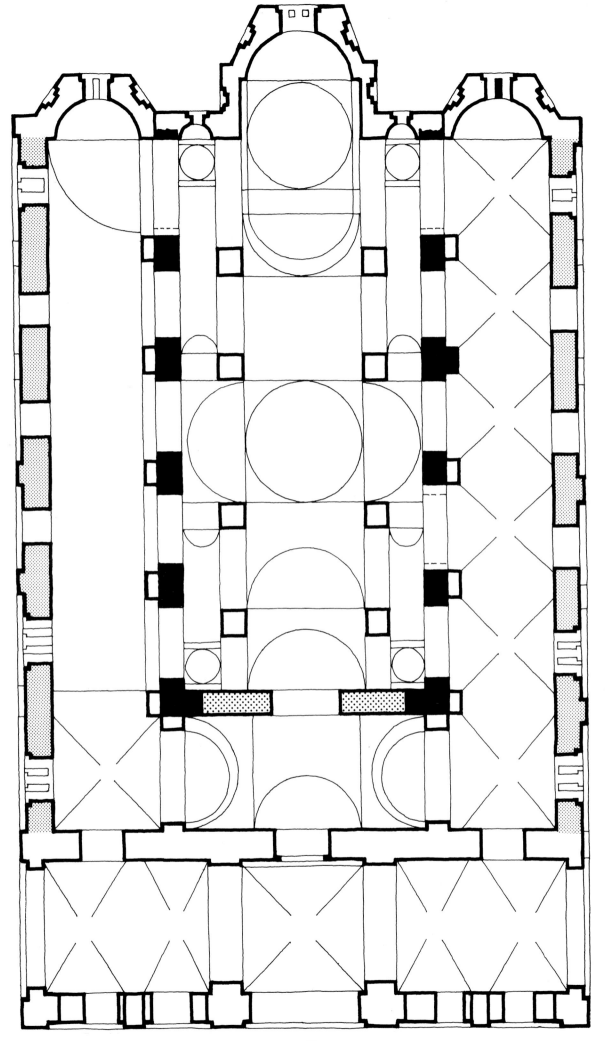

19-20. *The Virgin of Ljeviša, longitudinal section and plan.*

surfaces except in the center where a representative of celestial powers, a six-winged seraphim, blocks the entrance of the evil powers while reminding the approaching believer that his heart must be pure. As part of the painted decoration, this was usually conveyed by Archangel Michael with his unsheathed sword and unfurled roll of unequivocal warning. The vine and floral pattern which had been around for quite some time in the Romanesque tradition was to be found on later shrines as well, especially in Dečani which was decorated by master-masons from the Adriatic coast.

These heralds of new ideas and the builders of early shrines in Serbia, have mostly remained unknown to us. However, the name of the talented craftsman of the Prizren cathedral was unexpectedly recorded. As was the custom, several years after the completion of a building, the interior would be painted. The painting included the arches and sides of the portico in front of which the commotion of town life never ceased throughout the day, even in the Middle Ages. This open space was a link between the church and life outside it where local and foreign tradesmen, emissaries and messengers, soldiers, merchants and travellers walked by, but most of all the poor from near and far came to the church for alms. Among the Serbs, as in Byzantium and the West, monasteries gave food to the poor and to all who came to their gates. On certain days people who came were offered wine, and on special occasions even money. The first *typica* of Hilandar and Studenica monasteries in the early 13th century modeled after the constitution of the famous Constantinople Monastery of the Virgin Evergetis prescribed the charitable duties of the fraternities. These instructions found a place in the middle of the next century in strict provisions decreed by Emperor Dušan's Law Code which stated: "...and in the churches, the indigent are to be fed as the founder decides, but if a metropolitan or bishop or *hegoumenos* fails to do so, he is to be stripped of his rank." Just as the wall near the entrances to the monasteries were inscribed with the charter of the founders confirming their privileges and properties, so in the exonarthex of the Virgin of Ljeviša there is a record of how much aid was to be distributed to the poor. These words were inscribed on the arched surface of the entrance in fresco technique and were certainly an excerpt from the lost deed granted by King Milutin which is only partly preserved here and which ordained that at all times in summer and in winter, food and drink and salt were to be placed "at the portal." Interestingly, this order contained a statement to the effect that the same amount of food was given to master-builders Nikola and Astrapas who "built the church and painted its interior."

There is no indication of the builders' origins following this mention of their names. In the Serbian inscription the name Astrapas given after the name of Nikola may refer to a man from Greece where architecture of this style was nurtured. It has been noted, however, that Astrapas appears in another instance as the name of a master-builder who, with his brothers Djordje and Dobroslav two decades later, is mentioned in a deed given to Dečani monastery. Nikola evidently worked for King Milutin but one should not hastily conclude that this refers to one and the same person. Many artisans convened to raise the Kings's shrine; it is possible that two different men had the same, common, name of Nikola. It is also of interest to note that in Dečani Nikola was not a master-builder but only assistant to his brother who held the master's title. The significant question, however, is whether a person with experience gained locally in the 13th century – the name of the brother, Dobroslav, reveals Nikola's Serbian origin – could have been such an excellent connoisseur of utterly different notions and of the special techniques that characterized the architecture of the Empire's northern regions. The familiar layout of a western ground-plan with a bell-tower above the portal, a colorful façade and a number of other features can be found, for example, in Omorphokklesia near Kastoria, a definite extant remainder of the practice of Epirote workshops.

The title of master-builder Astrapas, one of the painters of the Church of the Virgin of Ljeviša, was, with his assistant, as has been said, rather well-known. His name appears in a note written by

the artist Michael who in 1294-5 painted the frescoes in the Church of the Holy Virgin Peribleptos in Ohrid and heralded major changes in painting in the new spirit. The discovery of his name beneath age-old layers of grime soon gave rise to disputes which have not been resolved even today. The basic dilemma has been whether one interprets the names of Michael and Astrapas as referring to two separate persons or to only one who appeared at first in Ohrid with a surname, and then later in Prizren without one. It seems natural that in the document ordaining the duties of the Ljeviša Church regarding the town poor, a master-builder would be mentioned only by the name of the illustrious family to which he belonged.

From the preserved excerpt itself, though inscribed in fresco technique, it is evident that the work on building and painting had already been completed. At the same time, the language of the inscription, as in others, suggests that Astrapas had local artists on his team or else that he engaged men of letters for such needs who were well versed in Serbian church literature and able to accompany the frescoes with the appropriate quotes.

The interior of the Church of the Virgin, on the other hand, required of the artisans that the arrangement and nature of the decorative elements should fulfill all the requirements of religious rites and an increasingly sophisticated understanding of wall painting and its role. The elaborate space available after the earlier building was reconstructed was not suitable for the portrayal of certain scenes associated with the functions of its respective parts. Many of the frescoes were destroyed during the ensuing centuries of Turkish occupation when the church was converted into a mosque and the walls covered over with plaster and slaked lime, thus masking their Christian content. Nonetheless, the array of the cycles reveals their more or less preserved scenes while the position of the main themes can be detected by the remaining fragments.

In undertaking the vast task of painting the frescoes several years after the church was built – probably from 1310 to 1313 – the Thessalonian painter had the opportunity in the Prizren cathedral of demonstrating his exceptional erudition and experience gained over the years in the lively transformation of Byzantine pictorial art. Most certainly King Milutin was well-informed of the excellence of the artists to whom he entrusted the decoration of his endowments through his royal court in Thessalonica where he occasionally stayed. In this he would have been following a long-standing tradition of bonds between the Serbs and Thessalonica, the second largest city of the Byzantine Empire, where St. Sava sojourned while travelling to Athos, and where he met with church dignitaries and commissioned artistic works for the needs of the churches in Serbia and on Mt. Athos.

Starting from the initial concept of a church as God's dwelling on earth, the builders placed Christ Pantocrator in the main dome and Christ's four other images in the adjacent ones – firstly in his usual aspect, then as the Great Hierarch, then the Ancient of Days, and then as Emmanuel. The Prophets who presaged the coming of the Saviour were placed in the tambours between the windows, on the pendentives, and underneath them, the Evangelists as witnesses to his life and deeds. In the altar space, in the calotte, and on the lower surfaces, there is the wide scene of the Ascension. The sequence ends on the eastern side with the Holy Virgin and the Service of the Hierarchs in the apse, the Communion of the Apostles on the sides and a row of the Holy Fathers.

Little has remained of the Great Feasts, usually situated on the highest surfaces as well as underneath them in the naos, on the lateral arms of the cross and in the subdomical area, where we see the Healing Acts of Christ followed by his Sufferings, the events linked to the Resurrection and his second coming. The last scenes illustrate excerpts from the Gospels read in order at matins between Easter and Pentecost.

These scenes, though more extensive for the inclusion of individual cycles previously painted in the narthex, adhered fairly well to the tradition of the previous century. Moreover, the story of

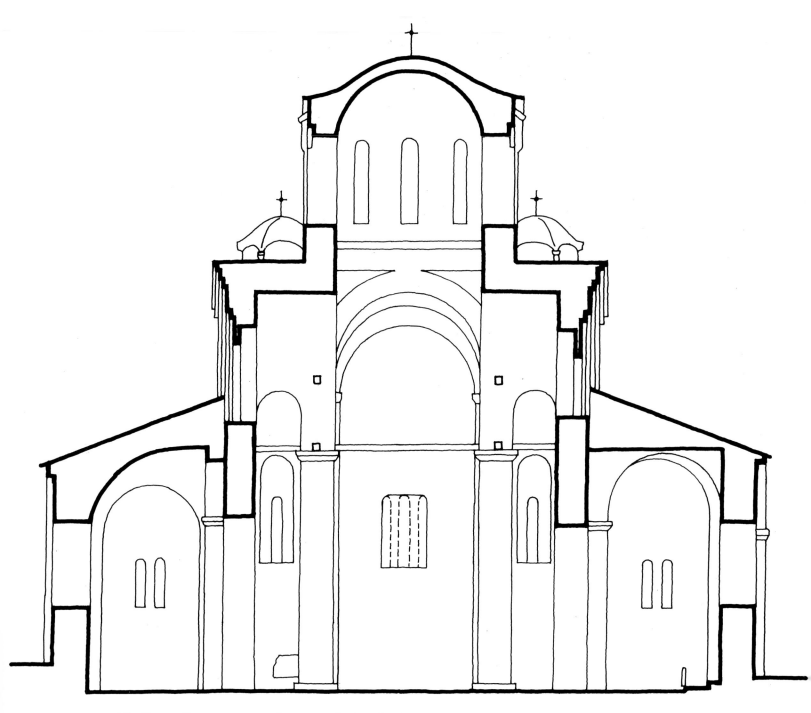

21. The Virgin of Ljeviša, transversal section at the dome level.

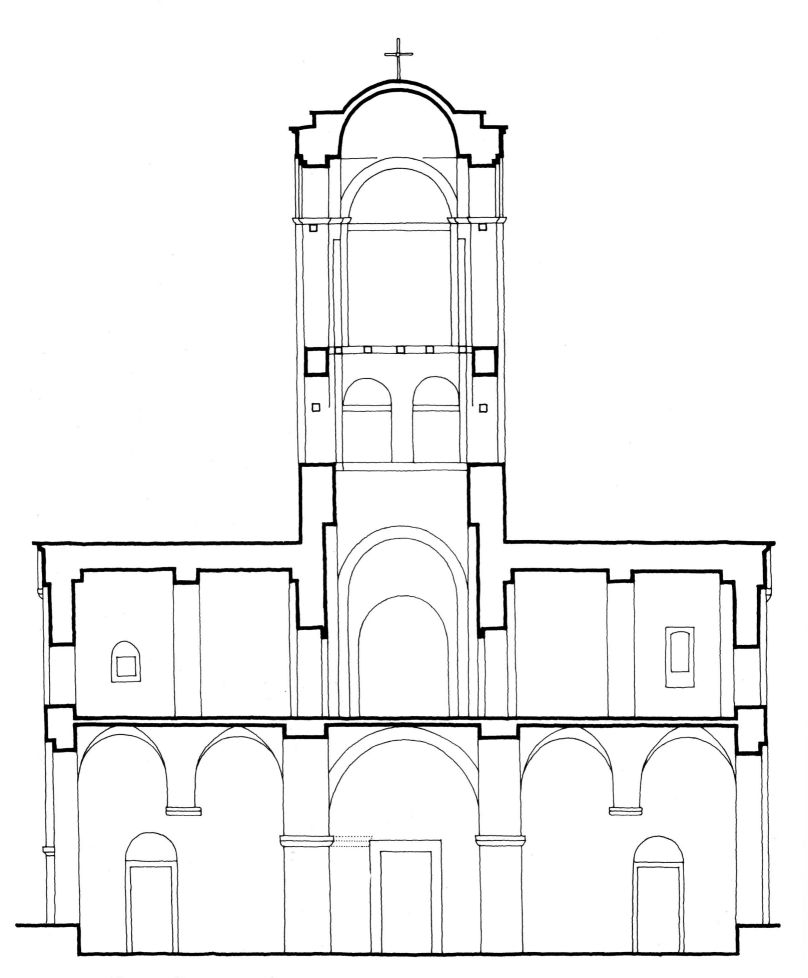

22. The Virgin of Ljeviša, transversal section.

Christ's life – his teachings, activities, sufferings, resurrection and repeated manifestations, all assembled in the central space – was depicted to the believers in all its segments and messages. The parishioners could find both consolation and encouragement in their cathedral. In the previous century, the infant Christ in his Mother's lap and with the bread-basket had already been denoted as the Provider, while on a fresco dating from King Milutin's time his large picture bore the epithet of the Prizren Provider. In the ever-open main church in the town, its inhabitants did see in the holy pictures not only lofty examples of the Christian martyrs but also the Saints whom they venerated for personal reasons. Among them the holy physicians were given a special place as the populace often addressed them for help.

The additional space available for paintings following reconstruction did not necessarily result in a greater number of subjects treated, since narrative tendencies in art had led to expansion of the number of specific cycles and of their episodes, lending them a more complex aura. In the central part of the Ljeviša Church, the scenes, though of a smaller format than the previous ones, did not yet have the character of developed compositions. Despite the changes in use of space, they retained the simplicity of the basic scheme, a special monumentality marking the older paintings.

It is in the same spirit that we see on the surfaces of the groined vaults and lateral sides of the southern outer aisle, the life of St. Nicholas to whom this special chapel was dedicated. Moral themes customarily adorning the monastic premises are portrayed at the other end on the floor above the internal narthex, in the catechumeni accessible primarily to clerics gathered round the archbishop's throne. The popular medieval tale of King Joasaph and the monk Barlaam illustrates the story of human pride with the tree as a symbol of life whose roots are gnawed by mice. This is shown on the western side of the church. And while man light-heartedly sips honey, Hell is lying in wait for him with its jaws wide open. The images of deeply venerated warriors George and Demetrios on horseback are shown on the northern and southern side of the same space. In the east is Daniel the Prophet whose firm faith saved him from the lion's den.

The frescoes of the exonarthex are of a different character and have been better preserved. They mainly repeat scenes painted earlier in the western parts of the church in the

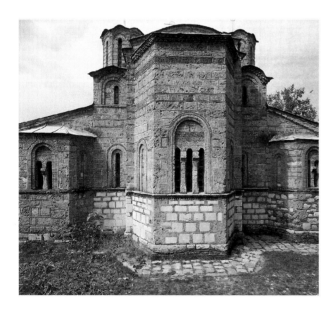

23. *The church, eastern side.*

24. *Apse detail with* ktetor's *inscription.*

narthex or in the frescoes behind the porch. But the internal content and artistic mode reveal profound changes. Thorough investigations into the paintings of that time and specifically of the Virgin of Ljeviša have explained its new character and the spiritual layers it stemmed from.

It is usually the narrative character of sacral themes in increasingly complex depictions that used indirect language which was not always easy to follow. Some manifestations were presented in symbols and their meaning in allegories which often demanded a theological and literary education on the part of the viewer. This kind of language, incomprehensible to the needy expecting help at the church door, but interesting and convincing to those who endeavored to fathom what the wall-paintings interpreted, found in the outer narthex a veritable treasury at the very entrance over a wide arch. Believers came upon slender winged female figures borrowed from a series of classical personifications. The northern one represents Day with a *rhipidion* in her hands, whose brilliance intimates the coming of the New Testament, the truth as preached by Christ. The south personification is Night with an extinguished torch. There are intricate compositions on the arches of the open porch. On the northern side there is a picture of Christ's forbears, the Tree of Jesse, in a detailed pattern with small figures intertwined in fluttering tendrils. In the opposite field is the Last Judgment with the Saviour hovering in the light of the celestial arch, comprising numerous elements of the rich story of Christ's Second Coming. More *PLATE 31* pronounced than in previous visions of this event here, too, the artist used figures from classical antiquity: nude female figures representing Earth and the male figure of Hell, all astride monsters, bearing symbols in their hands.

The Baptism, often depicted outside the Great Feasts, is the richest representation of the new character of art. It is located in the western part of the church and is connected to the rite of baptism or consecration of the water. This theme was given a ceremonious place on the central vault below the bell-tower, and consists of a series of circularly arranged events recounted without any separation in a unique landscape with the River Jordan overflowing the land in the forefront. In order to portray this rich story, the artist culled its elements from different Gospels just as he used various sources for his other themes.

Other pictures exhibit a profound erudition and effort to express complex theological thought. Portions taken from a broad collection of religious literature, especially poetry, which in delicate terms and metaphors celebrated phenomena and personalities in Christian history by returning to their prefigurations in the Old Testament, interpreted them in the language of dogma. In honour of the Virgin to whom the church was dedicated, the hymn "The Prophets have predicted you..." is illustrated in the arches, below her representation above the entrance to the church. Old Testament figures six on each side, point to the objects of their visions: David seeing the Virgin as a shrine, Solomon as a temple with seven columns, Daniel as a mountain and Jacob as a ladder, and the like. It was difficult to transpose ideas and poetic statements into pictures so the artists had recourse to the traditional words of the ancient world, its symbols and allegories which had a continued life in Byzantium and were repeated in literature and the arts. Connected with this are also sayings attributed to old sages and prophetesses who allegedly forecast the coming of the Messiah. The well-educated Thessalonian painter Astrapas in whose city the young learned of the works of the ancient philosophers, portrayed on the northern arch, similar to the nearby prophets, Plato, Plutarch, the Ethiopean prophetess Sibulla and others. All these figures reasserted the favorite idea of the harmony between the Old and New Testaments, the conviction that all great personalities and events in Christian history were anticipated by e-vents which preceded them. To these are added paintings of Jacob's struggle with the Angel and Jacob's Dream in a special segment under the Tree of Jesse. A rare illustration of the first

stychirion from the second canon of John of Damascus written to the glory of the Virgin's Dormition is also represented here.

Like others, the Prizren bishopric itself reminded its believers, in the lowest zone of its cathedral, of its own past and role within the Serbian Church. Six local archpriests are shown on the northern side of the western wall, and also on the south where we see St. Sava's successors to the archbishop's throne from Arsenije to Jevstatije II. The valuable figures of the local bishops preserved not only name, though most of them are unknown, but also in facial features which may also have been drawn in the earlier church. The Serbian church dignitiries were consistently portrayed in their traditional Orthodox vestements with their white *stycharion* with *epitrachilion*, *polystavrion* and *omophorion*. From those times on, archbishops were also shown in other, more colorful ceremonial garb which the Serbian Church adopted from Byzantium.

The portraits of King Milutin and other members of the Nemanjić dynasty convey a sense of the opulent clothing that prevailed locally at that time. These portraits cover the surface of the inner narthex. Even earlier, especially in the final decades of the 13th century, the Raška rulers looked to dress and life-style in the Constantinople imperial court. In this sense, it is sufficient to see the portraits of Kings Dragutin (1276-1282) and Milutin (1282-1321) in a slightly earlier founders' composition in the cathedral of St. Achilleios in the town of Arilje (1296) to confirm the impression of a consistent emulation of the clothing worn by Byzantine emperors. This inclination is also confirmed in an interesting account written by one of the most prominent personages in Constantinople, writer Theodore Metochites. As court chancellor and confidant of Andronikos II, Metochites travelled to Serbia several times in an attempt to settle disputes arising from Serbian conquests in the northern regions of the Empire. During the negotiations he conducted with the Serbian king they finally agreed that Milutin would wed Simonis the Byzantine Emperor's young daughter, a member of the house of Palaeologos. This marriage was expected to improve relations between Serbia and Byzantium. A frequently cited passage from one of Metochites' letters to the Emperor from Milutin's palace eloquently describes the King and prevalent Serbian custom:

The King himself was beautifully arrayed in jewels. About his body he had numerous jewels of precious stones and pearls, as many as could be worn, and he veritably shimmered with gold ornaments. The whole palace shone in silken furnishings and gold ornaments. Briefly, everything was arranged in Romaic taste and in keeping with the ceremony of the Emperor's court.

The figure of the King-*ktitor* in the Ljeviša Church of the Holy Virgin, in the attire known to Metochites, corresponded indeed to the formal dress of the Byzantine Emperor: Milutin is portrayed against a strong, deep red background, dressed in a dark *divetesion* with an *epimaniakis* and *loros* of golden-ocher hue, covered with semi-precious stones and hemmed with a double row of pearls. On his head he is wearing a typical Byzantine crown topped by an *orphanos* and *prependulia*, from which hung pendants of pearls and other jewels, holding in his hands the insignia of his rule – a scepter and *akakia*. The impressive portrait is larger than the others in the *Plate 26* narthex and has a lengthy inscription naming him as founder of the church, listing his ancestors and stressing that he was the son-in-law of the Byzantine Emperor. This portrait is located on the eastern wall alongside the entrance to the naos. Next to him on the surface stands another figure, probably Queen Simonis, while on the right side believers used to be able to see depictions of the ruler's father King Uroš and his mother Queen Helen, a French princess, who was still living at the time (†1314). Both these portraits are now no longer visible. However, the portraits of the two kings, the founder and his father, composed an ideological entity with the clear message that their power was derived from the Lord himself. Divine will is also reflected in the three-quarter length portrait of Christ above the entrance with his arms extended towards them in a sign of blessing. The depiction also suggests the succession of the ruler's royal dignity, but the elder brother of the founder, King Dragutin, is absent from this group since Milutin seized the throne

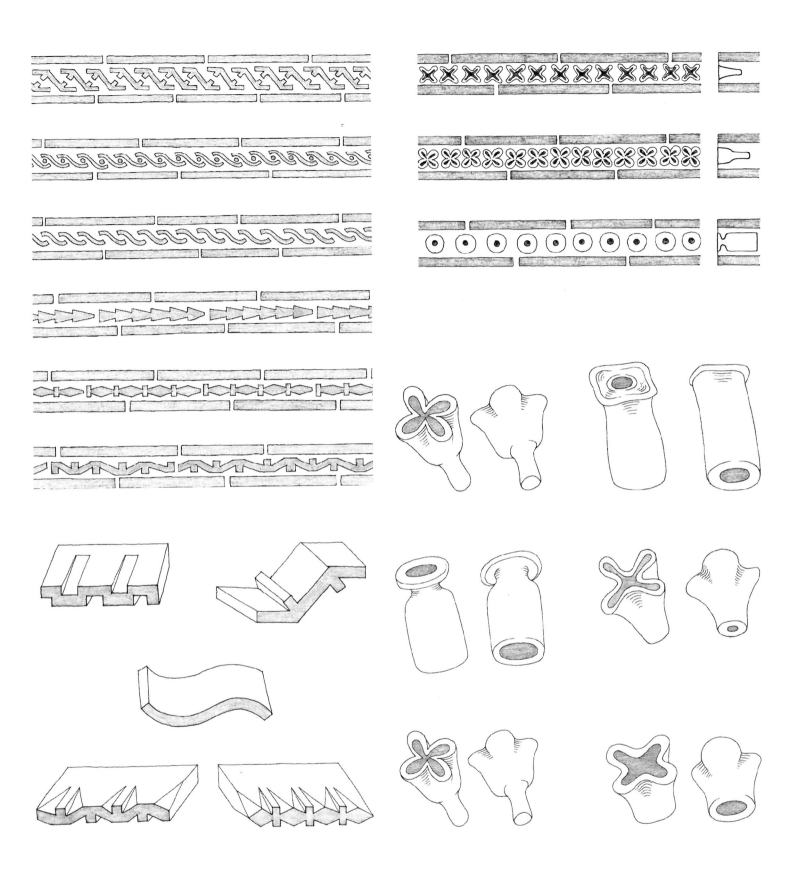

25. Drawings of backed clay ornaments and their constitutive parts.

49

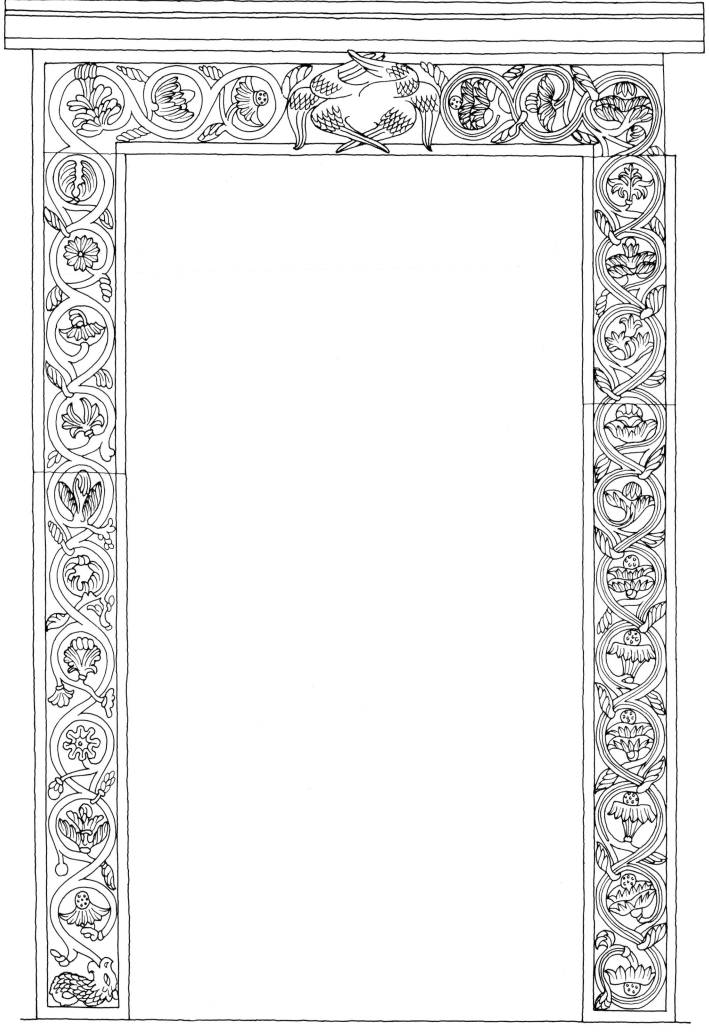

from his brother some thirty years before that. Still, such the choice and disposition of the portraits indicates that the conflict between the brothers had ended by the time the murals were painted, at a point when Milutin was able to assert his full legitimacy to the crown, in all probability in 1313.

Directly reflecting the current political relations in the land, the narthex portraits also expressed the idea of the saintly origin of the dynasty. Emphasized by the inscription next to King Milutin (...*the independent, of divine birth and the God-fearing Stefan Uroš, King of all the* PLATE 25 *Serbian lands...*), it was also illustrated on the opposite, western wall of the narthex: the founder of the dynasty, St. Symeon Nemanja, with outstretched arms is pointing to the chosen descendants – on the south side stands St. Sava who ensured that the religion would have an autocephalous status, and to the north is his heir, King Stefan the First-Crowned, and possibly the future ruler, Milutin's son Stefan Dečanski, dressed in attire also worn, modelled on Byzan- PLATE 27 tium, by the highest dignitaries in Serbia. Below them on a fairly high socle and on the opposite wall as well there are two double-headed eagles, emblems of the family of Palaeologos, close kin to the Serbian king. 28

The space entered from the open porch was dedicated entirely to the ruler, his ancestors and family members in a way that reflected profound changes in the life of the country, its political precepts and the ruler's pretensions. He did not present himself as in the other endowments holding a small model of the church, offering it to Christ or the Virgin, nor was he in a humble posture as were rulers in the Raška shrines of the 13th century, or in a procession of ancestors headed by their founder, Symeon Nemanja. The King is represented to the local population and everyone coming to this open and busy town in full splendor, invested with power as the scion of the holy dynasty by Christ himself. Whatever could be learned from the Byzantine and Serbian sources – biographies, chronicles, charters and inscriptions – was vividly manifested by the new form of portrayal of the ruling family and by the intimation that the path to be trodden lay in the future of its younger members.

Portrayals of earlier historical personages were adapted to the new spirit prevailing in the life of the royal court and the Church. Even St. Sava – separated from the group of the heads of the Serbian Church and shown in the family circle – is adorned in sumptuous vestments and a richly embroidered *sakkos,* not actually worn in his day. This modernization can be also seen in the garments of the saints who were far removed from the historical reality of Serbian or Byzantine society of the time. People from the early history of Christianity, such as SS Constantine and Helena, sacred personages of imperial origin and others all wear costumes of the Byzantine Basileus and court dignitaries of the time when the frescoes were

27. Detail of the inscripiton in clay mentioning Prizren Bishop Sava, later on Sava III, and some examples of stylized brick crosses.

Opposite page:
26. Plastic ornaments of the portal.

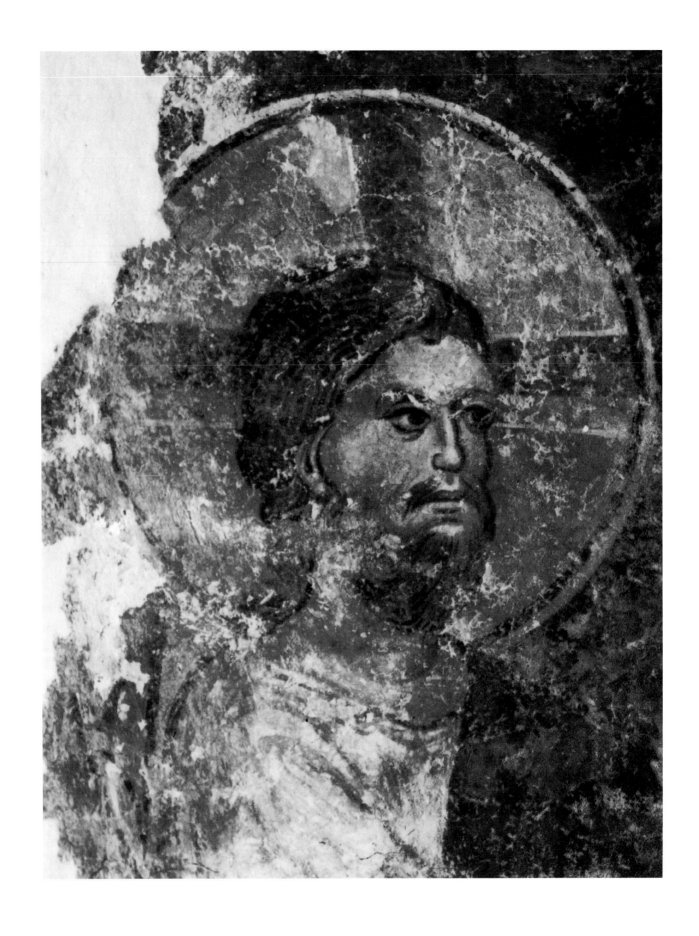

28a. Wedding at Kana. Jesus Christ, detail. 13th Century.
Now at the National Museum, Belgrade.

painted rather than of the periods to which they belonged. In the same way, the writings referring to earlier periods sometimes echo relations and phenomena belonging to the times when they originate.

As other churches which were first devastated and then restored to serve the needs of the Islamic confession, the Ljeviša Virgin preserved only fragments of the stone ornamentation from former times. Nonetheless, it was admired for its structural beauty and for the still uncovered wall-paintings by Christians and Muslims alike. One of the latter, a lover of poetry and perhaps himself a poet, carved next to one of the paintings the first part of a couplet by the great Persian poet Hafiz: "The pupil of my eye is your nest."

The wealth of ritual objects, primarily icons, ancient furnishings, holy vessels and textiles most likely date back in the cathedral to the time when the Greek bishop, subordinate to the Archbishop of Ohrid, sat on the throne. The church's treasury was doubtlessly enhanced in the 13th century, particularly when the earlier Byzantine edifice was rebuilt and its façades refaced by King Milutin. We do not know from which epoch the"Miraculous Visage of the Virgin Immaculate" mentioned by King Stefan Dečanski in his charter to the Virgin of Ljeviša (1326), actually dates. It is possible that it belonged to the earliest history of the church which received gifts at a later time as well, especially when the Prizren episcopate was raised to the rank of Metropolitanate in 1346.

In the meanwhile, in Kosovo and Metohija other shrines, even more splendid, were raised, which, favoured by destiny, attest with their preserved ambience and collections to the character of the royal endowments of the age.

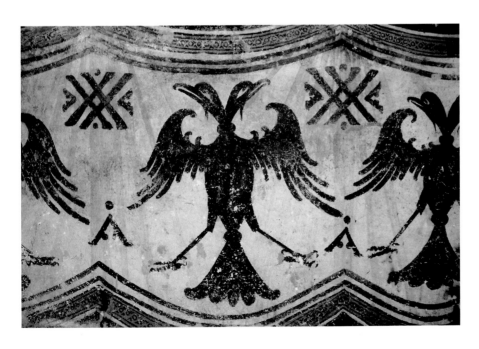

28b. Double-headed eagles, socle fresco.

The Banjska church

Direct and reliable information about the endowments of the Serbian rulers and church dignitaries has come down to us from the writers of their *Lives*. These were writings belonging to a special literary genre which combined hagiographical narration with reliable, often personal testimonies of the writers themselves. The most significant of them is a collection entitled *The Lives of the Serbian Kings and Archbishops* whose first and longest section was the work of Archbishop Danilo II (1324-1337), a gifted writer and participant in a number of major political events. A description of the building of St. Stephen's Church in Banjska by one of Danilo's disciples was appended to the vividly written biography of King Milutin. Danilo played a considerable role in this impressive undertaking.

Prior to the restoration of the earlier monastery which was also the see of the Banjska bishopric there were disorders in the land caused by the unresolved question of succession to the Serbian throne. One segment of the King's noblemen, as noted in his biography, even went over to the side of his elder brother Dragutin, the previous ruler who held sway in most of the northern regions of the state. Milutin, however, enjoyed the support of the Church. He therefore invited Danilo, whom he knew well and to whom he entrusted his valuables for safe-keeping in the Banjska monastery, to come from Mt. Athos during the final period of the dynastic conflicts. His choice was no coincidence. Earlier, Danilo as the *hegoumenos* had valiantly defended the Hilandar Monastery during a siege laid by a Catalan company of mercenaries who pillaged and ravaged the monastic settlements on Athos throughout the years from 1307 to 1310. At one point during the turmoil, Danilo deftly managed to remove valuable objects from Hilandar and deliver them to the King for safe-keeping.

It is known that a powerful *pyrgos* (tower) was built near the entrance to Banjska during Danilo's administration of this monastery where he was appointed bishop. This was an exceptional redoubt with pronounced pilasters and an enclosed lower part which is thought to have housed the ruler's treasury in troubled times. It fully corresponded to the towers on the Athonite peninsula, particularly to Milutin's tall fort in front of Hilandar which protected approaches to the monastery from the sea. It was undoubtedly Danilo himself with the experience he had gained on Mt. Athos where fraternities were constantly exposed to sudden attacks – who required that the redoubt should have a specific appearance and size; he may well have personally selected the skilled masons who raised similar structures on Athos.

TAV. 33 The monastic complex has not yet been completely freed from centuries-long debris which until lately covered its greater parts. Alongside the *pyrgos* built in the Byzantine mode of stone, bricks and mortar, the remains of a well-placed entrance with a tiled vestibule and a rectangular area embellished with frescoes have been excavated. From here, the monastery extended down a gentle slope along a mountain rivulet which flowed calmly into a fertile plain several hundred meters below.

The fact that the monastery was well-fortified must have influenced the King's decision to build a new large shrine on this site which was to be his sepulchral church, cautioned by the instance of Peć, for which a safer location was found after the devastation of the old archbishopric in the vicinity of Trepča, a major mining center and a powerful citadel in the south of the state. Milutin's

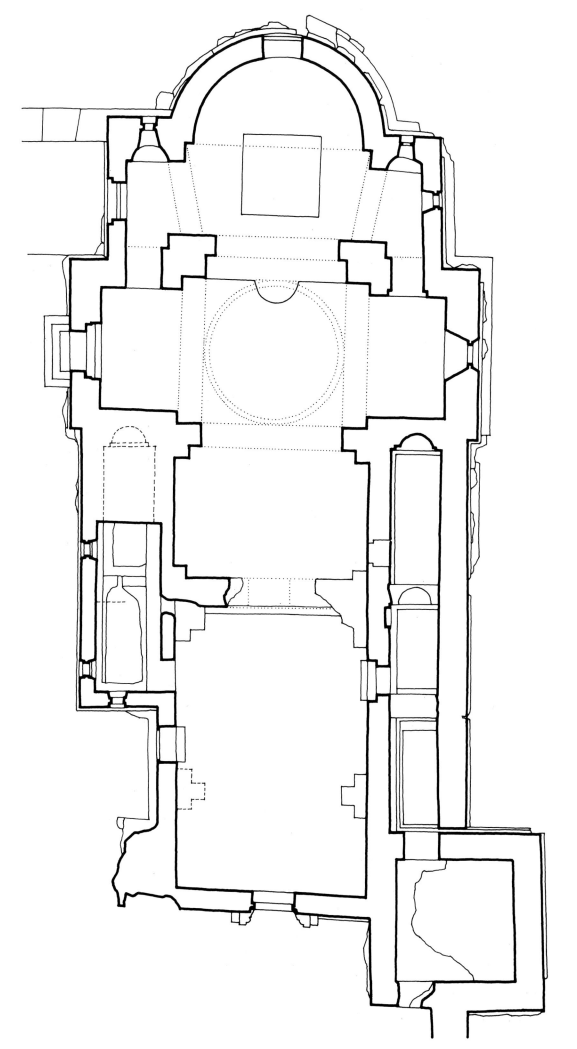

29. *Banjska, St. Stephen, plan.*

biographer states that in this regard the ruler sought the advice of his mother, Queen Helen, his brother Dragutin after their reconciliation in 1312, and Archbishop Sava III. Then he issued a chrysobull to the monastery granting it a large estate of seventy-five villages and hamlets and nine summer pasturelands with five hundred families, as well as certain royal privileges. The *hegoumenos* of Banjska was allotted the fourth position in rank of the most prestigious monasteries in the land after Studenica, Mileševa and Sopoćani. In the aforementioned monasteries there lay the earthly remains of Symeon, the progenitor of the Nemanjić dynasty, the Archbishop Sava, founder of the Serbian Church, and the ruler's father King Uroš. Banjska was no longer to be the bishop's seat. The new church with the ruler's tomb was to enjoy a peaceful existence and that is why the charter of St. Stephen stipulated that "the church should be the seat of neither an archbishopric, nor a metropolitan, nor a bishopric." The King entrusted the building of the sumptuous endowment to Danilo himself who, as his disciple testifies, was well-versed in the builder's craft.

All the sections of the Banjska complex reveal the underlying concept of unity and the skillfulness of its master-builders. Today we can see only certain structures on the northern side where during Ottoman rule buildings housing the *imaret* (Turkish mess halls for the poor) and a mosque were built within the fortification which itself had encroached upon a part of the church. Inside, one can today still see the elements of construction materials which suited the requirements of the Islamic cult.

In the upper section of the monastery, separate from the *pyrgos* and the ramparts was the refectory with a broad apse for the table of the *hegoumenos* and distinguished elders who shared the most important duties with him. The elongated rectangular part had built-in seats with carefully carved stone tables which could accomodate a large number of monks. A wide span between the walls indicates that, as was customary, the hall had a wooden roof, while its proportions and beautiful execution rank it among exceptional specimens of this kind of premises, of prime importance in the life of monastic communities.

Below the refectory, downward along the southern ramparts there follow a string of cells with a common portico facing the church. Although basically simple, preserved only in its lower part and made of spatial elements of equal-sized floor plans with rhythmically placed piers, the building allows us to imagine its former appearance with perhaps the same or similar premises on the upper floor and with porches that gave the façade a lightweight appearance. By analogy with other monastic complexes whose ground plans are known to us, the initial excavations on the northern end have already indicated that the residential quarters and subsidiary buildings followed the line of the external walls on the other sides as well, thus enclosing the complex almost totally.

Today the open prospect of Milutin's church enables us to view its monumental forms in their overall harmony, better than they could be viewed in medieval times when this was not visible from inside the walled edifice. Present restoration of the ruined parts of the edifice, however, reveals only a section of its former sculptural ornamentation. In the days when it served as a mosque, especially in the subdomical area, these ornaments were altered with regard to their original condition. On the other hand, excavations have shown that the church, erected on a rocky base high above the other structure, was clearly visible from the outside.

While building his sepulchral church in Banjska, King Milutin did not retain parts of the early, still well-preserved cathedral church as he did in Prizren. According to the ruler's design this new church was to be built "after the image of the Church of the Virgin at Studenica" because it held the remains of Stefan Nemanja, the founder of the Royal House. The previous building was therefore demolished and completely replaced by a new one. The recently adopted Byzantine architectural mode was replaced here by the older Raška type. The special reason for this was that

the ruler, devotedly remembering his forefather had clearly in mind "the kind of building and religious ornamentation he chose to preserve the peace of his holy body."

The large new church did not, of course, literally copy Nemanja's endowment. Its forms point to the spatial structure of later thirteenth-century shrines with subsequently appended elements that came into existence here simultaneously with the others. In the central part beneath the dome, the wide naos was given a broad span subsequently not seen in any blueprint. In the north and south, churchgoers had an unrestricted view of the rectangular choir as wide as the diameter of the dome. On the east side this developed into a three-part altar space with a semi-circular apse whose proportions were meant to be seen from the center of the subdomical area. From outside, the church looks like a three-aisled basilica with low lateral roofs traversed by a high transept. In front of the naos there was also a broad narthex and on each flanks two parekklesia, some of which were undoubtedly of a funeral character. One of King Dušan's charters reveals that his mother Theodora, the wife of King Stefan Dečanski, was buried in St. Stephen's Church. It appears that two rings were found in her tomb in the northern chapel near the narthex, one of which bore the inscription: "May God help one who wears this."

The chief entrance to the church, reached by steps, was located on the western side framed by towers of which only the lower part of the southern one still stands. The comprehensive and delicate task of restoring the former appearance of the church which could be undertaken only after all the parts have been excavated would demonstrate more tangibly the sculptural values of the church. It is not very probable, however, that we could obtain reliable data about the height of the dome preceding the present one which was constructed without a drum or an opening at the time when the church was converted to a mosque.

The powerful and harmonious proportions of the monumental edifice were made of superbly cut blocks of blue, pink and white stone. Their neat surfaces are not disturbed by the shallow pilasters which divide them in regular intervals or mark their ends. This kind of masonry of multicolored, alternating blocks in the pattern of a checker board, was not unknown in Romanesque architecture on the Adriatic Coast; it especially recalls the tradition of Tuscany churches. The design relies on the founder's mausoleum and its relation to the basic layout and Romanesque exterior which did not have the customary white marble façade with pilasters. On the other hand, the two churches did have the same ceremonial portals with archivolts and columns resting on lions as well as Romanesque windows which on the altar apses had three-light

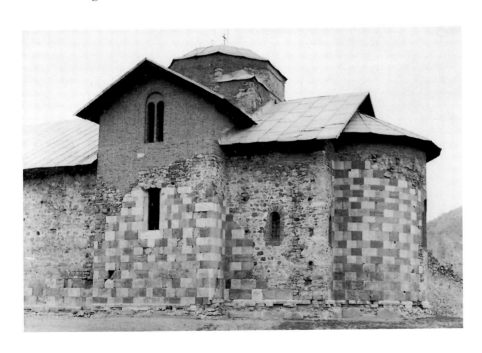

30. St. Stephen, apse, eastern side.

31. Fragments of plastic ornaments that belonged to St. Stephen's.

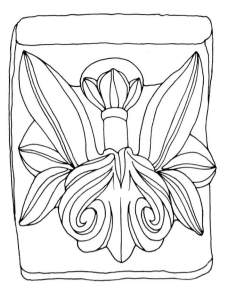

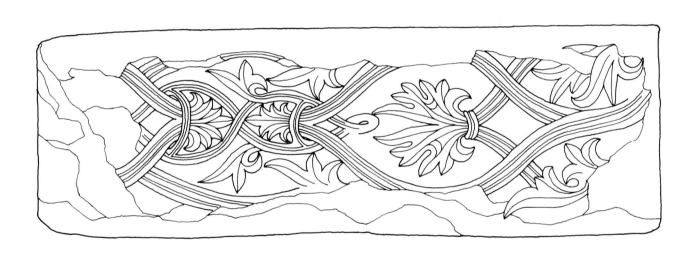

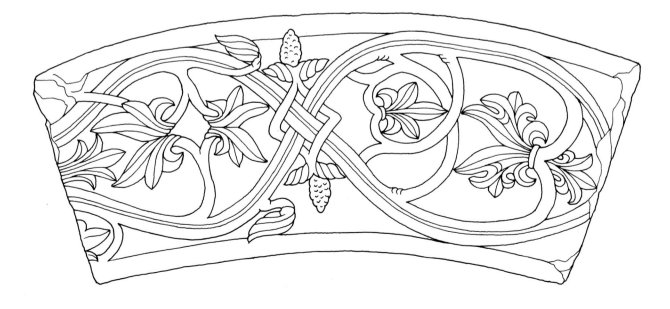

mullioned windows and consoles of small blind arches running beneath the roof, decorated with stylized floral motifs and animal heads. Judging by all this, the lateral portals of the Banjska church were built in much the same way as they were in Studenica.

The scattered fragments, today mostly in the church's *lapidarium*, do not help us to reconstruct a sense of the whole. In order to understand its nature, one needs to study in particular the richly sculpted representation of the enthroned Virgin with Christ in her lap, which writer Rastko Petrović found in an unexpected condition after the First World War in a village church at Sokolica near Banjska. The village parishioners, honouring the sculpture in their own peculiar way, had dressed it in a folk costume. Although quite badly damaged, the Virgin's face recalls the ornamentation in the lunette of the portal of the Studenica church. There can thus be no doubt that the artisan, told to emulate Studenica, first wanted to familiarize himself with the Virgin's image and especially the carved decorative motifs which he undertook. This is why it can be assumed that as in Nemanja's church, the Virgin and Christ here were flanked by the figures of the Archangels Michael and Gabriel. The traits of the earlier Studenica sculptoral decoration with visible elements of the late Comnenan manner and rich, trembling folds of draperies were, however, not repeated in the Romanesque modelling of the figures in the Banjska church. Here, too, we note the reverberations of Byzantine influence, especially in the selection of ornaments on the Virgin's throne. These could have reached the artisans indirectly by way of the Romanesque art of the Appenine Peninsula whose 12th and 13th century depictions display some similarities with them. It is certain that the artists of the Zeta

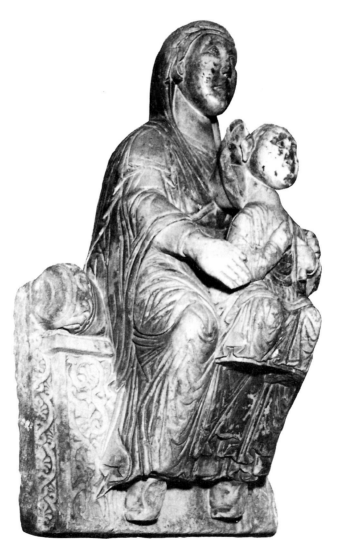

32. Virgin Enthroned with Christ, once by the portal of St. Stephen's, actualy in the village church at Sokolica.

60

coastal area worked in the same spirit by creating characteristically large, heavy static figures. The very surface of their broad heads and necks corresponds to the placement of the sculptures above the entrance, visible only from the front, allowing the artist to disregard their side appearance.

Parts of the archivolts which earlier found their way into the collections of the National Museum in Belgrade and the Archaelogical Museum in Skoplje with entwined figures of beasts and birds also echo the ornamentation in Studenica. For example, the motif of a wolf with a sheep in his jaws has been copied here exactly. Moreover, similar works – not precisley dated – are to be found in coastal towns as well as in later shrines which coastal master-builders created in the interior of the country. This is confirmed by the continuity of the stone-masons' workshops along the Coast engaged to work for rulers and other commissioners from Serbia. A Dubrovnik document dated August 1313 mentions the departure of five master-builders and stone-masons to Serbia where they appeared to have remained for several years in view of the fact that the Dubrovnik Archives do not refer to them again until 1320. It is feasible that they were the ones who worked on the Banjska Church. One year earlier, in 1312, one of the skilled Dubrovnik artisans, Giovanni della Vecchia, signed a contract at the request of King Stefan Uroš to spend one year roofing his churches with lead. During those years, construction was underway on sites throughout the country; the exodus of good craftsmen from Dubrovnik early in 1314 compelled the authorities there to express concern for the needs of their own city and decree that builders, stone-masons, carpenters and caulkers could no longer accept jobs in Serbia without a special permit from the Duke (*Knez*) of Dubrovnik and the Minor Council.

At times, builders engaged by the ruler travelled from further afield. It has been noticed that certain animal heads of Romanesque charatcter situated on the consoles of the capitals under the eave in Banjska, are virtually identical with those on an earlier portal of Milutin's church in Hilandar, although that church was chiefly executed in the spirit of Byzantine sculptural decoration. On the other hand, parallel with western-style sculptural ornamentation in Banjska there are fragments which by their stone-cutting and ornaments in the niello technique – meaning a carved-out back filled with a dark paste accentuating the drawing – reveals the work of artists trained in the tradition of Byzantine art. This was perhaps an influence which came via Italy, where Byzantine art dominated in certain periods. The shrines of Kosovo and Metohija as well as the coastal parts of the medieval Serbian state and even a broader area of the Mediterranean reflected in various degrees the symbiosis of two stylistic modes visible mainly in their structural forms, building practices and ornamentation.

In the devastated interior of the Banjska Church, numerous ornamental fragments have been found. These will find their proper place in the restored whole. Among them we recognize certain elements of the early, rich, stone furnishings of the churches and on the high arches we still see the remains of dazzling painted ornaments. It was in the tradition of the rulers' endowments of the 13th century for frescoes to gleam against gold backgrounds. The paintings of the King's mausoleum church largely covered in gold leaf confirm this in a rather convincing manner. For this reason, a Belgrade writer of the early 15th century ranked "Banjska gold" among the finest works of art in the country. A small number of remaining images which by their soft delineations, broad modelling and warm colors harken back directly to the then still vital Hellenistic tradition in the major Byzantine centers speak of the work of skilled artisans, probably from Thessalonica. They represent the mature phase of a style to be found here as somewhat later ornamentation on other shrines.

Further excavations will probably clarify the nature of the edifice on the slope south of the monastery, built in the same technique as the others in the complex. Judging by available evidence we can infer that this was Milutin's palace to which reference was made in his biography, namely, that he built "royal palaces" in Banjska.

After King Milutin's death at Nerodimlje, in Kosovo, in October 1231, his body was placed in the tomb he had prepared for himself in St. Stephen's Church. However, by the time of the Battle of Kosovo in 1389 his body had to be removed because of the insecurity of the location and reinterred in the Trepča citadel, and subsequently, in the 15th century, to Sofia where it still reposes.

Gračanica

In the last year of his long reign, 1321, King Milutin issued a chrysobull granting estates to the monastery of Gračanica, the seat of the bishops of Lipljan, after he had built a church there and was about to finish painting its walls. A copy of the document has survived, spelled out in fresco-technique on the wall in the southern chapel, most probably functioning as a *diakonicon* here – storing precious liturgical vessels and important manuscripts, especially foundation and gift-granting charters. In addition to a list of assets enhanced by the king with his own contributions, the charter discloses that here in the fertile plain of Kosovo he had completely rebuilt the earlier cathedral of the Bishopric of Lipljan. Excavations of the church interior suggest as much. They PLATE 49 reveal not only the remains of an early Byzantine basilica with a narthex and lateral wings, but also foundations of a smaller, elongated religious building above its central nave. It is not certain whether the lower structure was the old episcopal seat of Ulpiana, a nearby ancient town whose tradition was continued by subsequent spiritual dignitaries. The ground plan of the upper edifice, however, certainly was the seat of the Bishop of Lipljan, one of the first archpriests ordained by St. Sava in the autonomous Serbian church. It was a modest single-aisled building with pilasters, suggesting that it was domed (the excavated fragments of murals show that the frescoes were painted in the decades around the mid-13th century). Apparently it was demolished when King Milutin had the new, monumental edifice built. Nowadays, the king's charter is all the evidence that remains of a formerly grand, still uninvestigated monastic complex of which only a few buildings can be reconstructed on the basis of preserved foundations.

The church of the Virgin in Gračanica – the last in a series built in the second decade of the 14th century by the greatest patron in medieval Serbian art – represents the most significant achievement of the Byzantine architectural tradition he embraced. With its complex and gracious forms it deeply impressed writers of travel accounts and was sung by folk epics. Experts, for their PLATES 36, 37 part, early saw in it a creation of outstanding artistic skill. The focus of their research has, naturally, shifted from the analysis of forms and the outer appearance, whose beauty is captivating, to consideration of spatial structure, its elements and origin.

The church's floor plan is rectangular, while further up it develops into forms which articulate into sloping masses, ascending towards the main dome. Basically simple and easy to comprehend, 33 the composition of these masses reveals to a great extent the intricate internal plan, although the character and disposition of all spatial and constructive elements do not have corresponding counterparts in the exterior. In the core of the building is a cross-in-square form with four free-standing piers crowned by the dome which springs from a square base. It is supported by lofty 34,35 barrel vaults spanning the arms of the cross, dominating the enitre entity. Spatial elements encompassing the central section play a special role in the external composition. Of diverse forms and height, they create with their harmonious relations and characteristic rhythm an entity of unique compositional value: in the extension of the arms of the cross, bays maintaining the same width are covered by barrel vaults placed at a lower height, while the corners are topped by domes of appearance and structure identical to the main dome. It has been emphasized in scholarly literature that this simplified scheme is formed "by placing one cross-in-square onto another"; the whole is assembled in a fashion aiming to achieve a perfect outer appearance.

"Double, two-level intersected vaults" with the dome in the center and four elevated cupolas at the ends as counterparts, certainly represent the skeleton of the structure. Symmetrically placed as the vaults rising above the outer bays, they cover different elements of space invested with articulated meaning and function.

The real character of the whole and parts in the intricately designed space can be established only by observing the structure and all its components, the easiest approach being their analysis on diverse levels. As a matter of fact because it is divided by a multitude of supports which block the view of some of the sections, the interior does not readily expose itself to the observer, though *PLATES 43, 44* impressing profoundly with the richness of forms and interplay of light. The spaces on all sides are open to view below the dome, depending on the height and manner in which the respective bays are vaulted. Through the arched apertures placed between piers and pillars in the east there is a large bema, the width of which is equal to the naos whose central bay carries a blind calotte. The broadest, unrestricted views from the center towards the exterior sides of the church opens to the north and south where the last segments, somewhat lower, originally had direct lateral entrances, while in the west the round-arched passage allows a view of the space of the esonarthex with the groin-vaulted central section. On the upper floor above it there is a middle-sized chamber which in other episcopal churches had the function of a catichumenon. It was reached by a stone staircase through the southern part of the wide wall between the narthex and the naos, lit by a window on the western side.

To the north and south of the naos and the altar the church had special ambulatory wings terminating in the east with the enclosed parekklesia with semi-circular apses. In the interior these spaces were of uneven height, vaulted in a different manner, and the domes at their corners were not placed at the height of the neighbouring bays. With their square bases resting on relatively

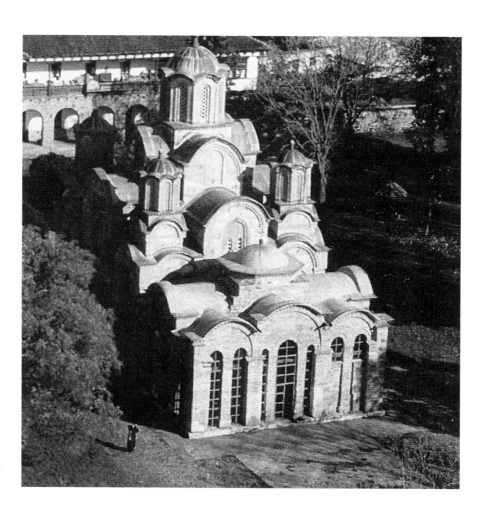

33. Gračanica Monastery, an airview of its harmonious domes.

64

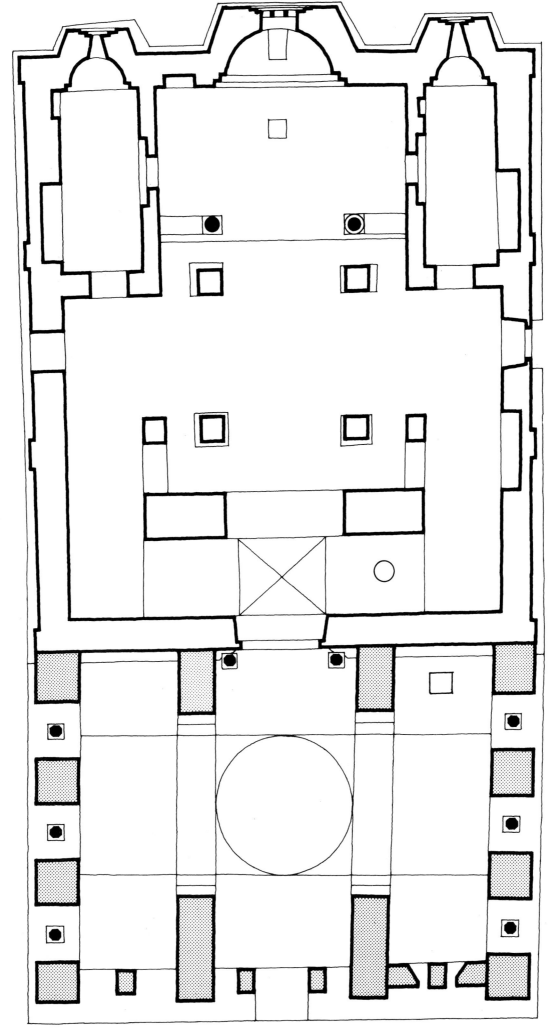

34. The church and exonarthex, plan.

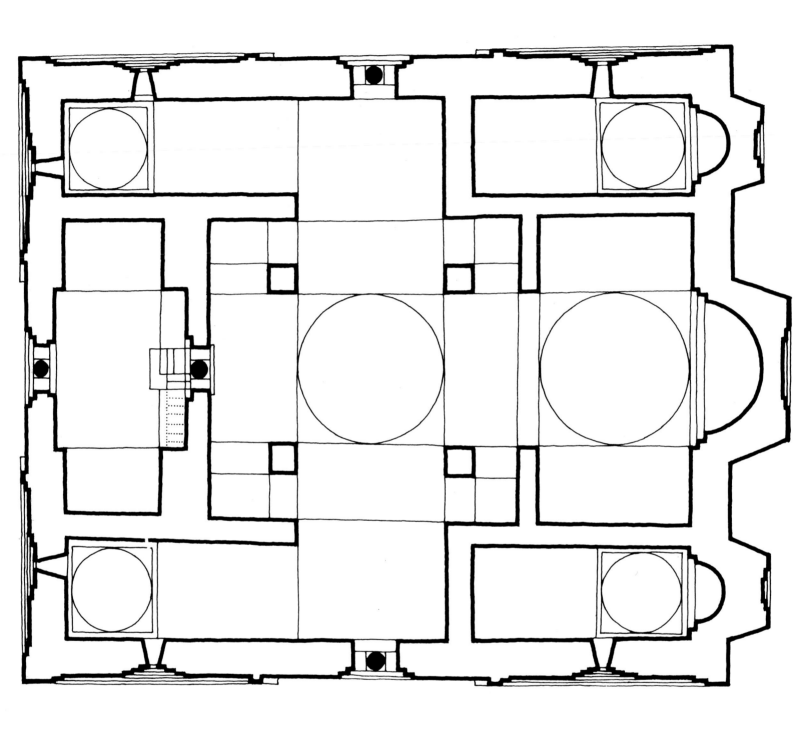

35. *The church, horizontal section at the first level height.*

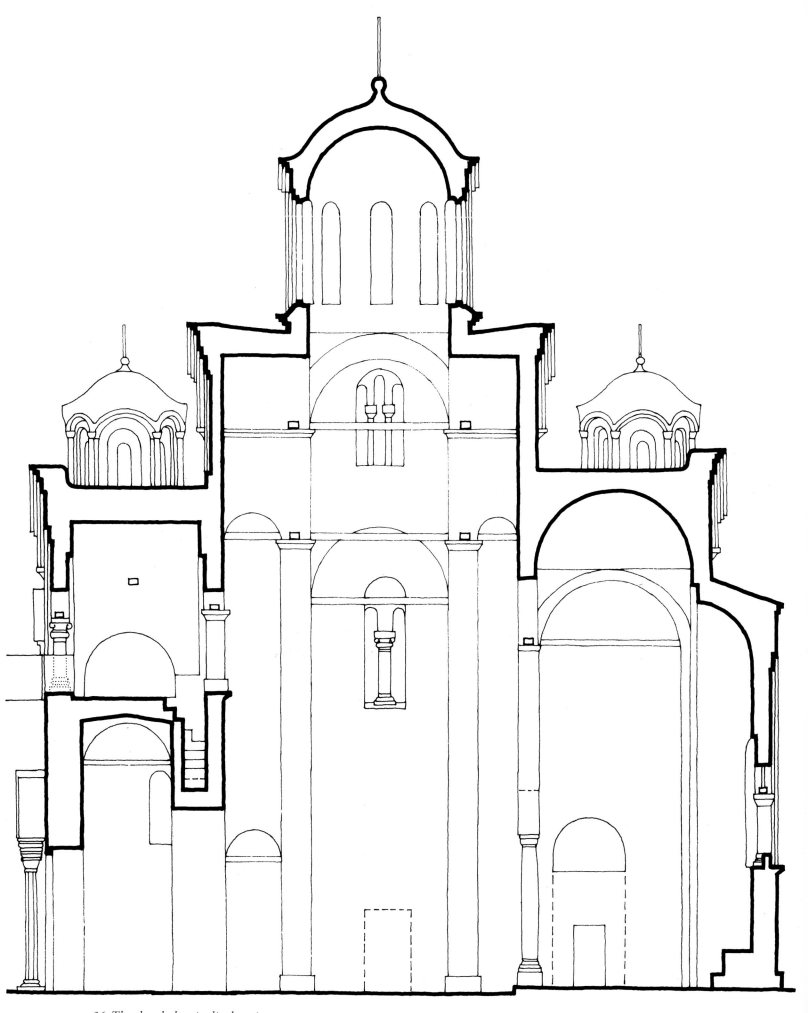

36. The church, longitudinal section.

narrow rectangular spaces they rose to a height at which they established a remarkable harmony with the central section, thus constituting an entity whose forms rank among the noblest in Late Byzantine architecture. The effort to repeat particular forms consistently and preserve their sophisticated rhythm also contributed to this. Thus, the roof over the low *blind dome* of the sanctuary was turned into a barrel-vault in order to correspond to the forms of the vaults on the other sides. It is evident that the gifted architect concentrated his attention on the plastic articulation of the edifice, not completely fulfilling the well-known tenet regarding the relationship between the interior structure and the outer appearance of the building, so that the spatial forms and construction elements in it became easily distinguishable from the outside. In Gračanica, the wide wall areas of the lower portion thus had shallow pilasters dividing them into well-proportioned, harmonious surfaces, but the space behind them was designed in an utterly different manner.

The building material and construction techniques were typical of widespread building practices used for shrines in towns and the western provinces of the restored Byzantine Empire, chiefly in the closing decades of the 13th, and the beginning of the 14th centuries. The standard use of stone, bricks and mortar reached a high degree of sophistication here, manifested in the choice of material and its adaptation to the proportions and structure of particular parts. The face of the dome, the sides of the arms of the cross and the surfaces of the base of the dome were executed in tiers of large blocks of sandstone and limestone of different hues, interpolated by of two rows of brick with layers of mortar. Stone blocks were mostly framed by mortar joints and

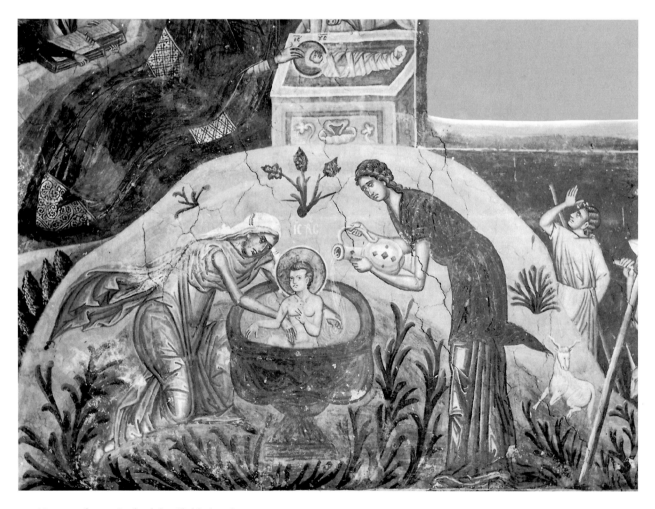

37. Nativity, fresco, Bath of the Child, detail.

vertically placed bricks – thicker in the lower zones – in the so-called *cloisonné* technique. However, the cornices below the eaves, the frames of openings, the archivolts closing the gables of the particular sections of the façades and the cubical base of the drum, and the entire dome as well were carried out in brick whose rows, in color and fabric, stood apart from the level surfaces made in stone. The lunettes above the windows, as was customary, were an opportunity for ornamentation: the bricks, in fairly simple, mainly semi-circular rows, formed several motifs there. The manner of their arrangement and construction was neither rigid or strict. The best sample of masonry workmanship is the eastern façade of the church, its silhouette slender; adorned areas clustered more closely together than on the other sides. The relatively tall surfaces of the externally three-sided apses broken by elongated windows topped with fields of ornamentation also contribute to the density of the façade. With regard to this angle, the builder enlarged the height of the upper portions in order to convey full proportional harmony.

The interior, subdivided by piers, received unequal amounts of light not only because of the diversely proportioned sections of the structure, but also because of unequal light sources. As in other domed churches, the greatest amount of light, chiefly admitted by the tall windows piercing the drum, spread over the surfaces of the subdomical area and the neighbouring bays; it penetrated into the arms of the cross through three-light mullioned windows placed on the gables of their lower segments. But the smaller domes, raised high over the relatively narrow spaces in the corners, could not provide light of the same intensity to the lower parts, nor could light directly spread from them and illuminate the bays next to them to the same degree. In such an

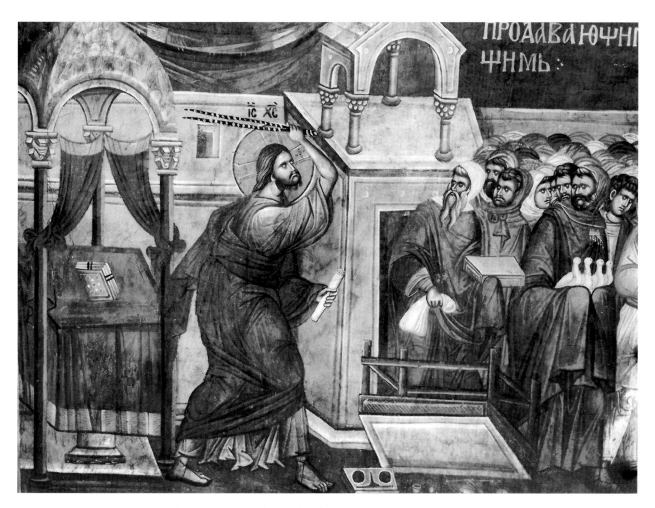

38. Expulsion of the Merchants from the Temple, fresco, detail.

interior the lighting of the upper sections – a celestial residence in the cosmic understanding of God's abode – was replaced in the lower zones by deep shadows, enhanced by dark fumes of candles and incense in which holy paintings lost their contours during most of the day.

PLATES 38-42
As work on the wall-paintings was drawing to an end – probably in the summer or at the beginning of the autumn of 1321 – King Milutin and Queen Simonis were painted on the lateral sides of the passage leading from the narthex into the naos, dresssed in solemn vestements echoing Byzantine imperial garb. High above, accommodated at the apex of the arch, Chirst pronounces a blessing on them, while the angels, expressing God's will, are offering crowns to them.

The king on the left side holds a vividly articulated model of the church in both hands. This depiction, however, does not show the exonarthex, today forming a well-balanced, inseparable and, it seems, logical part of the whole. The confidence with which all the details of the sprawling, compelling building model were executed leaves no doubt that at the time when the fresco-painting of the church was about to be completed the exonarthex still did not exist. In all pro-bability, it was added soon thereafter. Excavations have revealed that it was of the same volume, but with a different spatial disposition: massive piers subdivide it into six bays above which a belfry formerly rose at the west end.

A large part of the original exonarthex appears to have been destroyed in the first Turkish raids and in a fire in the monastery before the battle of Kosovo (1389). It is difficult, however, to say what was retained from its original plan in the reconstruction undertaken soon afterwards. Having gained experience in the erection of open narthexes in the second and third quarters of the 14th century, the master-masons raised a serene structure whose height, forms and construction were a fortunate addition to Milutin's endowment. The lateral sides were composed of sturdy piers with arches resting on the pillars between them, while the western façade featured narrower piers between the corresponding supports, also linked by arches – two on each side and three in the central section providing access to the church. In that, the narthex successully adopted the rhythm of the upper portions of the church which was of tremendous importance for the entire structure: the apex of the blind dome above it was placed in continuation of the slanting plane, whose angle was determined by the height of the main and subsidiary domes.

Light and transparent, the narthex remained open in the course of almost two ensuing cen-turies. It was blocked up afterwards before being furnished with new wall-paintings after the renewal of the Patriarchate of Peć (1557). Prior to this time, in a wood-cut showing the con-temporary appearance of the church in a book printed in Gračanica (1539), a belfry was depicted above the narthex. This belfry may have been demolished after that because of stricter measures imposed by the Turkish authorities regarding the use of bells.

The full extent of the remodelling of the exonarthex carried out in the 16th century has not yet been ascertained. It is therefore difficult to perceive the character and all the merits of the former structure. Its present-day appearance does not display the same polished, refined masonry as the church itself does.

In searching for the origin of the master-masons employed by King Milutin and the place they were trained we cannot name any single workshop. The analogies regarding the articulation and conception of space open up a series of possibilites in the northern regions of Byzantum, especially Thessalonica, while similar designs occur primarily in Epirus and Thessaly. The masters from these regions readily joined building projects undertaken by the Serbian ruler and having brought in by local associates, developed ideas and experiences with them.

PLATE 44
Now that the building has been cleaned the details are more visible; the wall surfaces in the interior of the church of the Virgin accommodate numerous representations, comprising the culmination of wall-painting in Serbia during King Milutin's epoch with their profusion and selection. It can be claimed with considerable certainty that until the very end artists from

39. *Teodor, son of Despot Djurdje Branković,*
fresco, detail, 1429.

Thessalonica were exponents of the new style which matured before the eyes of the Serbian founders and the clergy. Architecturally preceded by the five-domed churches of the Virgin of Ljeviša at Prizren and St. George in Staro Nagoričino, created some years before in the restoration of earlier structures erected in the Byzantine tradition, the Gračanica wall-paintings grow out of this tradition in a confident manner. The underlying ideas and forms of expression neither fluctuated nor flagged in further elaboration of the program and the refined interpretation of messages which the earlier seat of the bishopric had striven to transmit to its congregation. Finding a place for the entire subject matter in such a complex space necessitated experience and skill. We are not sure, however, that this was done in a manner befitting the abilities of the faithful. Aside from those thematic segments which, despite noticeable differences in the shape of the building, were common to all, only with considerable effort could great connoisseurs of ecclesiastical history and doctrine follow the painted thought of the man who commissioned the building and the artist. Representations were frequently placed at a large distance from the observer on surfaces difficult to be seen due to the angle. The question at issue, understandably, was not merely recognition of the subject matter, although this in itself was not always simple. Scenes which were iconographically similar or even identical were interpreted by, and occasionally differed from each other only through Biblical quotations or verses from ecclesiastical poetry the texts of which, situated far from the observer, could only be read with great difficulty. It is possible, however, to single out certain larger cycles, although their sequence is not always easy to grasp.

The sanctuary posed the least problems though it does include representations invested with various meanings. In the spherical area of the wide apse beneath Christ Emmanuel, the Virgin is painted with archangels Michael and Gabriel in a circular segment of light surrounded by cherubs. With her appearance and outstretched arms, the Mother of God corresponds to her frequent epithet Wider than the Heavens because she carries in her the Lord himself. Liturgical themes – the Communion of the Apostles and the Service of the Hierarchs are below it. The last composition features the fathers of the church preceded by John Chrysostom and Basil the Great whose mystical action evokes Christ's sacrifice. It repeats an oft-used iconographic formula formed at the end of the 12th century. In accordance with the character of the space, several individual images of the holy fathers were painted on the other sides as well, while the Resurrection was placed over the central section in the blind calotte. The neighbouring vaults and areas below them display a series of events from the Virgin's cycle (The Refusal of Gifts by Ioakeim and Anna, the Return of Ioakeim and Anna from the Temple, the Annunciation, the Presentation of the Virgin at the Temple, etc.). The second significant group includes the Sacrifice of Abraham, the Invitation of the Three Angels into the Home, Abraham Giving Hospitality to the Three PLATE 53 Angels, Gideon's Fleece, the Tabernacle, Divine Wisdom Which Hath Builded Her House, etc. Several scenes evoked the Eucharist, but in accordance with the Old and New Testaments they represent at the same time protoptypes (prefigurations) of the Mother of God and the embodiment of the Logos. More recent studies dealing with the complex meanings and stock iconographic content typical, for instance, of the Old Testament Tabernacle, disclose not only an early established dogmatic foundation, but also expresssions in religious poetry which disseminated certain ideas that prompted painters to include them in their wall-paintings.

Certain scenes linked with the Virgin's life are painted in her parekklesion, i.e. the southern one, while the northern contains illustrations recounting the life of St. Nicholas to whom this PLATE 50 space is dedicated. The chapel's apse, however, also received St. John the Forerunner. His impresive image with its vigorous features became widely known and contributed greatly to a proper understanding of the values of the Gračanica frescoes.

The subject matter of the main dome is similar to that of many such churches: at its apex personifying the celestial heights in the notion of church as universe, Christ All-Sovereign (Pantocrator) is customarily represented; below him is the Divine Liturgy painted after the model of the

liturgical service on this earth, itself invoking the participation of the heavenly powers with the small Christ – the Lamb on the communion table (*hagia trapeza*) and rows of angels dressed as diacons in stycharia with oraria, holding liturgical vessels.

The Great Feasts are in a fresco on the tall vaults of the naos, while the emphasis on narration typical of the epoch has come into full play on the lower sections of the corresponding areas. This was an important feature, by which the new current in the Palaeologian painting was simply called 'narrative'. Numerous passages relating to Christ's teaching are portrayed from the Gospels, while his parables are vividly illustrated. Christ's Passion, in the main position beneath them, is represented in as many as twenty compositions, from the Last Supper to the Resurrection, in which the Crucifixion, although painted within the Great Feasts, appears as well. The significance given to Christ's suffering renders its illustration essential to each sequence, though several decades later it was considerably shortened. They had soteriologic significance – the suffering and death of the Son of God were a pledge to the salvation of mankind.

Christ's appearances after his death form a special cycle. They were embodied in the liturgy itself with the appearance of the priest at the Royal Door blessing the believers and retreating afterwards like Christ, while the selection and order of representations corresponded to the order

37,41

38-40

43

PLATE 46

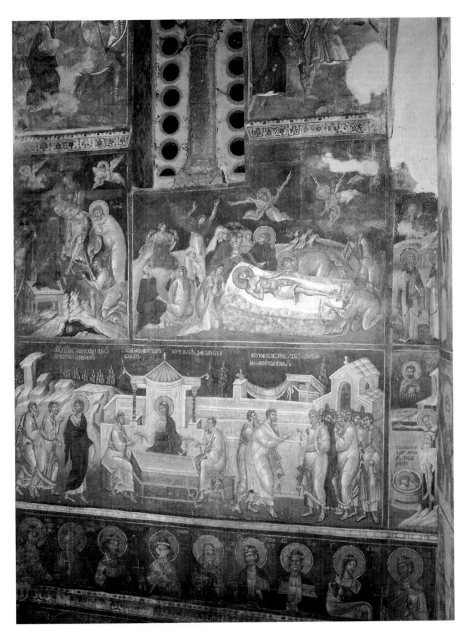

40. *The Lamentation over the Dead Christ* (above*); Christ at Emmaus* (below*), fresco, 1318.*

PLATE 45
in which the appropriate passages from the gospels were read in liturgical services during Lent before Easter – Three Women and the Virgin at Christ's Tomb, the Myrrophoroi, Do Not Touch Me (*Noli me tangere*), the Myrrophoroi Informing the Apostles, etc.

The painters, inspired by a wealth of religious literature, depicted in the west part of the naos the end of the Virgin's life, illustrating it in a series of episodes: the prayers before her death announced to her by the angels; trees, bending, bow to her, her farewell to the Apostles who, when they are summoned, arrive on clouds, and the Dormition featuring numerous participants and Christ with the accepted soul which the angel is to carry through the opened door of paradise. In the continuation, one can see the passing of the Virgin into heaven with the apostle Thomas

PLATE 47
who is given a belt from her; the Apostles find the empty tomb with Thomas behind them confirming that he encountered the Virgin by showing her belt. Evolving this theme in great detail, painters produced various versions of it in the second decade of the 14th century, obviously well acquainted not only with the writings attributed to St. John the Theologos and his contemporaries, but also with several more recent works which relied on them, ranging from synaxaria to various poetic creations.

In the outlined themes with liturgical and dogmatic content, special significance was attached to the idea of incarnation, while "historical" representations derived inspiration and motifs from various apocryphal texts. They also altered the character of painting. Their profuson and arrangement on relatively small surfaces, frequently only on the sides of piers, had as a consequence the reduction of scenes, especially the number of participants recounting the events. Only by such reduction was it possible to depict the calendar with representations of holy events and personalities for each day of the year. Several centuries before that, the *Menologion* had been illustrated in codices. Apparently it made its first appearance in wall-painting in the 13th century. Locally, however, it had been represented in a similar vein in Staro Nagoričino two or three years preceding Gračanica. The masters from the same region must have been using the same source: the calendar of the Constantinopolitan church for both churches. It is certainly interesting that, except in Serbia, the *Menologion* appears only in Thessalonica whence the masters must have come, in the church of St. Nicholas Orphanos, quite a well-known structure which King Milutin had built and dedicated to this saint in the second town of the Empire.

The reasons why the cycle of the Calendar occupied a different position in this church than it had in the others lies in the spatial scheme and the general disposition of ornaments. As a matter of fact, their entire repertoire and exact arrangement cannot be established on account of considerable damage to particular surfaces, and we therefore cannot be sure whether the *Menologion* – analogies for this exist as well – was illustrated here in its entirety. However, large sections, sometimes in bands, can be followed on different sides – on the piers and passages, below the small domes on the western side of the church and in the narthex. With their appearance and disposition, they correspond in many aspects to individual images of saints, most frequently martyrs, predominantly encountered here in the lower zones.

In a series of themes the subject-matter of which has eschatological connotations or bears a message associated with salvation, the representation of the Last Judgment in the western part of

PLATE 51
the church was customarily given the central place. At the entrance to the narthex the faithful were encountered by a complex vision of the Apocalypse – Christ, the Virgin and John the Forerunner, the apostles, the angels rolling up the heavens, sounding the trumpet and weighing souls, the lake of fire from which fish, beasts and birds on its banks are returning parts of human

PLATE 52
bodies at the last hour, the personification of the Sea and the Earth from which the dead emerge, and terrible suffering awaiting the sinful (cold, fire, worms and gnashing of teeth); on the other side is the fenced garden in Paradise with Abraham, the righteous in his lap, the Virgin and the Righteous Criminal, while the choirs of the heavenly powers and the righteous (holy women, martyrs, prophets, monks, etc.) are represented separately. The picturesque scene, primarily based on the narration of John the Theologos, had its pendant in theological literature which the artist

used with endless open or implied references to the end of human life and the road of salvation which can save a man from a terrible sentence.

In the same space, in the passage leading towards the naos stand King Milutin and Queen Simonis in a scene of the ruler's investiture, wearing Byzantine imperial garb with angels offering them crowns. The close tie with the Constantinopolitan court is especially emphasized by the inscription next to the young queen designated as "Palaeologina, daughter of the Emperor Andronikos Palaeologos". PLATES 38, 39, 42

In a more ornate manner the divine origin of rule is stressed in the depiction of the holy dynasty of which King Milutin is a descendent. The elaborate genealogical composition of the ruling house over a century and a half on the Serbian throne repeats the imagery of Christ's family tree branching out of Jesse's root in the shape of foliage. The bottom of the Serbian rulers' tree is taken by Nemanja, while his descendants are placed in four rows above him, in tendrils. The most distinguished members of the dynasty have been selected from this lineage teeming with offspring, including, understandably, those who, following St. Sava, belong to his spiritual branch. In the vertical, direct line, kings Stefan the First-Crowned, Uroš and Milutin are represented as the most significant upholders of Nemanja's work. At the top, Christ is blessing the entire Tree with outstretched arms while angels on the lateral sides, flying, repeat the symbolic investiture, handing his regalia – the crown and the loros – to the king in power.

After several changes in the manner in which the Serbian sovereigns were painted and the emphasis on the divine origin of power invested upon them, the house of the Nemanjićs in Gračanica for the first time was represented in a meticulously designed, visually clear iconographic formula. The number of its members displayed on the joint picture is considerably larger than on other compositions of this kind. In a broader aspect such a representation, understandably, was not new and it could be traced back to antiquity, from which the Tree of Jesse also originates; the Arabians and dynasties in the West were also familiar with it. However, it is not encountered in Byzantine art from which Serbia, as a rule, derived all iconographic patterns. The

41. Descent into Hell, fresco, Adam the Progenitor, detail.

42. Portrait of a saint.

very position of these Nemanjićes in relation to the position of the Second Coming of Christ, opposite Paradise – that "fortunate" segment of the apocalyptic vision which threatened other sinners on earth – was certainly selected by the master himself or his spiritual counsellor from the ranks of the local clergy, in charge of such undertakings.

The wall decoration at Gračanica, the work of Thessalonica masters commissioned by King Milutin, concluded the maturation of painting during his reign. The numerous frescoes, considerably damaged, yield no information about their painters, as was true with the frescoes in several other shrines. There is no reason, however, why they should not be associated with the reputable artists Michael Astrapas and Euthychios. The frescoes in Gračanica are closely aligned to their perception of art and style, the development of which can be followed on signed and dated frescoes over a quarter of a century preceding Gračanica. It seems unlikely, therefore, that as early as 1319-1321, after Staro Nagoričino was completed (1317/18), entirely new artists came along, fully mature and sophisticated, who belonged to the same stylistic circle and produced works indistinguishable from those of their predecessors. These brilliant artists introduced new styles from the major Byzantine centers, while also participating creatively in their adaptation to the environment where they were engaged for many years on grand churches under obviously favorable conditions. Their work secured for them in scholarly literature the name of the "school of King Milutin's court." Their sojourn in Serbia concided with his reign and ended in about the same month, after they had completed the last in a series of the king's portraits when he was already of an advanced age with a long, grey beard, and "seemed to have been touched by death."

Under well-protected vaults roofed with lead the fresco-paintings remained undamaged for many years and did not require renovation, as otherwise was frequently the case. There are only two frescoes created at a later date, linked with events which came about in the meantime. In the southern chapel dedicated to the Virgin Intercession (Parakklesis) under the arcosolium where the tomb was originally situated of Bishop Ignjatije who supervised construction of the church stands a depiction of the Death of the Bishop of Lipljan Teodor: over his body lying in state is a monk-priest a prayer and swinging incense, accompanied by singers with pointed caps and a reader with an open book which is being read by all of them.

In close proximity, on the surface of the former entrance to the same parekklesion, young Teodor, the eldest son of the Despot Djurdje Branković (1427-1456) was painted after his death, some time before 1429. The confidently and meticulously drawn portrait features and the nobility and beauty of the painted subject-matter attest to the value of the painting of this epoch, only known, in fact, in a small number of surviving works of art.

In the hardships that befell Gračanica and other monuments following the first attacks of the Turks, the original outer narthex with its entire fresco decoration was devastated, and subsequently, after its restoration, a greater part of the frescoes dating from a later time were destroyed as well. Several representations have survived in it, of which the depiction of the Second Ecumenical Council and the illustration of the poem "In the grave bodily..." are especially interesting in thematic terms. The Baptism in the southern portion of the east wall, however, is the most telling example of the character of the style: of a very complex iconographic pattern, it features the troubled and wide course of the Jordan River cutting across the scene, and several episodes accompanying the event. Superbly painted and of glowing harmonies of colours, almost all the figures of the participants and the antique personifications have, unfortunately, lost their facial features, so that opinions concerning the exact date of their creation differ considerably. In all probability, they can be dated to the second querter of the 16th century, during the time of the educated and energetic Metropolitan of Gračanica Nikanor who took an active part in spiritual life, renovated the library which had burned down, and even established a printing press in the monastery. The large icon of Christ the Merciful (139x269 cm) with the Ancient of Days and the apostles, offers a more direct testimony to the painting of this period, very poorly known in the Balkans. On the lower part of the frame, between the ancient sages and the prophets, the

Metropolitan Nikanor comissioned his portrait, outstandingly painted in the proskynesis, with a poetically composed prayer written on a long scroll, and an angel offering him in Christ's name the Archbishop's mytra in the act of investiture.

The icon of the Virgin, of smaller dimensions with prophets holding scrolls and the objects of their visions in their hands probably dates to the same period. Nowadays, the iconostasis of the church and its parekklesia do not contain earlier works; neither does the treasury, which must have been very rich. However, several works created at a later date have survived, of which the most significant is an icon from 1607/8 depicting the life of St. Feuronia, who rarely appears on her own with a portrait of Viktor, the Metropolitan of Novo Brdo (Gračanica) in that epoch.

The restoration of the Patriarchate of Peć stirred up the spiritual life in the state, having left a visible trace primarily in the large centers of ecclesiastical administration. At that time, the character of the Gračanica exonarthex was significantly altered by blocking up the space between the columns on its open sides, although with their light structure and the form of the vaults they had been excellently adapted to the plastic values of Milutin's temple. In the most recent conservation works it regained some of its former value, but all elements of its original appearance have not been established with certainty, neither was it possible to remove all sections subsequently added because of the fresco-paintings these later additions contain.

Newer murals which were completed in September 1570 exhibit a genuine profusion of themes and even iconographic rarities. Most of the paintings relate to the Virgin to whom the church was dedicated: episodes from her life previously depicted in the church, scenes from the Old Testament which have the meaning of her prototype, and illustrations of the Akathistos in which she had been venerated from the 14th century. Special stress was laid on the role of the Virgin as the mediator of mankind addressing the Son, on her own or with John the Forerunner in the

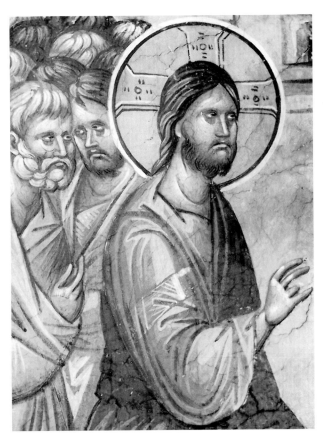
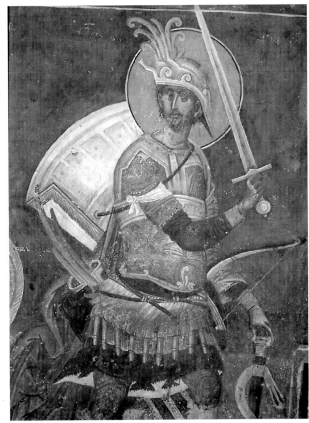

43. Christ with the Apostles, fresco, detail. *44. St. Arthemios.*

77

developed Deësis with the apostles. In the last scene she is humbly approached by the founders, the Patriarch Makarije, the first head of the restored Serbian Church, with the Metropolitans Antonije and Dionisije. In all probability, the latter archpriest passed away some time before the work on the fresco-painting was done, so his death was depicted here. Because of the moment at which Metropolitan Dionisije died and undoubtedly because of his merits, in the depiction of his funeral dozens of spiritual and secular dignitaries have gathered in groups with their arrangement and expanse forming one of the most beautiful compositions of its kind. At the same time, with emphasis on the long tradition of the Serbian Church as confirmation of its autonomy, its heads were depicted in the lowest zone, starting from the first Archbishop, St. Sava, to the last, Patriarch Makarije, whose image has been damaged.

In comparison with painting dating from King Milutin's time, whose masters produced works which resonated with tension even in their later years, always creatively modulating their visions, the decoration of the exonarthex was duller and more schematic, evolving from extinguished artistic centers which were being brought back to life, repeating the traditional features of earlier art. Nonetheless these paintings can be counted among the fine work by masters who had, before that, left their art in the earlier shrines of Peć and Studenica.

Color plates

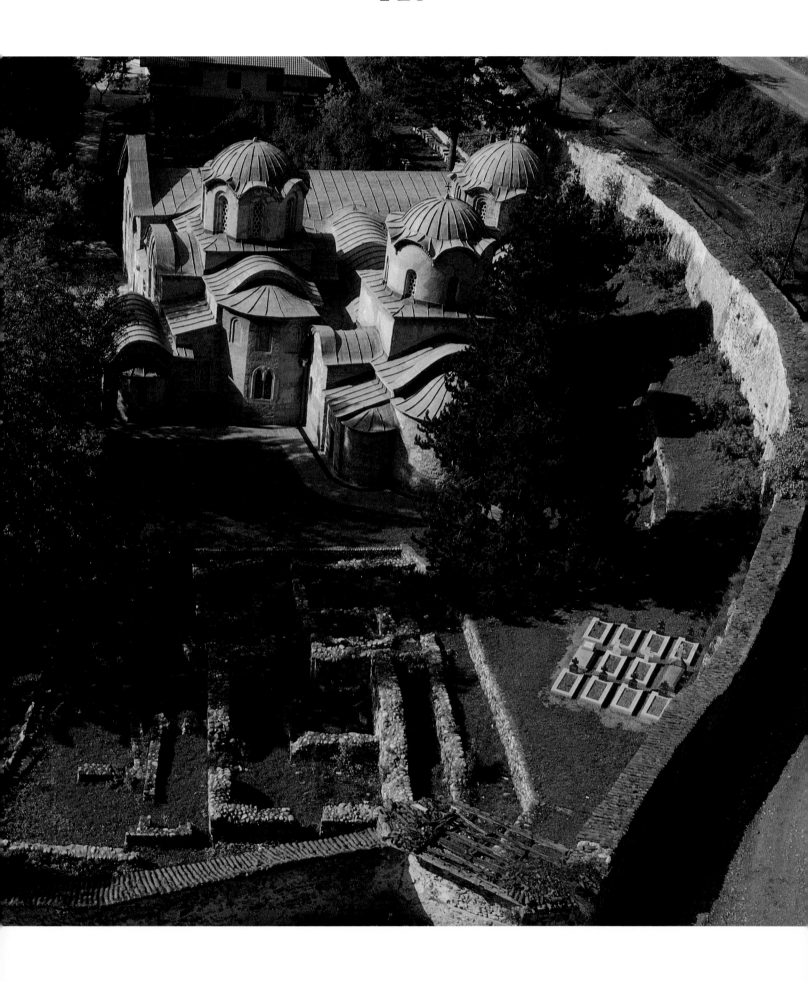

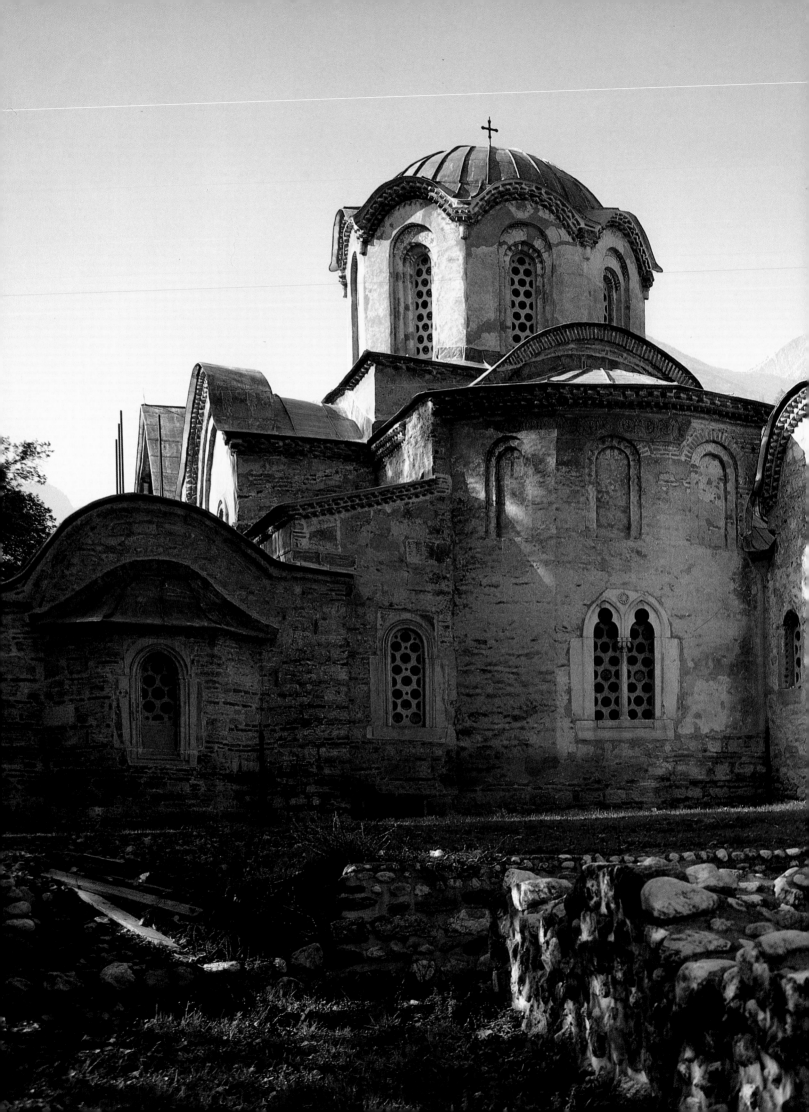

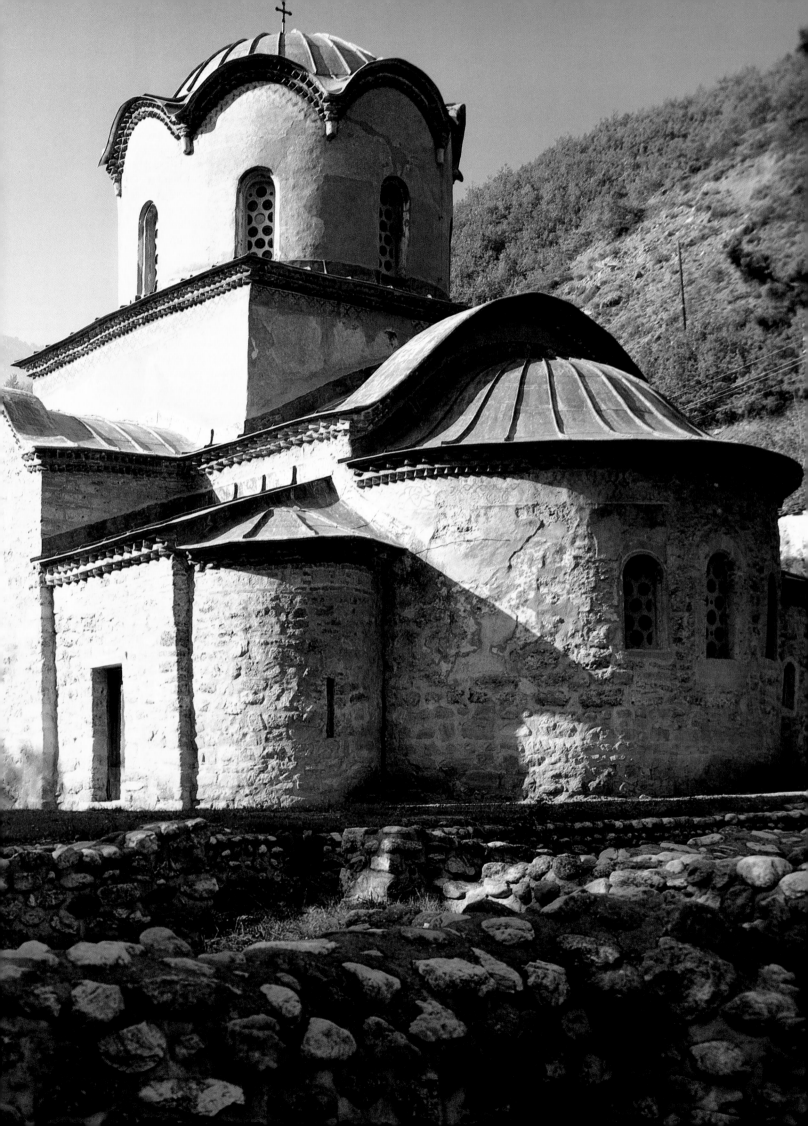

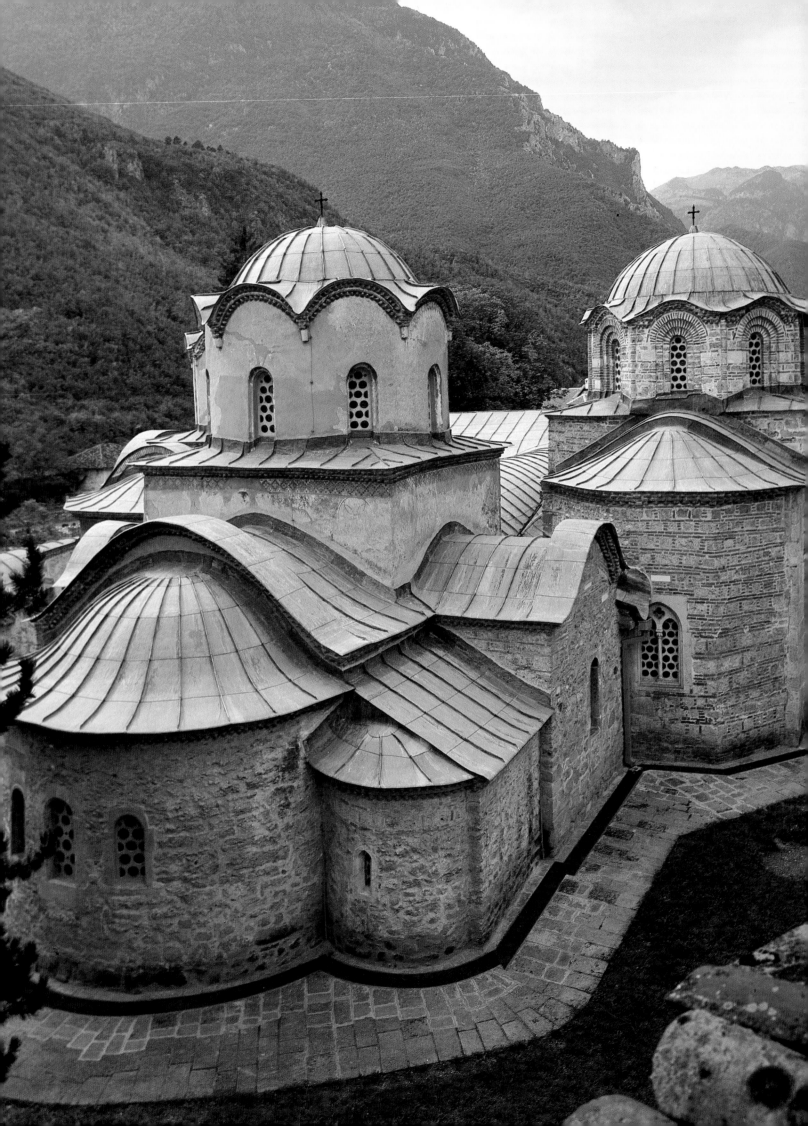

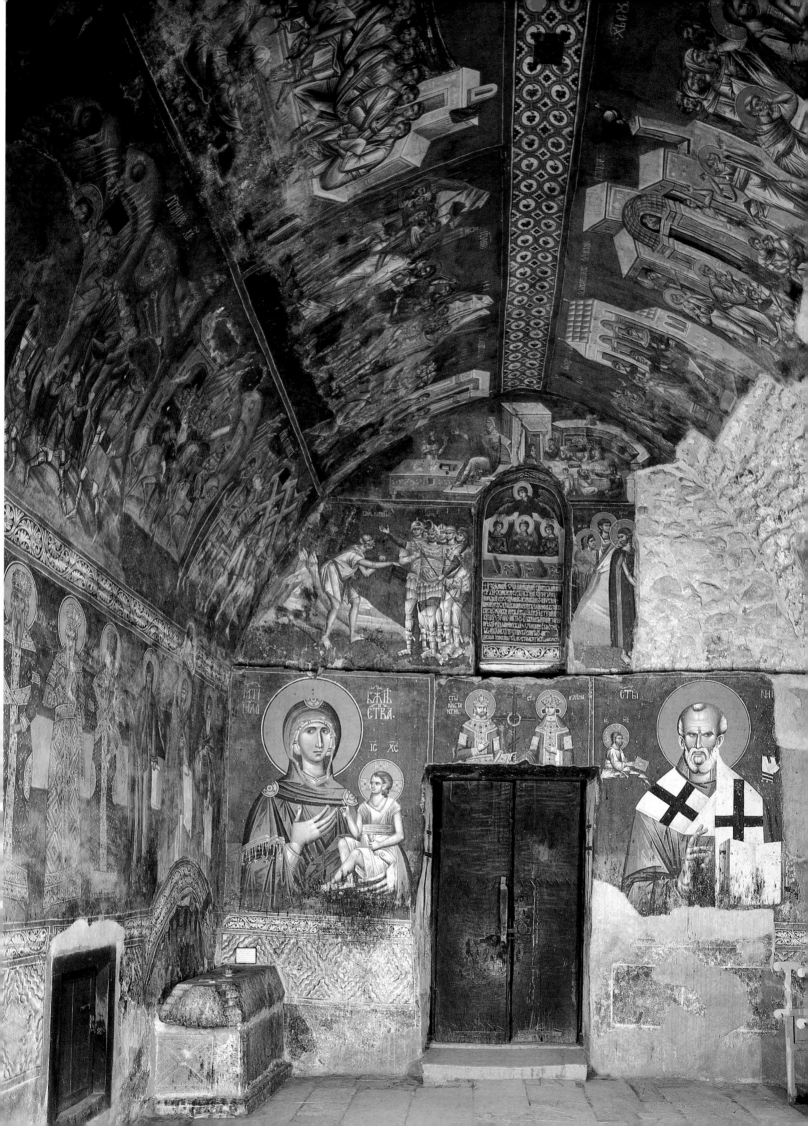

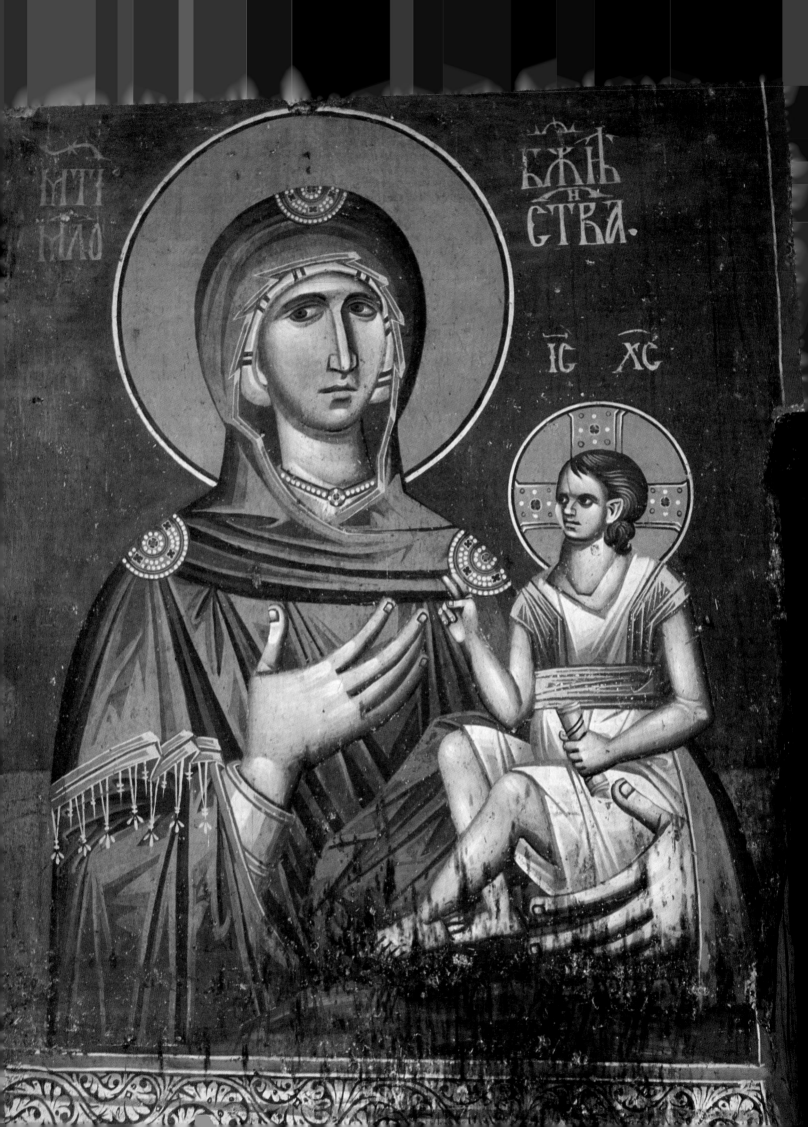

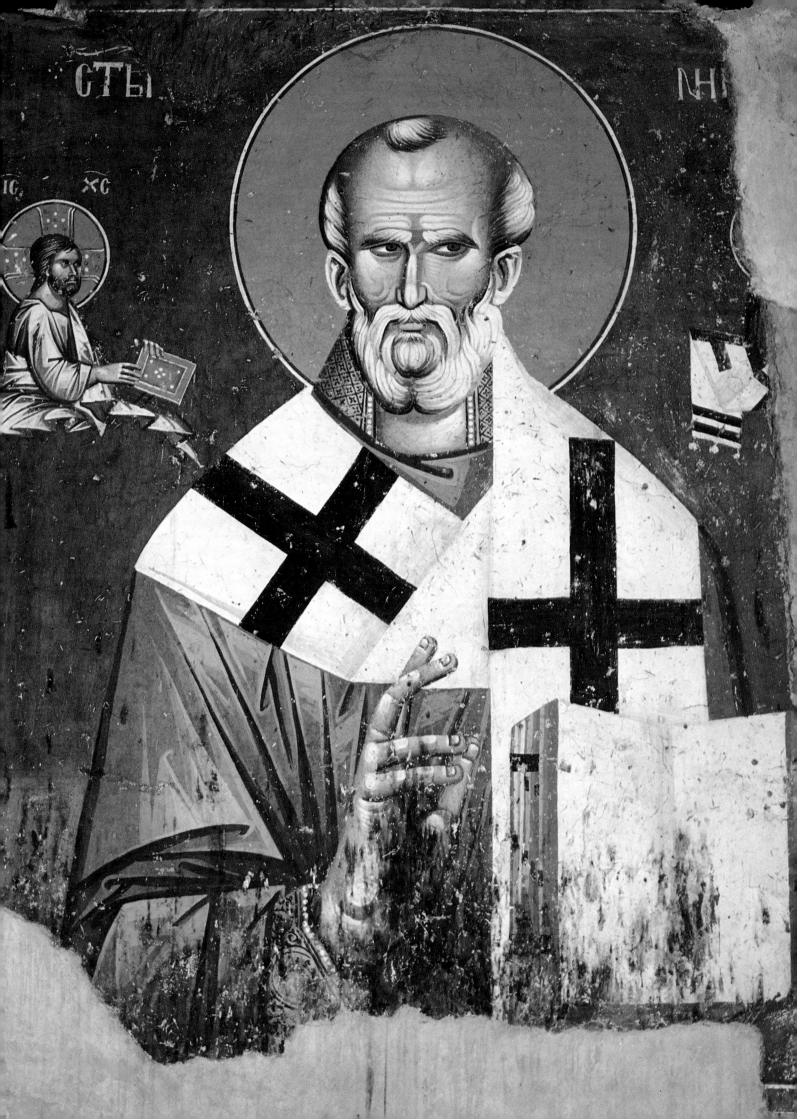

СТЫ НН

IC XC

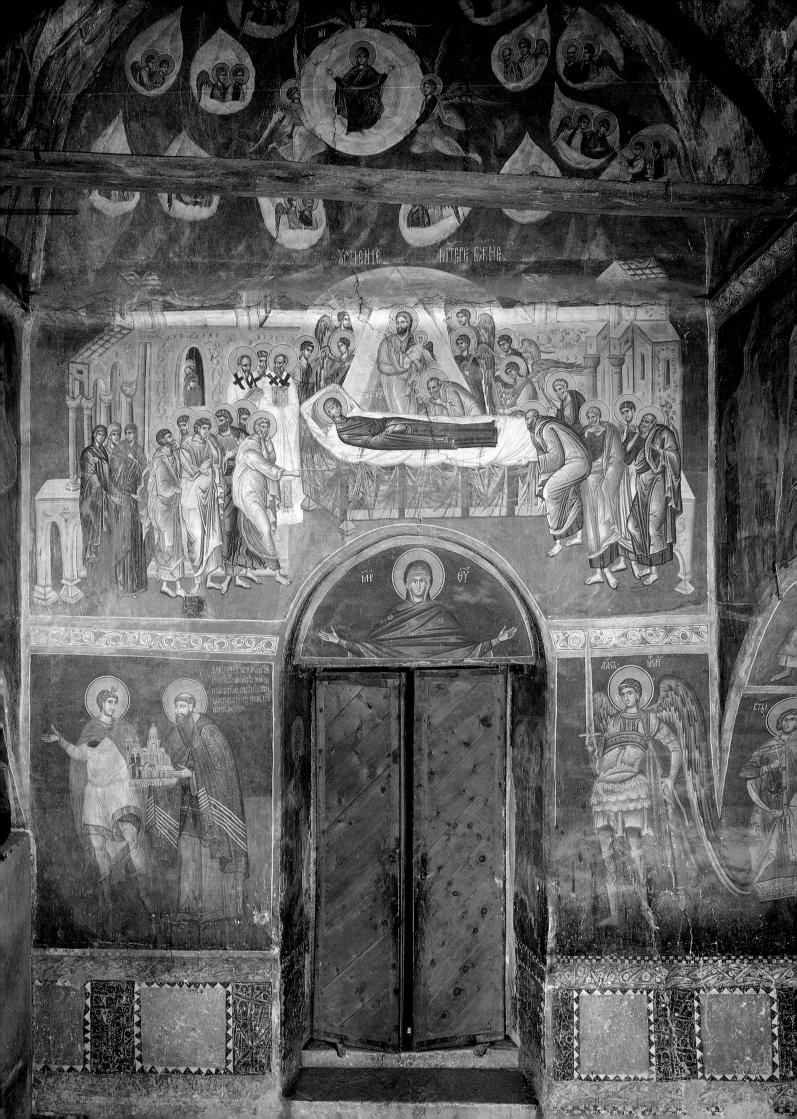

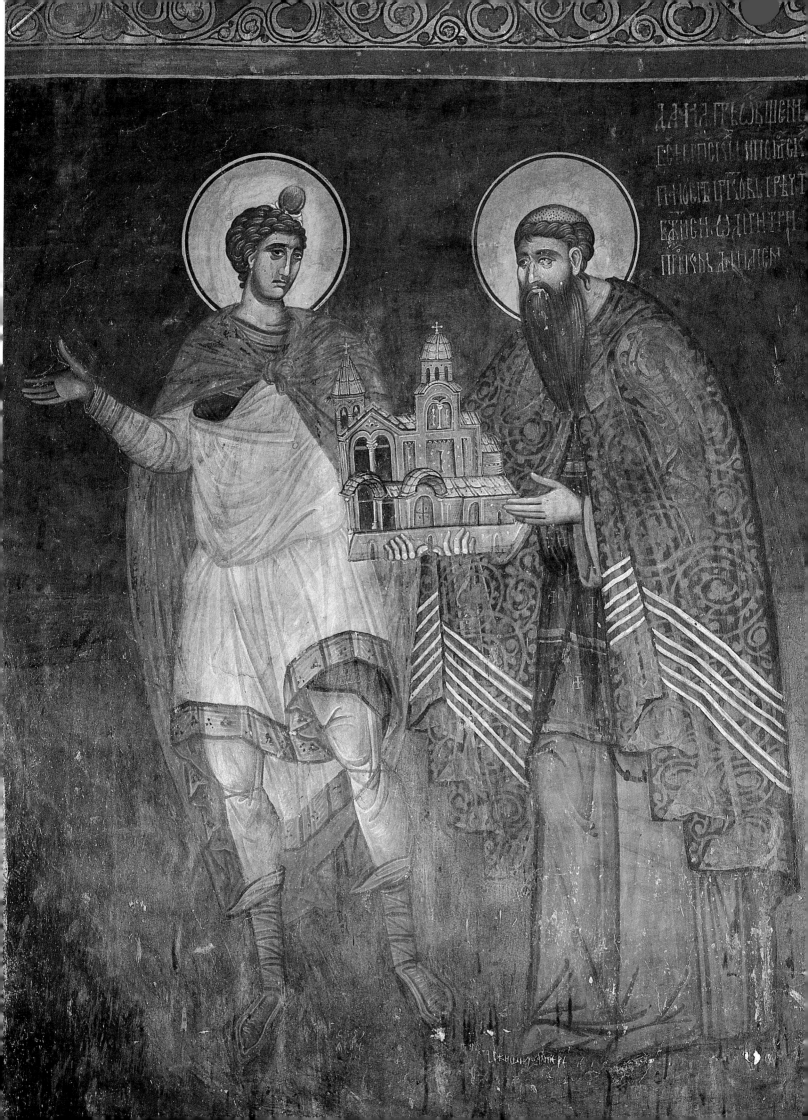

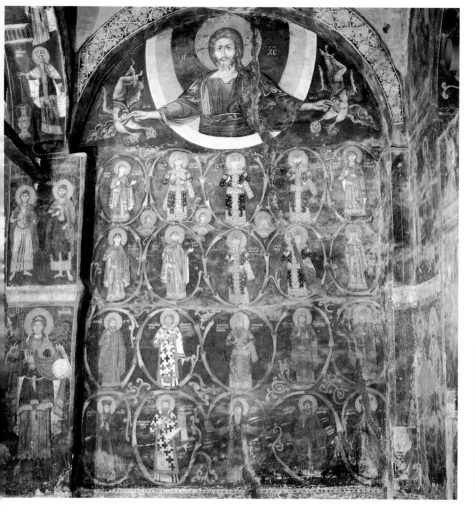

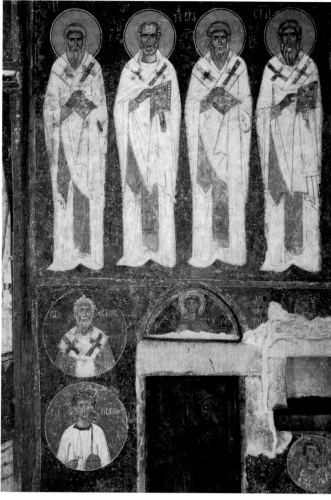

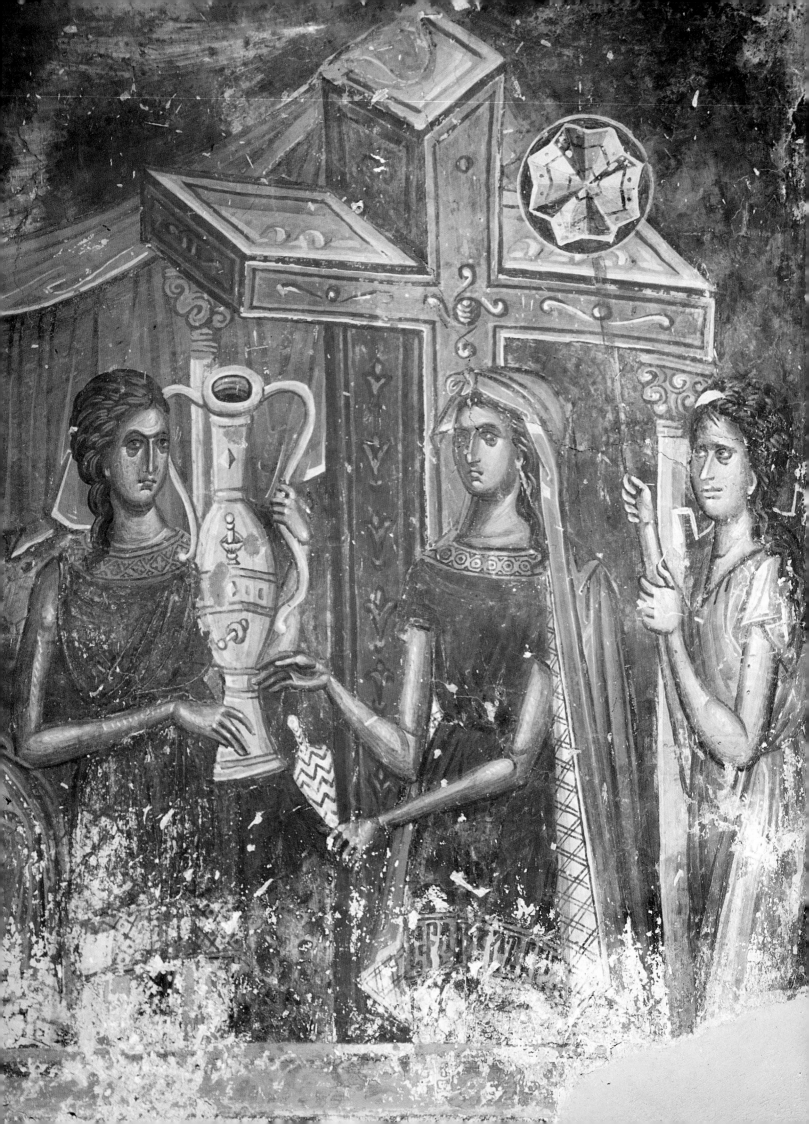

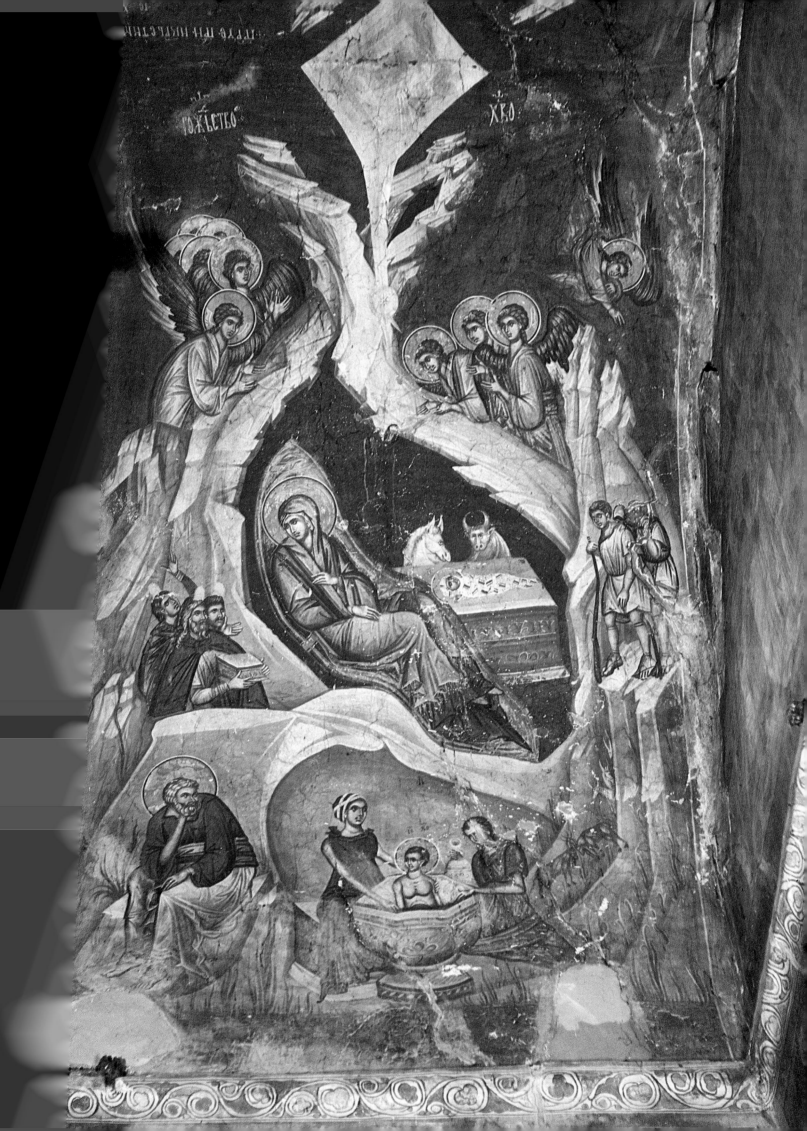

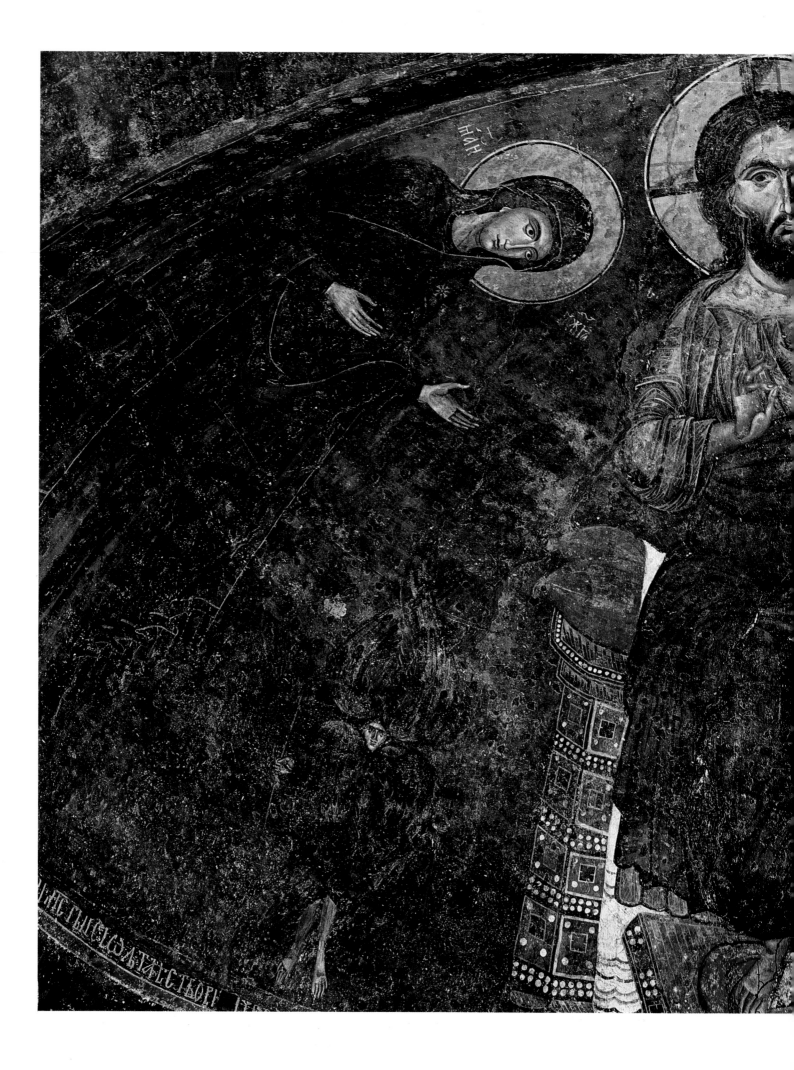

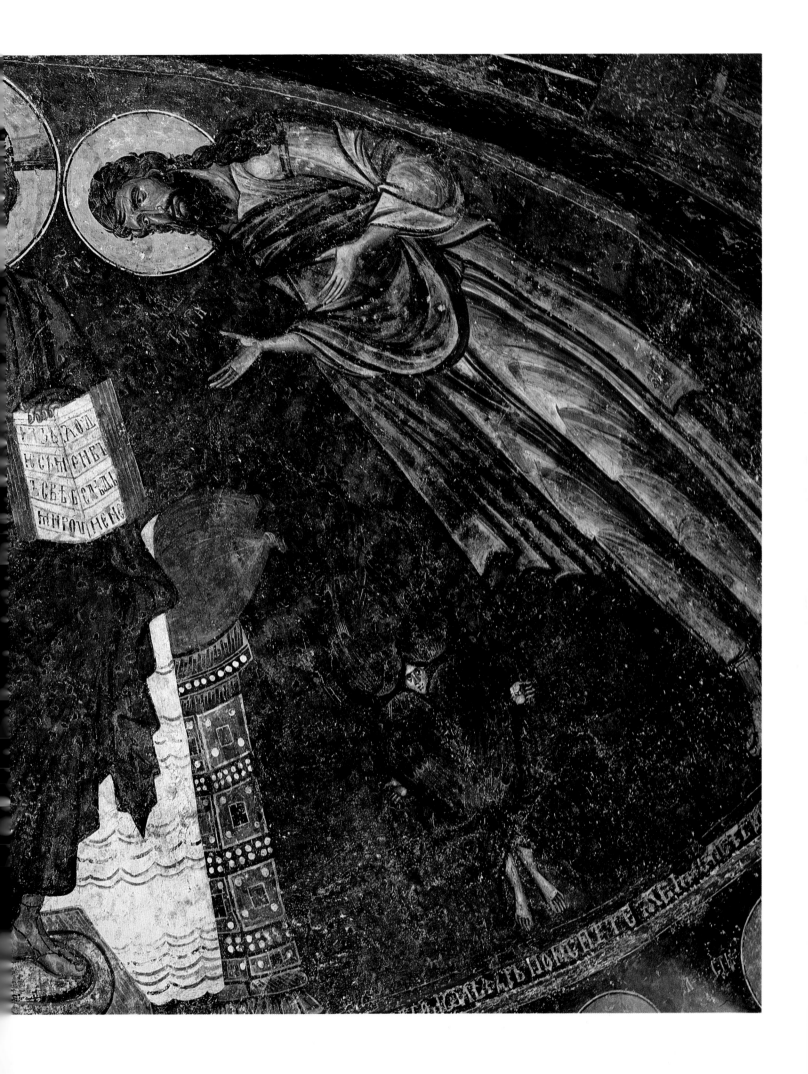

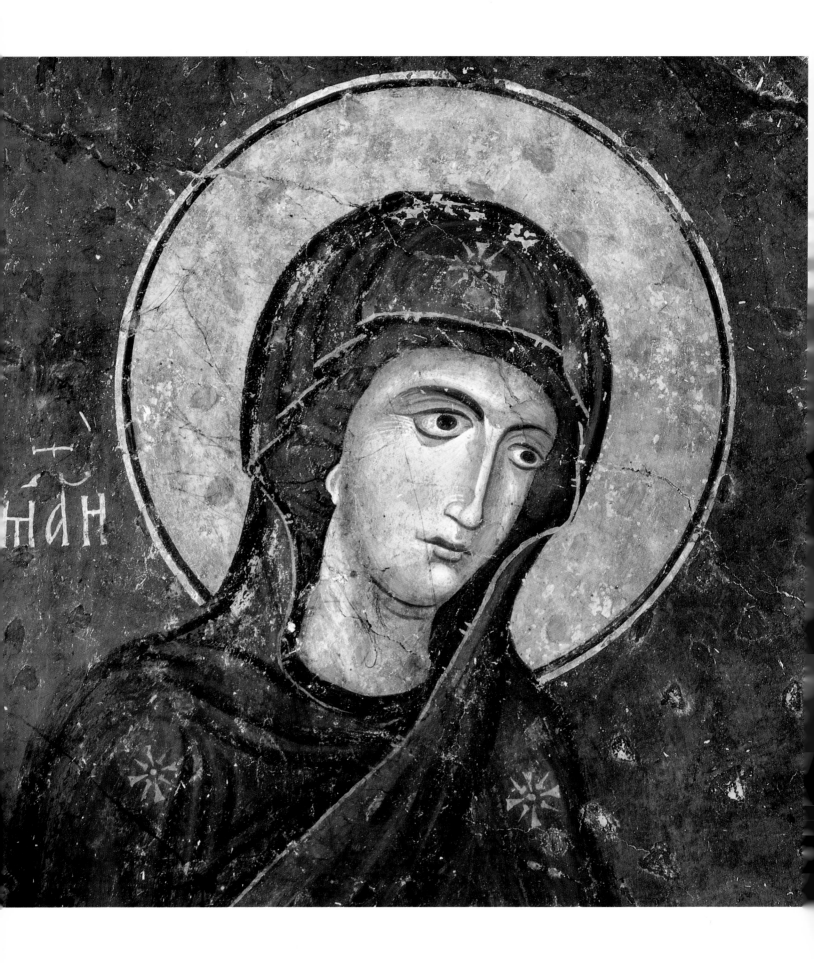

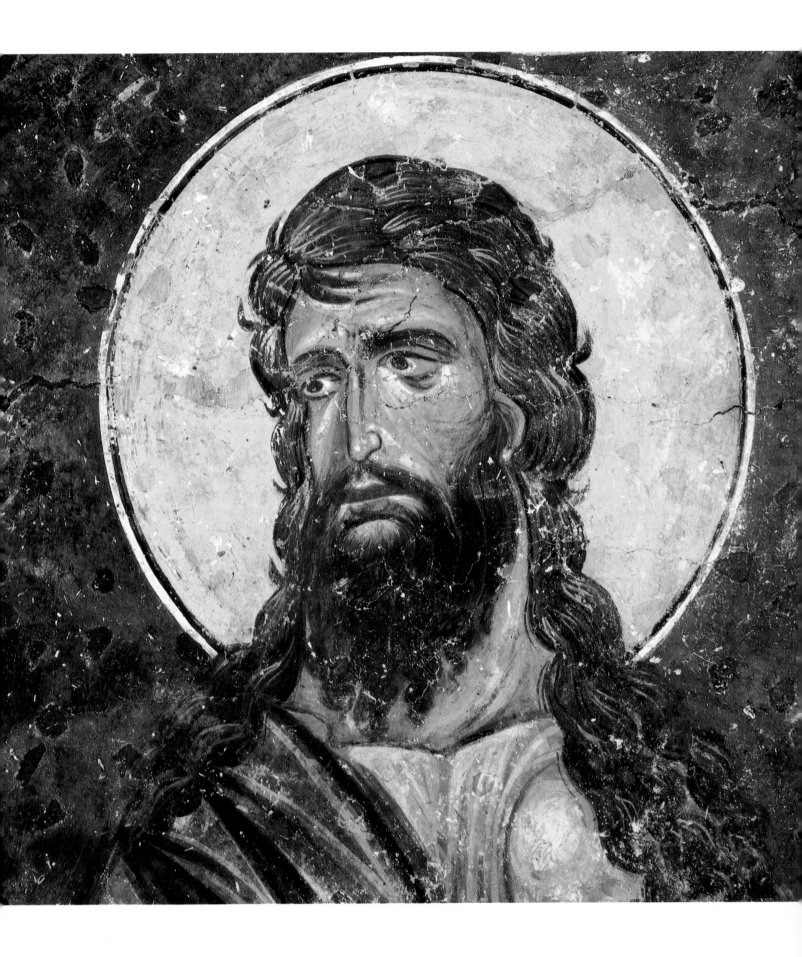

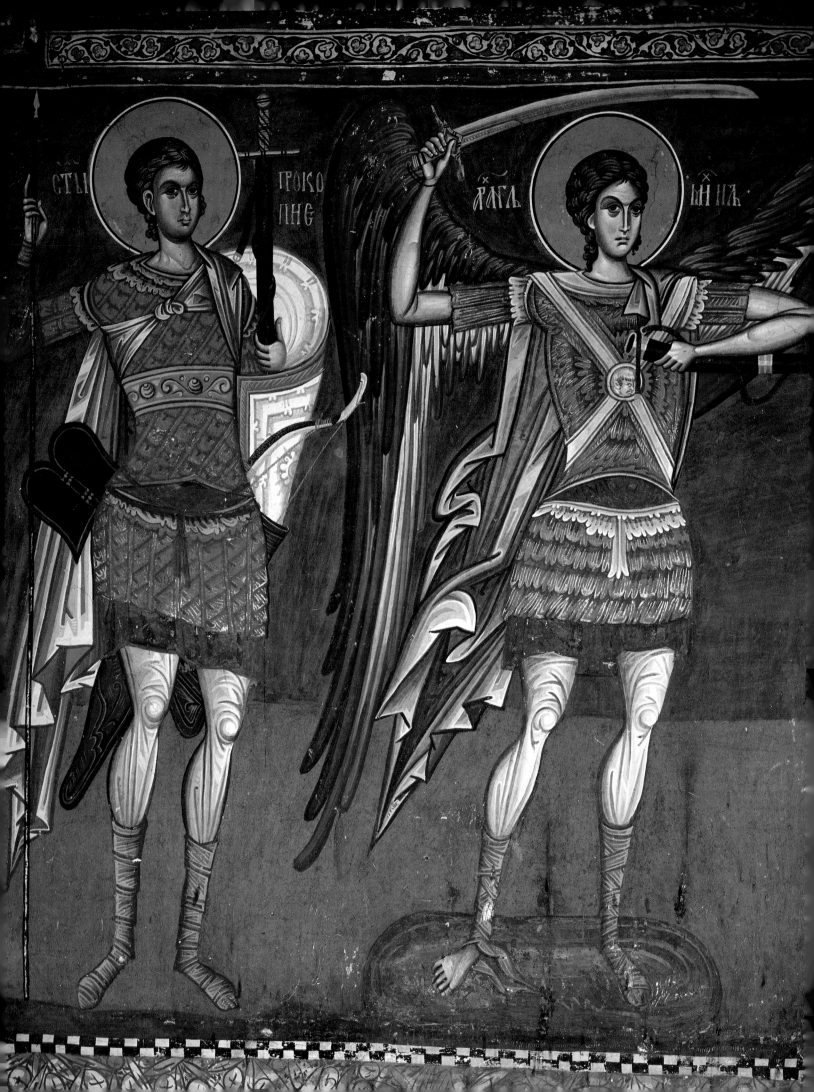

СТЫ АЛЕѮІН ЧЛВѢБЖН

ермоладе

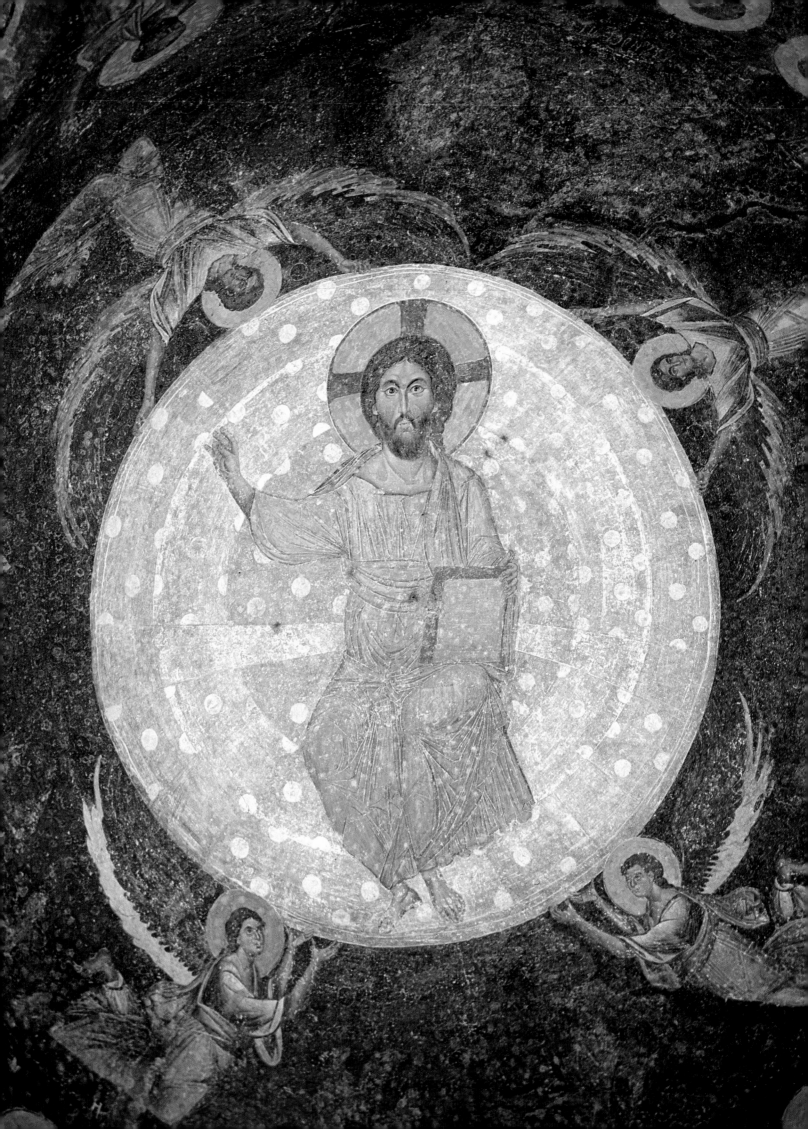

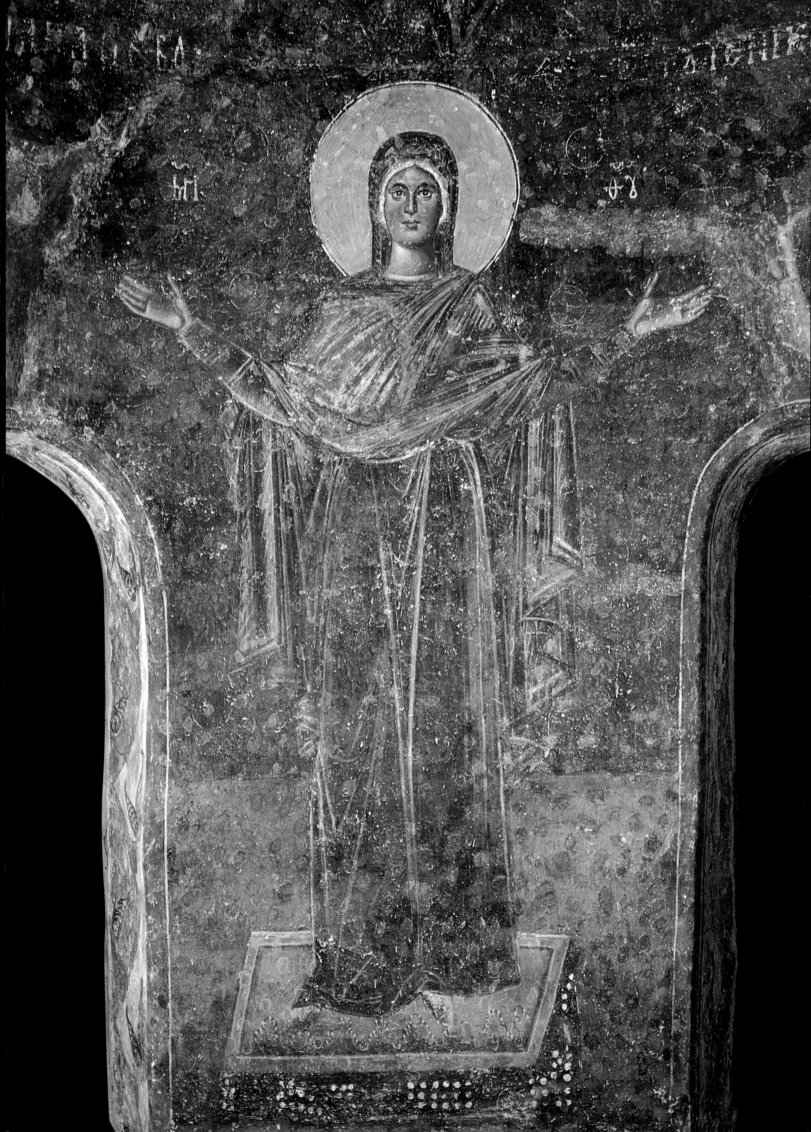

МАКАРІЄ ПР... ... ПАТРІАР...

ІС .. ОБИТЕЛЬСТВО ПРЕСТОЛА СЕГО

...ГДАКОЙ
МОИГДЕ.СИ
АСОБ.ДАЕВ.
СВ...НИГРАДЕ
СКАПА.АТЕ
ПРТОПНОЕ
НАСТРАНОШЕ
НІЕ.НА.ОСО.Н
ОЕН.ЕМЕН.НЕСЕ
ОСМАКОЛЮ.ЦЕ
НСУПОНІ.ВАТ...
ПОНГ.ВАШИГО
ЖЕН.СЕТЕПТ
СЪ.НСН.СЛ
СТН.БЛАГОД...
ДІЕШИХТИ

ПРЕѠЩЕННИ АХІЕПКПЬ КѴ
ІѠАНЬ

ВЬЛ Ꙃ РК В ПѦ ТА ПЕ ПРЕѠЩЕ
ІН АХІЕПКПЬ ЛГПДАЛЬ МОН ІѠАНЬ
Г ѠБНОВИ ТАА СТЮ ПЕТА СЬ Рⷪ
ЖЕ БЬ ВН ГТЕХЮЩЮ КОⷮАⷮНЕ
ЕЖЕ БЛНЕНИ КНꙀ НИ Ѿ ДІ
ТКО ЕМУ СЛУХѴС ПОКⷮКОДЕНІЮ
ЕЖПО ПОСЛЕПІⷮТЕНІ ВЕЛКОН
РКИ И ПЕСЬ ДⷪНИ НАЕДⷮНЕ С
ІСПЛКЬ ЛАУСЕН СⷪЛⷪВЕНІ
 И ХРⷪДⷮ

+ СⷪЛНЕПО
РОУМАА ГПⷪЖЕ БРЦЕ ДВⷪ
КУЦЕ ЕⷱЕ НЖЕ БА СЛОВО ПЛАНⷮО Рⷪ
ЖⷣⷪЩИ БЬ СУБⷪⷱЕ Жⷪ НЕ БⷪБⷪЛЕНО
НⷤЕ ДⷪНⷪ КНⷪЕ СⷱⷮРⷪЩИПⷪК НⷪЕ
Пⷪ РЕБНОМ СⷪБРⷪ УАПⷪ Ѕⷪ ꙀНЕ ТЕ
ПЛАТⷪ ХⷪДⷫⷮⷮЮ НⷪНАНⷪУ СЕⷬПⷮⷮⷱⷮЕЮ
Пⷪ НⷪНО Кⷭⷮ ТЕ БⷪЕⷨⷮⷤⷤⷤⷪⷰⷨ СⷮУ НⷪКⷪ ДА
АⷬНⷪꙀ БУДⷪЕ СⷮАⷬНⷪ НⷪКⷪꙀⷱⷤⷤНⷪ МⷪⷴⷪЕ
АⷬⷮНⷪ НⷪⷤⷤⷤН Мⷪⷤⷤⷪⷪⷰ МⷪⷪЕ ТⷬⷮⷤⷤⷪⷰⷱⷤНⷪЕ
Ꙁⷤⷤⷪⷱⷤⷰⷪⷰⷤⷤ ПЕНⷤⷤⷪЕ, НⷪⷤⷤНЕⷪⷤⷤ Кⷪⷤⷤⷪ Нⷪⷪⷪⷰⷪⷨⷤⷤⷪⷱⷤⷰⷪ
Сⷤⷤⷪⷮⷤⷪⷨ Жⷤⷤⷪⷮⷤⷪ Дⷪⷤⷰ Сⷤⷤⷤⷪⷪⷤⷤ БⷤⷤⷪⷤⷤНⷪⷤⷤⷪ
Сⷤⷤⷪⷮⷪⷤⷤ Гⷤⷤⷪ Сⷤⷪⷤⷤⷤⷪⷤ Хⷤⷪ Гⷤⷤⷪⷪⷤⷤⷤ
Бⷤⷤⷪⷤ Нⷪⷤⷤⷪⷤ ⷪⷤⷤⷪⷮⷪⷤⷤ Мⷤⷤⷪⷤⷤⷪ ПАⷤⷤⷪⷤⷨⷤⷮⷤⷤⷪⷤⷤⷤ Уⷤⷤⷪⷤⷤ
Тⷤⷤⷪⷤⷪⷤⷤⷪⷤⷤⷤⷤ ВАⷤ Цⷤⷪⷤⷤ ⷤⷤⷪⷤⷤⷪⷤⷤⷪⷤ
Ꙁⷤⷤⷤⷪⷤ Мⷤⷤⷪⷤⷤ Ꙁⷪ

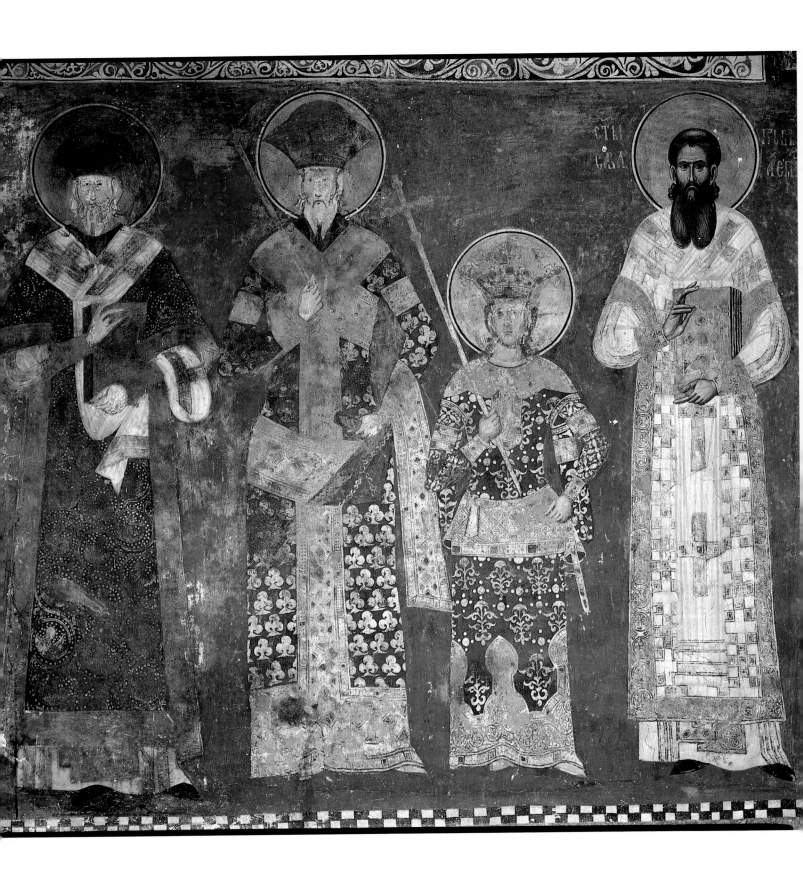

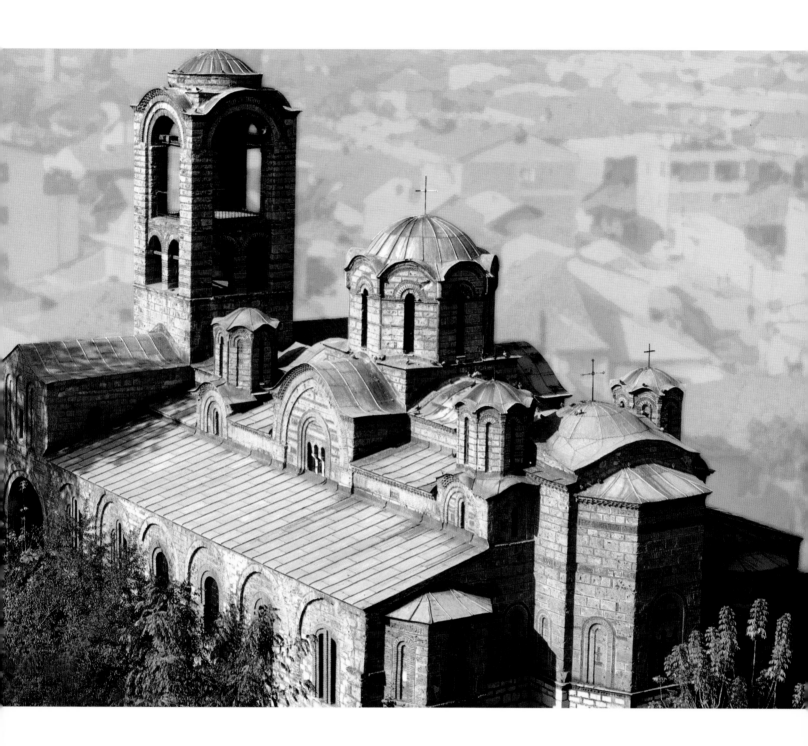

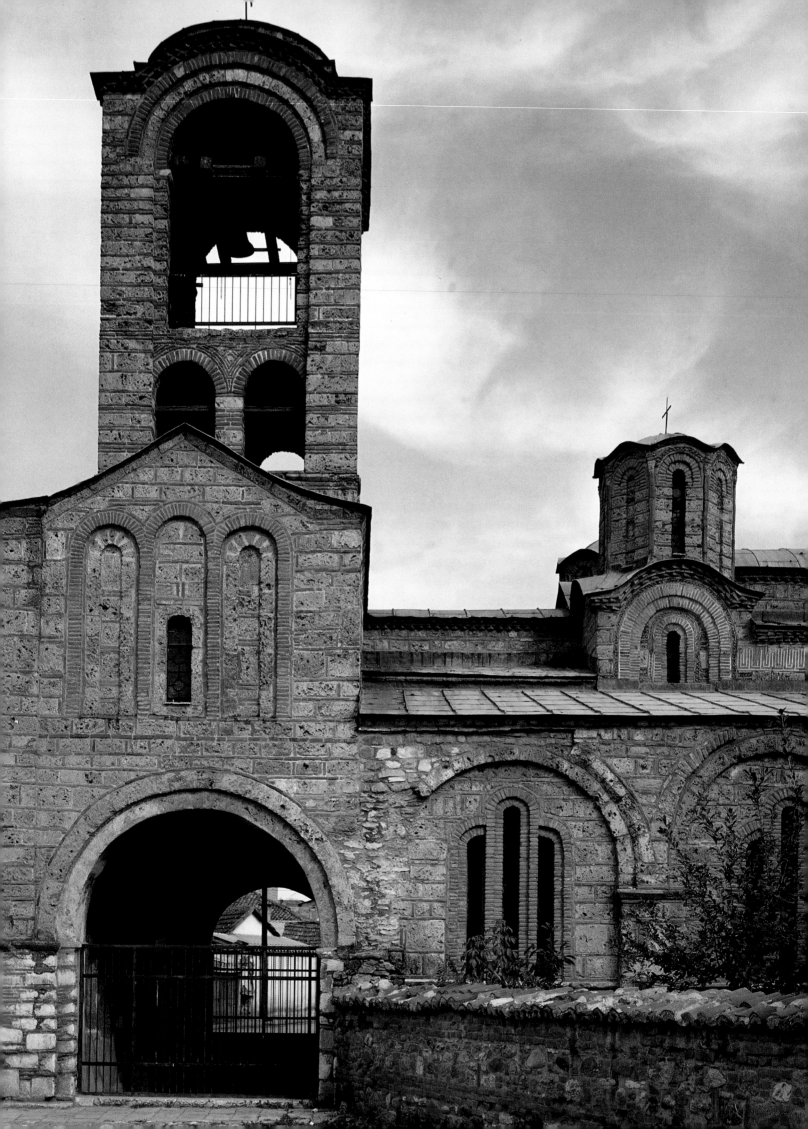

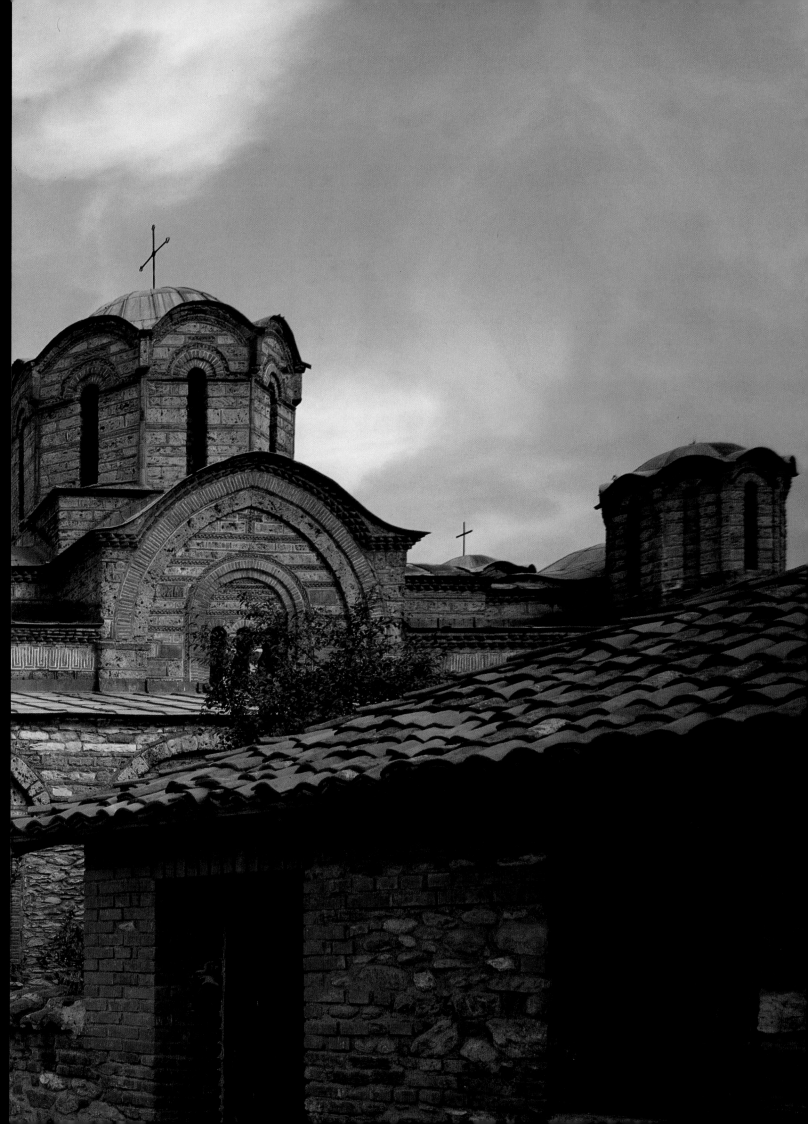

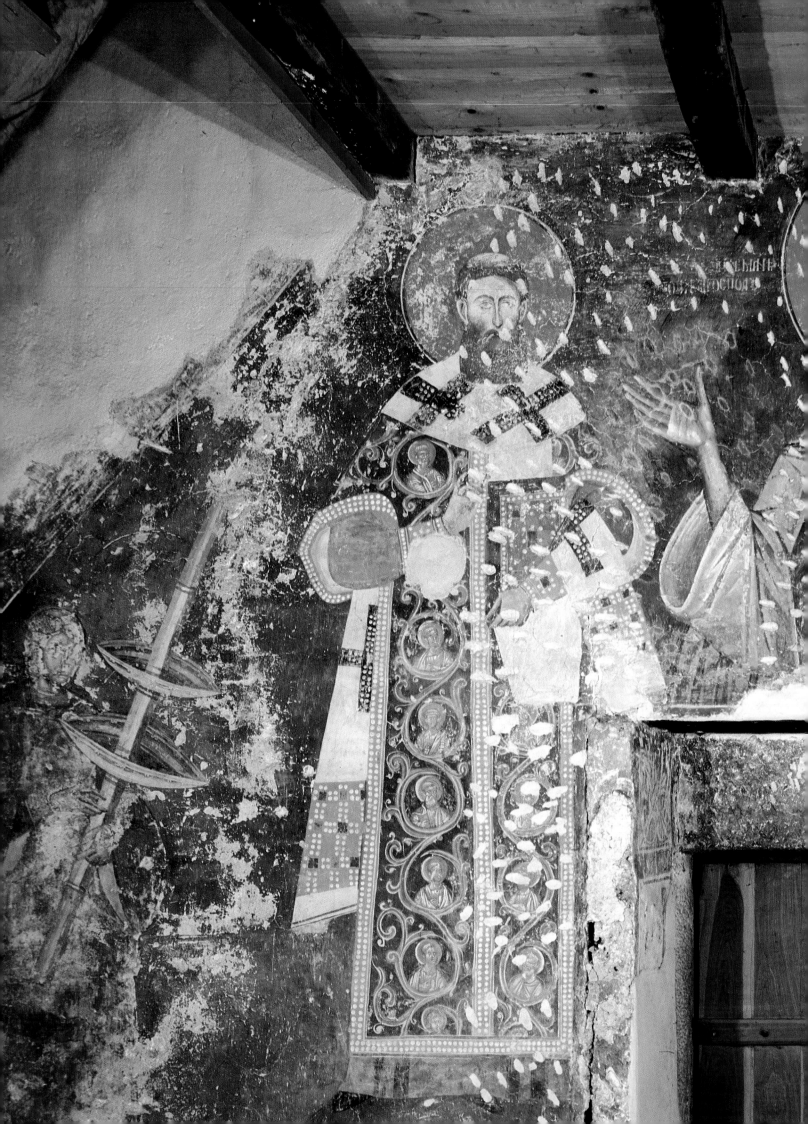

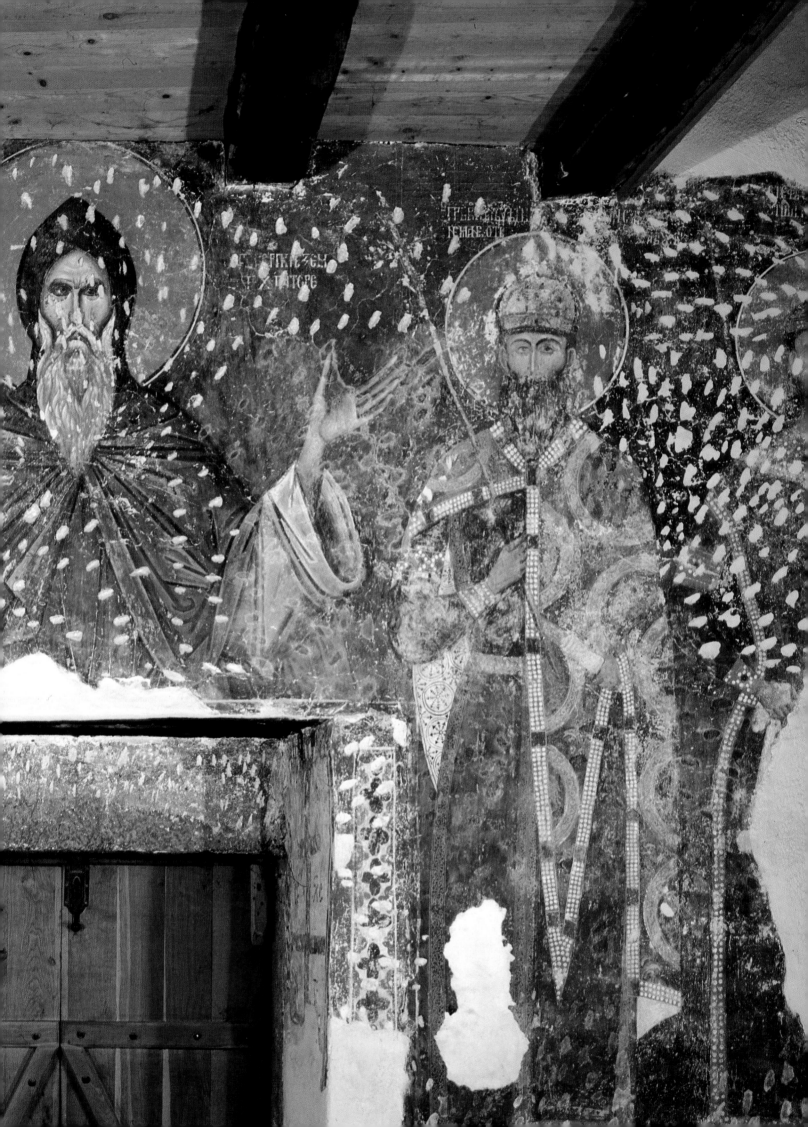

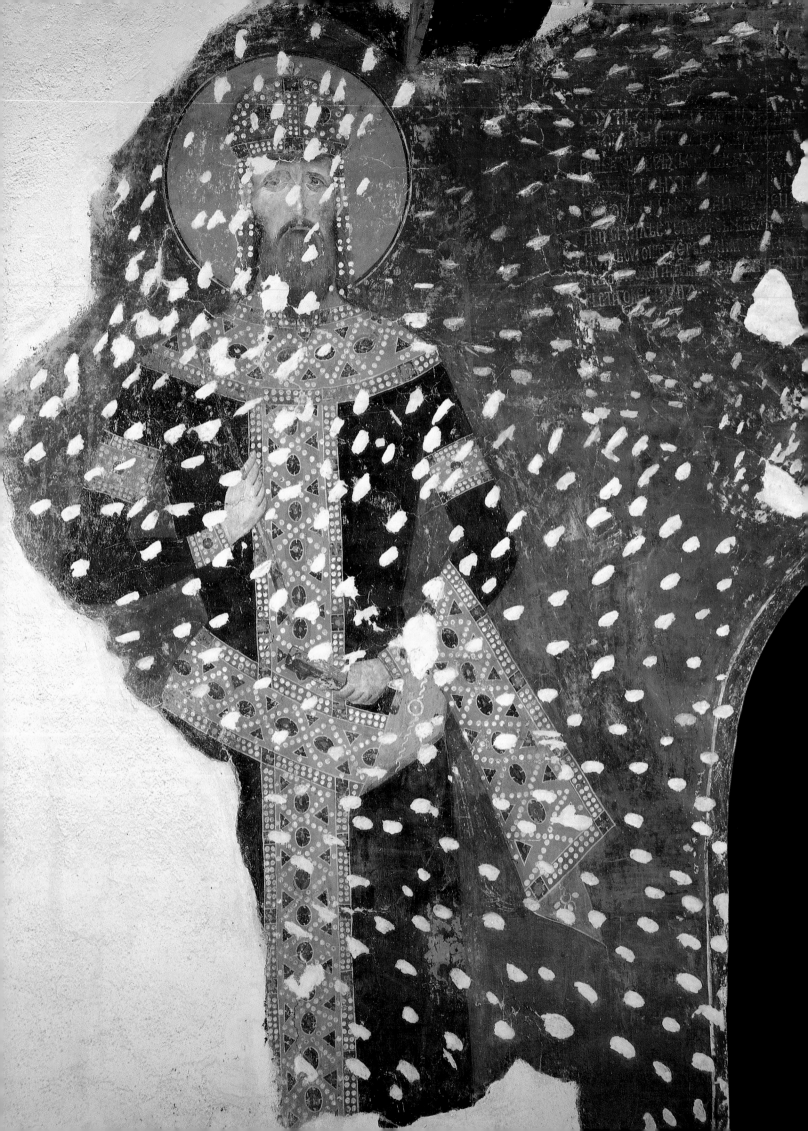

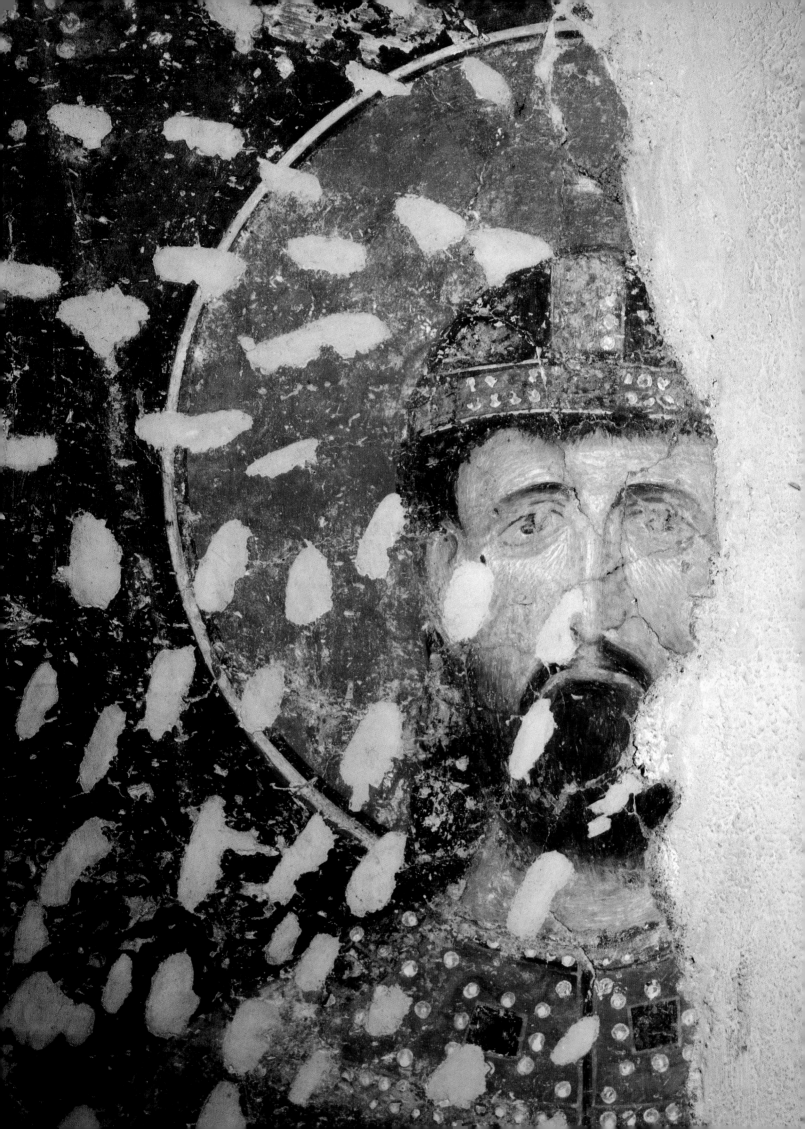

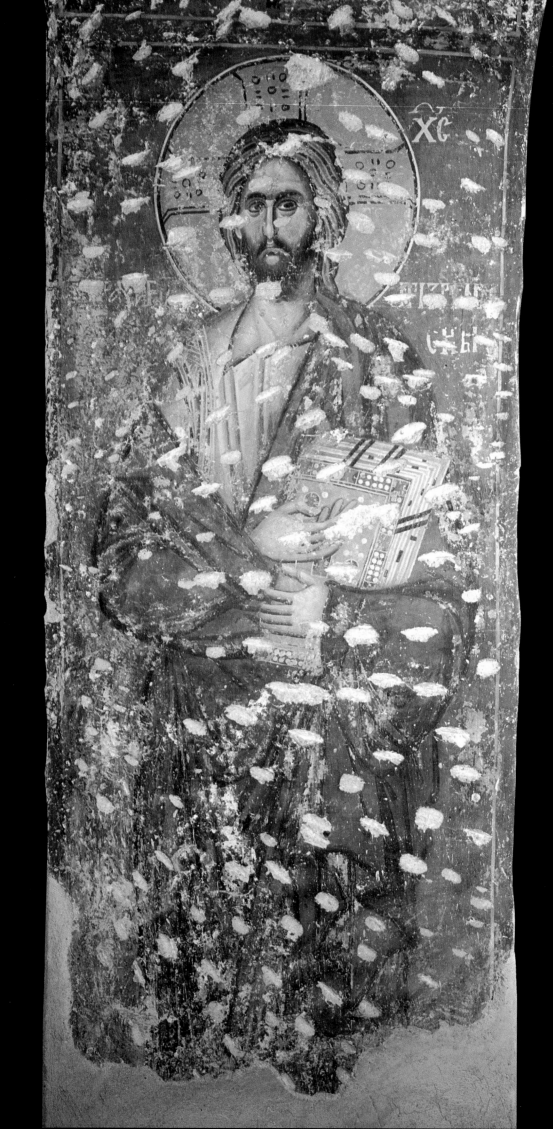

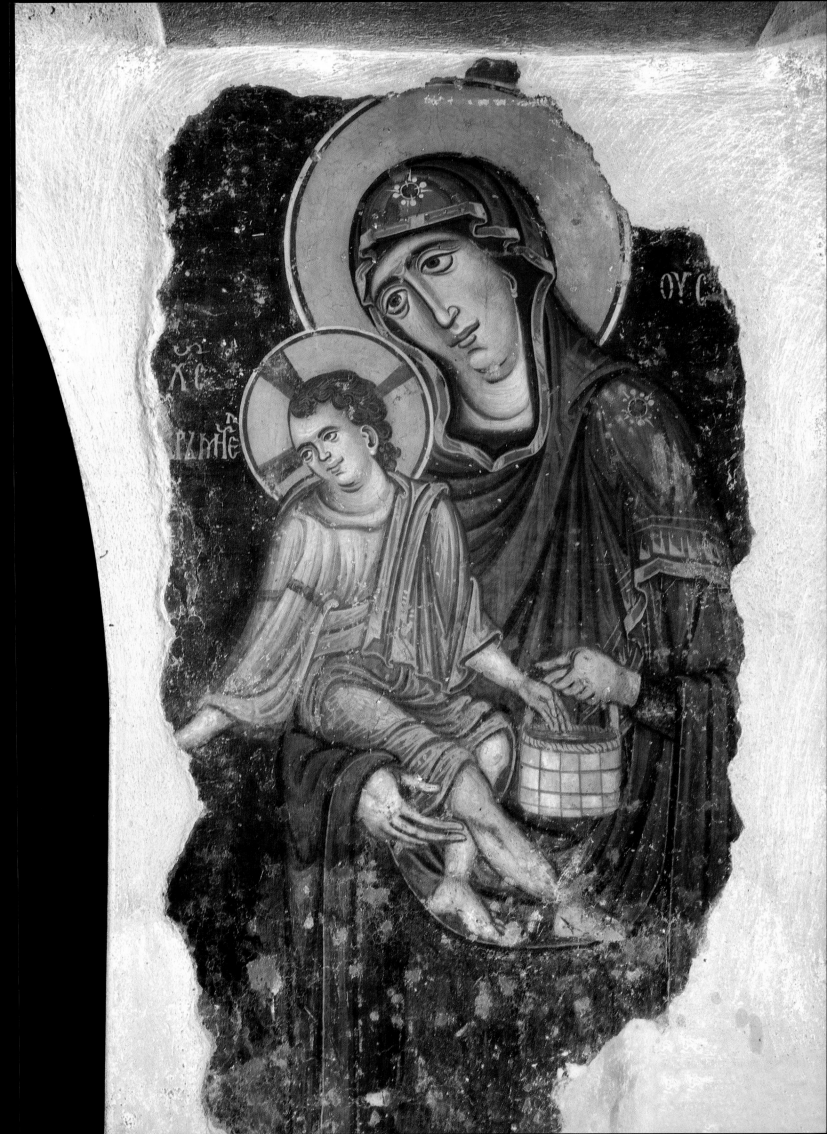

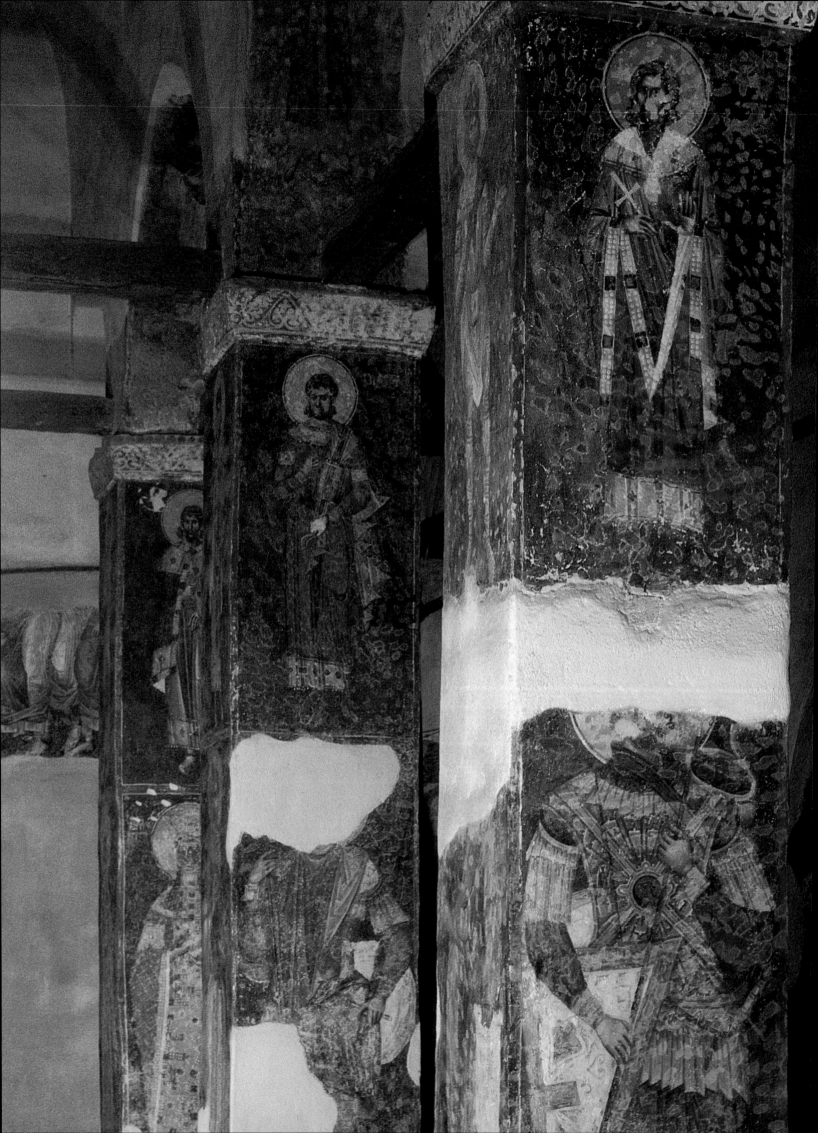

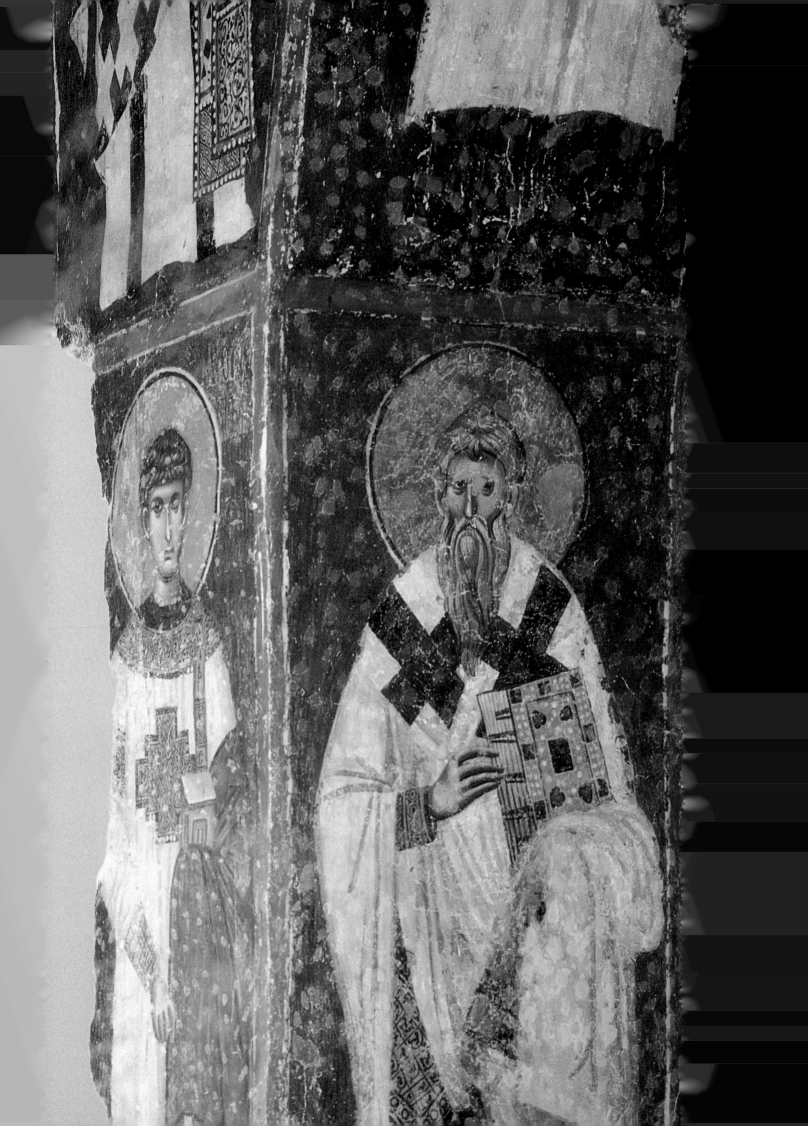

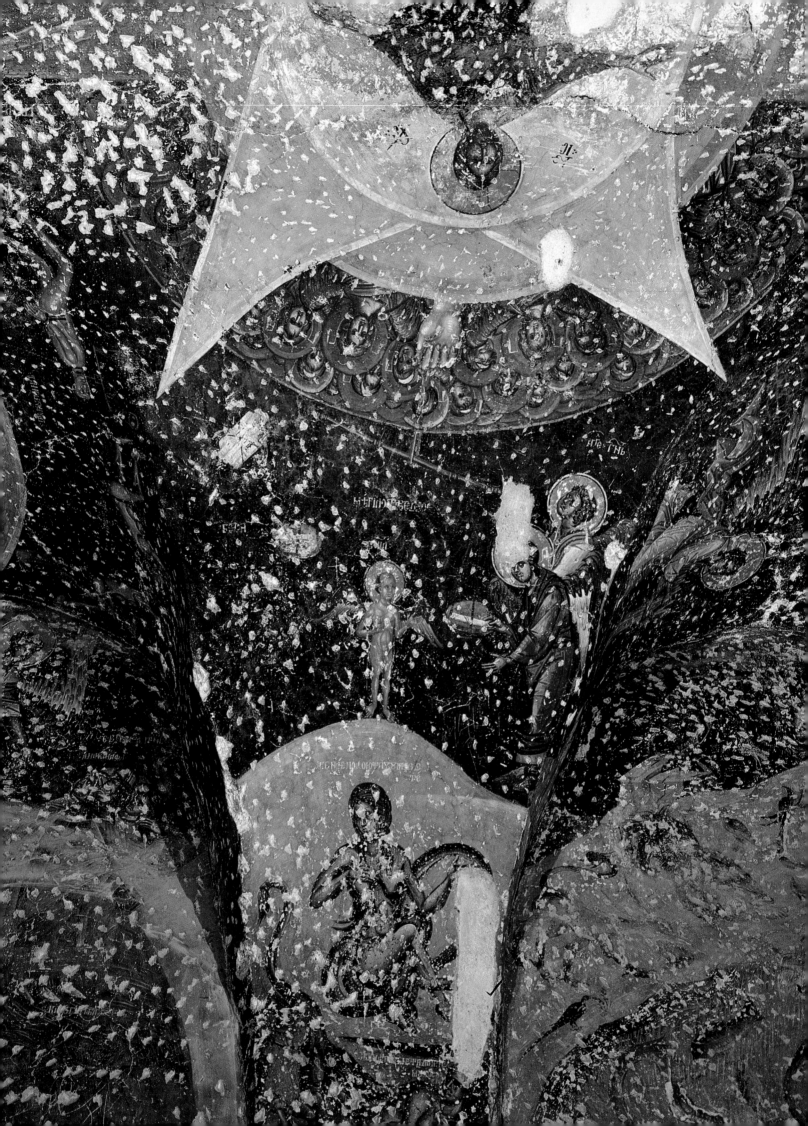

ІС ХС

Ѿ ПА ДО КРАТОРЬ

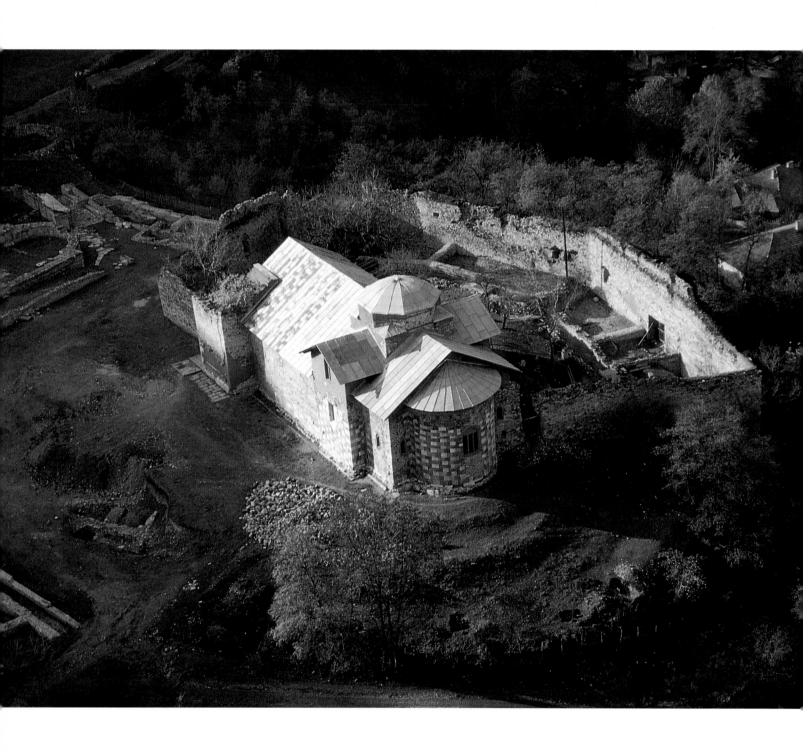

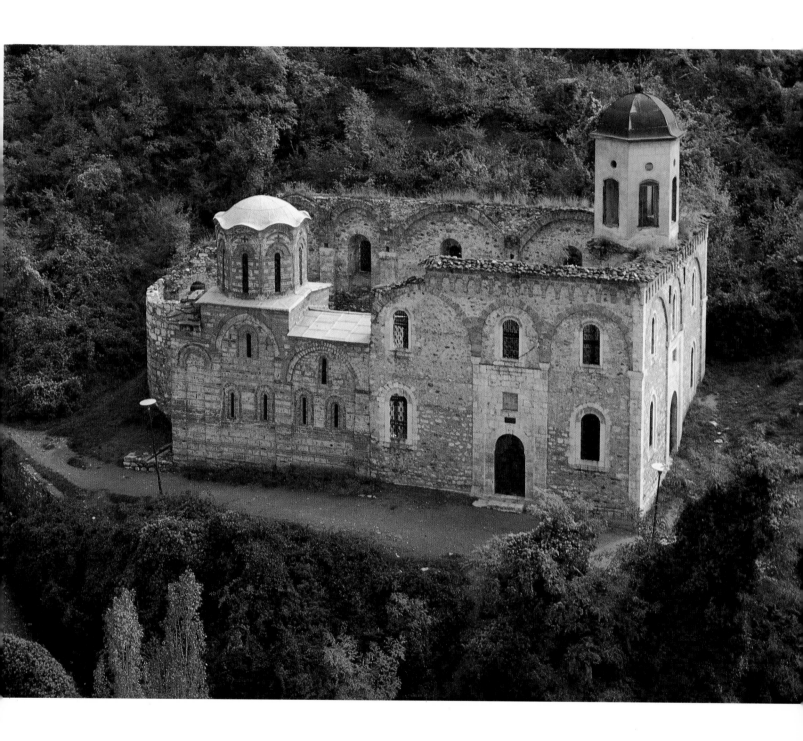

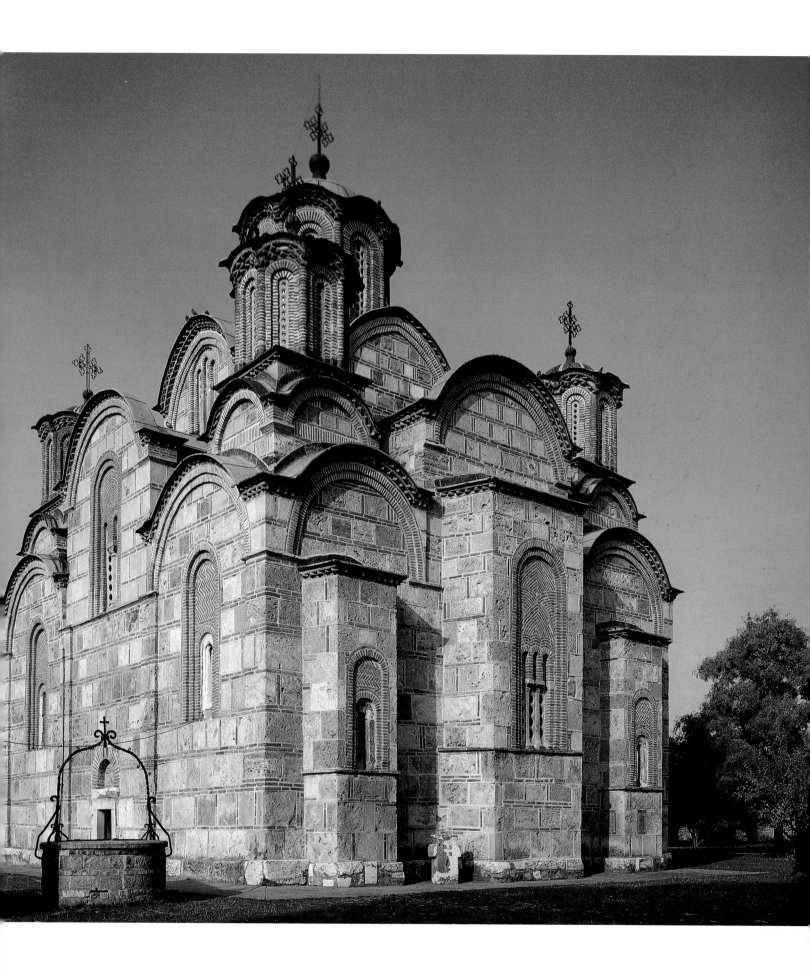

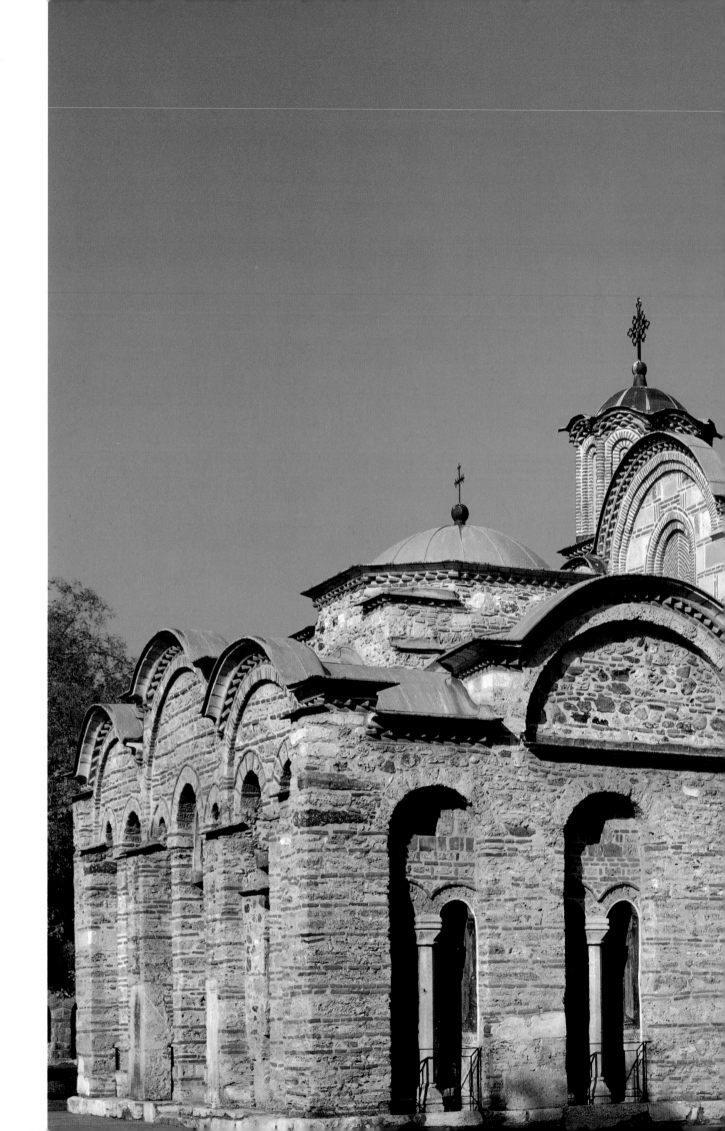

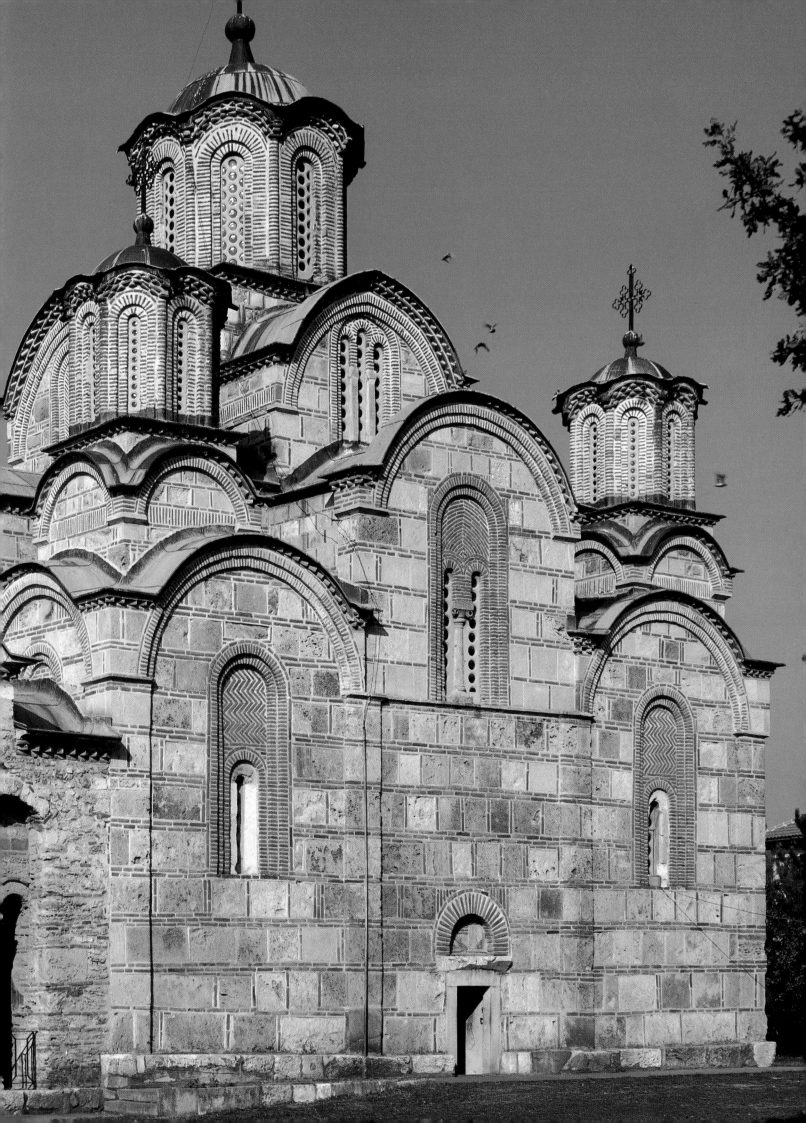

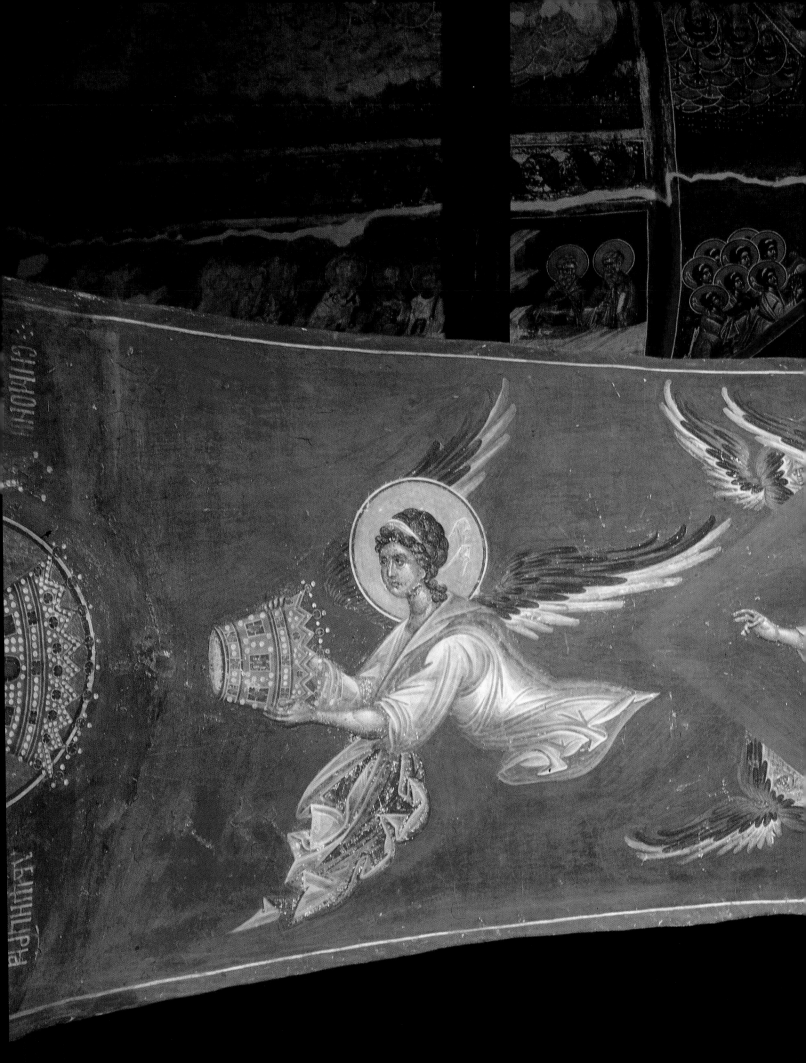

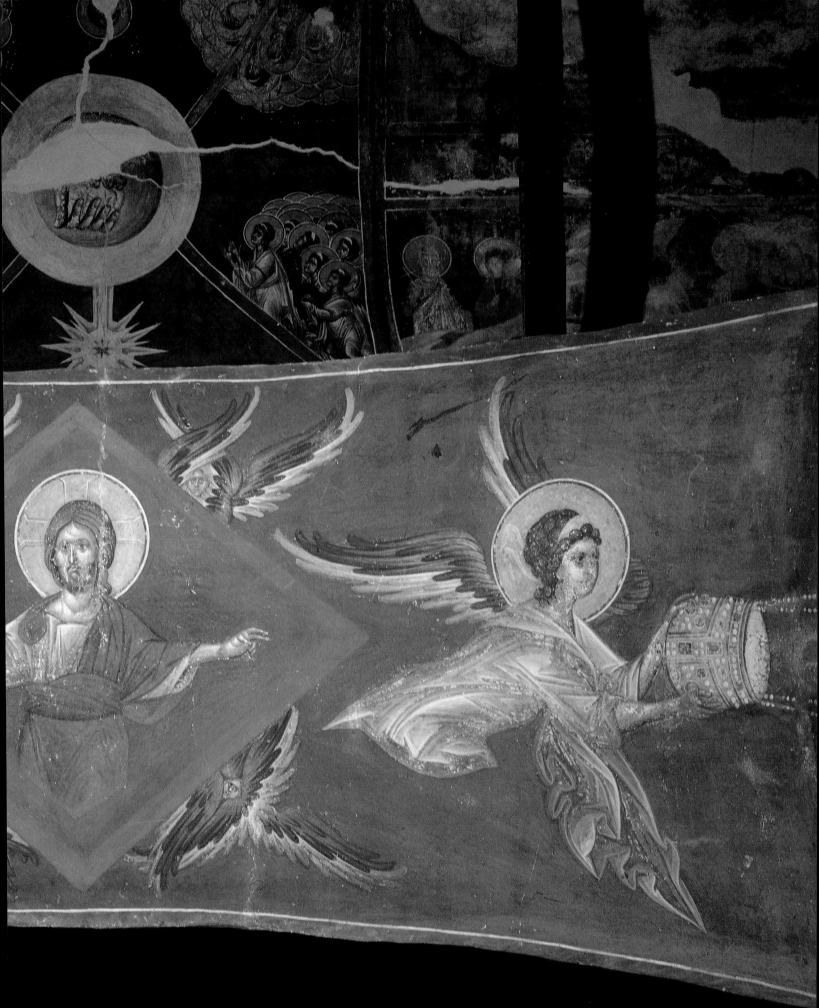

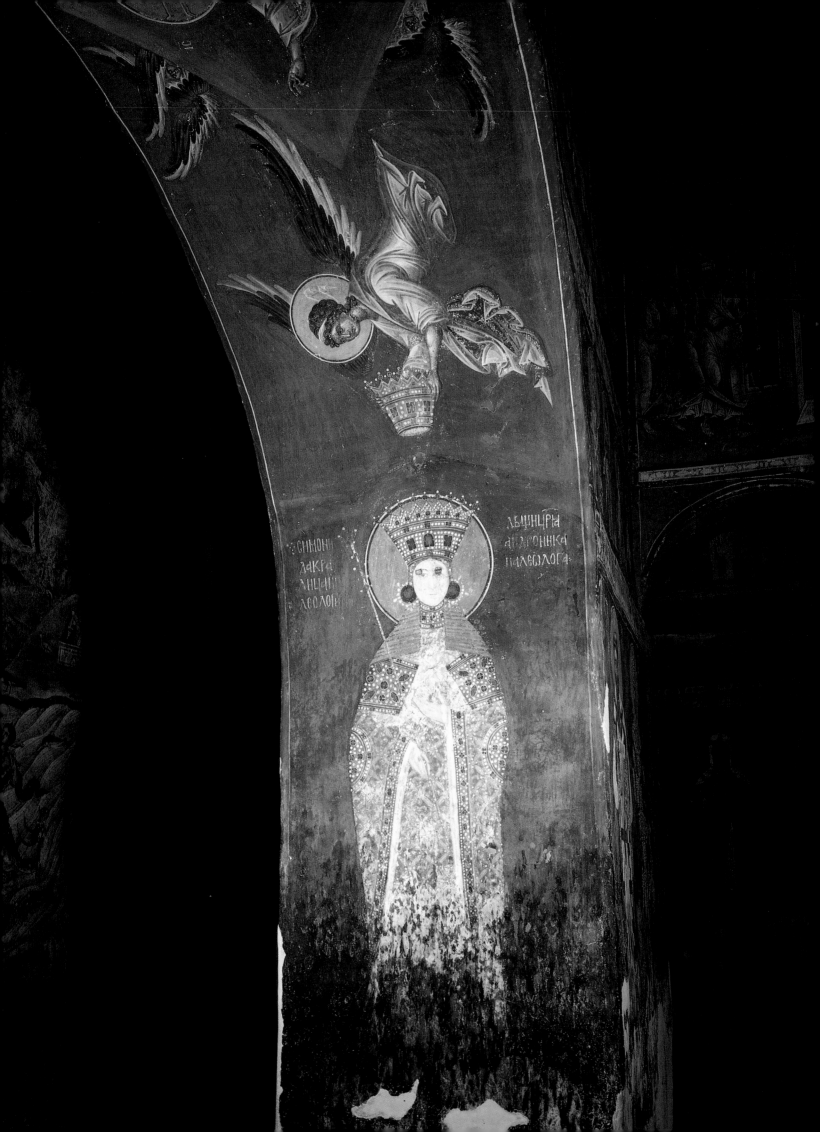

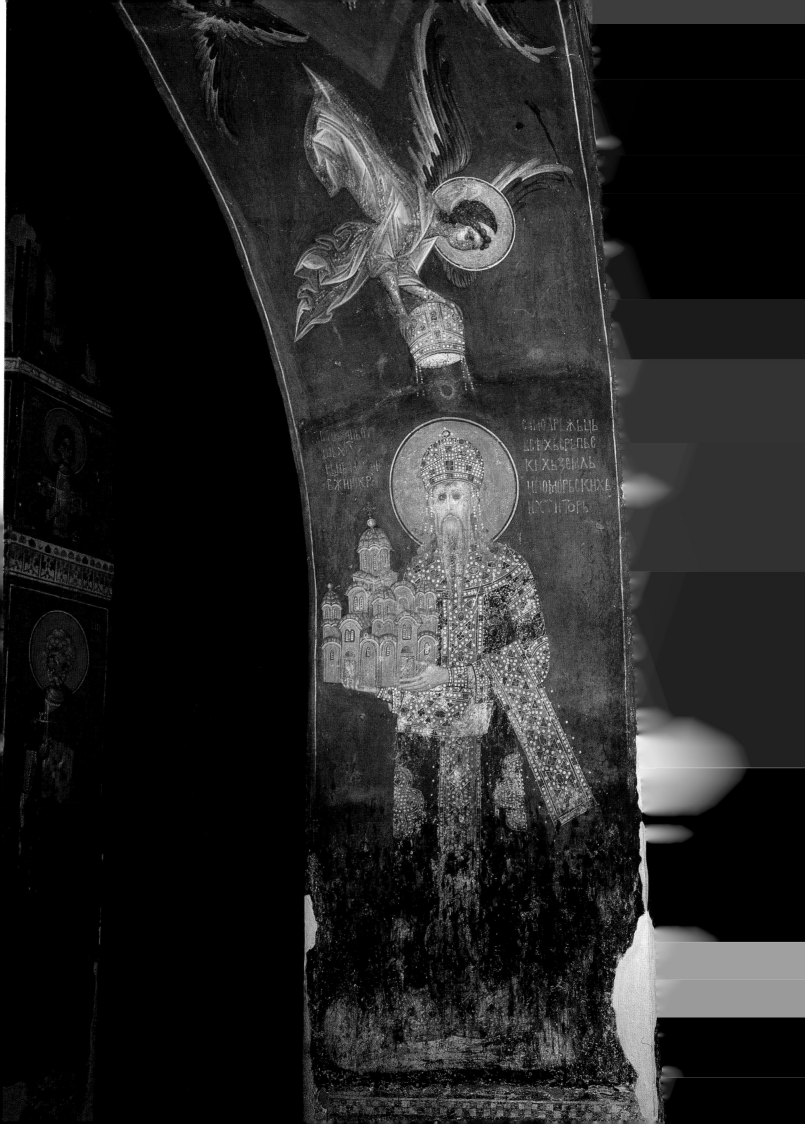

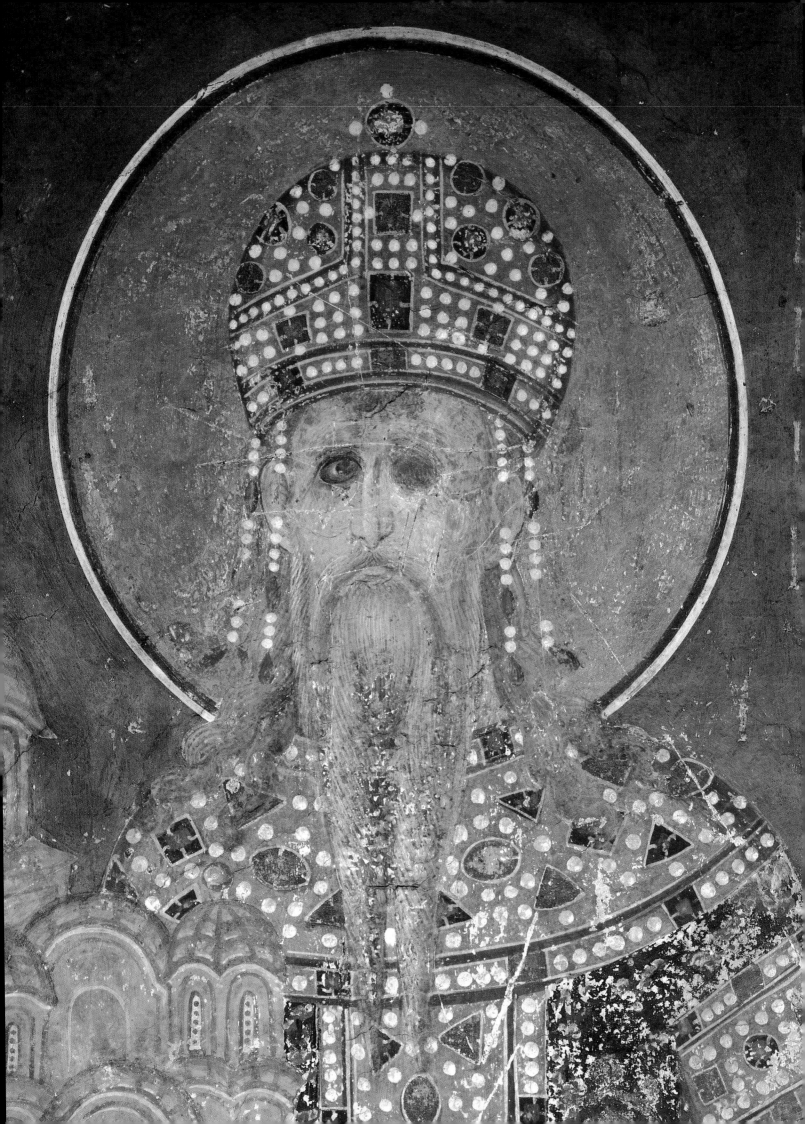

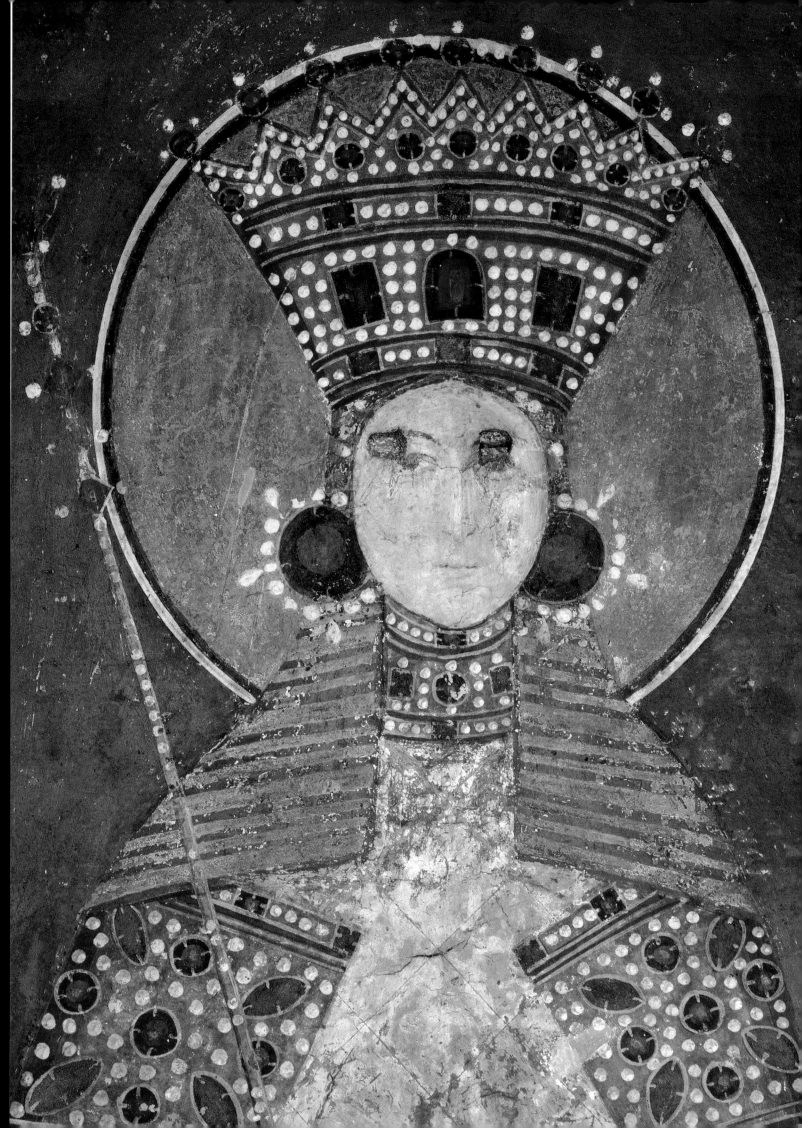

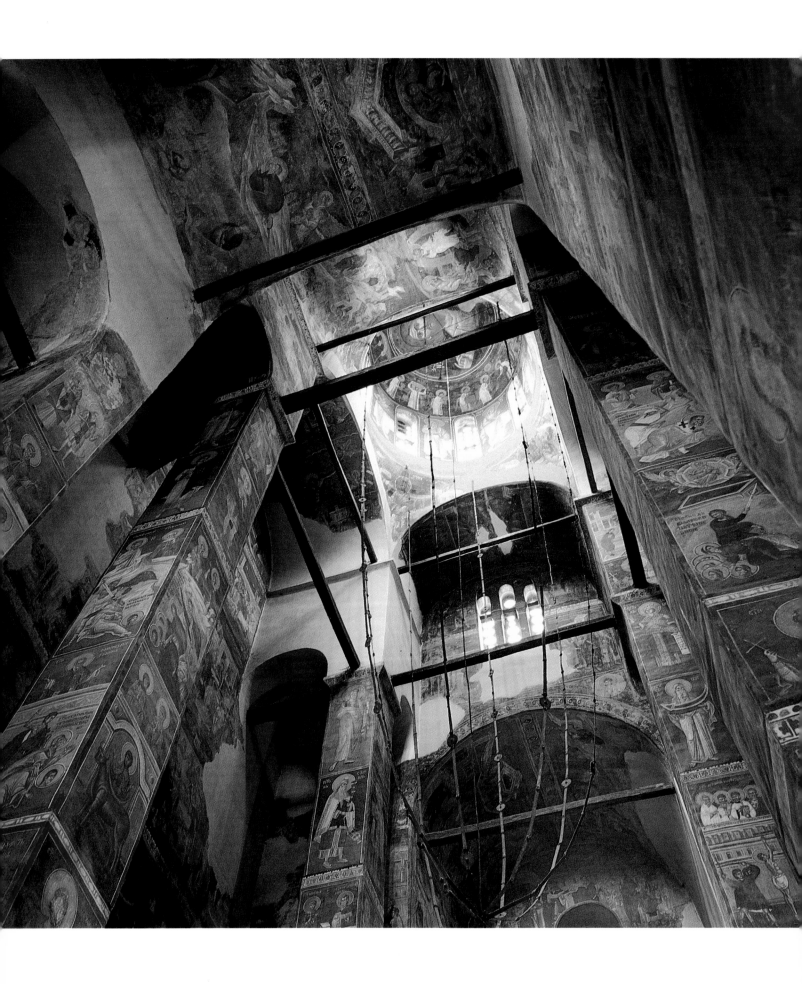

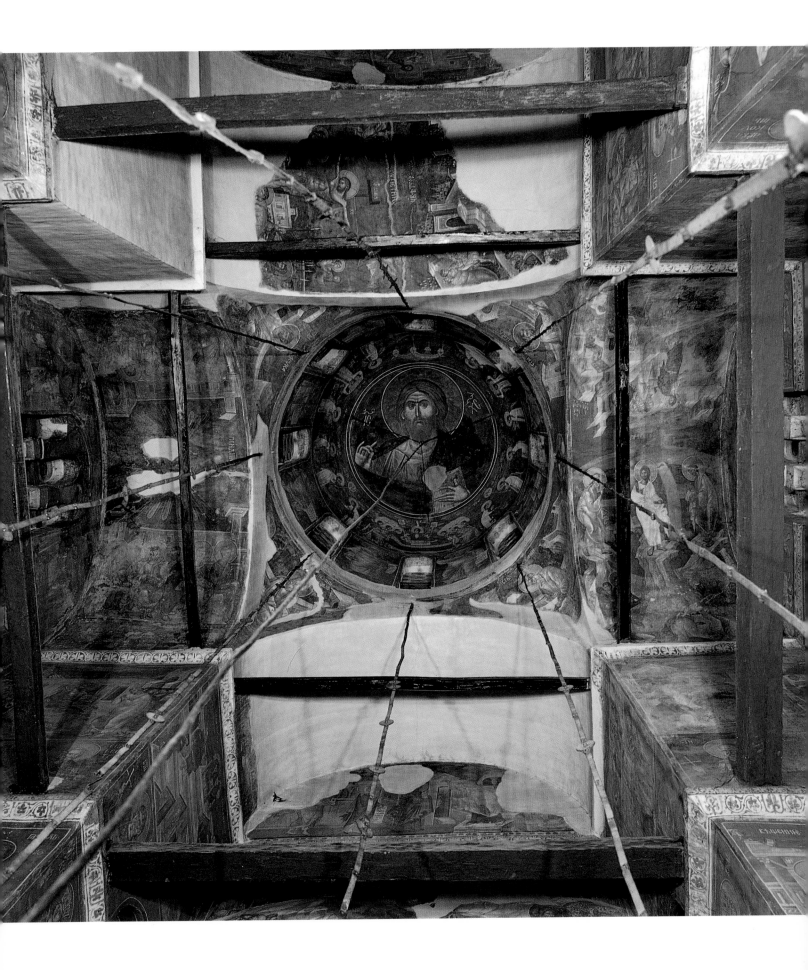

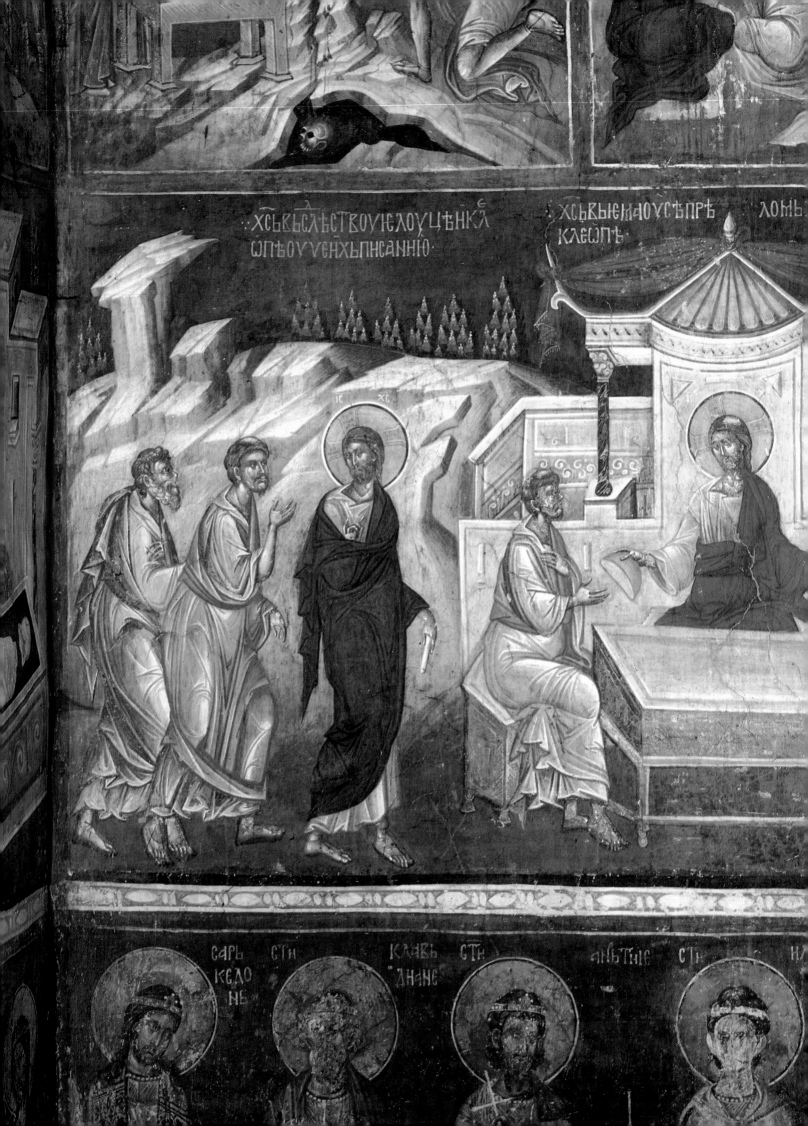

ХСЬВЬСЛ҇СТВОУ҇ЕЛОУ҇ЕНКА Ѣ ХСЬВЬ҇ЕМДОУ҇СЕПРѢ Λ ΛΟΜЬ
Ѡ҇ПЕ ОУ҇ЕНХЬ҇ПИСАНИ҇Ѡ КЛЕѠПЬ

САРЬ СТИ КЛАВЬ СТИ АНѢТИ҇Е СТИ И
КЕДО АНАНЕ
НЕ

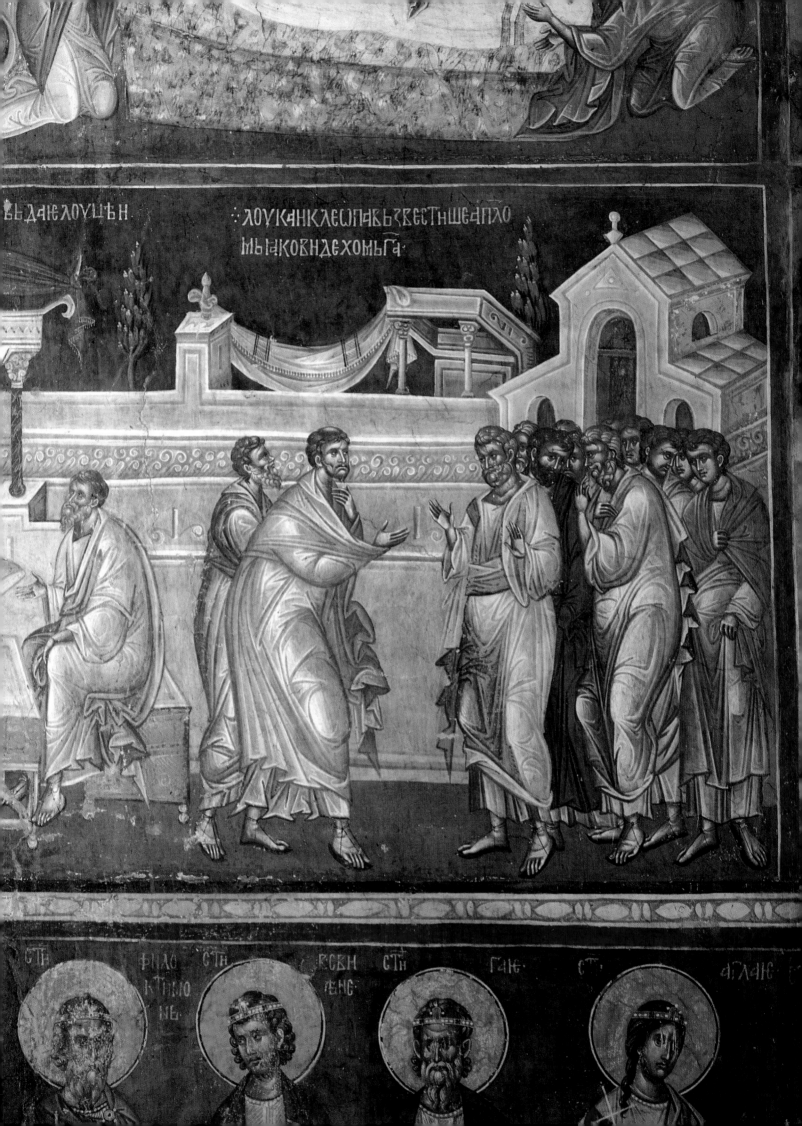

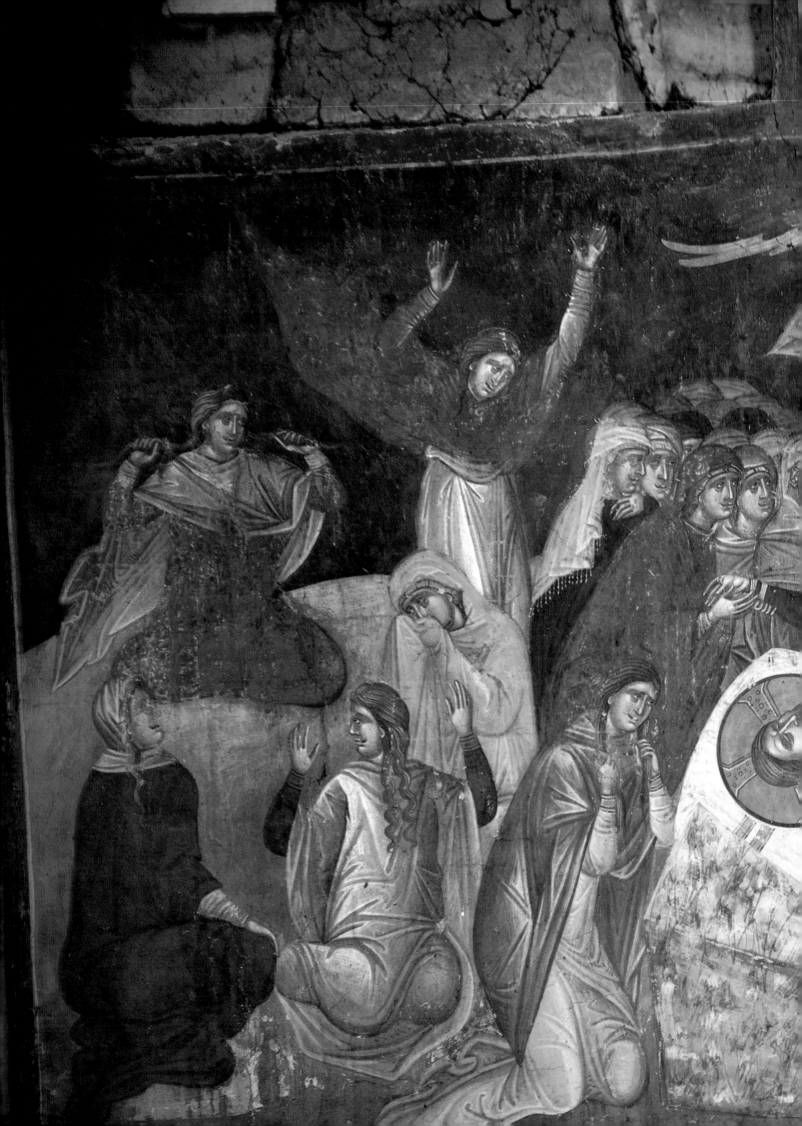

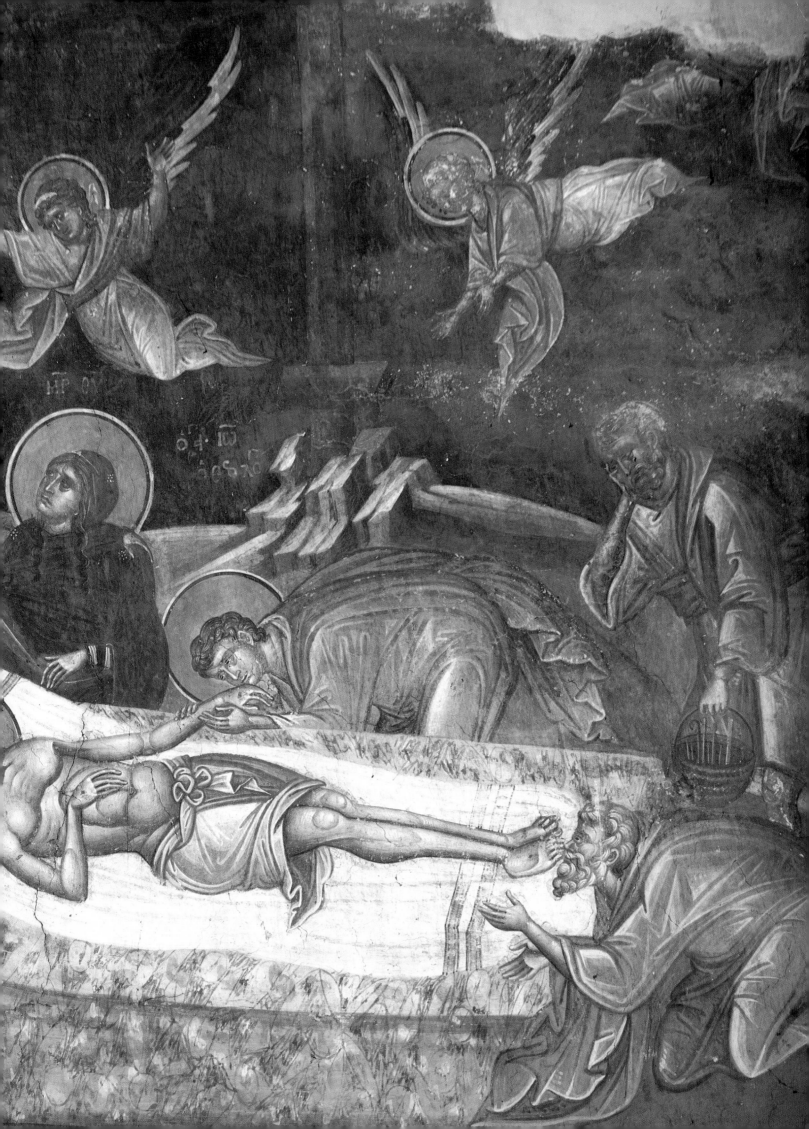

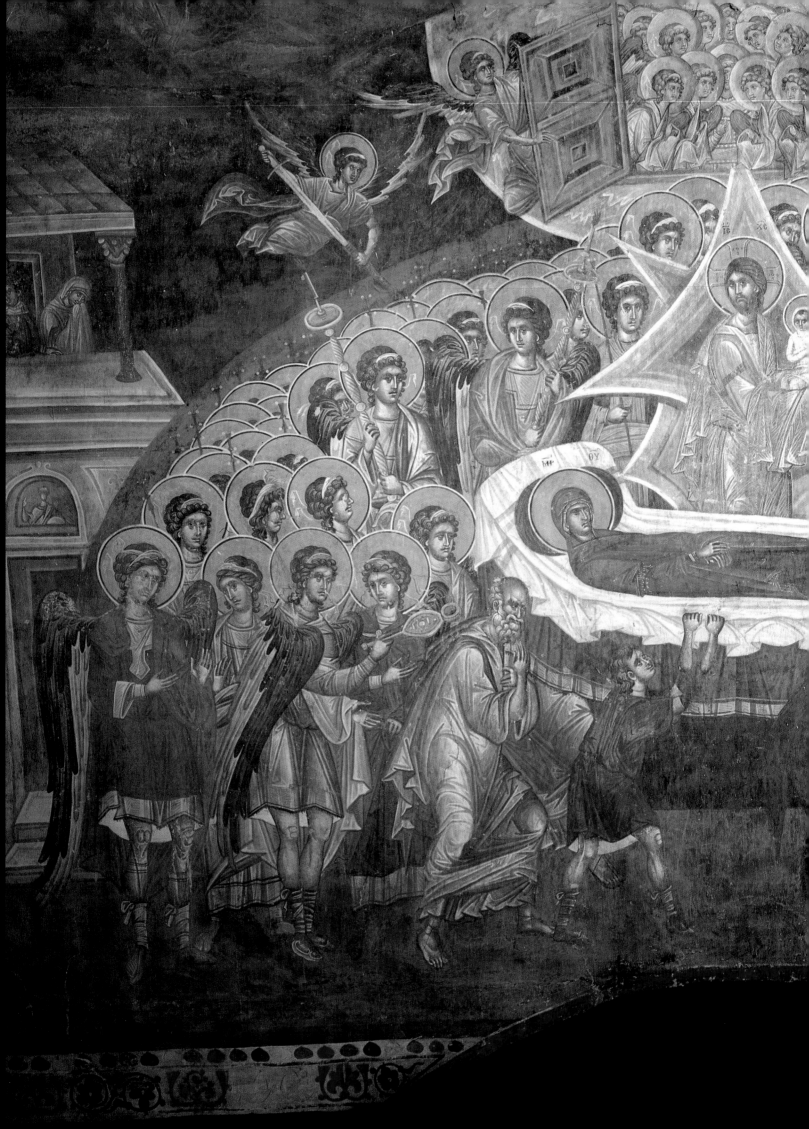

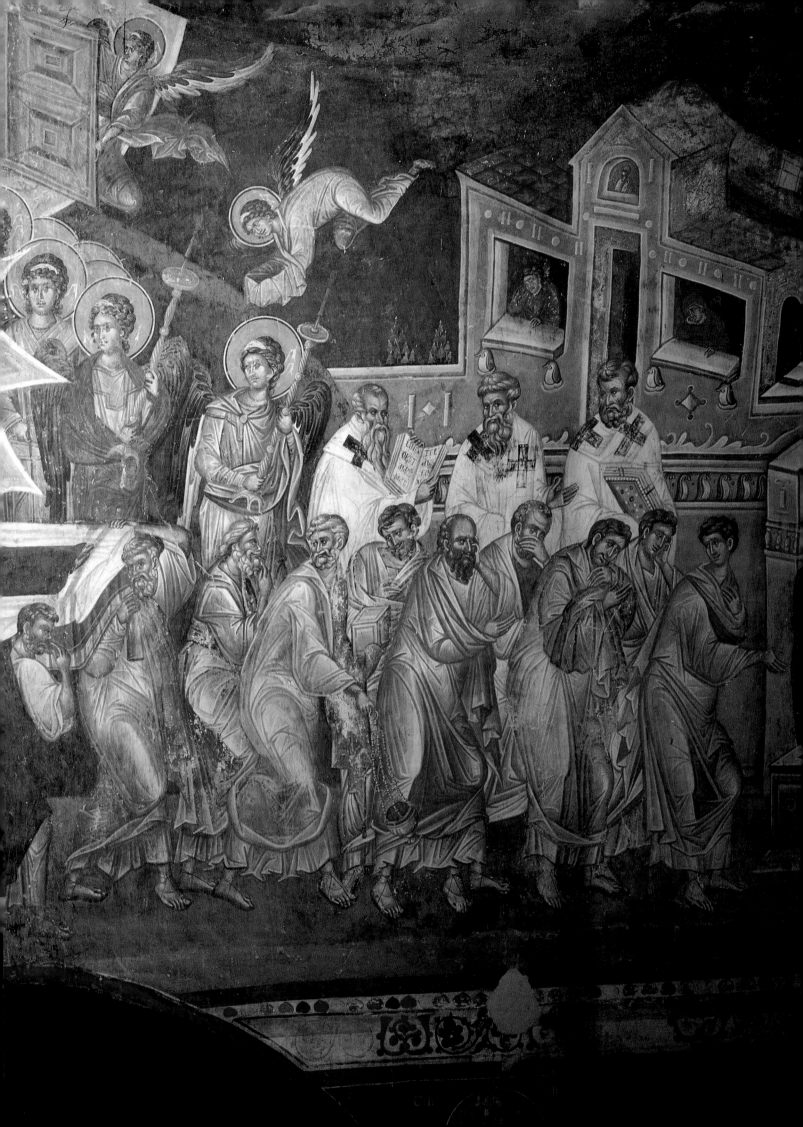

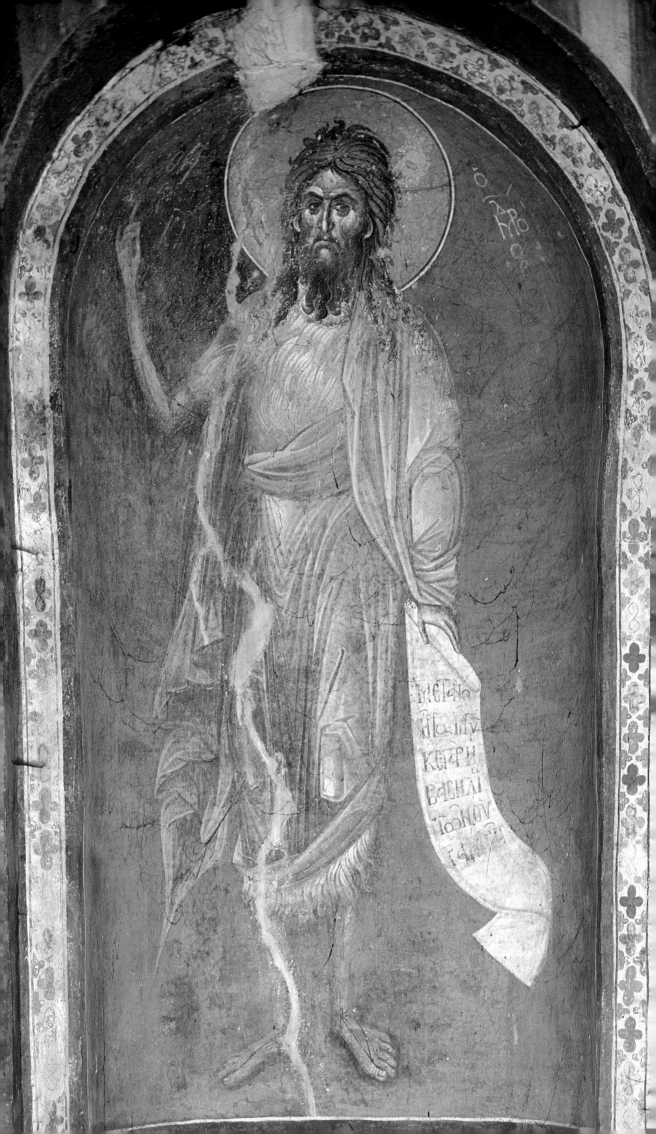

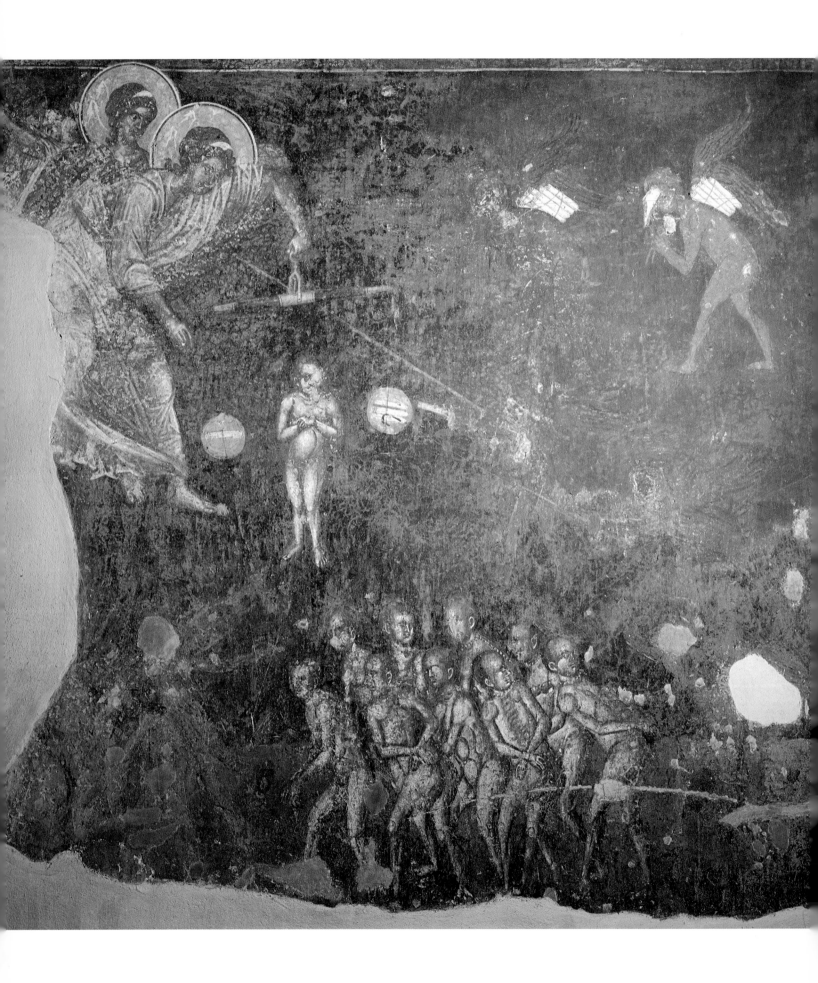

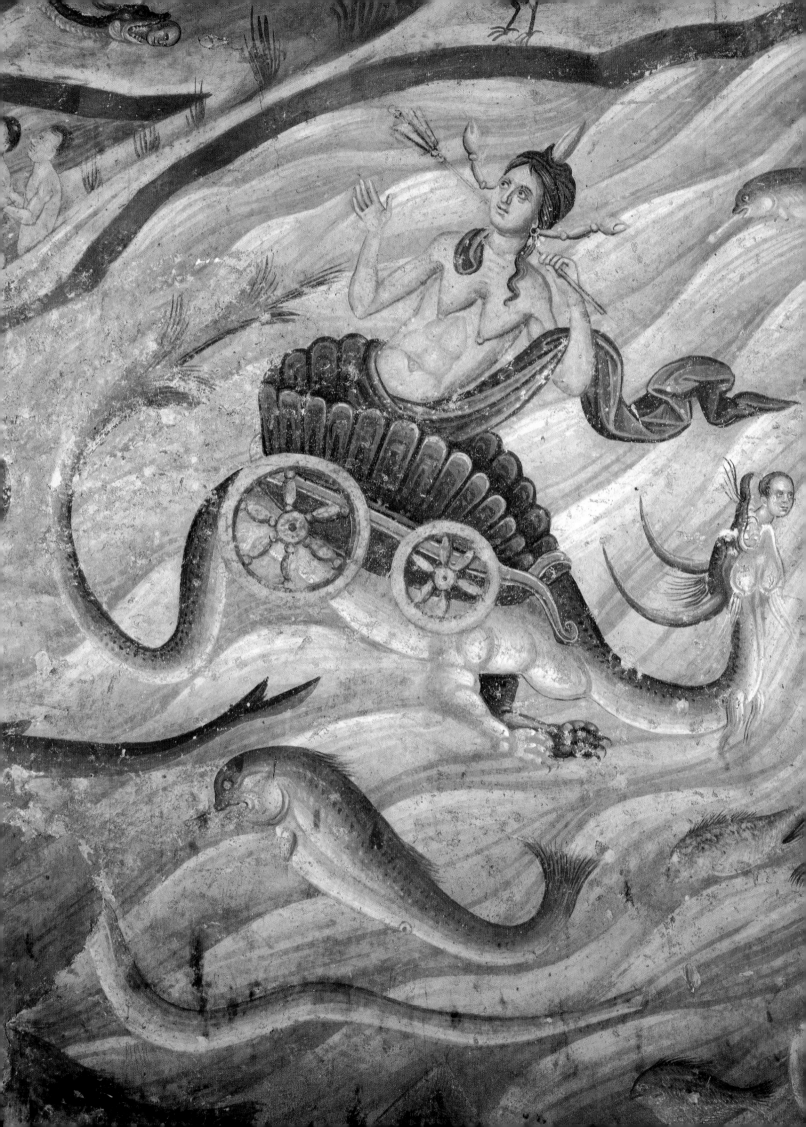

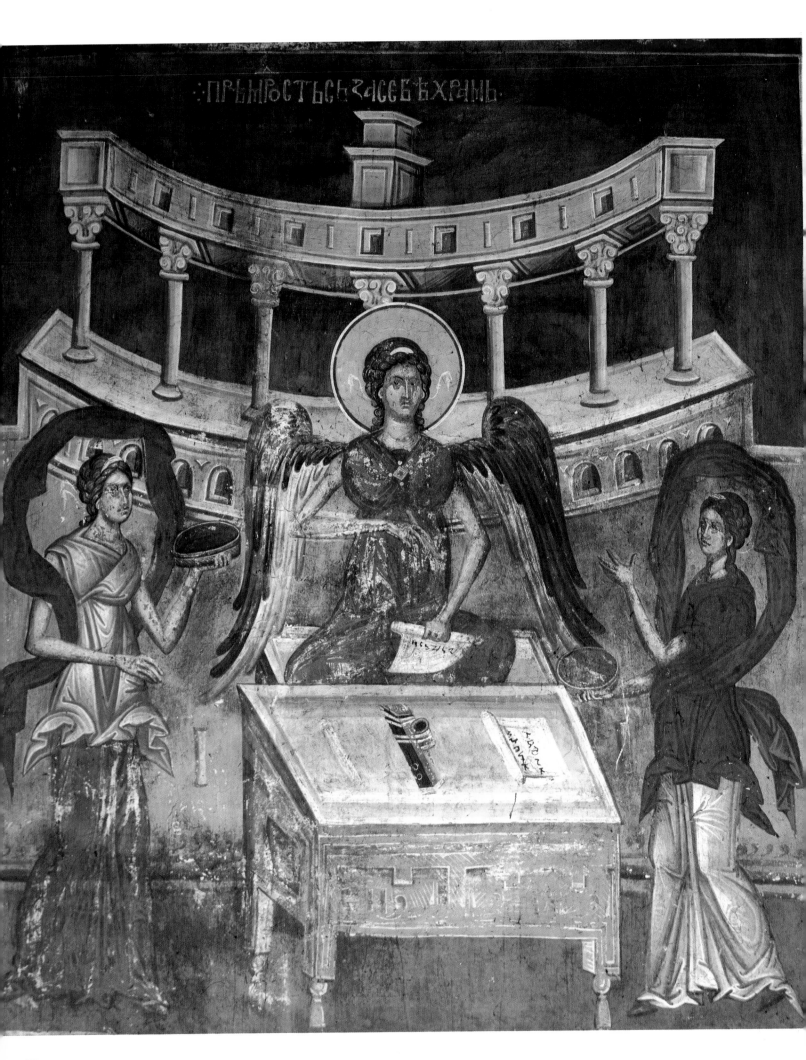

DEČANI

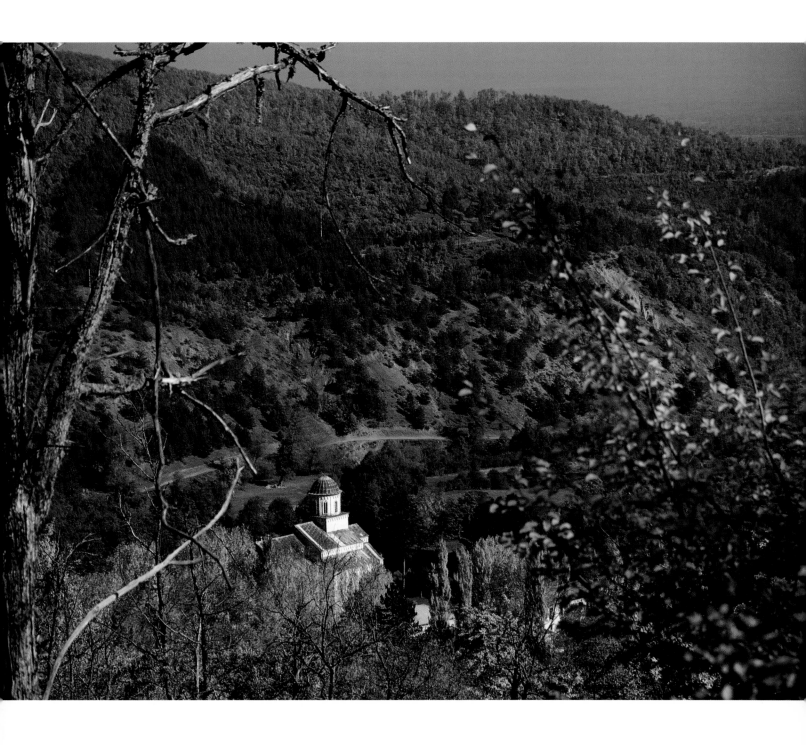

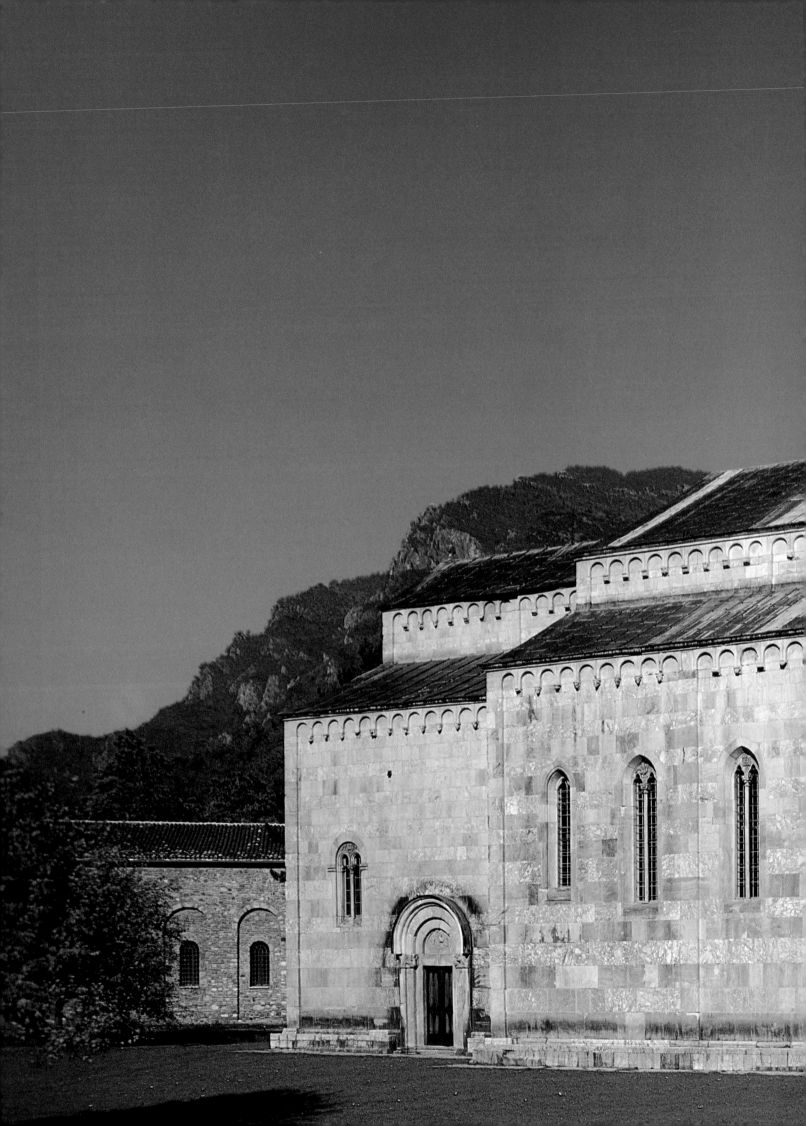

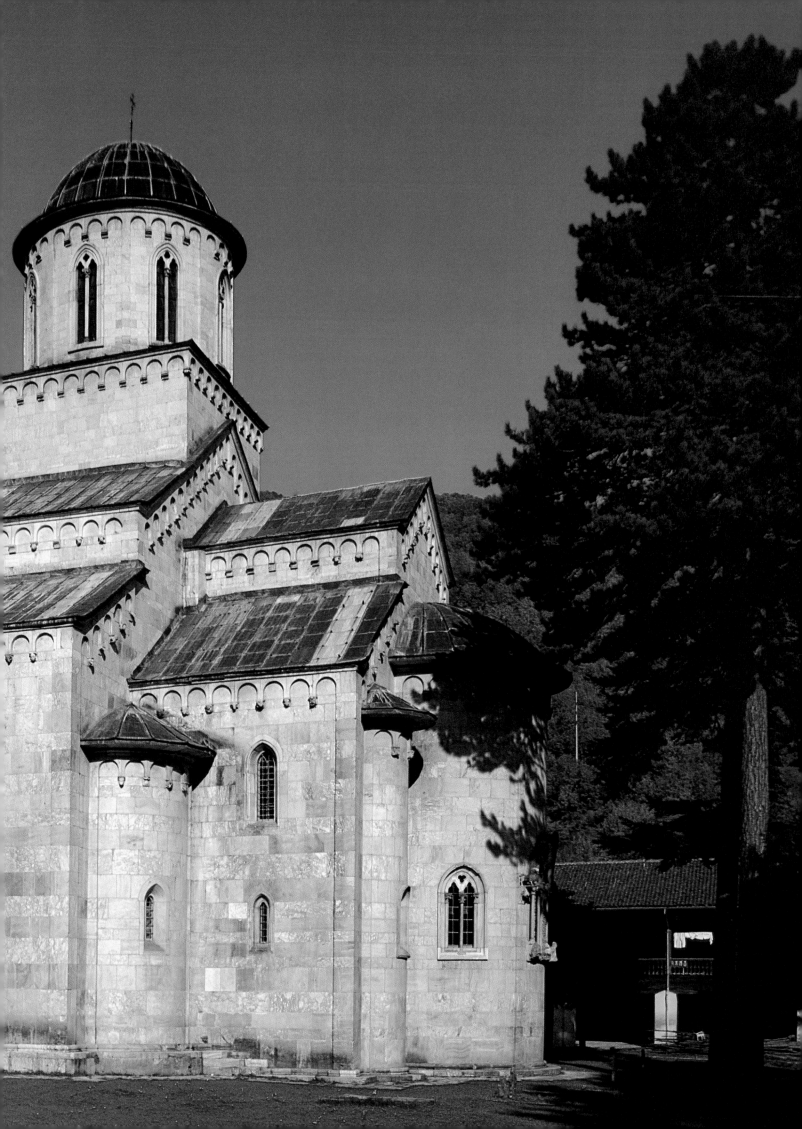

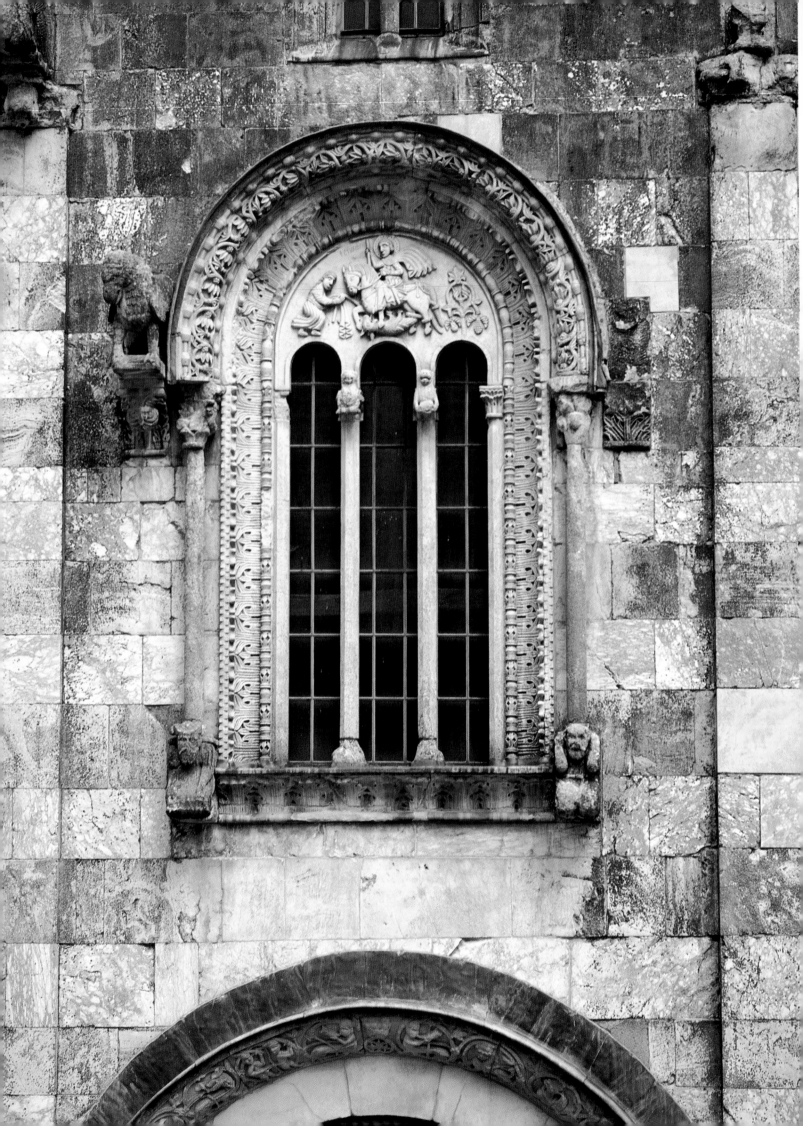

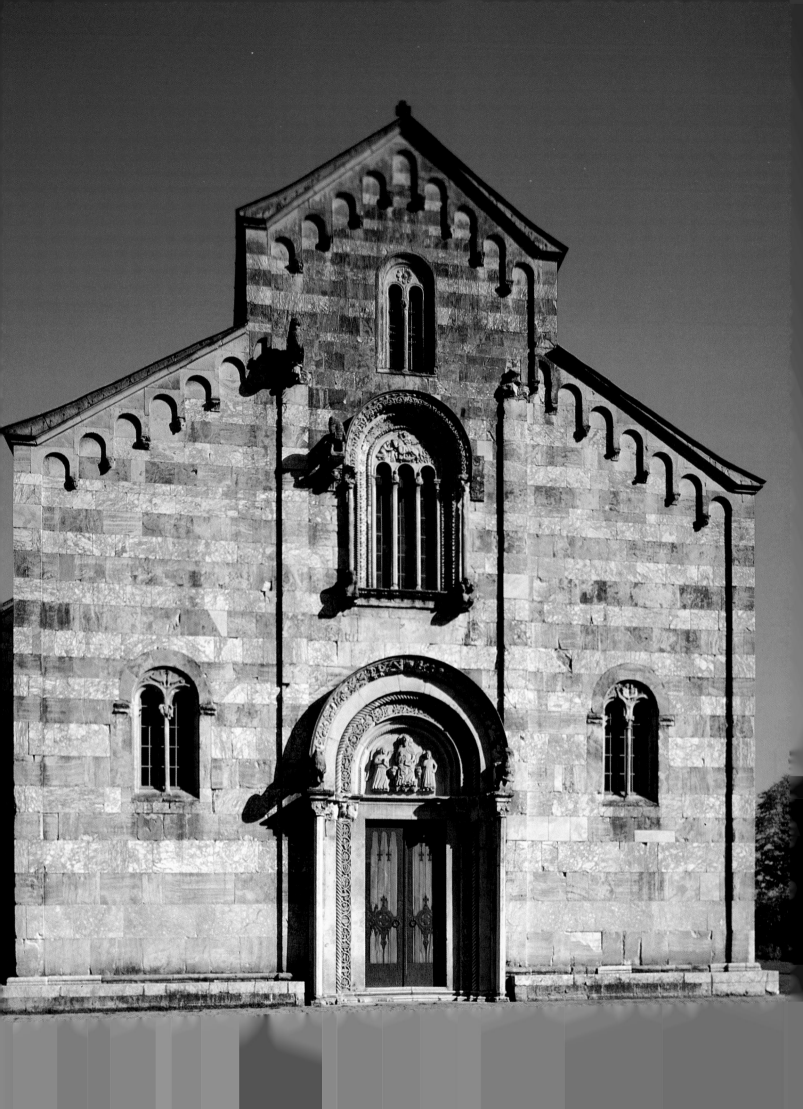

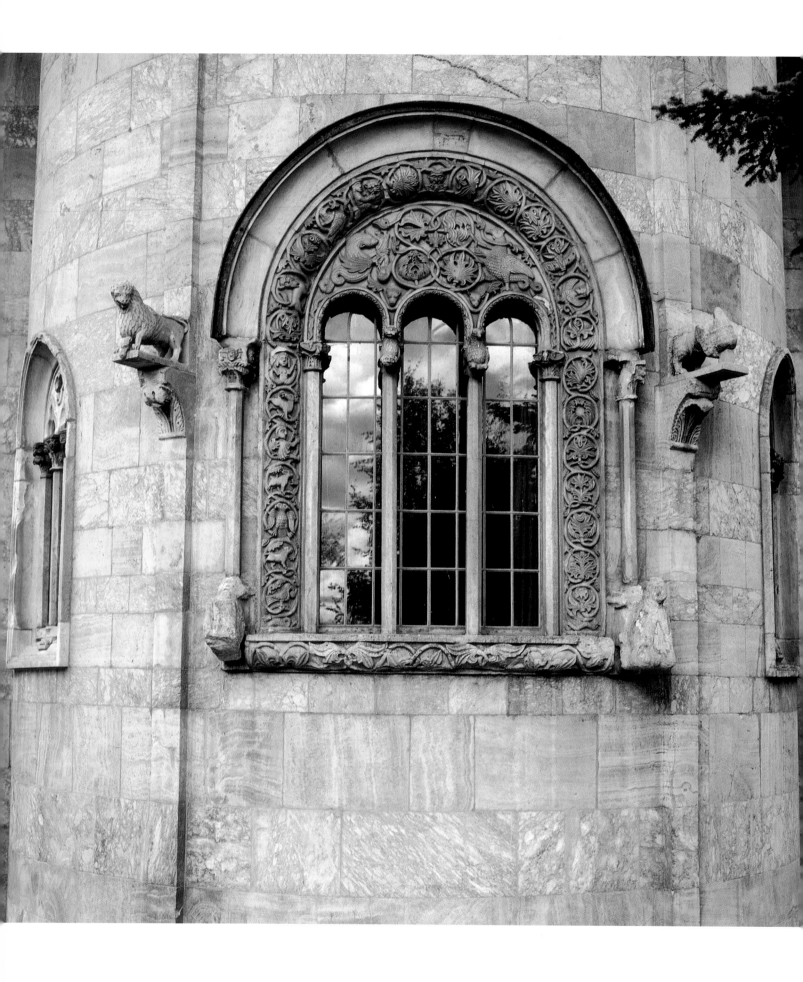

59

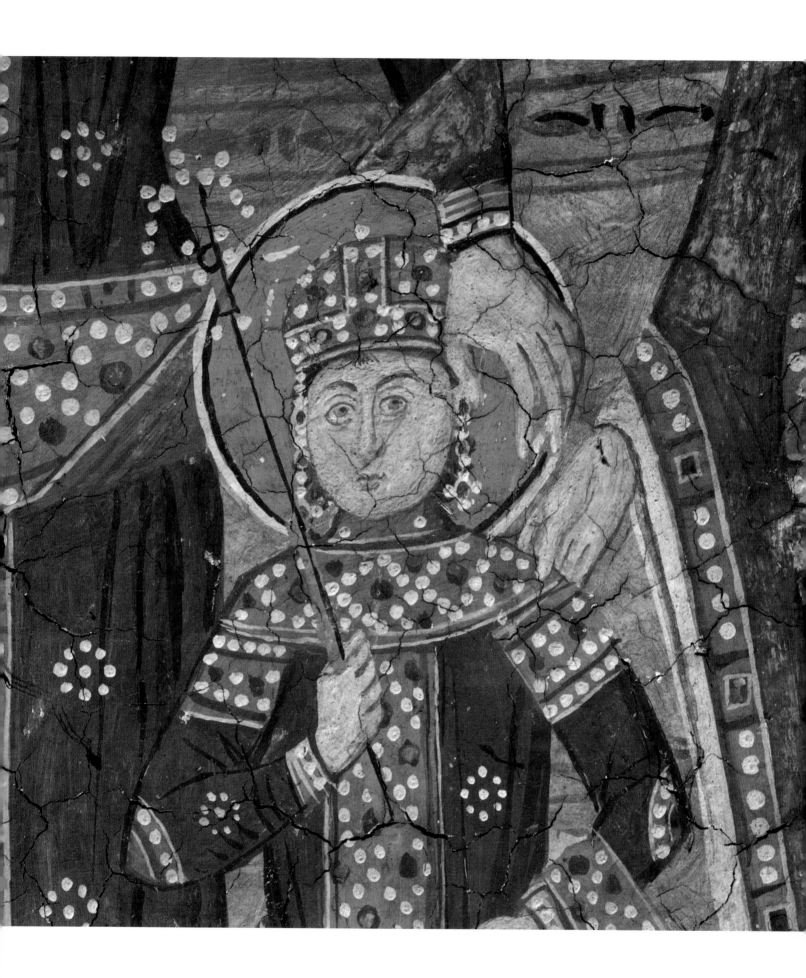

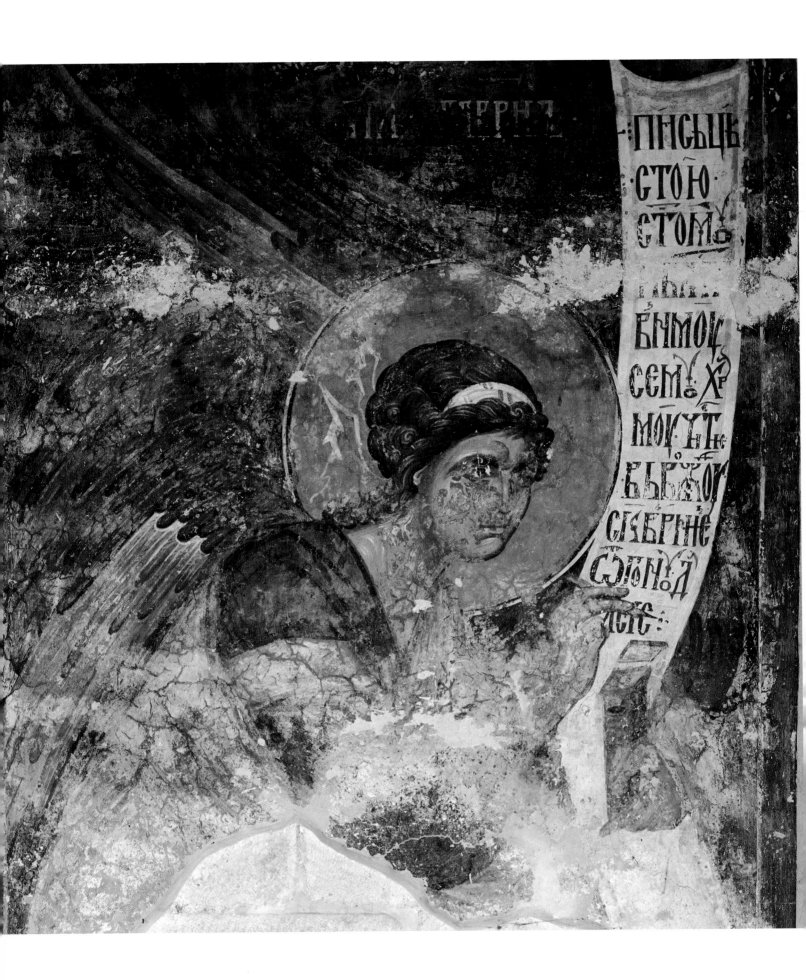

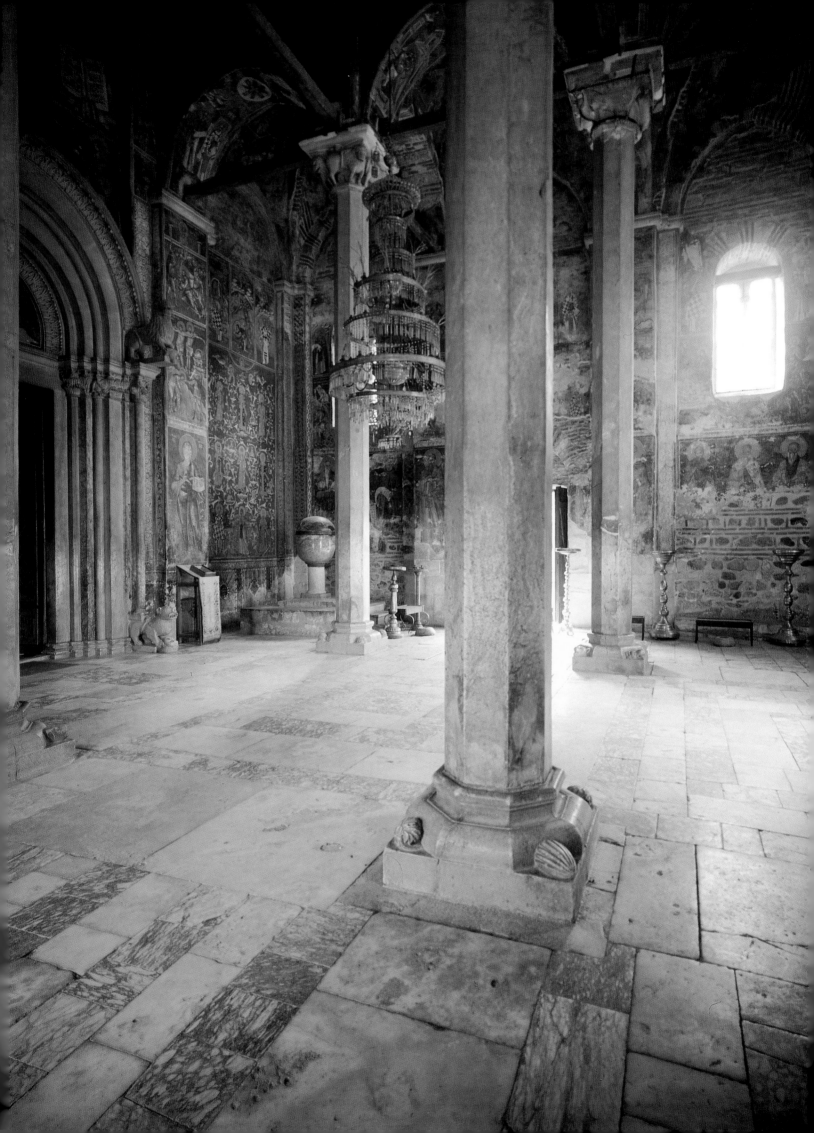

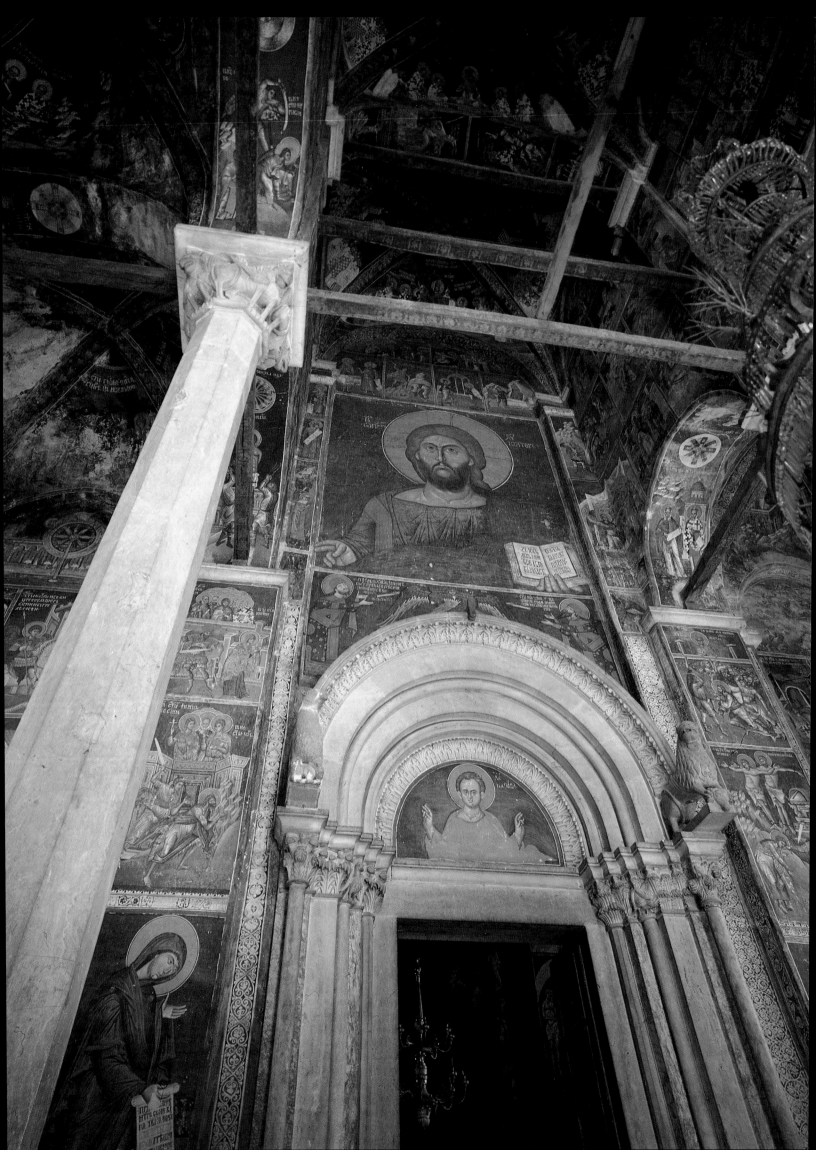

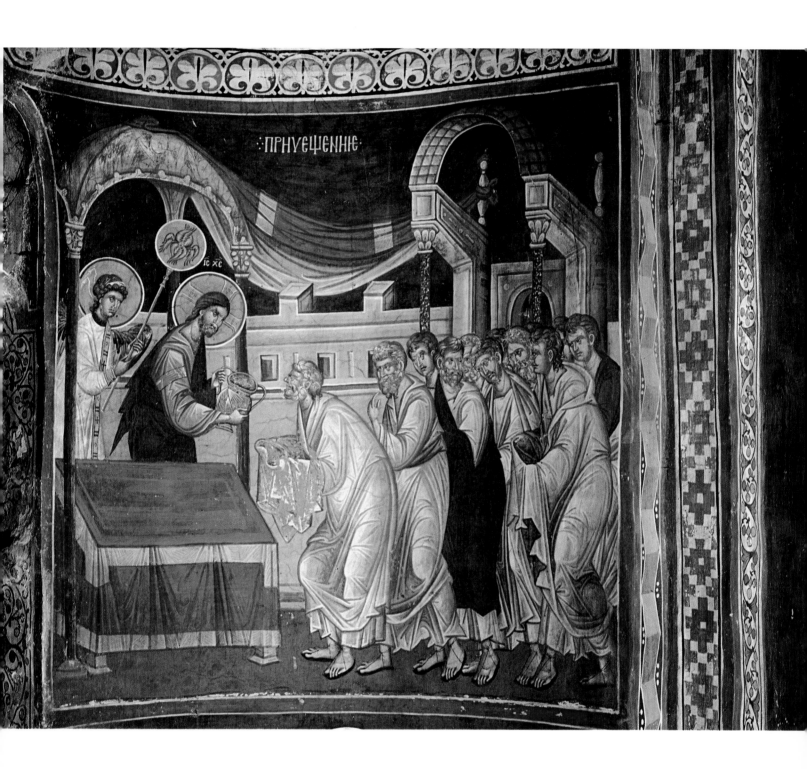

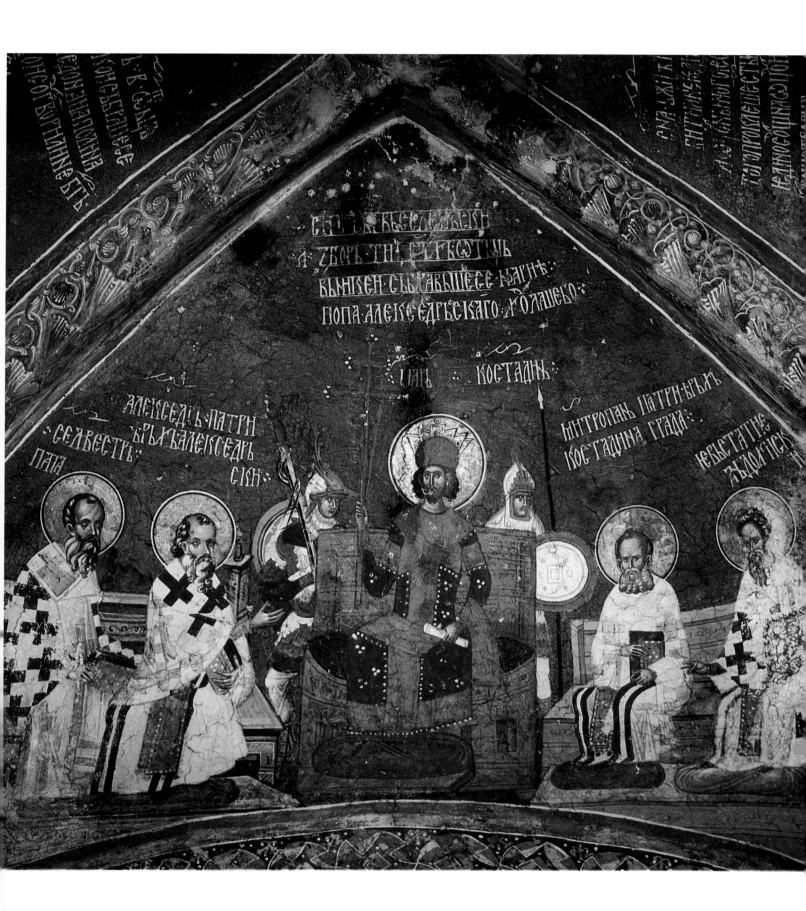

СВЕТИ ВСЕЛЕНСКИ
А ЗБОРЬ ТНІ ФУ БКОТ ВЬ
ВЬ НІ БЕН СЬБІ АВШЕЕ СЕ МАРНЕ
ПОПА АЛЕКСЕ ДРЬ БСКЫ АГО ХОЛАШЕБ

ЦАЬ КОСТАДНЬ

АЛЕКСЕДРЬ ПАТРН
СЕЛВЕСТРЬ БРЬ БАЛЕКСЕДРЬ
ПАЇ СНН

МНТРОПАН ПАТРН ВРЬЇ
КОСТАДНІА ГРАДА

ЕВЬСТАТНЕ
ЗЬ ДОГНСК

67

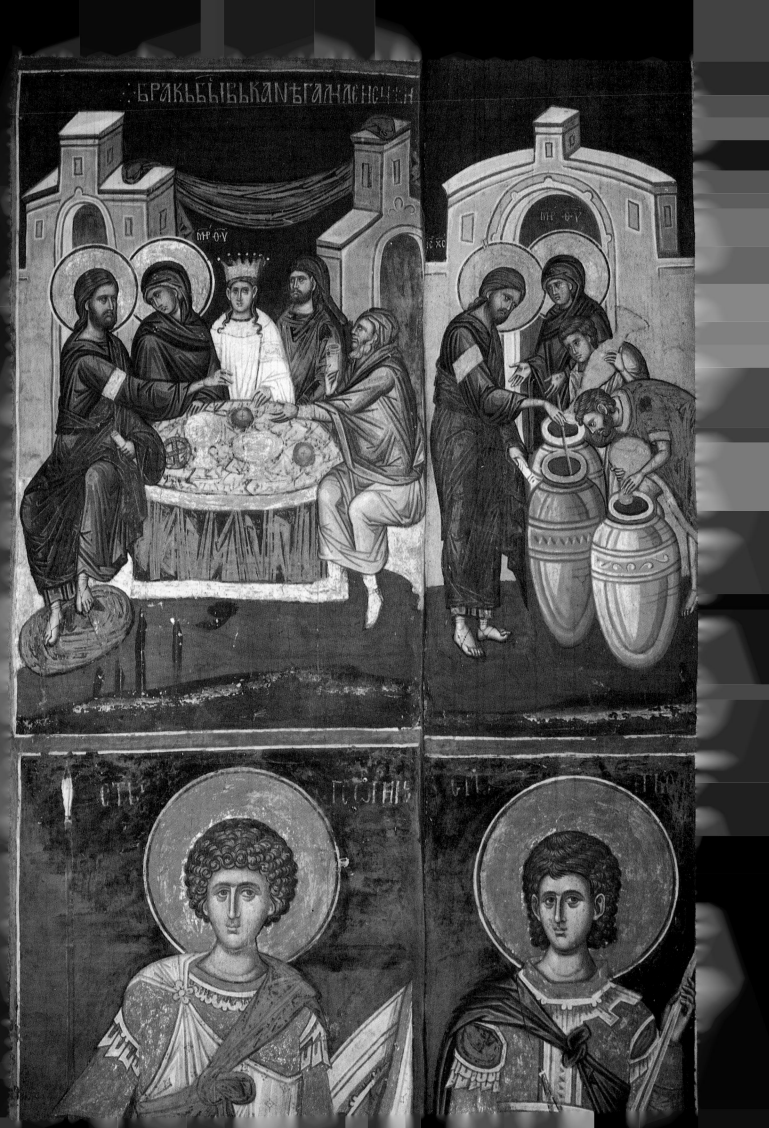

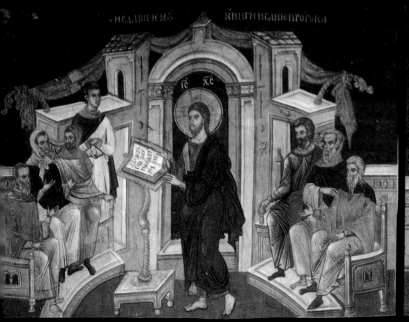

НЕ ДЕЛШЕ ЮМЬ КНИГН ИСАИЕ ПРОРОКА

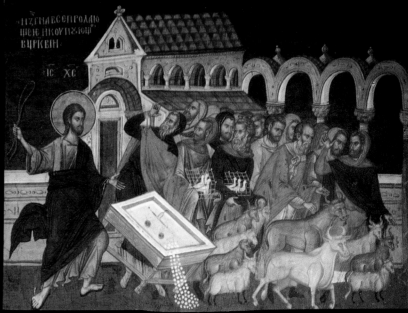

И ИЗГНА ВСЕ ПРОДАЮ ЩЕЮ И КОУПУЮ ЩЕ В ЦРКВН

IC XC

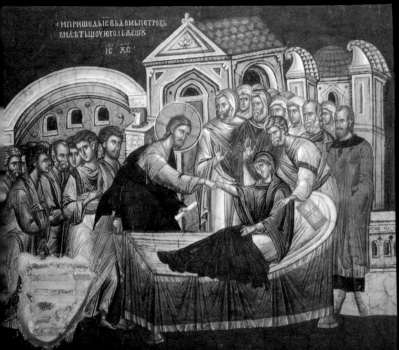

И ПРИШЕДЫ IC В ДОМЪ ПЕТРОВЪ ВИДЕ ТЬЩОУ ЕГО ЛЕЖЕЩ

IC XC

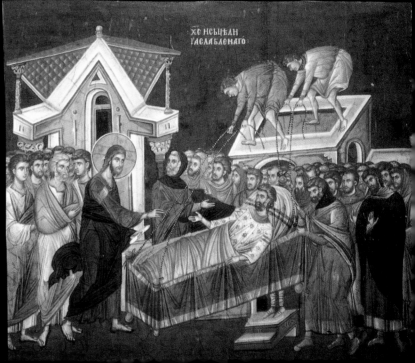

ХС ИСЦЕЛИ РАСЛАБЛЕНАГО

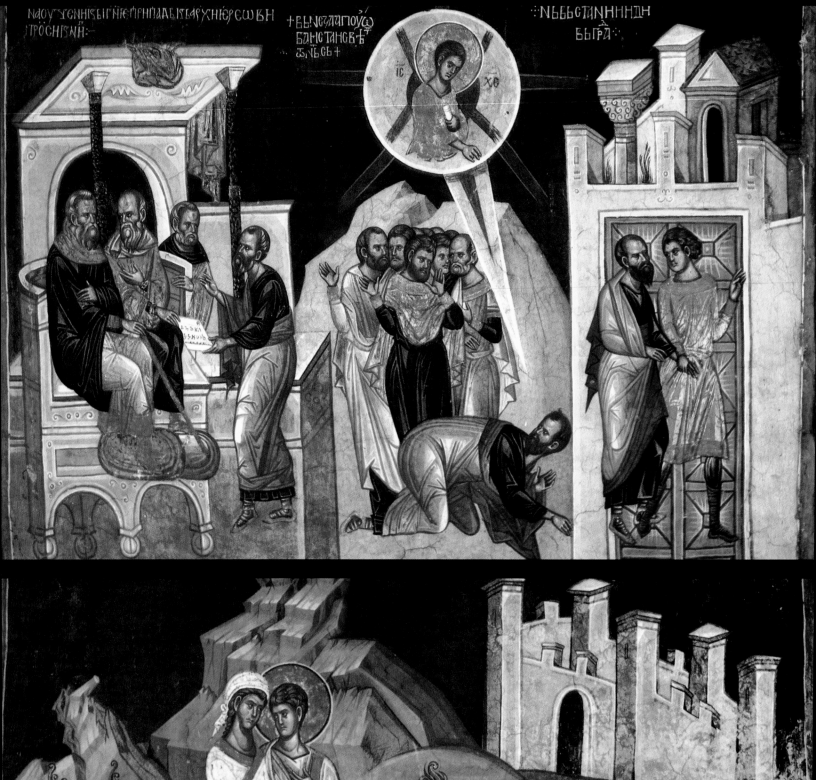

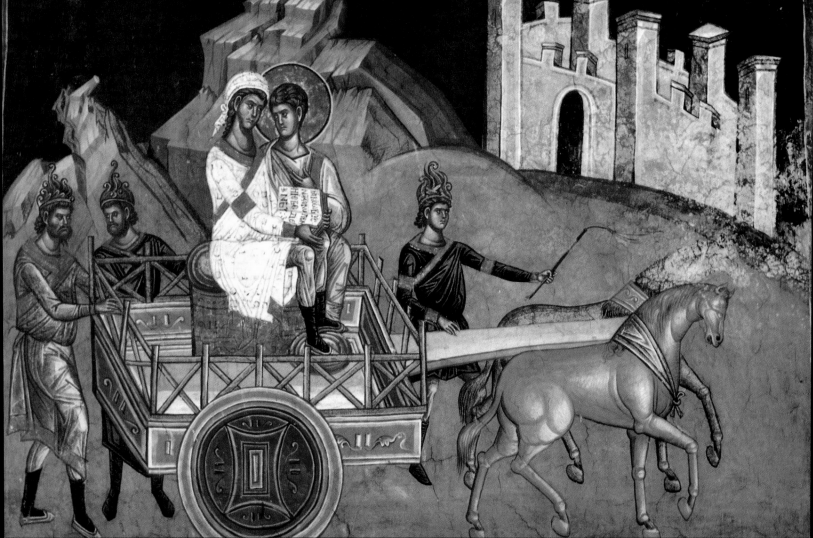

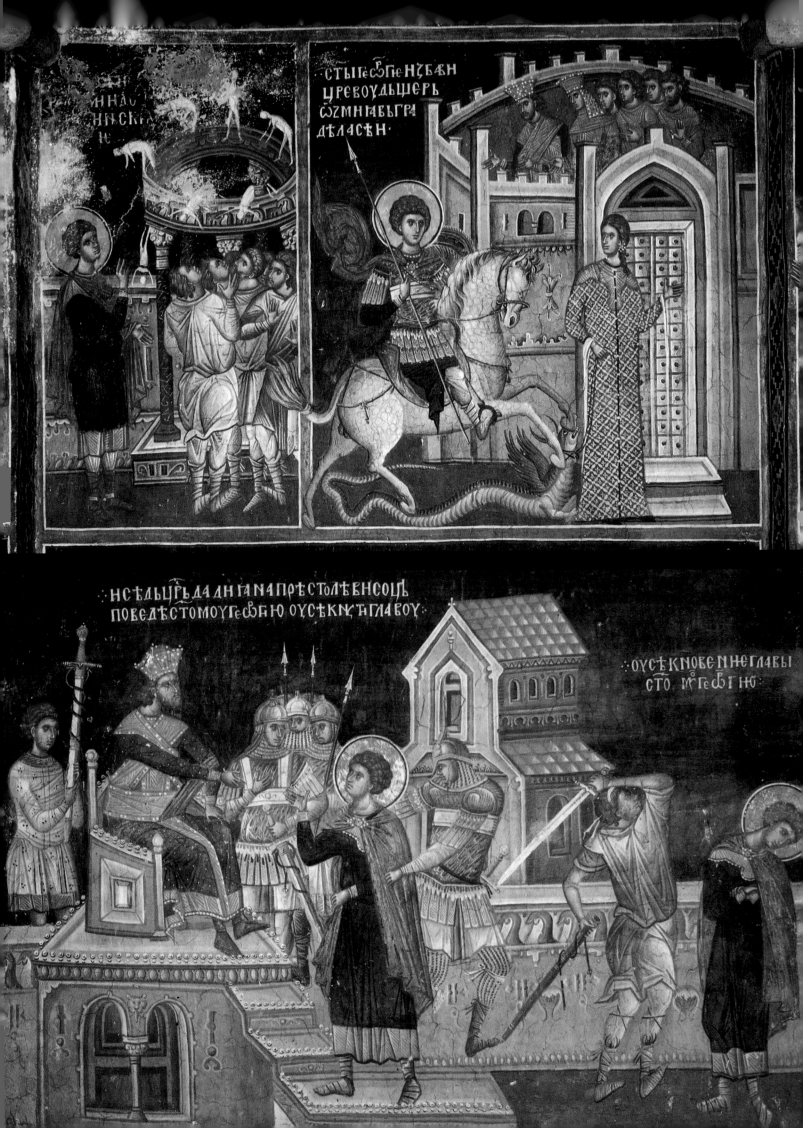

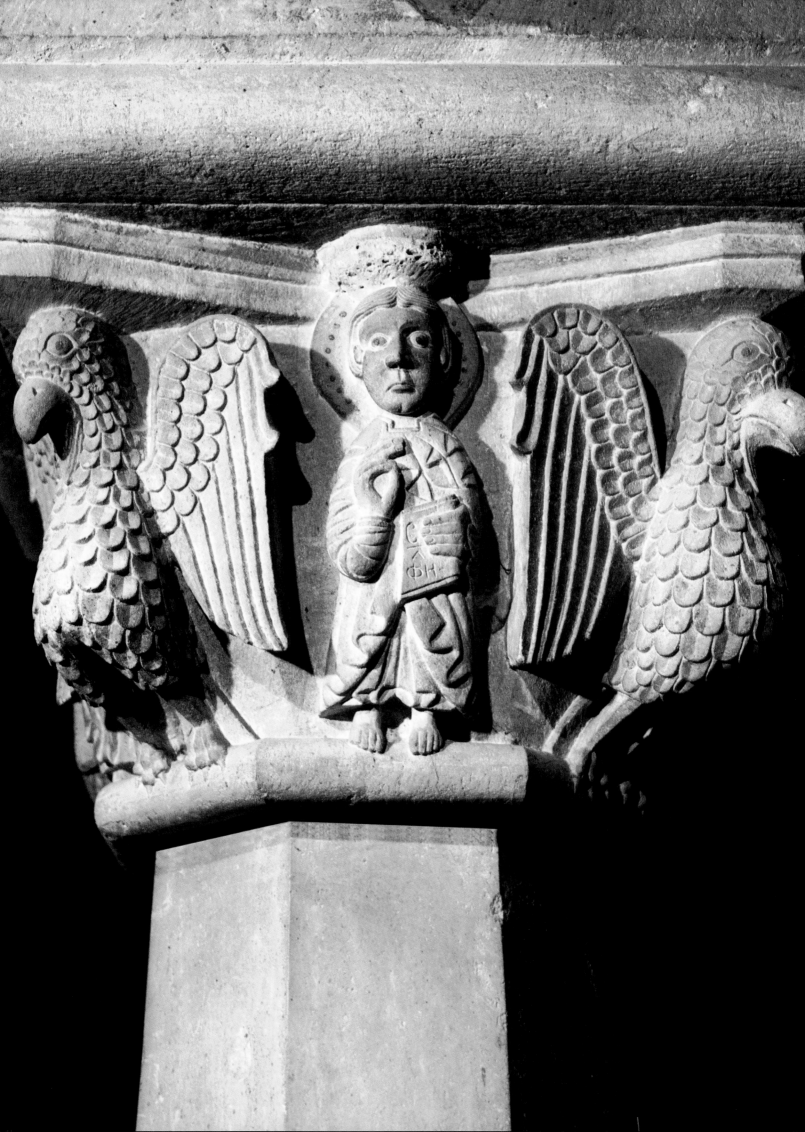

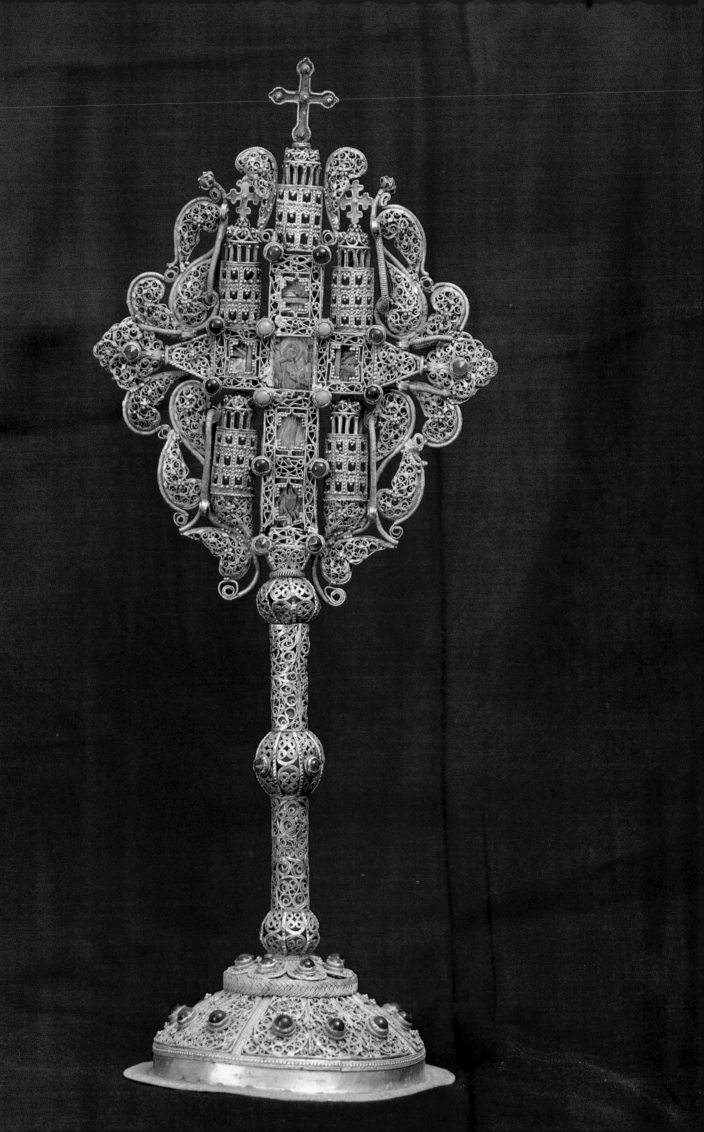

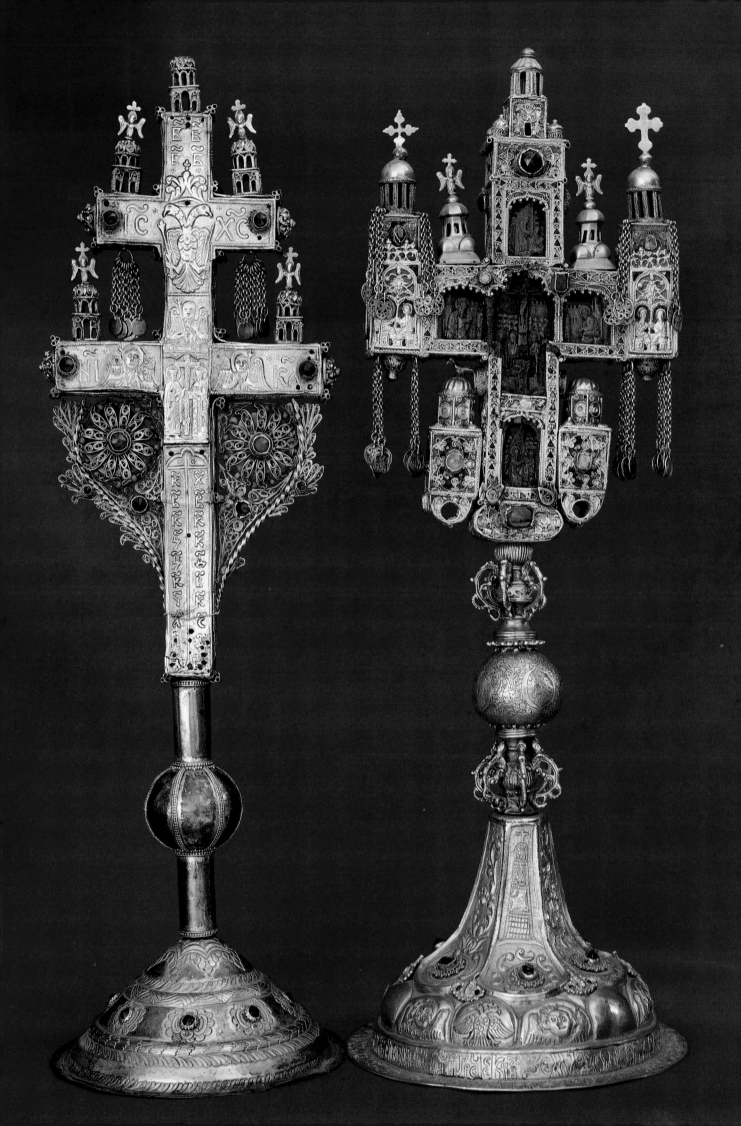

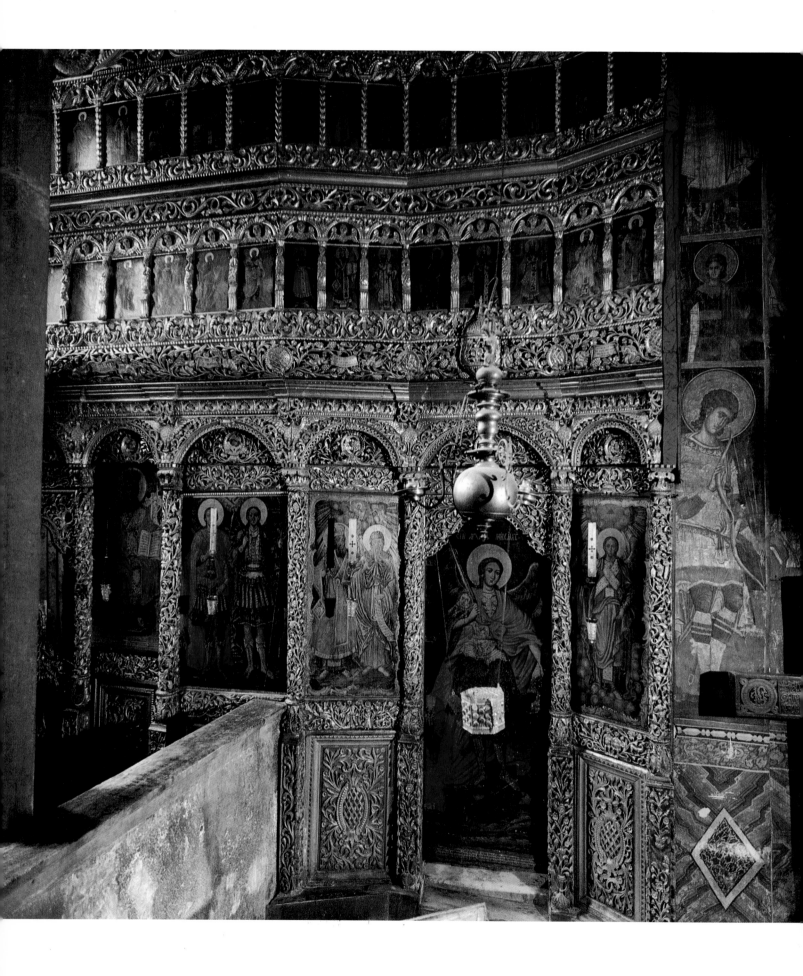

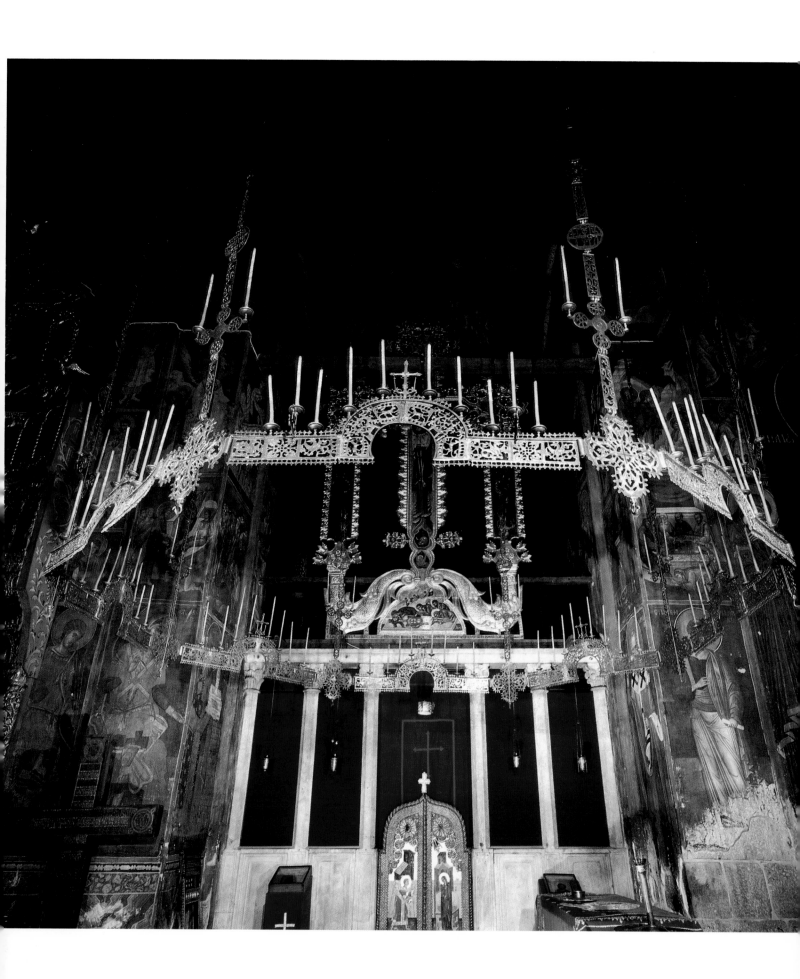

се дрьжнтель гь н творьць всачьскымь. седрьжен область ю всоу
тварь. едннь вь сѣ пр но соущень вь трехь сѫставѣ хъ прѣбыва
ен. бъ сьі свѣть свѣта. жнвоть н жнвотоу податель прѣ
вѣчна прѣмоудрость н снла. н же бесь лѣте нань всѣхь. н ныель
н пакы нашего распеенна безь сѫца начеллн съ нль трекнль.
бъ лвьсь н аулвьсь спеть. нь прьбоу н породоу вь вѣ тьрансна
го веселна вса прѣтавль начеллн хоень. англомь н архангло
мь н сѣ кьлмбны мнь снллмь влзань. по хоулмн н кльнесл
вѣта нель. пороугань распннаюень н крьть поносноую прнне
ль. нь вьскрь н крьть ныхь создавь нь еже ствоуатьвсѣон. н аньба
въ несесе нсь соною. а плокь ноу ученнкомь его грешнкмь. н влаф
юнкмь зрацлоу ученнкь его. н намь есь бешасе послатн прѣ стыа дхьн
наставнть ны вь всоу нстнноу. нетьюн еднне мьбоу ученнкомь нле
го. нь н вь сѣ мль верою ющнмь вь нме его. нлаже вь разоумьллме каннн
на оучь лаюмнн вь нстнн славоу полоучнше. неже сокь невнде нноухо
слышнм. нн на срце улкасокь вьнде. нсто довелнь нсгллтн н лы гме нсне
моу женна нль лѣ пою. вь перннше ерунь н нашень несоун сьлмысль
но разоу клетн. н тесьнн прьтрекль нгь гдель создллн н дынь цре
кльннспедель. вь нме го мероу нсоу всако дыанне. съ страхомь н радо
стню прнпатнкмоу. попрркоу двоурекнюмоу. работантегь не
страхомь н роунтесе нклоусь трепетомь. н пакы вь слмѣ тель рьтвы
н кьхо днте вь дворыего. н пакы н прнмесь тегьнель доу нуть. его же
вь злюбнше сѫцн нашн н намего ѹ пваше. оу пваше н спеллнесе соуть.
вь земенавнде кьше бо все го зель калнаго. попечεннеь дхо вны разоумь.
нстрахь ѣ нныь лнь ше. нн сллѣ ннше ελлныкль цртвомь немею
фнтне. не лѫ несоу я кльлоую. съ стая льше нань дохвалныε па
клетн начеллн всакого насллаженнн н веселнн. н на пьлнаю
нε дшентелесе на ша. рεкоу жесѹ вь сонанеελлню. прьваго
нстого гла съ чьтвоу лнбна. просвѣтнтεла ерпьскагон нокаг
алнротоуца нс знне горожεн наго сна нс клла вельвсь любленл
го сто н прѣ освнщεннаго съвоу прьвлаго архнепнла срьвсклаго. н вра
его по пльт н прѣкокεнчаннаго ка стефана. н посεнкь весь хрроднте

ЕЖЕ ѿ ІѠАННА СТОЕ БЛГОВѢСТОВАНЇЕ

стꙋю и великꙋю недⷧ҇ю пасхы. на лⷮꙋргїе еѵⷢ҇ ҃а

зачало. искони бѣ слово, и слово бѣ къ боу ·
и бъ бѣ слово · се бѣ искони вь бѣⷮ ·
вьса тѣмь бышше и без него ничтоⷤ
же бысь еже бысь · вь томь животь
бъ, и животь бѣ свⷮѣ чл҃комь ·
и свⷮѣ вь тьмѣ свѣтитсе, и
тма его не обьеть · Бы чл҃кь
посланыⷲ ѿ ба име емоу іѡаннь · сь
приде вь свѣдѣтельство да свⷮѣ тельскꙋ
еть ѡ свѣⷮ пⷮⷣь да вси вⷦꙋ ри имоуть
имь. не бⷮѣ пⷮⷣь свⷮⷮѣ пⷮⷣь нь да свⷮⷣѣтель
ствꙋⷮеть ѡ свⷮѣ пⷮⷣь. бⷮⷦѣ свⷮѣ пⷮⷣь истиⷩ
нии иже просвⷮѣщаеть

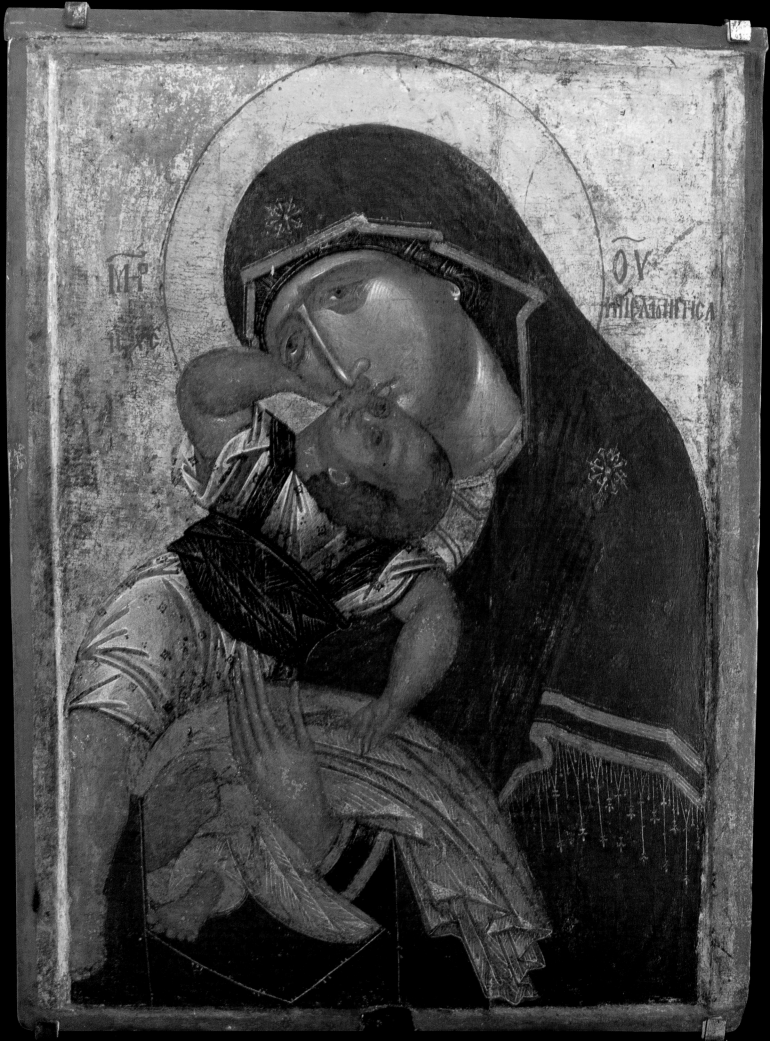

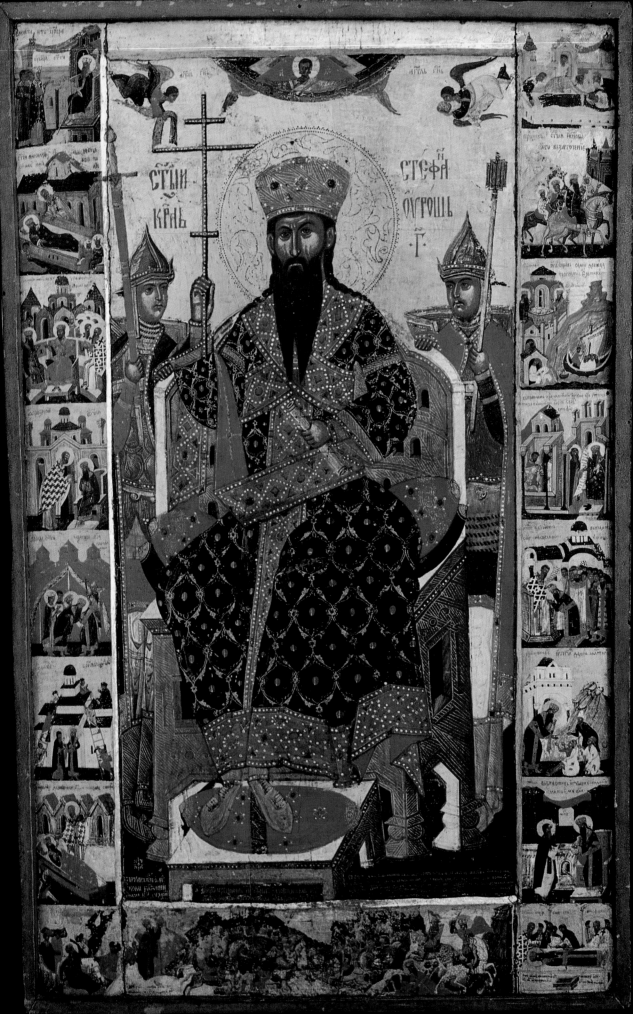

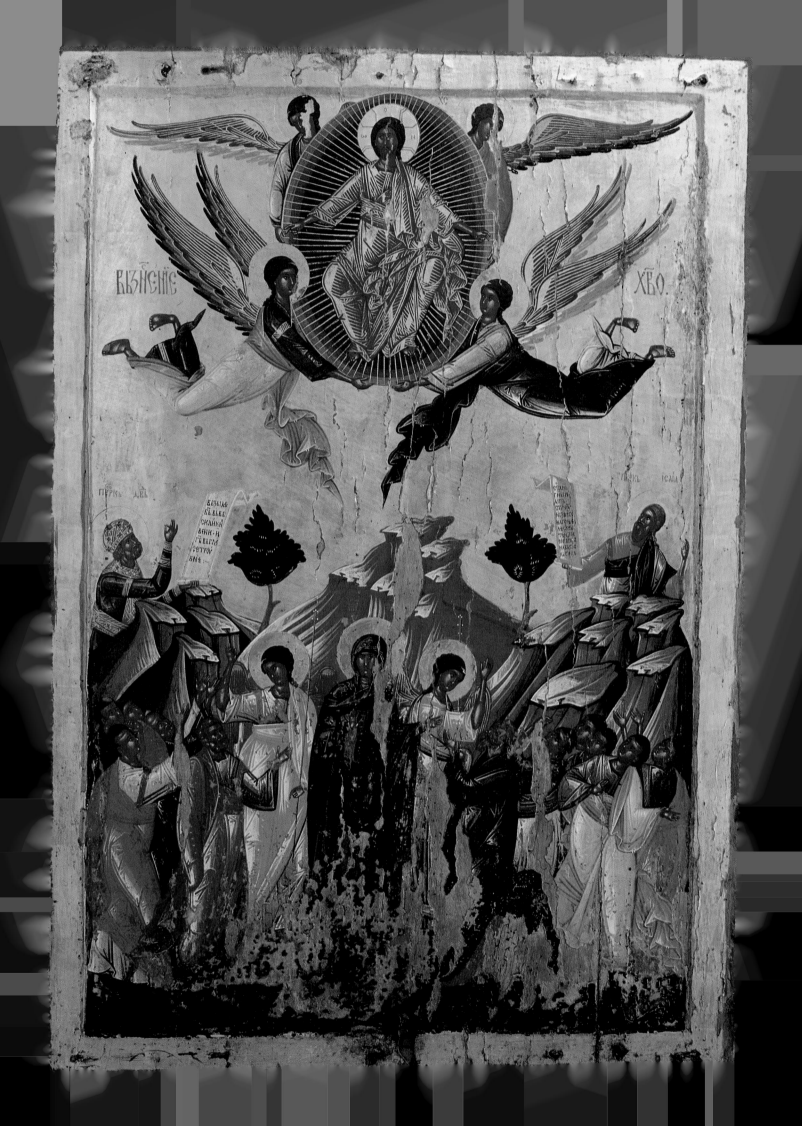

NOVO BRDO

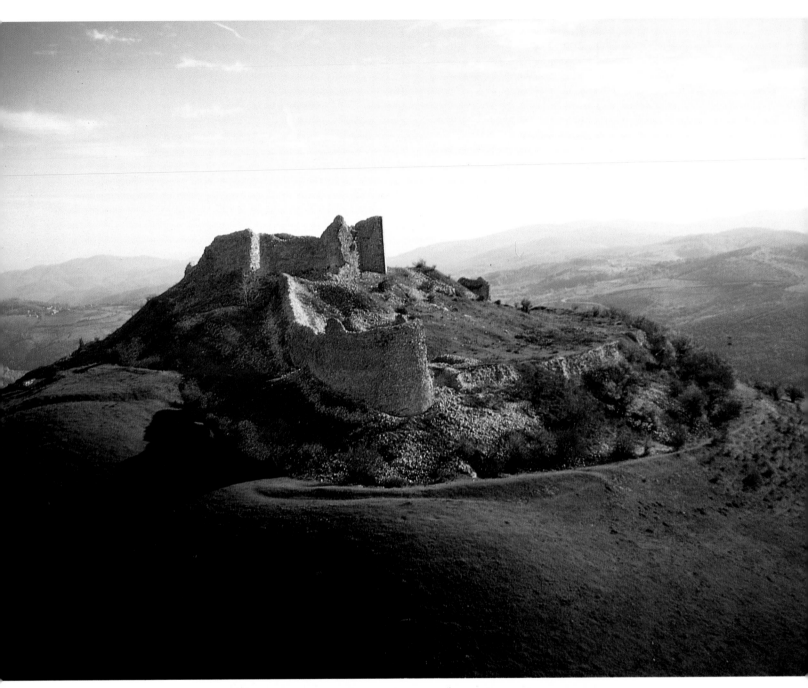

Dečani

At the very end of his life, King Milutin allowed his elder son Stefan – who, after rising up against his father and being blinded, lived in exile with his family in Pantocrator Monastery in Constantinople – to return home to his country. Even though before this he had borne the title of young king (heir to the throne), Stefan had not received a place in the scene of the Family Tree in Gračanica Monastery, painted, judging by available facts, shortly before this. In the unrest resulting from the death of Milutin, however, Stefan, aided by some of the landowners and rumors of a miraculous return of his sight, succeeded in seizing the throne. These events have also left a direct trace on the shrines that he built. In Banja near Priboj where due to ill health he resided from time to time for its medicinal waters, a church was dedicated to Saint Nicholas, to whose aid his cure was attributed; and in Metohija, south of Peć, he undertook the building of Dečani which he dedicated in remembrance of the years of banishment, to Christ the Pantocrator. In gratitude the King also richly endowed the famous Holy Site in the capital city of Byzantium.

The excellent location of Dečani Monastery near a river with wooded hillsides on one side, a gorge cut into the mountain behind and fertile land before it, was already described with rapture by Grigorije Camblak, a gifted writer and head of a brotherhood, at the beginning of the 15th *PLATE 54* century in his *Life of Stefan of Dečani*.

Most of the information, however, on the construction of this great endowment is found in the founding charter itself. Its first, original version – officially written on a roll of parchment over five meters in lenght with the ruler's signature in red ink and a seal of gold – in cultured language, presents the motives which moved the benefactor to undertake this work, emphasizes his royal birth and in a special, moving way describes the unfortunate misunderstanding between father and son.

The document furthermore calls to mind the King's great donation to the monastery in expensive items, and the lists the numerous lands and the people on them by name, which, alongside the estates of Hilandar Monastery, made up the greatest landholding of this type in medieval Serbia. All of this, one learns from this Act, was ratified at an assembly which met most likely at the palace in Nerodimlja where the Charter was written. Some time before this, it is also noted, while the Document was being put togeter, the country was attacked by Bulgarian Czar Mihailo; at the battle on Velbužd on 28 July 1330 he was defeated and also lost his life. The result of this great battle, in which young King Stefan Dušan proved himself, permanently affected a change in relations with the neighbor to the East.

The detailed Charter of Dečani – also preserved in other versions allowing the life of the monastery and its large landholdings and changes to be subsequently followed – includes excellent topographical and onomastical material of 14,000 names; and also offers, rare for an act of this kind, information on the state of building project and the experts who took part in them. Thus the overview of estates verifies the village of Manastiric, granted already by King Milutin to Protomaster Djordje with his brothers Dobroslav and Nikola "for their work in the *PLATE 80* adornment of many churches throughout all the Serbian lands." It adds furthermore that in the "home of the Pantocrator" – as the entire monastery is called here – they built a refectory and a great tower over the entrance gate, and in the "city" (the monastery complex is surely meant)

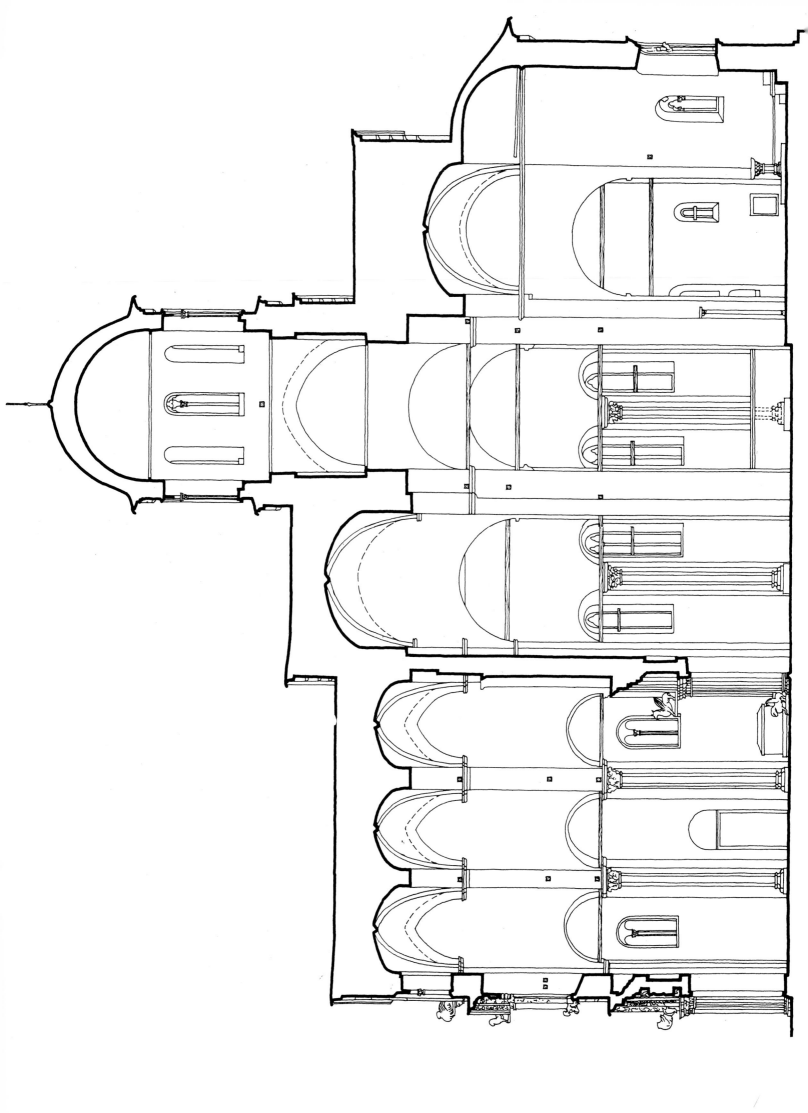

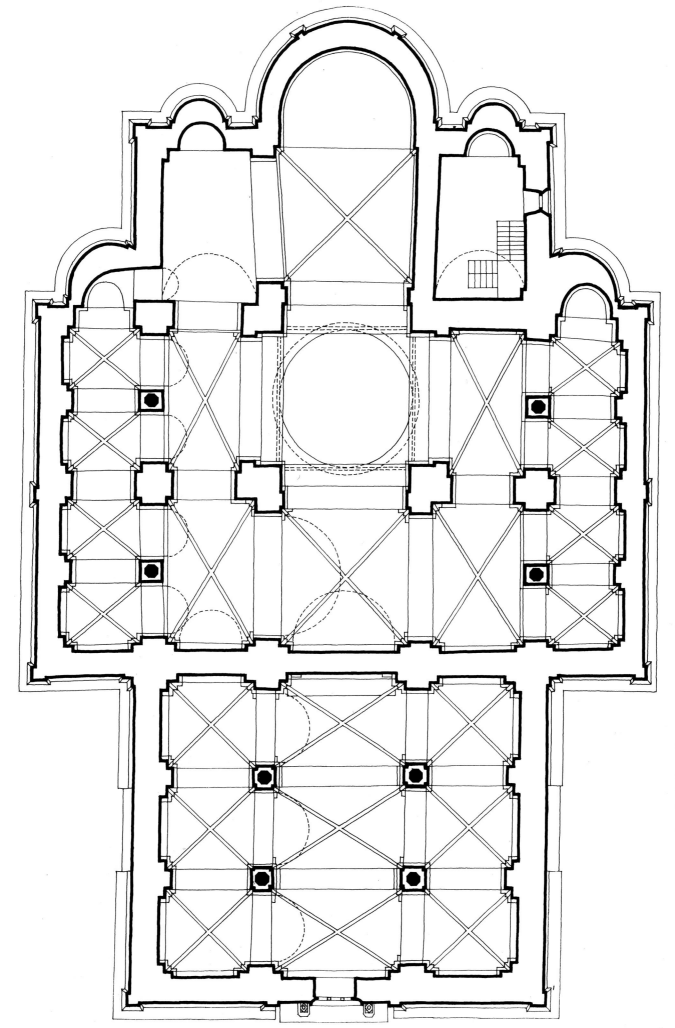

45-46. Dečani Monastery, Church of Christ the Pantocrator, longitudinal section and plan.

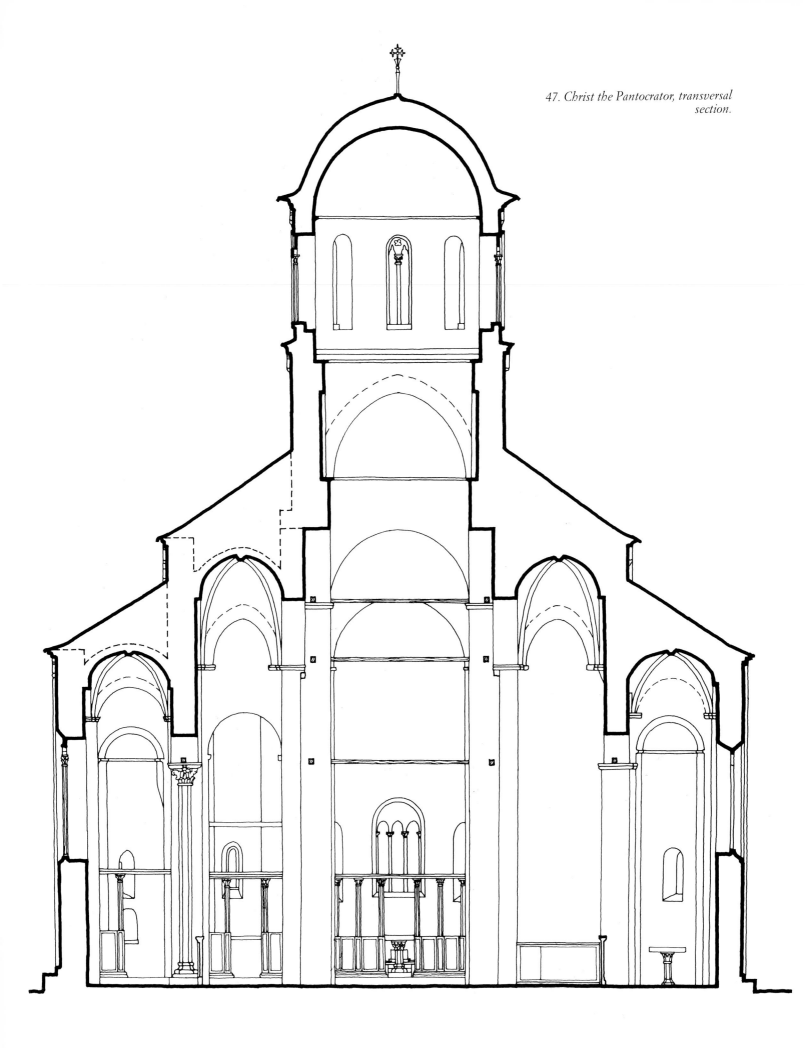

47. Christ the Pantocrator, transversal section.

180

and "around the church" (on buildings no longer extant today) they also carried out many other jobs. The refectory, thus, was finished before the great church, whose construction – the charter mentions – was underway when the conflict with the Bulgarian Czar broke out; and at the same time certainly, the ramparts were built which provided solid protection for the complex in the valley.

The refectory, whose primary appearance is, fortunately, known to us, and the tower with an open area facing the interior through which even today one enters the monastery, bear witness that the builders – as their name also suggest – were born there and raised on the local tradition. The refectory, as is often the custom, was situated west on the church, its placement adapted to following the outside walls. In later centuries, however, its appearance changed numerous time. A primary room with tables for monastic meals and a wide semi-circular apse with the abbot's table occupy the larger, northeastern part of the building; in front of this, in the center, was a so-called *mutvak*, a kitchen with heart – similar even today to the preserved examples on Mount Athos – with a vaulted structure and raised chimney which became narrower by degrees. The onetime character of the other, western wing of the refectory, as well as its appearance in its entirety could reasonably be reconstructed, so a few years ago it was rebuilt. On the exterior, shallow pilasters along the walls separated the even areas of the façade into fields, but it appears they were without relief decorations. Masterbuilder Djordje and his brothers, judging what is by known, were given jobs which did not require special stonecutting experience.

PLATE 55

The construction of the great church was entrusted to builders from the coast, led by master-builder Vita of the Franciscan Order, who after the work was completed left an inscription over the southern entrance: *Fra Vita, Friars Minor, from Kotor, city of kings, built this church of the Holy Pantocrator, for Lord King Stefan Uroš the Tird and his son, the eminent and all-great and all-glorious Lord King Stefan. Built in eight years. And the church is finally completed in the year 6843.*

According to the Byzantine manner of reckoning time, this would be between 1 September 1334 and 31 August 1335. As the construction season ended in autumn and not in the summer, it is natural to assume that the inscription was engraved in 1334. The work on building the church which lasted for eight years began most likely in 1327 and was continued and completed during the time of King Stefan Dušan (1331-1355).

In his inscription Fra Vita mentions both benefactors of the great church, but alongside Dušan's name lists appellations which unpresumptuously but clearly express changes at the head of the country – as a faithful subject the Masterbuilder from Kotor paid special respect to the King who had in the interim taken reign. Behind all of this lies hidden the deeper tragedy of the first ruler who, because of his great endowment remained the most in memory and even received the name: Stefan of Dečani, whose eyesight was taken in his youth, who was imprisoned in Zvečan, and afterwards put to death in circumstances yet unclear. This most unfortunate member of the Nemanjids, however, received a special place as a martyr in the cult, particularly in his own monastery, and for centuries would be glorified in literature and rendition.

The decision of its founder to be buried in the monastery decisively influenced the character of this greatest memorial of Serbian medieval architecture, as it did in Banjska. That understood taking into account the Church of the Theotokos in Studenica Monastery to where the bodily remains of the founder of the dynasty, Stefan Nemanja, were transferred and interred; and ex-pressed itself in its own way in the iconography scheme distinctive for shrines of the Raška school and, especially, in the exterior adaptations in the spirit of western architecture.

The church in Dečani, of enormous dimensions – 36 meters long, 29 meters wide and high – is a basilica with 5 naves, a dome of a rectangular bed and a narthex with 3 naves. In the interior, the central part with a wide and spacious area was divided by massive columns of intricate profiles, with tall arches supporting the dome. On the eastern side, spanning the width of the appropriate

45-47

naves, is a monumental altar area with semi-circular apses – a large one behind the altar table and lesser ones on the sides. Opposite the prothesis, open by means of an arch of great dimension towards the center and altar table, the diakonikon is totally separated by a full wall with a low entrance in order to house the monastery treasury in safety.

PLATE 78

The end naves of the naos make up chapels dedicated to Saint Demetrios on the north, and Saint Nicholas on the south side, with separate altar areas, apses and iconostases. By their placement and function they have repeated the rôle of side chapels which at one time, in the Raška school, were built separately. Here they are separated from the central part of the unique basilican area only by colonnades and marble columns connected by arches.

From the exterior the three central naves are brought under a common, tow-sloped roofing, while the ones at the end have their own sloped roofs. In that way, the main part of the church, with hidden differences in height, gives an impression of a wide building with three naves. The central naves are also visible from the outside, over the eastern part and the narthex, raised in relation to those on the sides so that each of them has a special roof structure.

PLATE 64

PLATES 55, 57

The spacious interior of the narthex is separated by four slender columns into sections. From the exterior it repeats the appearance of the eastern, somewhat lower, part of the church by means of which a definite balance is achieved in the interrelation of the architectural masses. On the other hand, the central part of the church – the highest and, at the same time, widest – retreats by degree in elevation to its focal point and over the cubic bed ends with a dome with

182

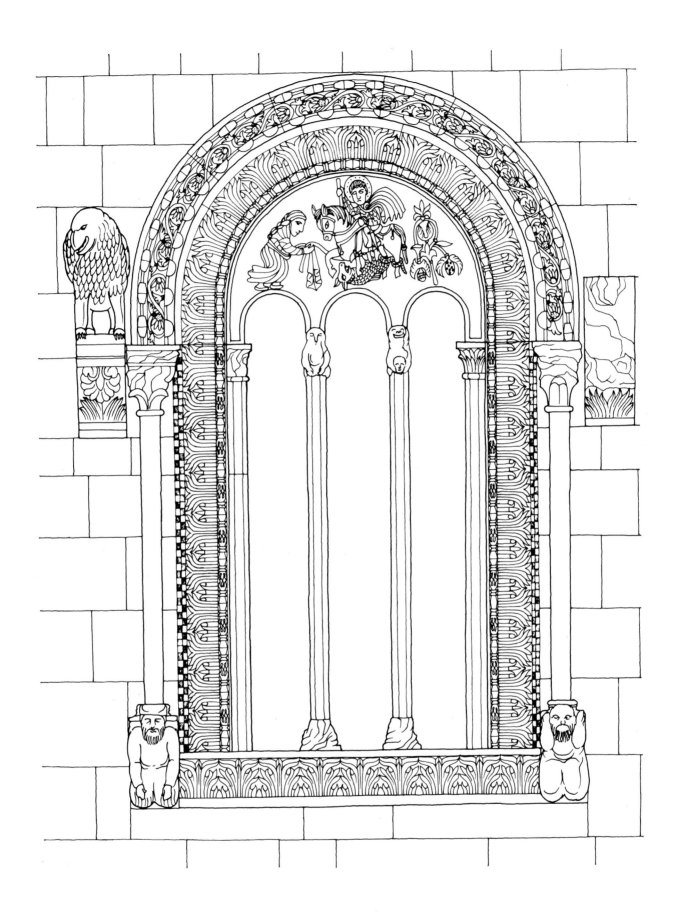

50. *Christ the Pantocrator, western façade, three-light mullioned window.*

Opposite page:
48-49. *Christ the Pantocrator, two-light mullioned windows.*

circular drum. Even though of massive dimensions, the entirety is thus to a certain extent divided and lightened.

In the well-lit interior, the lucidity of the area whose size is strongly experienced especially in the area under the dome, is kept in the heights. At the height of the faithful, however, the single space of the basilican area, characteristic for western architecture, is partitioned by parapetic blocks which have adapted it not only to the Orthodox ritual but also to the tradition of Raška architecture. That is to say, railings have partitioned the central nave of the church with its field under the dome and the sections of the neighboring naves on the north and south side, which agrees with the layout of Raška structures (wih one nave, a dome and transepts for singers). This type of appearance in the 14th century was also repeated in Banjska as we have seen, due to its purpose as a mausoleum.

The building language of the masters of Dečani, led by Fra Vita, reveals a high aptitude for stonecutting, fostered in Kotor, which from the end of the 12th century was not only a center of special importance for the economic life of the Serbian state, but also a valuable connection with the cultures of other regions, especially Italy. Special regal privileges which Kotor enjoyed within its borders prompted the builder of "the church of the Pantocrator" to call it in his inscription the "city of kings."

By its entire appearance and relationship, the great church of Dečani above all reminds one of the monumental cathedrals built in the spirit of mature Romanesque in the cities of the Adriatic region, but a number of its forms and structural solutions are distinctive of the Gothic style: excepting the prothesis and diakonikon which have been semi-formed, the entire complex has ribbed vaultings and end side naves, in keeping with the lower and lesser and their double in number sections.

As with other shrines of this region, the church of Dečani is roofed with lead plating which most securely protected the interior from moisture and precipitation in the long winter months. They are not, however, in the tradition of Byzantine construction – arranged directly over the vaultings, whose form they repeated – but rather over a wood construction which, as in Gothic monuments, could hide the true height or character of a section.

Certain damaged areas of painted decoration also allow the method of construction to be examined in the interior. The vaultings are made with bricks, as were the ribbings which in some places have parts of crystalline calcium carbonate, while the arches are regularly made by altering these materials. The walls themselves are, on the other hand, built with straight-cut or only chiselled blocks of stone, mortar and rows of bricks, so that during the three to four years – at least as long as the fresco painters had to wait to allow the building to settle – the interior appeared colorful. After the completion of masonry work, the church was consecrated according to tradition, and thus divine services were conducted in it without wall paintings.

The exterior face of the building is built of rows of perfectly cut golden-white and red quader. Here also Grigorije Camblak, describing the beauty of Dečani, expressed wonder at the skill with which its façade was cut and all *fitted together... so that it appears that the entire face of this church is one stone, so miraculously combined with skill that it is as though it has grown into one... thus appearing in inutterable beauty.*

54-57
The great smooth façade is framed with shallow lezens, and completed beneath the roof by a row of small, blind arcades resting on relief-inscribed consoles. Their clean planes have only openings, spaced in a measured and logical rhythm. On all sides of the narthex the only entrances into the church are marble portals, and alongside them, as well as on the areas of the naos and the altar area, single and double windows with semi-circular or interrupted arches and characteristic 48,49 Gothic profiles. Of large dimensions and well placed, all the openings are enough of a source of light for the interior; in the central area of the naos, light comes in through the dome, and from PLATE 58; the western and eastern ends – over the great portal and on the apse of the sanctuary – through 50,53,58 wide three-light mullioned windows.

The fundamental idea of the area, the exterior appearance, structural elements, relief designs and the building material itself moved researchers to look for an analogy among churches, on the Adriatic coast and in Italy, but also in Serbia itself, where masters of western building culture left their works.

The similarity of the endowment Dečani to some five-naved churches in the West has long been noticed, especially to Portonuovo near Ancona. The spatial organization, however, particularly in the upper zones, is quite different. It appears that there were certain similarities with the earlier Cathedral of Dubrovnik, which is poorly known, a three-nave basilica with a dome, damaged in the great earthquake of 1667. On the other hand, comparison to the layout of Saint Stephen's in Banjska shows in essence not only the same order or area elements, but also literal repetition of their forms and measures. At first sight, this is not obvious because on the older church all forms are clear, defined by full walls, while in the younger thus only marked by parapet slabs – i. e., in Dečani Monastery in the upper levels of the main naves they are immersed within the unique basilical area. The plans of the two churches when placed one over the other, 51 assuredly show an unusual similarity, and so it is possible that at least one of the masters took part in the construction of both of these churches.

No less interesting is the similarity with the Cathedral of Saint Trifun in Kotor, for which, in consideration of the origins of the builder of Dečani, should first be considered as serving as an example. Fra Vita, however, remembered a somewhat different appearance of the church. Certain parts of it had to be changed after a number of quakes hit not only the region of Dubrovnik but also of Kotor. Valuable information is therefore offered by recent excavations of its foundations where, in the northern nave, parts of walls and supports were found whose order and mutual relationships in great measure match those of Dečani. This is not a question, it should be understood, of the limited experience of local builders, but rather the respect for an example and the fostering of a defined method of work. This is confirmed also by the fact that the width of

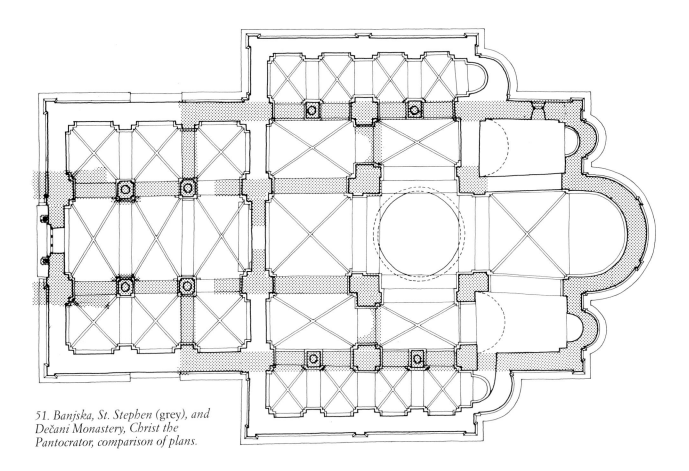

51. Banjska, St. Stephen (grey), and Dečani Monastery, Christ the Pantocrator, comparison of plans.

PLATE 66

Dečani and main church of Kotor are almost identical, even up to the number of units of measure which the masters made use of in planning.

Further research into the origins of certain structural elements, e. g., the vaultings with ribbings of brick, point to Lombardy from which they could expand to the southern parts of the Apennine Peninsula and the eastern Adriatic coast. Besides others, Dečani with its façade also reminds one of the churches of northern Italy, and especially of those of Tuscany built of interchanging rows of red and white cut stone.

Of special interest for the knowledge of builders' conditions is the person of masterbuilder Vita himself, a member of the order of Friars Minor, who, according to the order of the Monarch, here entirely appropriate to the ritual need of the Orthodox flock, left a work of beauty. The efforts of experts to recognize Fra Vita among the citizens of Kotor of that time have offered certain, if probably not conclusive, results. In the city archives in much of the plentiful material which dates from exactly the time when Dečani was being built, one person of this name is often mentioned. His activity is well-known – he was a priest in the Franciscan church of Saint Mary and guardian of the well-known Monastery of Saint Francis nearby, which was, according to tradition, built by Queen Helen, wife of Uroš I, outside the city walls (extra muros). There is not, however, any factual information which would bear witness that the Vita mentioned, a proven member of the Franciscan community, was also a builder.

Indirect witness to the extent of the engagement of masters from Kotor in the construction of Dečani Monastery is given by documents of the period. This city, which had many stonecutters, was left without them during the construction season: in its notary books they are mentioned only in the winter months when they returned from the great construction sites in the interior of the country and took care of the jobs awaiting them at home.

Artisans also brought to the façade of the "Church of the Pantocrator" experience which they gathered cutting relief decorations in their home regions. Portals and windows with their profiles and reliefs broke up the peaceful outer surfaces, and with a specialized artistic language added to the design which, in any case, richly interpreted the wall-paintings in the interior. Sculpturing in the southern regions of the Adriatic basin was different from the developed and especially rich complexes in the West in the extent of scenes and personages. Iconographically more humble and simple, the compositions in Dečani were limited mostly by the lunettes of the portals and windows. On the archivolts and frames of the entrances, the consoles and capitals, however, a world of mythological creatures and symbols lived, illustrating for the faithful in its own way beliefs, warnings and promises of protection.

On the festive western portal, in a semi-circular field, Christ is on a throne with lions and beside him are angels, iconographically unusual – on his left one praying with folded arms, and the one on the right blowing a trumpet. The figure of the patron himself, traditionally over the main entrance into the church, is not, however, named by an inscription which would iconographically more definitely determine him. In harmony with the Apocalypse, not only on the cut-fronts of western cathedrals but also on the painted surfaces of Byzantine churches, custom showed angels blowing trumpets as one of the basic iconographical motifs of the Last Judgment. With reason therefore, experts have seen in the relief of Dečani the central part of the eschatological vision of Saint John the Theologian. On the other hand, the church of Christ the Pantocrator celebrated the Day of His Ascension into Heaven where, along with others, he was awaited by angels with trumpets. Thematically, the design of the portal, as well as other decorated surfaces, must have been establishd in agreement wih spiritual counselors, first of all with Archbishop Danilo II, who had a great part in the building and decoration of Dečani; the iconography of this relief itself was the work of a local artist from Kotor.

The strong and roughlined, thickset figures of Christ and the angels are modeles in the tradition of Romanesque relief on the Coast, but the drapery of Christ's cloak finishes with broken

lines characteristic of Gothic; pointing also to this are the trefoil arches at the foot of Christ's throne, whose contour is also seen at the ends of some two-light mullioned windows.

The presence side by side of two styles, in a special local symbiosis here also marked the life both of sculpting and of architecture, noticeable on the eastern shore of the Adriatic as well as on the Apennine Peninsula. Totally in the Romanesque spirit there were also vines on the archivolts and door frames intertwined with scenes of centaurs, horseback riders with spears, lions, dragons, warriors with Phrygian headwear, a wolf with a lamb in its jaws, cherubim, birds which are biting grapes, et al. Many of them, together with the figures on the consoles, by themselves or fighting amongst themselves, personified the forces of good and evil. Great in number, these representations had an apotropeic meaning known to people of the Middle Ages, and in Serbia are found already in Studenica Monastery in the 12th century: near the openings of doors and windows they protected the interior of the church. It is, however, difficult to determine a sense of PLATE 74 the entire decoration, and efforts at foretelling certain meanings and solving messages in all these representations in the belief of respected authorities of iconography and literary sources, are doomed to failure.

The southern, lesser portal has in a lunette a relief of the Baptism, connected with the appropriate rites on this side. The composition itself, both iconographically and artistically concentrated only on the main participants makes a true apposition to the representations on this theme in the wall-paintings, with a great number of figures, details and dynamic action.

On the northern side, the field above the entrance is filled with a geometrical carefully carved and balanced cross and full-leaved branches, with a vine rising from its step-like base. In exactly this shape it is, almost regularly, painted on the sides of entrances, where it blocked the entrance of evil powers in the interior of a church. At the same time, it also expressed hope in resurrection, for which reason it was carved on the upper sides of the stone tombs, for instance, of the heads of the Serbian Church who lie at rest in Peć.

In the interior, better protected under the roof, the reliefs on the portal in front of the naos have perserved, among other things, excellent figures of griffins and lions on the upper consoles, with a sharply-cut motif of an acanthus on the archivolts, and at the base a strong lion's body on which free-standing columns rest. Both one and the other, the personification of evil, hold in their claws animal and human heads.

A special place in the entire relief decoration is taken by excellently proportioned Romanesque

52. Capital of the narthex column. *53. Altar apse, three-light mullioned window, detail.*

three-light windows, with narrow mullions, richly sculpted archivolts, and frames alongside which were free-standing columns and consoles. On the western façade, in the lunette of the three-part window, scene of Saint George killing the dragon is brought into direct connection with the vow which Stefan Dečanski himself gave to this Holy Warrior, calling upon his aid before going into battle of Velbužd. The appropriate opening on the eastern side, in the main apse, has, however, almost the exact likeness as that in the Church of the Theotokos in Studenica. It has already been said that this three-light mullioned windows was an example for the stonecutters when they worked on the reliefs on the façade on the later mausoleum-type church in Banjska where it found its replica. The sources themselves, in all truth, do not mention that the benefactor of Dečani also attempted to follow the pattern of Nemanja's endowment, but the coincidence with its representative window confirms that also on this occasion the stonecutter remembered the church in Studenica and repeated certain of its forms.

At the same time, the interior has a marble iconostasis with relief decorations and a throne on which – the founding Charter expressly warns – only the King had the right to sit. Also, carefully fashioned marble sarcophagi under which lie the bodies of Stefan Dečanski and his wife Maria Palaeologina in the southwestern part of the naos belong to the same cycle. Sometime later, after rumors of miracles which occurred at the grave and the proclamation of his sainthood, most probably in 1343, the relics of the benefactor were moved to a pre-prepared wooden coffin, a masterpiece of wood carving, placed in front of the iconostasis itself, south of the royal doors.

The most spacious church in early Serbian architecture also claims the largest assemblage of painted decorations in the world of Byzantine art. On the surfaces of the tall walls, vaultings and arches there are hundreds of scenes and thousands of people in greater and lesser thematic sequences, in which the Divine Order of the universe is presented to the faithful, the Incarnation of the Son is shown, the history of the Christian Church is displayed and her dogma is interpreted. The twenty cycles of which the Calendar had 365 illustrated days, and Genesis 46 scenes, as well as hundreds of individual figures and busts, contain often rare and sometimes unique images.

Even though more numerous than in other churches, the scenes in the Dečani church are not in general of small dimensions – its interior was not dissected nor were walls divided as they were in Gračanica Monastery, so the available surfaces also allowed the representation of monumental scenes. On the other hand, neither were all the scenes "readable," especially the *Menologion*, whose individual days without designation are difficult to differentiate. The faithful, therefore, were faced with difficulties attempting to understand the language of frescoes; along with this, but also because they were at a great distance from the observer or were placed in fields where the

54. Capital of a mullion.

55. Console under the eave, detail.

188

person who had ordered them and the painter knew full well that no one would be able to see them. The act of painting was, therefore, similar to the discreetly written signatures and prayers of zoographers, an *act of a higher order*, realized for viewing *from the other side*, as if the scenes were not meant only for eartly eyes: certain truths had to be stated regardless of whether they would be understood by anyone.

The painting of frescoes lasted ten years. The earliest inscription including a year was written on one crossbeam of the northern nave, 1338/9, and the latest, over the entrance to the naos, 1347/8. But as the season for fresco-painting in the interior on still wet mortar ended usually in autumn, the work was most probably finished in September or October of 1347.

It is difficult today to conjecture the magnitude of work in which, considering the size, only one group of masterpainters did not take part. Undoubtedly, firstly an order was made of the entire thematics on drawings with well measured relationships of the surface, and then the work was divided and carried out at the same time on different sides. The frescoing would usually run from east to west and from the highest, first of the spherical surfaces, downwards. In Dečani one of the artists with his co-workers might have begun work also in the Chapel of Saint Demetrius, where he in the inscription wrote down the name of Abbot Arsenije. According to a unique idea, realized in a scope which is difficult to comprehend in the manner in which it was done in other, smaller churches, the frescoes are placed in harmony with the general feel of a church, with the meanings of certain of its parts and functions of the services. As in Gračanica, the correlation of area elements in the upper zones did not prevent a view of the surfaces which, strictly speaking, belonged to parts of the Church with serving purposes. Due to this, not even certain thematical wholes limited themselves to appropriate segments of space – they passed onto the walls and vaultings of neighboring aisles, and in that way made it easier for the faithful to follow certain ideas. It is understood that for the painter himself this was an indispensable condition for realizing the complicated task which, in the spirit of the time, was expected of him.

Also in the tall dome at the top is Christ the Pantocrator, and beneath him the Divine Liturgy, being served by the Heavenly Powers, while prophets are between the windows. In the pendentives the evangelists are represented in a wide plane.

The area below the dome and neighboring sections on the sides received, alongside the Great Feasts, a multitude of pictures connected with Christ's Life – scenes of his miracles, parables which he made use of in his sermons and public acts, and especially his suffering. Alongside these, on the southern side is a part of the verses from the Akathist to the Theotokos, hymns during which when sung at services one could not sit.

PLATE 61

Part of the miracles of Christ, his activities and, especially, his appearance after the Re-

56. Console under the eave, head of a soldier, detail.

57. Another console, detail.

58. *Altar apse, three-light mullioned window.*

surrection passed, as it has been said, into the sanctuary. In them, the basic theme, as is understood, was made up of scenes with a liturgical content: the Communion of the Apostles with Christ adorned in a rich archhierarchal sakkos, the Theotokos with archangels representing the Incarnation of the Logos and the Service of the Hierarchs alongside which is connected a greater number of Fathers of the Church, placed on the adjoining surfaces.

On the wide arch toward the prothesis there are, among others, scenes from the Old Testament which, in harmony with the character of the area, have a eucharistic meaning; they, however, represent a prefiguration of the Theotokos whose cycle, together with liturgical and other Old Testament scenes, has a place in the prothesis. On the underside of the arch towards the naos part of the scenes of Christ's parables, miracles and his activities, have expanded also, and of living historical persons, Arsenjie, the deserving first hegumen of the Dečani brotherhood, received his portrait.

In the western parts of the naos the Acts of the Apostles and Fearful Judgment are shown in detail, presented in 33 scenes. The Dormition, as is custom above the entrance, has special episodes and makes up a small totality in itself, as with the scenes of the sermon of Saint John the Forerunner and his conversation with Christ about the Baptism. Special also are the Old Testament scenes in individual groups, making up the Wisdom Sayings of Solomon and episodes from the Book of the Prophet Daniel, having many levels according to dogmatic meaning. Finally, on a greatly lengthened surface of the western wall, in the southern part of the naos is the largest and most complicated scene of the Vine of Jesse – the tree of Christ's ancestors with His Countenance at the top, with the fundamental genealogical line, having a number of parallel rows in which there are many numerous scenes, not only from the history of the Old but also the New Testament, to which the spoken prophesies applied.

In the southern chapel are scenes from the life of patron Saint Nicholas, and then the second part of the illustration of the Akathist to the Theotokos and other scenes from the activities of Christ, his miracles and parables. It is similar also to the farthest northern nave, dedicated to Saint Demetrios: alongside scenes of the life and sufferings of the famous Thessalonican Martyr, in segment of the vaulted surfaces and under them is presented an exceptional cycle of Genesis.

In the narthex the greater surface in the upper zones is taken up by the Calendar. All the feasts and personalities celebrated by the Church are shown in a manner adapted to the area – not only by choice but also by the character of its scenes – entire compositions when important events are illustrated, simplified scenes of suffering, or only "portraits" of persons, who have found themselves a place in the great Christian community. Their order starts from 1 September with which the year began according to the Byzantine manner of reckoning time, and goes from left to right, clockwise, the sequence in the zones and in the framework of certain parts of the building in greatest measure attempting to make the following of this great cycle in painting in general easier.

Individual scenes represent the history of the Christian Church through the Ecumenical Councils, which confirm her dogmatic foundation, all together six (without the Seventh, dedicated to the condemnation of iconoclasm), each having two compositions: one with portraits of the Emperor and leading Hierarchs and the Council, and the second with the opposing bishops.

The cycle of Saint George, with scenes from his life and suffering, makes a special appearance in the northeastern aisle of the narthex. Its surfaces are, in fact – one can see from the scene of the Service of the Hierarchs in the lowest belt – divided up by the special cultic part dedicated to this saint. The chapel was in any case constructed according to the desire of landowner Djordje Ostouša Pećpal who participated here through his donation. As in western art, where certain parts of the church or altar were furnished by respected individuals, in the Orthodox Church there were rare cases when, during their construction or later, other benefactors also joined in with their

own means. In Dečani the area also had a sepulchral intent: tomb-markers bear witness that members of the Pećpal family where also buried here.

Alongside the abundance of pictures of sacral content, Dečani has preserved a multitude of historical portraits, in the first place of its benefactors. The ruler's ideology and its expression in art already in the time of King Milutin appeared in a number of iconographical variants, and sometimes made up exceptional totalities. In the great church of Dečani rare solutions also appeared, thought up or adapted to the conditions which were changing at the exact time it was painted. The period of military campaigns and the amassing Byzantine regions, especially after 1342, influenced the state-judicial understanding in the Serbian milieu and found an immediate expression in rulers' titles, so that changes could also be very clearly followed in the inscriptions near their countenances. Due to this, certain parts of the wall decorations can be more exactly chronologically determined, especially in the lower zones where the majority of portraits are located.

Interesting changes were also brought about by events connected to the cult of the founder of the monastery, Stefan of Dečanski. His oldest portrait, on the southern wall, following respected older members of the dynasty (Saint Symeon Nemanja, Archbishop Sava and King Milutin) was painted only somewhat later, together with the figure of his wife Maria Palaeologina. On a newer layer, Stefan of Dečanski is with his son, the other benefactor of the church, with whom he holds its model, while from a beam of light Christ blesses them with both hands. At the same time, the family picture of Stefan Dušan on the western wall also has been altered where in the new compositional scheme Empress Helen has received the place between the heir to the throne, young Uroš, on one side and most probably Dušan's half-brother, the later Czar of Thessaly

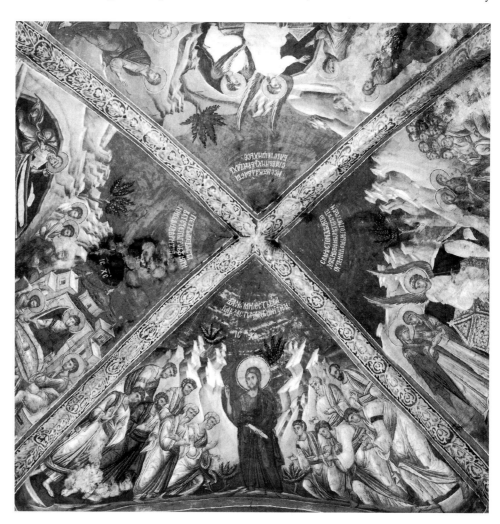

59. Scenes of Christ Appearing after Resurrection, church naos, frescoes.

Opposite page:
60. Service of the Hierarchs, narthex, fresco.

192

Symeon, on the other. All of these changes on the portraits near the sarcophagus of Stefan Dečanski were made, it appears, after his canonization. Dating also from that time is his excellent countenance on the pilasters in front of the iconostasis where, as we have seen, his remains where moved to at that time. And here with a model of the church which he offers up, the Sainted Benefactor bowing slightly, mouths his long prayer to Christ.

PLATE 59

In all cases, the countenances of the rulers and members of his family show that they continued the tradition of dress in example of the Byzantine emperors, whose etiquette and royal ceremonies they faithfully followed. To a great extent this can be seen in the aristocratic portraits of the time. The differences in their clothing allow, however, the possibility that elements of costumes of another origin can be found – especially with those people who did not belong to the highest circle of social hierarchy, so neither did their titles agree with those of Byzantium. Thus Djordje Pećpal is shown as a humble landowner of unknown rank and status in a short tunic with flower ornamentations, a belt around his middle and a decorated cape, whom Saint George, holding him as a protector, leads to Christ on His throne.

In humility the kings Stefan and Dušan also bow to the glory of Christ the Pantocrator in the large bust above the entrance into the naos, receiving from cherubim a scroll with the Divine Word. Even though they, as benefactors, are illustrated here in the known tradition of representation "over the doorstep," their countenances, here in an individual thematic context, reveal complicated ideas: on the book held by Christ is written the metaphor of the gates and salvation of those who enter, in connection with the mission which has been entrusted to them, while at the sides are figures of David and Solomon, also father and son, with whose appearance the Serbian rulers are also compared in local literature.

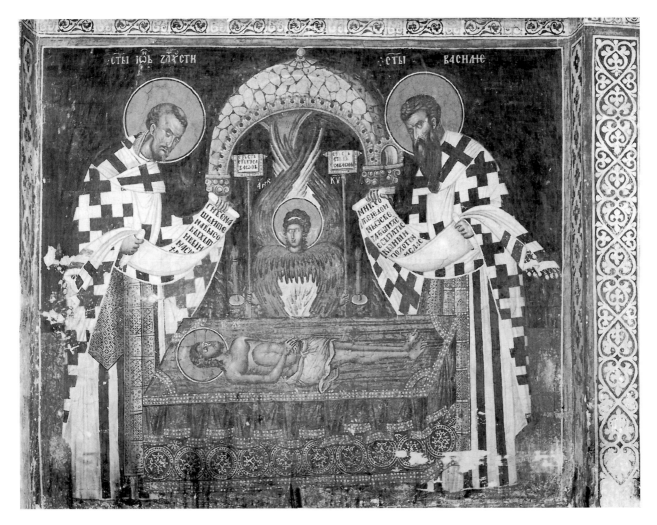

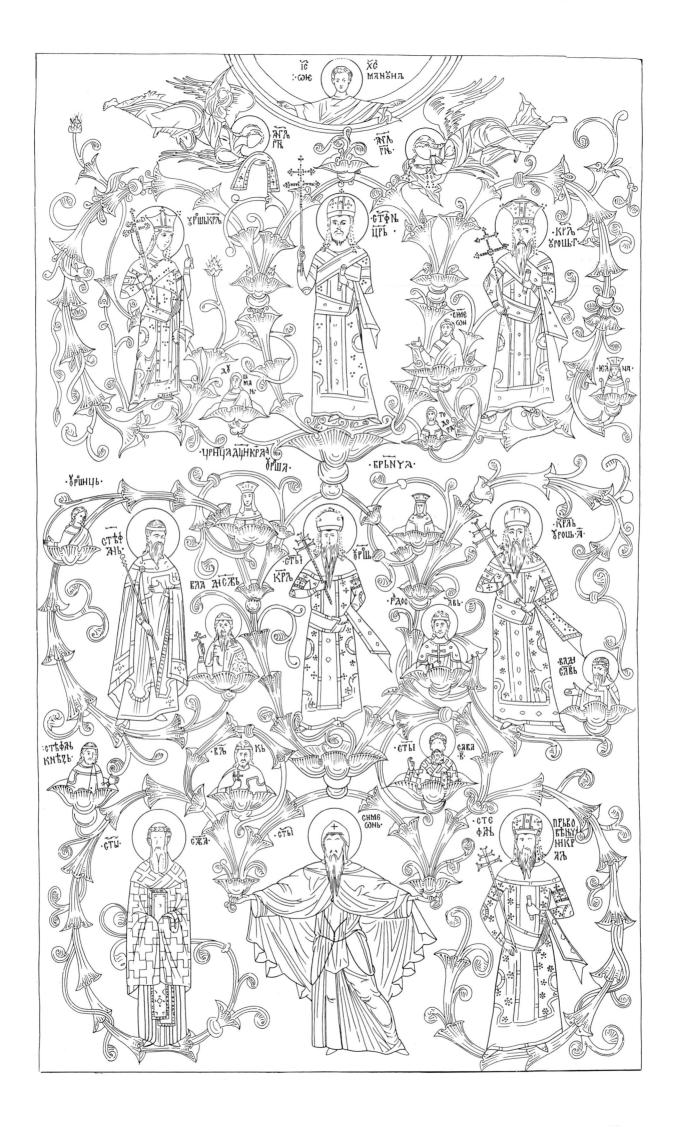

As with Byzantine emperors, humble before God whose servants they are as are all others, and glorious in their power on earth, the Serbian kings also clearly express this twofold rank with the portraits in Dečani. Thus, alongside the northern entrance to the narthex, Stefan Dušan once more is shown in an official way, between his wife and son-heir, but this time with a rank which reveals changes that have in the meantime taken place. After conquering Serres, an important city on the old road from Thessalonika to Costantinople, Dušan at the end of 1345, maybe on Christmas, there proclaimed himself, and in April of next year, on Easter, in Skoplje, was crowned, Emperor of the Serbians and Greeks. His portrait in Dečani with the Emperor's title, as is understood, did not also show the changes in appearance, because, as has already been said, Serbian rulers even before, as Kings, copied the dress of Byzantine emperors. The picture of the royal family makes up, on the one hand, a totality with the portraits of spiritual figures on the neighboring surface of the western wall – the hegumen of Dečani Arsenije, once more Saint Sava, as the founder of the Serbian Church, and Joanikije, her patriarch at that time. Rather, the last of these in the inscription is still described as archbishop, which tells one that the first part of the scene in the northwestern corner of the narthex was painted in autumn of 1345 before the changes in which he gained a new title, and the second painted later: i. e., before the onetime great logothet of the king and a person of trust, Archbishop Joanikije, before the crowning of Dušan as Emperor was consecrated as patriarch.

As also in Gračanica, finally a place was ordained for a group portrait of the dynasty in the form of a tree which grows from the roots of Stefan Nemanja. It stands on the same wall on which, on the other side, in the naos, is the Vine of Jesse – a scene whose iconography suggested the same manner for royal origins of the family of Serbian rulers. PLATE 60; 61

Rich in their scope, the frescoes of Dečani are often mentioned as an example of so-called encylopedism, in whose spirit generations of painters created in the decade around the middle of the 14th century. In its iconographical abundance – even though not in the same scope nor collected together in one place – the wall paintings of this character were already known in churches built and decorated during the time of King Milutin. Besides this, the frescoes of Dečani were not, even though this is sometimes stated or at least hinted at, an expression of dried-up aca-

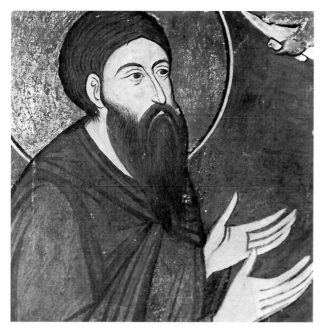

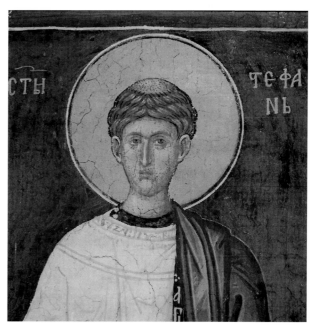

Opposite page:
61. Christ the Pantocrator, The Tree (Vine) of the Nemanjići dynasty.

On this page:
62. Portrait of the hegoumen Daniel.

demism which left behind the original freshness of meaning. It holds true that artistic reforming of examples chosen from art history characteristic for churches of the first quarter of the century lost rhythm and creative charge; but the scenes looked at in their entirety and mutual relationships still showed a lively and clever control of ideas which lends them a different and complicated meaning. It might be said that a passion for the showing of dense compositions with innumerous episodes and facts was missing, whose most obvious representatives were – keeping only to local ones and not the wider region of the Byzantine style of this time – in the King's Church in Studenica, Saint Nicetas, Staro Nagoričino and Gračanica. In Dečani this compressed exhibition of content is often represented in numerous scenes and sometimes made into entire small cycles. Its narrativity was different, but in no way larger than in shrines which received wall paintings two or three decades earlier.

The decoration of the expansive interior was also a great challenge for the masterpainters and for artist-counselors, since they had never had the occasion to create such a sophisticated composition, with the responsibility that its parts, in the spirit of the constantly developing interpretation of pictures and ideas which they express, be mutually connected. On the other hand, the great worksite brought together a number of groups of painters, of whom it was expected that they would coordinate their method of work. Behind the desired oneness, especially successful in the general gamma, one can nonetheless recognize artistic individuality and talent. Of the names of the masterpainters who participated, only one is known however, written down in color on the capital near the place where he painted: *Srdj the sinner*. The character of this name leads one to think that he was one of the artists of Kotor who had come, as did Fra Vita, at the invitation of the ruler. Sources in Kotor mention, of the other hand, so-called Greek painters (*pictores græci*), masters who in the coastal cities in the 14th century worked for Orthodox clients. For this reason, it is often thought that they also joined with their knowledge in the great work in Dečani. Nothing more is known, however, about their method of work nor of their true capabilities in decorating such a large interior. On the other hand, frescoes in a number of local churches show a similarity in style to such an extent that there is no doubt that they originate from one artistic climate and that the masterpainters of Dečani, with appropriate experience, should be sought within the country itself, in the regions in which the Serbian state existed, while they continued to employ Greek artisans who, painting in the same spirit, closely cooperated with local painters over a number of decades.

64. Il sarcofago del re Stefano Dečanski.

196

Better preserved than other large churches, Dečani also has on its marble altar railing icons from the time the walls were decorated, even in the same style, surely the work of the masters who painted the frescoes here, who, as was often the case, did the icons at the same time. The Royal Pictures of Christ and the Theotokos, on one and the other side of the royal doors, and Saint Nicholas and Saint John the Forerunner next to them, today make up a very rarely preserved totality of an iconostasis in the entire Byzantine world, as does the great collection of ancient works representing one of the greatest treasuries of Serbian art from the time of political independence but also from the centuries of Turkish rule. In its own right, the monastery's library preserved excellent collections of ecclesiastical manuscripts and literary works, one part of which was written in Dečani itself.

PLATES 76,77,86

PLATE 81

The Patriarchate of Peć

The church of Saint Demetrios (architecture)

The *Home of the Savior* in Žiča was considered the see of the Arcbishopric, but in the first decades of the 14th century Serbian church dignitaries preferred Peć, as it was safer and closer to the royal court. The archbishop's obligations regarding supervision of spiritual life, ecclesiastical judiciary and other matters imposed the need for more capable and broadly educated clerics; conditions for their work should have been but were not provided in the old *metochion*. Also some of the services which the archibishop needed to conduct were complex and required a more elaborate ritual space. The heads of church, therefore, rebuilt Žiča and added new churches to the Holy Apostles in Peć, enlarging the ritual space and adapting it to various religious rites.

The first archbishop, Nikodim (1317 - 1324), added a church to the northern side dedicated to St. Demetrios, patron saint of Thessalonica, whose cult, due to close ties with this Greek town, was revered by the Serbs. Nikodim replaced the 13th-century lateral parekklesion, its length corresponding to the western part of the Holy Apostles, up to the height of the added transept. Appended to the main church, St. Demetrios was constrained in its design; best suited was the concise form of a single-nave church. It had an octagonal dome, large apse and certain extensions in places where the choirs were located in the older tradition of the Raška school. From the outside, in the roof construction, this is noticeable on the northern, open side.

In accordance with the spirit of earlier architecture, the interior of the church is well-lit and designed of a piece, while the altar space is separated from the nave by a well-preserved stone iconostasis. Parapet panels with door-ways in the middle, where the royal door is situated, are placed between nicely fashioned colonnettes; they, too, stand on the northern side in front of the prothesis, while everything in the upper part is joined a whole by a horizontal beam (epistyle). The low-relief ornaments on the panels belong to the elegant and strict dictates of Byzantine sculptural art and probably are the work of the same master who made the frame of the church portal, also resorting to ornaments from the classical repertoire (astragal, vine with palmettes and billet moulding). Broader analogies attest to sculptural work distinguishing parts of the sculptural decoration in Banjska as well.

In appearance and construction – the already mentioned "cellular" (i.e. *cloissoné*) style of building with cubic stones, tiers of bricks and mortar links – St. Demetrios is an articulation of the Byzantine concepts. The procedure itself is closely aligned with the manner of building of the Dečani entrance tower, the work of master-builder Djordje (George) and his brothers. A wider circle of builders and stone-masons from Serbia and the Adriatic coastal area was employed on raising shrines in Serbia, particularly in Kosovo, during the entire first half of the 14th century.

The character and position of the church of St. Demetrios in relation to the Holy Apostles can hardly be understood if taken in isolation, out of the context of the entire complex of the Patriarchate of Peć, which was to be built at a later date. Subsequent construction on the southern and western sides gave full meaning to the endowment of Archbishop Nikodim. One may well wonder whether the first, early deceased, donor had in mind the same design achieved in the following

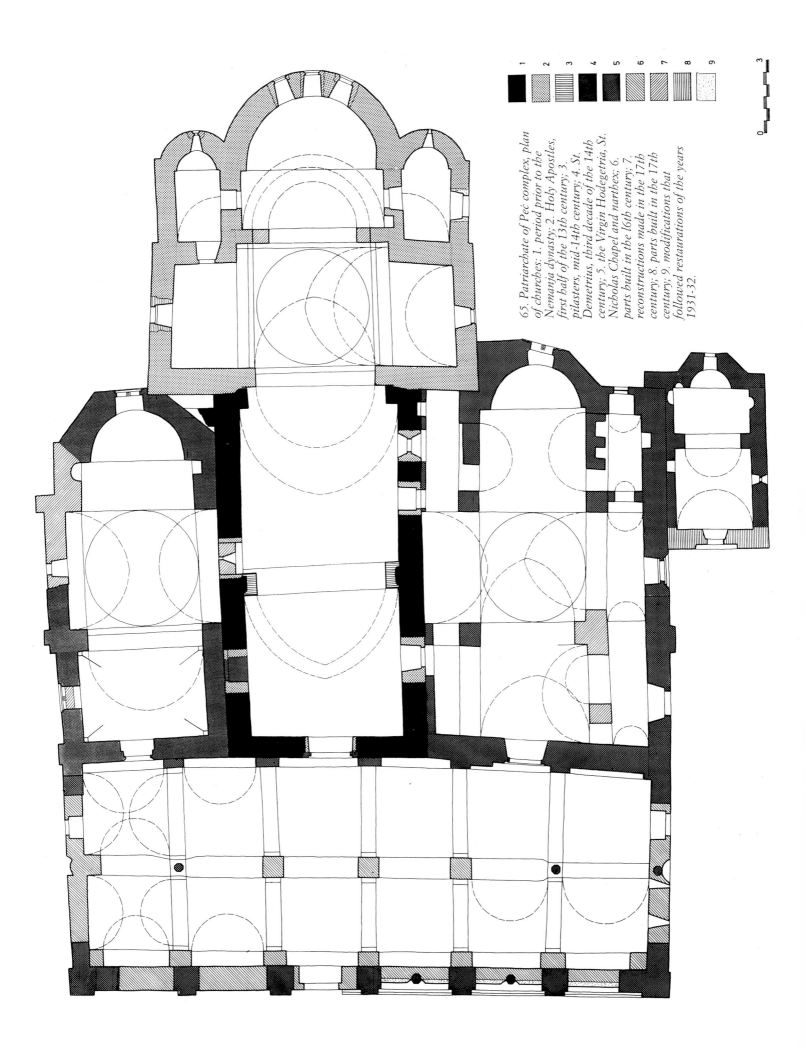

65. Patriarchate of Peć complex; plan of churches: 1. period prior to the Nemanja dynasty; 2. Holy Apostles, first half of the 13th century; 3. pilasters, mid-14th century; 4. St. Demetrius, third decade of the 14th century; 5. the Virgin Hodegetria, St. Nicholas Chapel and narthex; 6. parts built in the 16th century; 7. reconstructions made in the 17th century; 8. parts built in the 17th century; 9. modifications that followed restaurations of the years 1931-32.

decade by his teacher and successor to the spiritual throne, Danilo II (1325 - 1338). Similar examples show that both of them may have been inspired by the same idea.

The Virgin Mary Hodegetria

Archbishop Danilo – as recalls Danilo's anonymous biographer – had the church of the Virgin "Hodegetria of Constantinople" built to the south of the Holy Apostles. He did so out of gratitude for the support given to him in days of distress by the protectress of Mt. Athos and the imperial capital, and he provided "Greek books and all church necessities" for the shrine and let monks "of Greek origin to ... perform divine service according to their custom." Broadly educated, Danilo was emotionally tied to Greek-language literature, as was his predecessor Nikodim who had translated from Greek the famous Jerusalem typikon (rule) of St. Sabbas the Consecrated with its regulations of monastery life and description of divine services. Experts in Greek language and literature were needed in Serbia for many reasons, particularly after 1334 when Stefan Dušan conquered extensive areas of the Byzantine Empire.

The Virgin's shrine was symmetrical to the church on the northern side. With its forms and internal structure it repeated the widespread cross-in-square layout typical of Byzantine architecture, clearly manifested not only in the ground plan, but also in the lead-sheathed roofs. The central part is topped by an octagonal dome on a low cubic base supported by four piers; laterally, the arms of the cross are barrel-vaulted, making the upper section cross-like, while lower, longitudinally vaulted bays are in the corners. In accordance with the ideas of Archbishop Danilo himself, the prothesis chapel and the diakonikon as independent ritual areas are dedicated to St. Arsenije of Serbia and St. John the Forerunner. At a later date, when Archbishop Danilo was buried there, the north-western part of the nave was separated by a canopy. The interior, however, retained its original layout which was not disturbed by the installation of a stone altar screen with Romanesque capitals.

The apertures which were executed, either at the wish of the donor or by their own intent, by masters from coastal workshops, render a more complex image of the stonework. Single-light and two-light windows, generally distinct both in profile and in the selection of modest decorative

69,70

PLATE 9

68. Patriarchate of Peć, sarcophagus of Archbishop Nikodim, founder of St. Demetrios.

Opposite page:
66-67. Patriarchate of Peć complex, portal and parapet panels, ornaments.

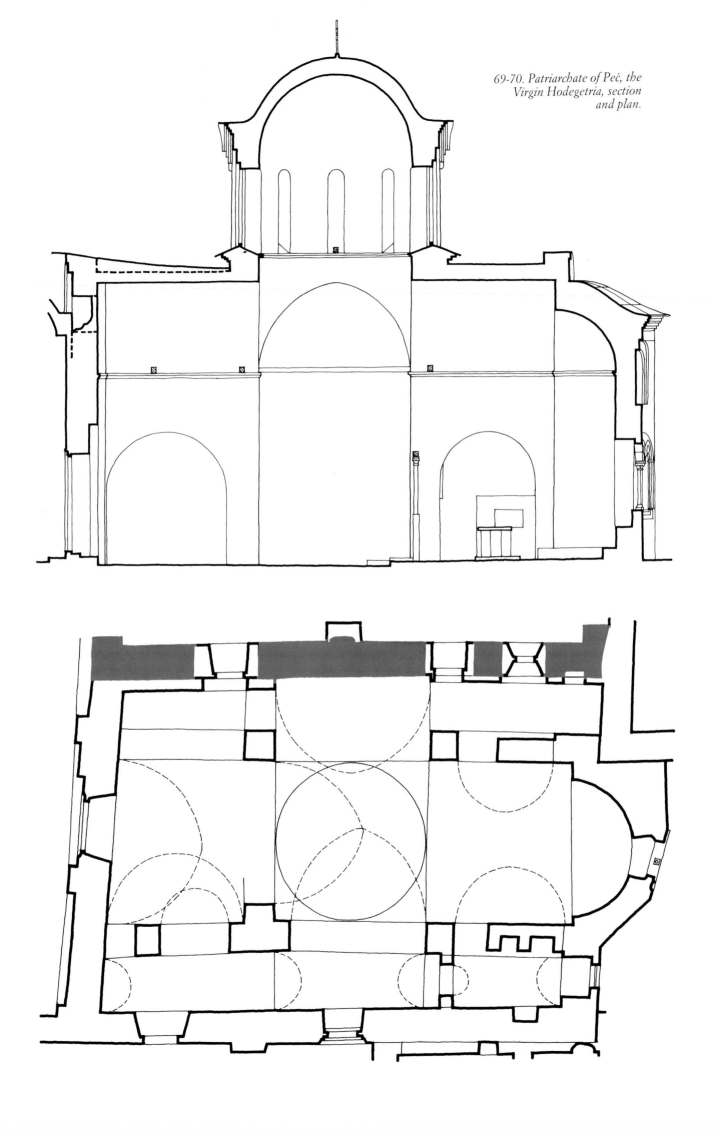

69-70. *Patriarchate of Peć, the Virgin Hodegetria, section and plan.*

motifs, display, in this case as at Dečani, Romanesque forms and Gothic slightly pointed arches, sometimes with quatrefoil apertures in the lunette. To them belongs the two-light mullioned window on the northern side of the St. Demetrios, executed at a later date, perhaps because the Archbishop Nikodim died before the building was finished.

The Narthex

To the south of the Virgin Hodegetria, Danilo added a chapel dedicated to St. Nicholas, and at the front of all three buildings he built an open narthex. The appearance of the whole viewed from the south is represented on a model which the donor, by the mediation of the prophet Daniel, offers to the patron, the Virgin Mary on a throne. The vividly modulated representation shows only the structures raised by Danilo II, and carefully registers their appearance. For this reason the model represents a precious source for reconstruction of those parts of the complex which disappeared at a later date or were rebuilt in another form. The portico on the southern side which protected the entrances to all three structures built by the Archbishop Danilo – the church of the Virgin, the narthex and St. Nicholas's chapel, belongs to them, as well.

Construction of religious buildings close to one another, particularly within the confines of a monastery, was a familiar feature of the architecture of the Byzantine Empire and Constan-

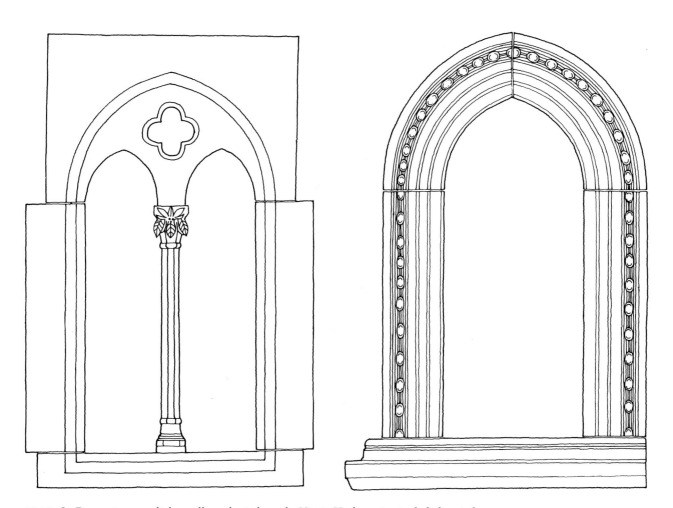

71-72. St. Demetrius, two-light mullioned window; the Virgin Hodegetria, single-light window.

203

tinople itself. The Peć donors had opportunities to see similar complexes, particularly at Mt. Athos. Both Nikodim and Danilo were priors of the Hilandar Monastery for several years and knew other monasteries well, the oldest of which, the Lavra of St. Athanasios, had similar spatial coordinates: three parallel churches with a common narthex. It is our belief that the monastery of Vatopedi, very close to the Serbian monks, may have been of special significance for Peć. Before founding their own monastery, St. Sava and Symeon Nemanja had lived there, lavished it with rich gifts and commissioned many buildings there; the fraternity of Vatopedi respected them as donors.

The cluster of katholika in Vatopedi is laid out in a similar fashion and dedicated to the same saints: the northern church to St. Demetrios, the southern one to St. Nicholas, and the oldest one, situated in the center, to the Virgin, the protectress of Mt. Athos. In Peć, at the Holy Apostles, all the shrines which by their position and ritual correspond to the Vatopedi complex were added in the course of a single decade. Both donors, who arrived from Mt. Athos to take high positions in the Serbian church wanted to transfer to Serbia prototypes from this great Orthodox monastic center.

This was reflected on the façades with strong red hues like those on the churches of the most prominent Athonite monasteries. It is likely that the walls of the original Hilandar church, replaced later by King Milutin, had been painted in the same way. The earliest traces of red color were found in Peć on the Holy Apostles which were painted having Žiča as a model, and that practice, within the framework of emulating Athonite customs, continued to be pursued in finishing the other churches in the complex.

Archbishop Danilo's buildings with their dark red façades had rich ornaments covering the entire surface below the roof cornices, archivolts, lunettes and window frames. Earlier, the rows of stones and bricks had been painted to imitate builders' facing, covering the coarse tissue of walls and mortar. Only some of the decorative elements were adopted in Peć, for example: the checker

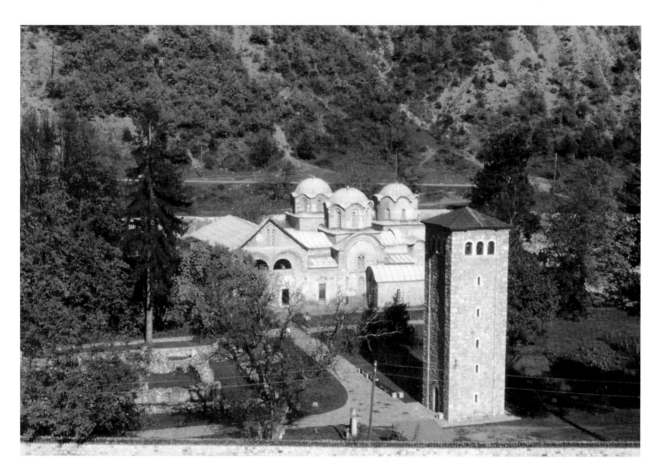

204

board. However, ornaments typical of wall painting and book illumination were predominantly used in a rich repertoire ranging from antique motifs to geometric patterns, mazes and ornaments characteristic of the Middle Ages. All the decoration was carried out in fresco technique which 74 enabled it to retain its basic forms and freshness of color after six and one half centuries of exposure to sun and precipitation.

Painted decoration of this kind later became the object of interest among experts because of the fact that several decades later bas-reliefs with similar decorative elements appeared on the façades of the Morava style churches – mainly in the same places. As a matter of fact it was supposed that the painted ornamentation on the outsides of the Peć churches date from a later period, taking its place in a new form of expression. Careful examination, however, has proven that the painted ornamentation preceded the stonework, i.e. that the new style of sculptural art from the last decades of the 14th and the first half of the 15th century had already been developing among local builders in another medium: it did not appear out of the blue, completely formed.

Archbishop Danilo's large, open narthex was of exceptional beauty; a chronicler from the early 15th century included it in his selection of the most valuable works of ancient Serbian art. It has reached us, however, in a significantly altered appearance following damage and the subsequent reconstruction undertaken by Patriarch Makarije around 1560. The original view of the narthex is shown on the painted model in the hands of Archbishop Danilo. Precious data are also supplied by his biographer praising his work. After deciding to build "a bright narthex," he says that first "in his mind he measured everything … what its height should be, what length, what width, so that it leans on" and is "in unision" with the churches of the Holy Apostles, Saint Demetrios and the Virgin.

The spacious narthex was open and bright indeed. Three piers in the middle and one on the northern and southern ends divide the interior into two aisles, each with six bays. The upper sections were almost completely rebuilt after the restoration of the Patriarchate of Peć, but the standing remnants prove that, like today, the supporting pillars were connected by arches and the 65 fields between them vaulted; on the eastern side they rested on pilasters added to the churches, and on the western side on corresponding piers of the façade. All the bays, of the same size, had

74. Narthex façade, rosette, fresco.

Opposite page:
73. The Virgin Hodegetria, narthex and church.

and on the western side on corresponding piers of the façade. All the bays, of the same size, had groin vaults capable of carrying chambers on the upper floor.

The light construction of the edifice became apparent in the appearance of the façade. Colonnettes with apertures terminating in arch-form openings are approximately of the same width as the supports in the interior. Their rhythm and outer elegance were particularly stressed by slender octagonal pillars with narrower, somewhat recessed, arches. These reduced the span between the piers and contributed to the static value of the whole. Such a structure was too fragile to withstand the test of time. Today only the features of its lower part can be well observed. Fortunately these lower original forms have been preserved, though the upper ones were quite interesting. Both information the *Life* of Archbishop Danilo, and the model he is holding as donor testify to that.

The southern front had two broad arches leaning on the marble pillar in the middle, beyond which was a deep and spacious interior. Above the aperture a gable corresponding to the height of the upper floor was pierced by a two-light window illuminating the space probably stretching across the vestibule. According to the words of Danilo's biographer and disciple there was a catechumenon here, but we know too little about the various forms of chambers – even comparing this one with those in other cathedral churches – to assume its appearance and guess its function.

The statement of Danilo's biographer that he (Danilo) "built a high pyrgos in front of the church" and a chapel in it devoted to his namesake St. Daniel, is particularly interesting. A belfry is depicted in this place on the donor's model; not very tall, with an open upper section in which the bells are visible. The bells were depicted with special attention; it was stressed in Danilo's biography that he had spent much gold in order to have "bells with a pleasant sound" made in the Coastal area, which he brought here and installed with great effort.

The painted decorations of the Peć narthex deeply impressed the medieval observer: there were frescos not only on its vaults and walls visible from the outside, but also on the outer sides of the piers, and the upper, broader surfaces, as there were on the churches behind them, covered with painted ornaments on a red ground.

In this form, with its elaborate spaces dedicated to various rituals, the Peć churches could respond to the requirements of the complex rites of a large spiritual center whose needs Danilo

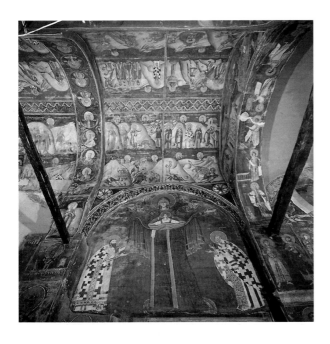

76. Narthex, inside, frescoes of the 14th and 15th century.

Opposite page:
75. Patriarchate of Peć complex, narthex, the Tree of the Nemanjići dynasty.

knew best and, experienced as he was in building, was able to meet thoroughly. The memory of his great merits was simply expressed by the addition to his name of the epithet "Pećki" ("of Peć"), just as the memory of the great donor from the ranks of rulers Stefan (Stephen) Uroš III has been preserved by calling him "Dečanski" ("of Dečani").

Simultaneously with his care of the great royal churches, first of all of Dečani which was built under his supervision, and then of other places of worship he erected, the Archbishop Danilo made an effort to furnish the interior of the Peć church with frescos and to provide the objects necessary for divine service. The wall decoration of the church took a course different from the builders' works: although the narthex with the belfry and the parekklesion on the upper floor were put up last, frescos were first painted there around 1330 rather than in the churches added on the south side. That is indicated, first of all, by the appearance of Danilo II above the entrance to the church of the Virgin, where he is significantly younger than on the donor's composition in its interior. This is a fact to be trusted. The portraits carefully transferred features of represented persons and recorded changes brought about by the passage of time. It is sufficient to consider the twenty-odd surviving portraits of King Milutin from his young days till the closing years of his life among which the last portraits registered his decline of strength and the approaching end. The reason for the aforementioned sequence of decoration in Peć could be explained by the wish of the spiritual dignitary to arrange the access to the main sanctuary first, the Church of the Holy Apostles which, together with the church in Žiča, held the highest place in the hierarchy. Inspired by the old see of the Archbishopric, the Church of the Holy Apostles started to observe the feast of Ascension, and sources mention it as the Holy Savior and the Great Church, where the most important archbishop's divine services and rites were held, in addition to the ordination of the highest church dignitaries.

Of the comprehensive thematic sequences from the time of the Archbishop Danilo in the narthex, representations have survived devoted to the Virgin on the surfaces of the southern bays and the space in front of the church. Most of the themes represented relate to her. Above the entrance there is a large figure of the Mother of God with outstretched arms, expressing, with the

76 child at her breasts, the idea of the Incarnation on a wide, decorated vessel. The mercy of the young Christ blessing with both hands is directed to the Archbishop Danilo and St. Nicholas, whom, as a bishop, the Serbian spiritual leader held in high regard, dedicating a separate church to him on the southern side. On the nearby arches the Old Testament fathers celebrate the Mother of God, thus illustrating the verses of the song "The prophets announced you from the heaven ...," and on the southern wall stands a rare figure of the Virgin nursing the Christ child in her guise of *Galaktotrophousa* on a wide decorated seat, in front of a ciborium, and angels, freely positioned in space, exalt her.

PLATE 10; 75 The Tree of the Serbian royal family occupies the whole height of the eastern wall by the entrance. Below a large portrait of Christ are depicted descendants of St. Symeon Nemanja, five in each of four regularly arranged rows. The stylized vine tendrils encircling their whole figures is not as rich here as it is in other versions; only in places are its curves replaced by portraits of the younger members of the dynasty in small cups, without disturbing the strict general order. In the highest zone of figures below the angels – two on each side – lowering crowns for the king and queen, Milutin is depicted in the middle, to the right of him are Stefan Dečanski and his brother Konstantin, and to the left, sons Symeon and Dušan. The noticeable respect paid to King Milutin and the choice of the persons around him indicate that the Tree was painted while Stefan De-čanski was alive, before 1331.

The rest of the painting in the narthex – predominantly dating to 1565 – may well repeat the earlier scenes it covers, so that, chances are, in the time of Archbishop Danilo most of the wall surfaces were covered by the Calendar, versions of which are also to be seen in somewhat earlier

84 Gračanica and later Dečani.

The Church of the Virgin articulates simple, legible and harmoniously arranged religious themes. The words from the psalm extolling Christ as the Lord of the universe are inscribed around his portrait in the dome, the Divine Liturgy is in the lower parts of the dome, a row of prophets with six-winged seraphims above their heads is between the windows, while the evangelists are on the pendentives in the developed spaces or "interiors" represented with painted architecture, engaged in writing or turned toward the personifications of the Wisdom inspiring them.

On the highest parts of the vaults over the arms of the cross are arranged the Great Feasts, while on the lower surfaces of the northern side – Christ's appearances after the Resurrection; on the southern side are scenes from the life of the Virgin. In the northwestern part of the nave a rare representation of the Virgin as protectress of the humble and poor on the wall above the sarcophagus of Archbishop Danilo belongs to the series of paintings dedicated to the patron. PLATE 7 PLATE 9

The lowest zone of frescos contains the figures of saints, mainly of the great martyrs in the northern, and the monks in the southern part, while by the entrance the portraits of St. Zossimos and Mary of Egypt remind one of the story of a great sinner who, halted by an invisible force at the door of the Jerusalem church converted into a Christian and finished her life by expiation in the desert.

Contrary to the strict order for arranging saints on the walls of the lowest zone, the donors' composition is freely developed in the southwestern part of the nave. Here the prophet Daniel commends the Archbishop with a sweeping gesture. He has stepped freely into the space towards the Mother of God with her Child on a sumptuous throne, turning his head towards the donor with whom he holds the model of the building. Danilo, bowed a little, wearing the robes of a PLATE 8

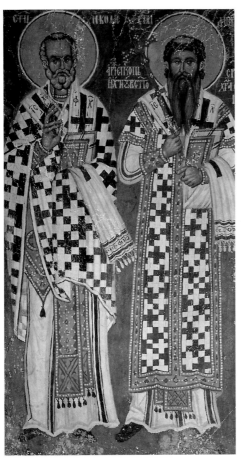
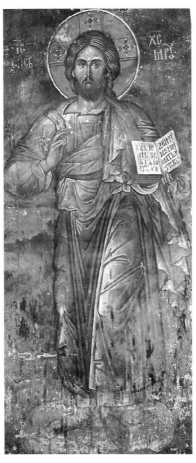

77. The Virgin Hodegetria, St. Nicholas and Archbishop Danilo II, presumably of 1337; Holy Apostles , The Savior, mid-14th century.

209

monk but wrapped in a bishop's gown covered with ornaments and criss-crossed with "the rivers," is following him humbly, addressing himself to the Mother of God in a prayer by the gesture of his left hand. The beard with its occasional gray hairs discloses Danilo II's age, but his solid features still show evidence of vigour and indicate that the portrait was not made in his last years. He does not look like a person whose life was filled with many hardships under the reigns of three kings – Milutin, Stefan Dečanski and Stefan Dušan. Prior to becoming the head of the archbishopric, he demonstrated his capabilities as the *hegoumenos* of the Serbian monastery on Mount Athos whose monastic community and treasury he successfully protected from Catalonian mercenaries. He was the bishop of Banjska in times of unrest, a versatile diplomat in negotiations abroad and mediator in internal conflicts. In addition, he also was a writer and connoisseur of construction techniques, on whom the rulers themselves relied when commissioning their pious endowments. The portrait of this many-faceted, gifted person holds a dignified place on the wide surface of the western wall, in a composition which, in terms of unrestricted movements and their rhythm, is one of the most beautiful works of old Serbian painting.

In keeping with his predecessors, and nourishing their cult, Danilo expressed special respect for Archbishop Arsenije. It was not by chance that he devoted the prothesis of the Virgin's church to this eminent prelate, the heir to St. Sava. The space stood next-door to the Church of the Holy Apostles whose famous frescoes were linked with Arsenije's name and where, under a sarcophagus, his body rested, separated from the prothesis only by a wall. This provided a chance to represent the life of this archbishop on the walls of the parekklesion. Like the other sanctified figures from local history, Arsenije has his Service and *Life* abundant with data about him, but the frescoes were restricted only to his ordination as deacon, priest and archbishop, as well as to his death with representation of the last prayer over his body in the presence of the king, the nobility and the clergy.

In the southern part of the church, in the diaconicon, is illustration of the life of St. John the Forerunner. Several years later, after his death (the end of 1337), Danilo was depicted once more, this time by his grave, wearing archbishop's dress decorated with a big cross. As in the narthex above the entrance, St. Nicholas, the bishop who was his model and protector, is next to him.

77

The church of St. Demetrios (painting)

And finally, only the church of St. Demetrios remained undecorated. The care of its painting was entrusted to Danilo's heir to the spiritual throne, Joanikije, the king's former chancellor (from 1338 the Archbishop, and from 1346 to 1354 the Patriarch). In this simpler space, most likely at the wish of the educated donor and religious dignitary who enjoyed the personal confidence of the ruler, the painter displayed some theological and ecclesiastico-political ideas.

78-81
In the dome, as in the Holy Apostles, the Ascension is presented with the apostles among the windows. The prophets, thus, are placed on the arches, at the height of the evangelists on the pendentives and the Great Feasts on the vaults.

Like other Peć churches, St. Demetrios was a mausoleum for ecclesiastical leaders; its donor, the Archbishop Nikodim, was buried here. His sarcophagus with sculpted decoration is in the northwestern corner. This might have been the reason for painting the scenes of Christ's Burial and the Two Marys at the sepulcher in that part of the church, while at the opposite end, on the
PLATE 11
eastern wall, are the Annunciation, the Nativity of the Virgin and the Presentation of the Virgin at the Temple.

The two Ecumenical Councils in which the dogma of the Christian church was founded form a fascinating ecclesiastical and historical subject; there were also two Serbian Councils which are represented here in frescoes. The First of the Councils was held in the same spirit by Saint

Sava – probably the council in Žiča, when the head of the new autocephalous (autonomous) church delivered his famous speech on the righteous faith. The Descent of the Holy Spirit to the apostles, a fresco in the same section of the Church, describes the apostolic mission facing the Serbian bishops and clergy: tongues of flame convey to them the ability to preach among nations whose language they do not know; that is why the image of the young Christ, painted here above the participants of the synods, bestows a similar divine benefit on account of his blessing.

The other Serbian Council joined two persons whose reigns were an entire century apart – St. Symeon Nemanja and King Milutin – in an interesting manner. The gesture by which the holy founder of the dynasty points to his great grandson, imparting majesty to his rule on the throne, represents symbolic investiture to this ruler whose merits in building and restoring churches were immense. The representation of the local council has not only ideological and political significance, but also extolls the support given by the ruler to the church and profession of faith.

The large, solemnly arranged cycle of St. Demetrios on well visible zones on the lateral walls formerly comprised eight scenes which flowed, interestingly, from the right to the left. On the northern side is St. Demetrios in front of Emperor Maximian Galerius, St. Demetrios in prison blessing Nestor for his combat against the gladiator Lyaios, the Victory of Nestor over Lyaios and the Execution of St. Demetrios, and on the southern side the Ascension (Burial) of St. Demetrios and St. Demetrios defending Thessalonica from enemies. The last two representations on the northern wall date from the 17th century, when that part of the church had to be rebuilt and the frescoes repainted. The representations on the southern side were also partly repainted at that time. Legend vividly describes the destiny of the great martyr who as the protector of the second largest town of the Empire defended its inhabitants from barbarian sieges and helped in fighting against the enemies, a history closely connected to the arrival and subsequent life of the South Slavs on the northern borders of the country. At the same time, the great esteem for Saint Demetrios in Thessalonica, his large basilica sumptuously decorated with mosaics and reliefs, and his feast day in autumn with a great fair which attracted people from all walks of life to Thessalonica spread the cult of this saint, particularly through Serbia and Bulgaria. Detailed

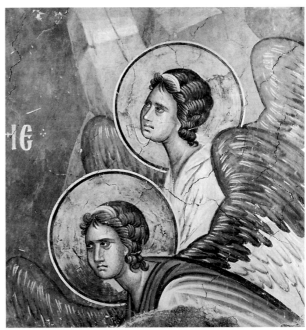

78. St. Demetrios, Nativity, Shepherds, detail. *79. St. Demetrios, Nativity, Angels, detail.*

representations of St. Demetrios' life, however, are very rare in monumental painting. The well-preserved cycles in Dečani and Peć belong to the most comprehensive and the most beautiful in all of Byzantine art.

PLATE 22 The southern wall of the western part of the nave displays four historical portraits. The first is of a spiritual leader in a sakkos (tunic-like vestment) with a broad golden hem, decorated with tendrils bearing the images of the saints, wearing on his head headgear of an unusual shape resembling an emperor's crown. The king and his young son are beside him – the visitor can read the names of Dušan and Uroš – they are in ankle-length attire strewn with golden ornaments, unusual for the tradition of rulers' dress in Serbia and the Byzantine Empire. They wear open crowns on their heads and hold crosses. The ruler is wearing a long loros (band of cloth) arranged in an X over his upper body, with peribrachions and epimanikia (cuffs) on his arms. The faces on all three figures have been erased, perhaps because they were painted on a dried surface on which the pigment could not survive as it did on the other surfaces. We surmise that the masters were not familiar with the appearance of the men to be portrayed; while waiting for the men to come

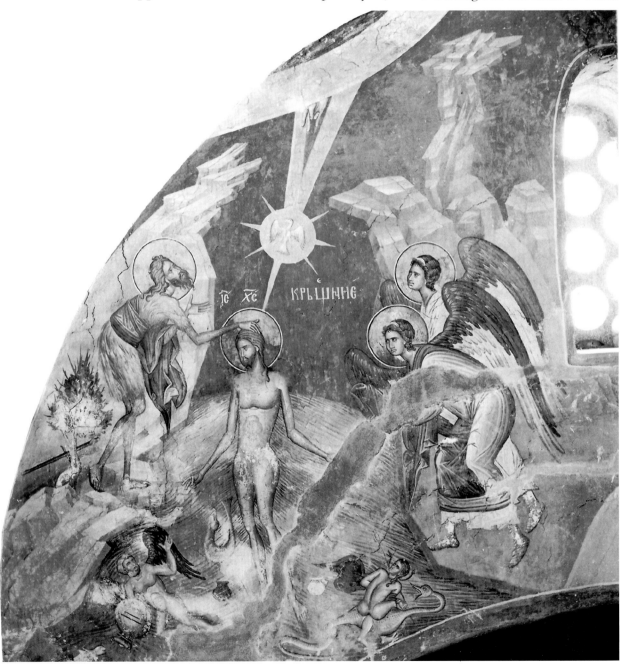

and pose in person they delayed finishing the fresco, preferring to portray them as precisely as possible. For this reason only the figure of St. Sava with an inscription on the western side of the wall is in good condition. The artists knew his figure well and were able to paint it immediately in its entirety. There is no doubt that the first in the row was Archbishop Joanikije II. This is proved by the text of the prayer inscribed below the Virgin in a niche of the walled window on the western wall, quoted from his namesake St. Ioannikios: + *O the most holy Mother of God, do receive the prayer of your slave Archbishop Joanikije.* The frescoes, apparently, had come into being prior to his elevation to the rank of patriarch. The large figure of young king Uroš, born in 1337, helps to date the fresco: it can be assumed with a high degree of probability that the last building in Peć was painted in 1345. In the smallest in the complex, the church of St. Nicholas, only the fragments of paintings have been preserved which do not allow any judgment of their character and the date of their origin.

Compared with scenes in the Virgin Hodegetria which were painted, in colorful landscape, by anonymous artists of unequal skill, the frescoes of St. Demetrios stylistically represent a much more homogeneous entity. One of the painters, most likely the leading among them, left in the altar apse *PLATE 12* – in accordance with the notion that a master is nothing more than a mediator between Providence and a work of art – a humble note of his work: *Θεοῦ δῶρον ἐκ χειρὸς Ἰωάννου (Divine gift from the hand of John).* The Apostles' Communion, the painting on which the painter – no doubt a Greek – left his name, makes it possible to identify his "handwriting" and recognize it on other representations. It is therefore obvious that when dividing the surfaces prepared for painting, master Jovan gave the left side of the composition to his associate. He himself executed

Opposite page:
80. St. Demetrios, Baptism of Christ, fresco.

81. St. Demetrios, Luke the Evangelist, fresco.

213

PLATE 16

most of the frescoes on the southern wall and some of them on the northern side, and the scenes of the church councils on the groin-vault of the western bay. Differences in the manner of work are noticeable in the specific drawing and composition, in the sculptural qualities and relations of the colors used. Master Jovan, strongly modulating in bright and dark tones, created robust, male figures with elongated heads and bodies which can easily be distinguished from the other, more finely proportioned, even gracious, figures in the lowest zone. Neither of them, however, made an effort to interpret the space in a more complex and vivid way: the scene always has two grounds – all participants are in the foreground, and the painted architecture and landscape in the other. Without diagonal elements which would define its depth and create a complex sense of space, the action proceeds steadily under master Jovan's brush with an emphasized tranquillity created by a vertical order of figures, high rocks and painted scenery. Contrary to this, the landscape is covered with various plants the exuberance of which gives serenity to the representations.

The comparison of the representations on the northern wall with contemporary frescoes in Dečani leaves little doubt that the painters of this great shrine, near Peć, took part in the decoration of St. Demetrios. It may well be that Archbishop Joanikije, perhaps anticipating changes in political and church organization, undertook to complete the interior of the churches, by which his throne stood, for new divine services.

Restoration of the Holy Apostles

Of more modest architecture than the great shrines of Banjska and Dečani in which secular rulers were buried, the churches of the heads of church in Peć repeatedly raised buildings, adapted and modified them but did not provide conditions for the lasting survival of their frescoes. Each

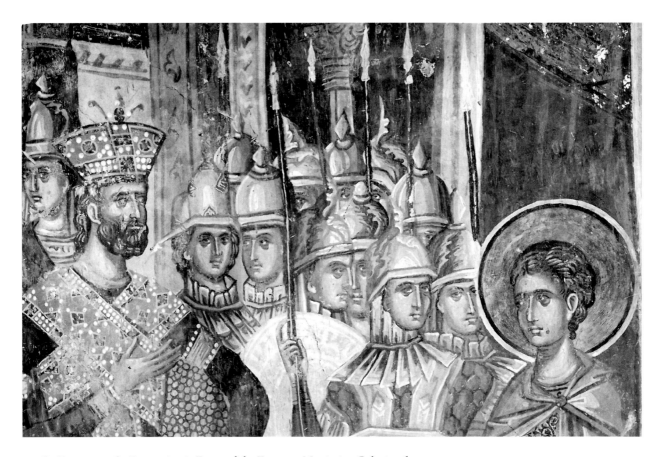

82. St. Demetrios, St. Demetrios in Front of the Emperor Maximian Galerius, fresco.

reconstruction, settling of the site or roof damage left traces on the wall paintings; repairs of its individual parts were inevitable.

The presence of many painters in nearby Dečani during the entire decade provided an opportunity to replace or add frescoes to the nave of the Holy Apostles, on the pilasters and the arch between them by which the vault was divided into two zones. These works, most likely, were inspired by the elevation of the Serbian Church to the rank of Patriarchate, and carried out in the early spring of 1346. At that time, one of the fresco masters of the Dečani narthex painted the prophets on the inner side of the arch, below Christ in the apex who is blessing, and the holy martyrs and hermits on its frontal surfaces. The figures of Christ the Saviour on the southern and the Virgin with Child on the northern pilaster are invested with a special meaning: here the Mother of God – in a conversation written down on a scroll – addresses the Son in a prayer for the salvation of mankind. Both representations, hence, remind of the funerary character of the space in which the sarcophagi of archbishops Arsenije and Sava II were resting. Joanikije's direct care of this wall painting, as in Saint Demetrios, is indicated by the figure of his namesake and protector, St. Ioannikios, who is painted next to Christ. The Archbishop had a special reason for that: he was also buried here in 1345 in the southwestern corner of the nave, and the funeral service over his body, in the presence of a great number of clergymen and laymen, is represented in the fresco on the arched surface above his sarcophagus.

Somewhat later, probably in connection with the rearrangement of the Great Church, new frescoes were painted in the choirs. Judging by all facts, these walls must have been damaged by humidity before the two other churches were built on either side, when the vaults over them were raised to a greater height. Higher up, previous scenes of the Great Feasts, probably dating to the 13th century, were replaced by more recent ones, while below them hermits were portrayed on the northern side, and warriors on the southern. In the right-hand choir there is an elevated spot fenced with red stone where stood the throne of the head of the Serbian Church. Christ the Righteous Judge is portrayed above the throne, and next to him, as in many cathedral churches, is the figure of St. Peter, because he represented the heritage of pastoral duty, a reminder of the apostolic mission of bishops. In front of the throne before the eyes of the archbishops sitting on it and in accordance with local tradition stands the figure of St. Sava, their predecessor. For this reason there is a customary expression in ancient sources: Serbian archbishops "hold St. Sava's throne." In a rich ambience whose wall decoration was then restored, the slender figures, dried in some spots, figures of vivid coloring and desliberate modulation, departed from the earlier, sculpturally richer, painting, announcing the style of the Morava school shrines.

The Narthex

St. Sava's portrait above the stone throne in the narthex by the entrance to the Holy Apostles represents an isolated example of such articulation which has survived in these surroundings. The founder of the Serbian church is invested here with the title of patriarch, belying historical fact. That title here, however, expresses in an unusual way an event of special importance in the ecclesiastical and political life of the country. The coronation of Stefan Dušan as emperor and the elevation of Archbishop Joanikije to the rank of patriarch (1346) provoked the protest of the Byzantine court and the Constantinople church, and subsequently the pronouncement of an anathema in St. Sophia's Cathedral. The profound conviction and separation from the Orthodox comunity placed a burden on the conscience of the Serbian clergy and the entire society and they strove to have the anathema lifted. The first agreement on reconciliation was achieved with the same Constantinople patriarch who uttered the anathema, but it never materialized because a bout of plague killed him, and with him part of his escort in the court of Despot Jovan Uglješa

in Serres. About ten years later through the efforts of Prince Lazar an agreement was reached and the anathema lifted, probably with the stipulation that Serbian ecclesiastical leaders could keep the title of patriarch within the borders of their country, while the Ecumenical church continued to address them as archbishops. The portrait of St. Sava with the unusual rank of patriarch above the throne of the head of the Serbian church was painted after the Councils held in Peć in 1374 and 1375, and, undoubtedly, right in the large narthex of the great church. Archbishop Danilo, having in mind the space required by Ecclesiastical Councils, arranged its interior by installing stone seats along the walls, the same kind of which could be seen in the interior of the buildings accommodated to the needs of various spiritual congregations all around the Byzantine world.

The relatively fragile construction of the narthex did not stand the test of time, and there were no conditions for its maintenance. In the course of the first century of Turkish rule, which permanently spread over Metohija in 1455, the monastery was no more the see of the spiritual heads, nor did it own its former large estates. The village of Peć, which owing to the proximity of the Patriarchate had developed into a settlement with a market-place, became a Turkish town. The fraternity of the monastery – it is seen from the registers of the new authorities – at times numbered only few monks, the life in it was dying out, and the buildings falling into ruin.

The decline and suffering of the large spiritual centre was halted by the restoration of the Patriarchate of Peć in 1557. The need to control more easily the life of the Orthodox populace in the Empire, which by the middle of the 16th century had been considerably expanded by the conquest of vast areas to the north of the Danube and the Sava, induced the Sublime Porte (Turkish Government) to separate Serbian bishoprics from the existing administrative division and to return autonomy to them within the borders of the Serbian church in the second half of the 14th century. Such a decision was influenced by the fact that during these decades a number of highest dignitaries close to Süleyman the Magnificent were of Serbian origin. They reached the sultan's court by the selection from the ranks of gifted boys who were brought to Constantinople within the so called "tribute in blood."

Of the colourful façades of Danilo's narthex, only the southern one was preserved in its entirety

83. Holy Apostles, marble socle, painted ornament, mid-14th century.

– on the occasion of restoration, around 1560 – and, apart from it, a part of the western front. It is obvious that the whole edifice was badly damaged, so that all the groin vaults on the ground-floor had to be rebuilt, and on that occasion they became barrel-vaults. The upper floor with the catechumenon and the bell tower was not restored at all. The space which spread before the believers was not shrunk by that. However, the general impression changed, because the interior was not open any more. It is assumed that at that time it was difficult to bring skillful stone-masons and builders who would repeat the light shapes of the pillars and arches, but the main reason must have been the fact that the space of such a shape, in the conditions in which the idea of an open narthex had been achieved, was not suitable for the long prayers of the monks who, from autumn to the spring, were exposed to the cold and humid air blowing along the canyon of the Bistrica river toward the Metohian plain. Because of that the apertures between the piers and pillars – reclining and unsafe – were closed by thick screening walls, while the northern part of the edifice underwent considerable reconstruction.

Simultaneously with the restoration of the ruined and dilapidated edifices inhabited by the dignitaries and officials of the restored church center, the interior of the churches was rearranged, especially of the narthexes. At the beginning of September 1565, as seen from the inscription above the northern door, fresco-painting, entrusted to a group of local artists, was completed. They gathered around the new spiritual administration and in the course of the ensuing years re-paired and added decorations in several big monasteries, among which – as already mentioned – was Gračanica, whose outer narthex had also been rebuilt and closed.

84

In the Peć narthex the artists mostly repeated wall painting scenes from the time of Arch-bishop Danilo. But they also expanded on these, taking advantage of the possibility of painting the walls closing the interior. The largest parts of the upper surfaces, primarily the vaults, were covered with scenes of the *Menology* in the eastern bays and the scenes of the Christ's Miracles and Parables in the western, disposed in the order in which the Gospel was read on Sundays before and after Easter. There were special reasons for repeating as many as eight scenes of the Ecumenical Councils here: by returning church administration to Peć, the narthex regained its role in the hall where the prelates of the Serbian church convened and made their decisions. In this space, the fresco of the Council of St. Symeon Nemanja and the twelve apostles who appear on the piers in the middle, to whom the church in before them was dedicated were invested with the same meaning: the figures of Christ's disciples were reminders of the missionary role of the bishops entrusted with the care of the body of believers. The councils, as at the time of inde-pendence, were presided over by Patriarch Makarije, the first head of the restored Church (1557), without doubt sitting on a throne with the figure of St. Sava behind him. On the same wall he is surrounded by the twelve spiritual heads of Serbia – the archbishops on the southern, and the patriarchs on the northern, side. Among them, on the pilaster, stands the figure of Makarije as the donor holding a model of the restored narthex, different in appearance from the one held by Danilo II.

PLATE 20

PLATE 8

The figures of the celebrated Balkan anchorites, as well as of the saints meritorious for the expansion and preservation of the Christian faith, are associated with the row of the highest church dignitaries. The last among them, young gold-smith Georgije from Kratovo who refused to accept Islam, was burnt at the stake by the Turkish authorities in 1515. The emphasis on the local spiritual tradition was aimed at proving the right of the Serbs to their autocephalous church and fostering self-reliance: under foreign and infidel lords in a land bereft of its own bearers of political power, the Church assumed the responsibility of caring for and preserving the national character of the Serbian people.

The master painters of the Peć narthex were artistically mature at the time of its painting, probably educated in local workshops. They revived the tradition of painting and outstanding examples of their work are icons from Gračanica dating from the second quarter of the 16th

century. It is obvious that they were inspired by the "classical" works from the middle of the 14th century, especially by the wall decoration in Dečani, although the new frescoes of the Peć narthex were of drier and more rigid forms, without the imaginative elements of the painted interior and the richness of color. On the shield of St. Demetrios, still today, is the signature of "the most sinful Andreja, the painter." The most prominent painter who worked on these frescoes, however, is one whose hand suggests the young Longin. This educated, versatile and gifted artist who in many monasteries left not only frescoes but also icons, engaged in literature and on some occasions – as with the large icon of Stefan Dečanski in his endowment – wrote verses beside the scenes which illustrated his life. At the same time, the icons were equipped with excellent wood-carving whose masters, most probably, had a workshop right at the Patriarchate. Several works of that kind, though unsigned, can be attributed to Longin and anonymous masters who continued to nurture their brilliant skills in the decades to follow.

All the frescoes in St. Demetrios do not come down to us from the time of Archbishop Joanikije. During the restoration of the northern Peć Church undertaken in 1619/20 following an earthquake, Patriarch Pajsije entrusted the most famous master of that time, the Hilandar monk Georgije Mitrofanović, with fresco painting. In the course of the previous three years he had worked in Serbia, Montenegro and Bosnia where he acquired significant experience.

Like most artists of that time, Mitrofanović strictly followed the scenes of the earlier wall painting and endeavored to stay as close to it as possible in style and subject matter. He completely replaced several scenes but on a significant number of those which were not entirely destroyed he carefully restored individual parts. Nevertheless, his distinctive use of color and sculptural modelling in the spirit of Cretan painting which dominated Mount Athos shows a difference in comparison with the frescoes of earlier master Jovan and his associates. Ordinary believers primarily interested in "listening to" stories and understanding the messages conveyed

84. Patriarchate of Peć complex, narthex, inside view.

by the compositions probably did not notice. The gaze moved across the walls following the sense of the whole, lingering longer on less familiar scenes and rare details.

In the Holy Apostles, Georgije Mitrofanović finished an unusual posthumous portrait of the Patriarch Jovan II (1592 – 1614) commissioned by his successor Pajsije. With his refined facial features, which the painter could not have known, the dignitary is addressing the Virgin with a prayer beautifully written on a wide scroll, saying that he is offering a "small" gift. Separately, on a dark ground, is Pajsije himself, saying in a restrained manner with few words that the Patriarch's grave was in Constantinople rather than in the church. Behind these words, however, is the dramatic story of the captivity and murder of this Serbian Church leader in the Constantinople jail of Yeni Tower because of negotiations he had conducted with the West, particularly with the Vatican and various Italian courts. In those evil times, fully cognizant of the dangers he was facing but determined in his intention to overthrow Turkish rule, Patriarch Jovan kept dispatching envoys to distinguished figures whom the Serbian people would recognize as ruler and crown in one of ancient centers, proposing them as liberators of his country. His sufferings, nevertheless, did not put a halt to spiritual life or artistic creativity at the Patriarchate of Peć. In its very center the new leader Pajsije, in the course of his long and more cautious rule, restored parts of the early paintings in the "mother of all Serbian churches," and enriched the treasuries and libraries of many monasteries with works of art and manuscripts.

PLATE 21

The Holy Archangels near Prizren

In Prizren where he had frequently resided King Dušan set about founding the large monastery of the Holy Archangels in the spring of 1343, three kilometers south of the town. Preparations were extensive and elaborate. The already mentioned charter, issued at that time to elder Gregory from Hilandar, reveals that he left his church with the houses and estate in Koriša to Brother Jakov, *hegoumenos* of the brothers of the Holy Archangels, to conduct businesses from there and supervise the vast construction site.

The very place on which the monastery was being erected – on the left bank of the Bistrica, on an expansive plateau formed in the gorge by the river's fast course – had previously been the site of a church dedicated to archangels Michael and Gabriel. It was shielded by an old fortress towering above it, standing on one of the lowest slopes of Mt Šara. From there, the small town with towers, a simple church of St. Nicholas and the walls descending towards the river, overlooked and safeguarded the road leading to Prizren, and it is for this reason that it was called

87 Gornji Grad (i.e. the Upper Town), Višegrad and Prizrenac.

Several years later, when the construction of the monastery of the Holy Archangels was well

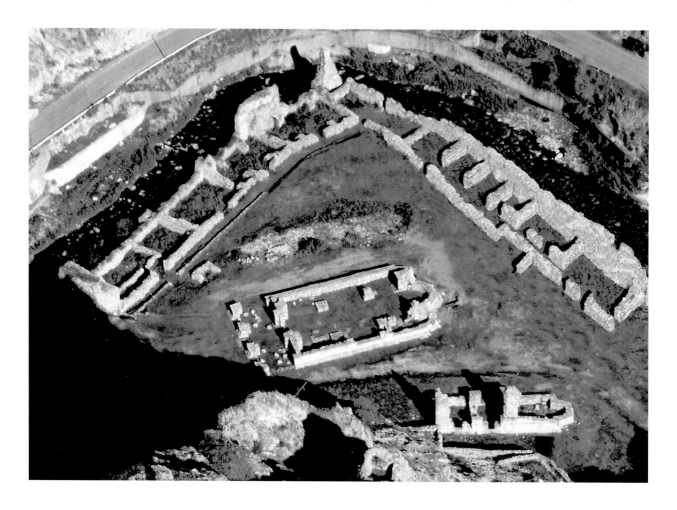

underway, a huge estate composed of 93 villages was formed, including, apart from houses, mills and other properties, summer pastures and artisans skilled in crafts of all kinds including goldsmiths. The majority of the monastery holdings spread over the region of Prizren, but a considerable number of them were situated in a broader area, in the environs of Skoplje and Tetovo, in Albania, and on the coast around Scutary. The extensive founding charter, probably issued in 1348, did not only state a list of assets, but also ascertained the position of the monastery in the social life of the country, its inner organization, and rights having a lot in common with the privileges and obligations of other monastic communities, especially those whose churches served as the burial-places of members of ruling houses. The monastery of the Holy Archangels, for instance, was placed under the jurisdiction of neither the Bishop nor the Archbishop, but of the Emperor himself.

During Turkish rule the Holy Archangels, like other monasteries, lost large estates and strugg-

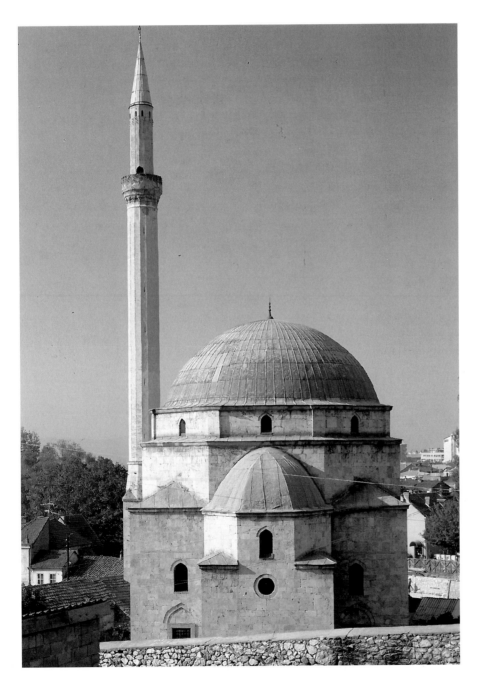

86. Prizren, Sinan Pasha mosque.

Opposite page:
85. Holy Archangels near Prizren, monastery complex.

221

led on the verge of subsistence level. Their misfortune, however, was even greater: at the outset of the 17th century, Sinan Paşa ordered a large mosque in Prizren to be constructed with remarkable dressed stone taken from the churches on the Bistrica. After that, the monastic complex fell completely into ruin, and, in the course of time, became largely covered with earth deposited from the hill-side.

After all the devastation it had suffered, only the endowments of the monumental monastic complex have survived, triangular in base with outer ramparts running along the course of the river. Their appearance has been uncovered in excavations, and the picture of the former character of the parts rising above the earth is supplemented by data revealed today by Sinan Paşa's mosque with its dressed stone, numerous architectural elements of exquisite profiles and rich sculptural ornaments. A careful analysis of all finds gives a complex picture of different ideas and stylistic influences intertwined in a specific manner in the ruler's mausoleum.

The main church, dedicated to the "strategists" and "leaders of the heavenly powers," Michael and Gabriel, was – as evidenced by the ground plan – one of the grandest monuments of Serbian architecture, a display of the sovereign's power in the epoch of the full ascendance of the medieval state. At the same time and in the same fashion, a smaller church of St. Nicholas was erected next to it. With its position and choice of patron it corresponded to the tradition of alloting special space on the southern side – either in the edifice itself (as in the Virgin Ljeviška and Dečani) or in the form of an added chapel (as in Peć) – to St. Nicholas, a much revered archpriest and patron whose cult was venerated in wide circles of society.

The investigation of the foundations of the large church has confirmed the statement from the endowment charter that the same site had previously been occupied by a shrine to archangels Michael and Gabriel, demolished before the construction of the new one commenced. In terms of architecture, parts of the old structure have shown that the new church did not stand directly upon it. Researchers have made an effort to discover any special reasons which may have led Dušan to dedicate his great foundation to the leaders of the heavenly phalanxes. Like several great Byzantine sovereigns, the mighty ruler, who only a few months later was to seize a number of important Byzantine towns and add to his title Greek lands as well Serbian, saw the *architstrategos* Michael as his patron. Besides this, in sepulcher churches the Archangel Michael was held in high regard because of the special role assigned to him to weigh souls on the Second Coming of Christ. On the other hand, it is known from sources that the ruler's health had been seriously undermined before that time. In 1340, news about the uncertain outcome of his illness reached Venice, and Dušan's words in the introductory section of the gift charter in which he thanks the Lord appear to have referred to it ("you raised me fallen and restored me dead to life"). He also expressed his gratitude to the Archangel Michael, in whose old place of worship on the bank of the Bistrica he sought remedy ("you showed me the church of yours as the source of health").

A specific connection between Dušan's main church and the Constantinople shrines he was familiar with and where he spent his youth has recently come to the notice of scholars. It has already been noted that his father, Stefan Dečanski spent several years with his family after an abortive uprising in the monastery of Christ Pantocrator, famous for its hospital where he probably healed his blindness, and that he therefore dedicated his endowment in Dečani to this cult. The middle church at the monastery of Christ Pantocrator venerated the Holy Archangels under whose patronage, in the interior, were the tombs of Byzantine rulers from the dynasties of the Comnenus and the Palaeologus. The form and volume of the church on the south side coincide with the shrine erected by Stefan Dušan for his eternal rest.

The elevated model that the Emperor harbored in memories of the Byzantine capital was of the renowned, classic cross-in-square type. A large dome resting on tall piers built of stone blocks 160 cm wide topped the central portion of the naos. The numerous remains of its cross-sections – a large number of which have been incorporated into the Prizren mosque – indicate that the drum may have had twelve or even sixteen sides. The windows piercing the drum, perhaps double,

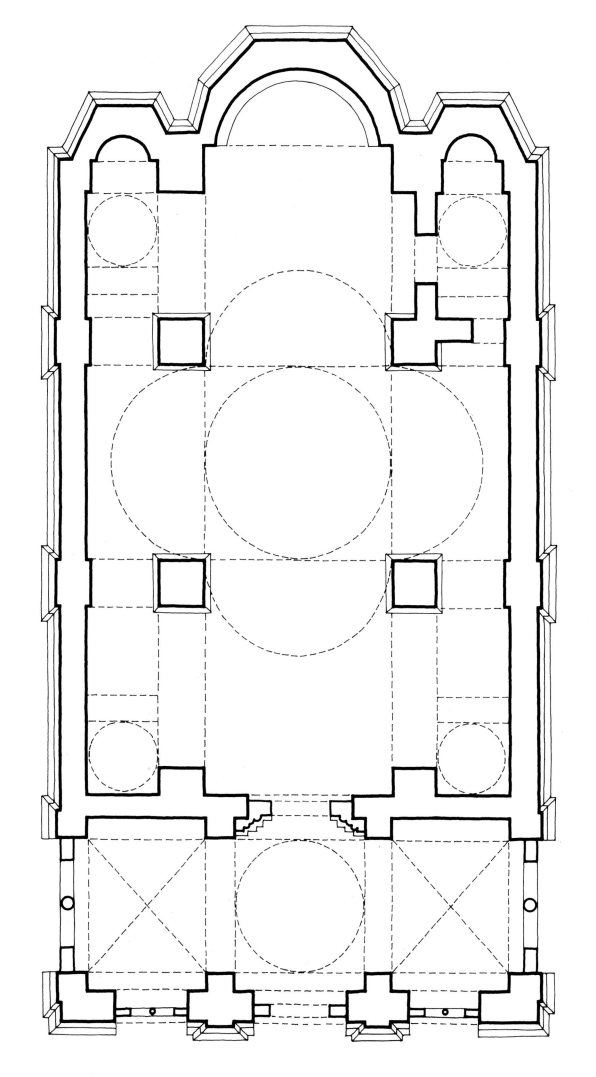

87. Holy Archangels near Prizren, main church (katholikon), plan.

measuring almost one metre in width, afforded sufficient light to the spacious and clearly articulated interior. The dome, however, after the Constantinopolitan practice which had left but a few traces in Serbia, was of a melon shape. Nevertheless, it is not possible to determine with more precision the height at which it stood, even when the logical proportions of the structure are taken into consideration; in all likelihood, it was not lower than the Dečani dome, always referred to as "lofty" (*Visoki*) in epic poetry.

The upper section of the church, although simply structured, was not only reduced to a high subdomical area and barrel-vaulted cross-arms. Numerous fragments of carved stone with characteristic profiles suggest that, as in the Virgin Ljeviška and Gračanica, the lower areas, i.e. corners, were crowned with octagonal domes. Finally, one dome, in all probability blind, rose above the central of the three bays forming an open narthex. Between the pillars on the west side, as well as in the north and south, were two-light mullioned windows with parapets in the lower portions, protecting the translucent interior of the narthex on windy and rainy days.

The character of the space and its construction scheme were readily distinguishable on the face of the building in a manner characteristic of Byzantine architecture. In the interior, behind the rhythmically arranged lesenes (pilaster strips), were shallow pilasters supporting the construction, or the walls themselves. The arches on the gables presumably marked the construction of vaults spanning the arms of the cross.

88, 89 The base of the entire building was reinforced with a tall slanting socle. It prevented water from penetrating the foundations, thus protecting the interior from moisture which especially threatened the murals. The roofs also safeguarded the frescoes with lead tiles whose forms outlined all elements of the upper construction, primarily the vaults, usually the first to suffer damage. Stefan Dušan's prohibition, to which the lessee of the mine in Trepča refers in March 1349, that lead was not be sold to anyone before the needs of the monastery of the Holy Archangels were met is, therefore, not surprising. At the time when this decision of the Emperor was in force, construction work was drawing to an end; it lasted, however, for another two or three years at least.

Like other endowments which rulers erected with the intention of being buried in them, the Holy Archangels echoed stone facing and ornamentation in the spirit of western art, a feature characterizing a church built in Studenica by the Emperor's grandparent Stefan Nemanja. The construction of Dušan's mausoleum was also entrusted to masons from coastal towns, chiefly from

88-89. Holy Archangels near Prizren, remnants.

PRIZREN

KOTOR

90. Capitals that belonged to Holy Archangels Monastery reused for building the Sinan Paşa mosque in Prizren.

91. Examples of capitals, preserved at the Museum of Stone Ornaments (Kotorski Lapidarium) at Kotor, Yugoslavia, similar to those of Holy Archangels.

92. *Holy Archangels, main church (katholikon), two-light mullioned window.*

Opposite page:
93. *Holy Archangels, pavement ornaments, mosaic fragments.*

Kotor, some of whom had probably been engaged on the erection of Dečani as well. However, the façades here did not entirely echo the exterior of that monastery. Characteristic Romanesque blind arcades from the 12th century commonly running along the horizontal and sloping terminations of the walls below the roof are not part of this shrine. In all likelihood they were replaced in the subdomical area by cornices containing densely carved slender, stooping stalks whose fragments have been found in fair numbers in the ruins. A novelty worthy of attention were horizontal, simple projecting cornices whose character and position can be determined with more certainty on the basis of the appearance of the church of St. Nicholas. They heralded the subsequent regular occurrence of cordon bands horizontally dividing the façades of churches within the decorative system of the Morava school. On the other hand, western sculptural practice introduced rose windows with radial mullions, tripled arches between them, framed with sculptural decoration. The profiles of their fragments suggest that there were two different rose windows, probably adorning the main fronts of the Holy Archangels and St. Nicholas, as was the case with churches on the Adriatic coast. It is interesting that twenty years later, although carved in a different manner, they became a common feature in stone decoration on the façades of a new stylistic trend in Serbian architecture.

Other elements of architectural ornamentation were executed, as in churches of an earlier date in a restrained manner characterizing Romanesque-Gothic style: some two-light windows, spanned by a round arch, displayed slim mullions with pointed or trefoil arches, and, occasionally, quatrefoil openings in tympanums. The portal, the appearance of which is difficult to reconstruct on the basis of surviving fragments, was executed in mulitcoloured stone and broadly developed with projecting door-posts and archivolts enriched by relief carving, flanked by lions which may have supported free-standing colonettes. The repertoire of ormanents framing the apertures was

94. Emperor Dušan's headless statue, once by the portal of the main church.

228

also characteristic of the long transitional period from the Romanesque epoch to Gothic. Apart from tiers of stylized acanthus, mazes of tendrils with foliage and flowers, bands with vegetative ornaments in shallow relief carving already announcing the approach of Morava sculpted decoration, etc., the windows were frequently surrounded with billet mullions, typical of Gothic in Dalmatian and Italian towns, particularly fourteenth-century Venice.

The disposition of the windows with corresponding ornamentation cannot be easily recon-structed, because, among other things, the site where these fragments were unearthed is still not known. On the other hand, the method of construction and features of carved decoration indicate that the same master masons engaged on the building of the Holy Archangels erected the church of St. Nicholas and produced all of its stone ornaments. The availabe data render it impossible to provide separate descriptions of sculpted ornamentation adorning the two churches. Neither would they contribute to a better understanding of their character, the more so since towns in the coastal region – Ulcinj and Bar, especially Kotor, and, further to the north, Dubrovnik – treasure specimens attesting to a very specific style and manner of work, previously characterizing the sculptural decoration of Dečani in many aspects. In those terms, the capitals preserved in Sinan 90-92 Paşa's mosque, on columns supporting the *machvil* – a balcony found in Islamic religious build-ings placed next to the entrance – are highly interesting. The identical puffy buds with full, bent leaves are encountered in the capitals of Dečani and in the Kotor Museum of Stone Ornaments, as well as in the Franciscan cloister in Dubrovnik whose vaults and translucent six-light windows with paired mullions and capitals were being carved during those same years by master Miho Brajkov from Bar. The funerary inscription engraved in 1348 when construction of the Holy Archangels was in progress informs us that this master mason was taken by the "black death," at that time raging throughout Europe.

The abovementioned capitals from the mosque are supposed to have belonged to the structure rising above the ruler's tomb in the south-west portion of the naos. Their reverse sides were not ornamented which suggests that they may have leaned against the wall corresponding to the

95-96. Holy Archangels near Prizren, pavement ornaments, mosaic fragments.

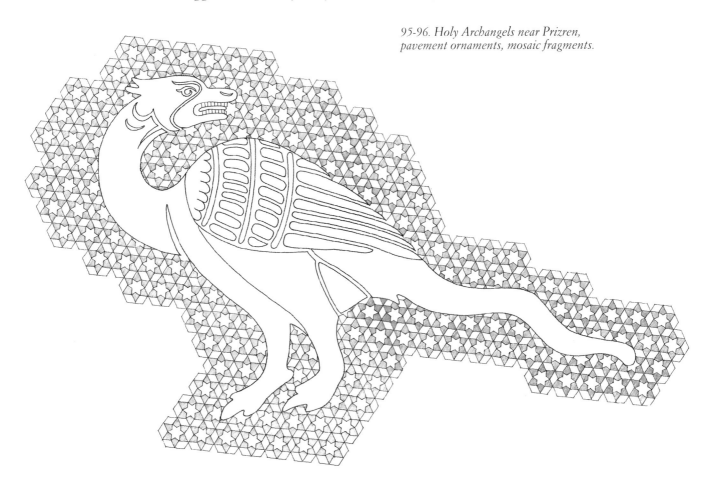

consoles and bases of the columns beneath them. It is difficult, however, to conjure up the appearance of the entire entity to which they belonged.

The Emperor's sarcophagus was built up and faced with slabs while his life-size reclining figure (*gisant*) was posed on the upper stone lid. Regrettably, particulars about his appearance are not known for not all uncovered fragments have survived to the present day. The representation, however, was interesting because it was the first time in medieval Serbian art that a ruler was depicted – after funerary portraits in the West – in high relief.

Several other segments of full sculpture served as the basis for a less probable supposition that the ruler's statue occupied the west section of the same space. His effigy, however, was certainly carved in the narthex, within the large composition in the lunette of the main portal. The Virgin seated on a throne with Christ in her lap, guarded by the Archangels Michael and Gabriel, was flanked by the praying figures of the Emperor Dušan and his son Uroš with their arms outstretched. The ruler's head has not been preserved while most of his figure, with the bent knees, in 94 two-dimensional modulation typical of Romanesque sculptural decoration, has survived. Dušan is clad in the imperial *divetesion* with the *loros* arranged in an X over the chest, one section falling straight down the front, and one of the ends draped over the right arm on which a *peribrachion* and a bracelet are clearly discerned, as well as the embroidered motifs (*appliquées*) on the elbow and the thigh. The front locks of the ruler's hair falling over the *maniakis* (collar), appearing on his painted representations as well, impart the full portrait quality to this effigy. Of small dimensions and of a reduced form, Dušan's portrait in white marble did not include only some details like a string of pearls regularly adorning the imperial robes. Only small fragments of the wings have been found of the figures of the heavenly "strategists" whom father and son addressed expecting mercy; of Uroš's effigy, on the opposite side, the bust with upper part of the right arm has survived.

Depictions of praying Byzantine emperors addressing the Archangels were known from monumental sculptures and coins, while the images of founders from high secular and spiritual circles "above the threshold" were encountered in sculpted decoration and frescoes. It has been noticed, however, that in iconographic terms, the reliefs of the Emperor Dušan and his son in the Holy Archangels were most similar to portraits of King Dušan and his father Stefan above the portal in the narthex of Dečani, painted three or four years earlier, bearing, understandably, a different message and meaning.

Visitors were most dazzled by the opulence of the stone pavement in the interior; it remained strongly impressed on the memory of those recollecting it from times before demolition. Praising the beauty of the church, the writer of the geneology of the "Serbian emperors" from the outset of the 16th century stated that he did not know whether any other such church existed "under the sun," and added, making mention of works elsewhere, that such a floor was nowhere to be found. Large tiles were embellished with massive figures of beasts and geometrical designs of broad bands on a mosaic ground. The general disposition of ornaments was determined by the space 93, 95-96 structure so that the surfaces of the related sections, the naos and the subdomical area in particular, comprised separate decorative units that render it possible to conjure up with more certainty the relationship between individual elements and their rhythm. Thus, it has been noted that triangular fields bore two figures of lions, birds with the tails of snakes, winged animals and dragons, always confronting each other, and that the space between the pillars supporting the dome was paved with alternate rectangular and square slabs. The representations of beasts, occasionally inlaid into smaller fields within tranquil and firm ornaments, were impressed on the smooth surface with delicate cuts not only defining the contours but also supplementing the shapes of bodies, outlining feathers and marking the eyes. After that, the cut-in, hollowed back-

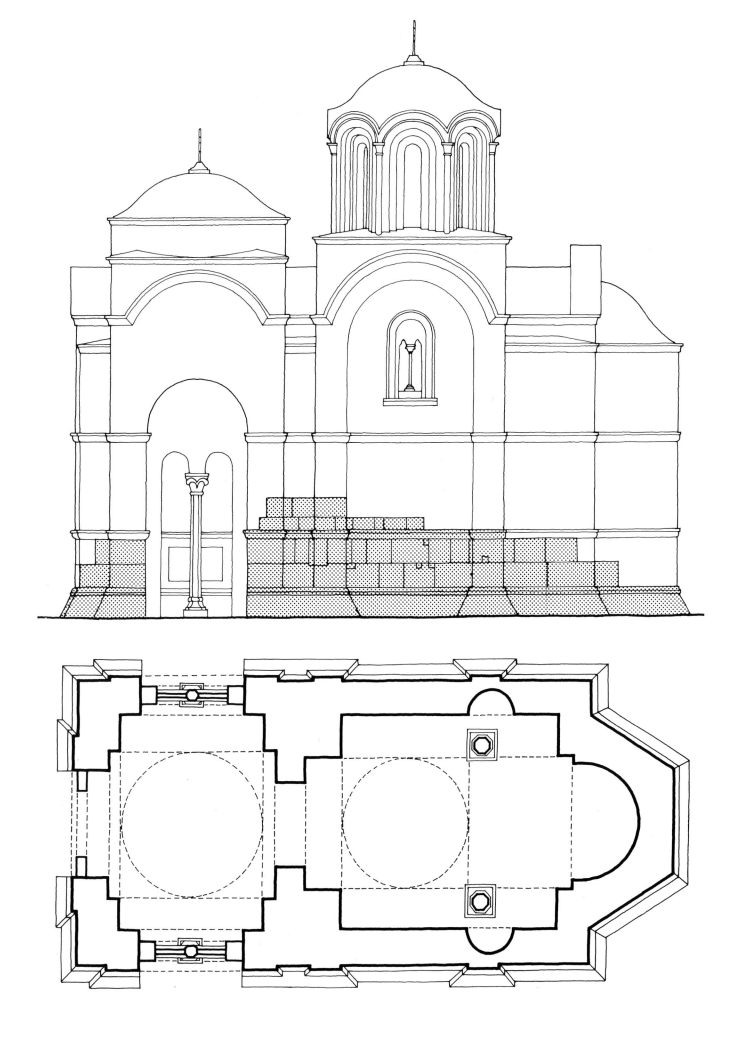

ground surrounding them was filled with rose-colored mortar (obtained by adding ground brick powder), and into it were laid differently cut cubes of multicolored stones. The slabs were predominantly of light-colored slate, but also of one type of breccia of a magenta color, quite similar to that utilized in the construction of Dečani. Thus, the whole attracted attention not only with its nobility of form for which the master had found excellent prototypes, but also with its pictorial richness.

Although not to be found in earlier Serbian shrines, this kind of stone pavement was familiar both to the commissioner and to the ecclesiastical dignitaries with whom he conferred. Such a decorative scheme and fine execution technique were in the tradition of Constantinople workshops which produced several artworks, as the floor of the church of Christ Pantocrator that served as prototype for the Prizren church. On the other hand, the floors in the katholika of the great lavras on Mt Athos – St. Athanasios, Vatopedi, Iviron, Xenophontos and Hilandar itself – were very similar. Numerous exquisite examples of the superb artistry of the sculptural and mosaic craft have survived in Italy where artists not only paved floors in such a fashion, but also walls, stairs, ambos and pulpits (the Palatina Chapel in Palermo, cathedrals in Ravello and Amalfi, St. Peter in Sessa Aurunca near Naples, etc.).

The church of St. Nicholas, built in the same manner but with more modest stone paving, is in a better state of preservation, thus enabling us to reconstruct its general appearance with more certainty. A simple naos is separated from the bema by two tall columns which, with corner pilasters, support powerful arches and the dome above them. The narthex with openings and leaning arches was also vaulted with a calotte, somewhat broader but certainly blind. Finally, the apertures on the north and south sides – as well as in the narthex of the Holy Archangels – were in all probability divided by columns with arches while its lower portions were covered by tiles in a manner known both in the architecture of Constantinople and Thessalonica, the latter being closer to Serbia. The parekklesion of St. Nicholas represented a remarkable achievement in the architecture of its kind, intended for special services, and of elegant proportions. Superb masonry work was utilized in its construction.

The monks whose number is unknown to us had their cells in the dormitory riased by the ramparts towards the river. According to the typikon, they gathered twice a day in the refectory which distinguished itself by its size and rather rare cruciform plan. Of its walls, only the lower sections have survived, but the dimensions and character of the structure leave no doubt that the spacious central part with a broad apse was roofed by a wooden structure supported on lateral sides – perhaps somewhat lower towards the spaces – by powerful pillars with arches. The style in which the refectory was built, however, was different – it was Byzantine, with blocks of stones, occasionally semi-dressed, interspersed with layers of brick. It is evident that the construction of this edifice, as well as of the dormitory and subsidiary structures, was entrusted to different artists.

Formerly, the refectory left a strong impression with its forms and volume, natural in the magnificent surroundings of other structures, powerful fortifications and the rocky mountain with steep sides between which, in the ravine, flowed the Bistrica river. This appearance of the monastery became deeply entrenched in people's memory and for centuries they concocted legends about it and lit candles on its ruins. Twice a year, on the feast days of the Holy Archangels, in summer and autumn, they gathered from afar at night, and waited for the sunrise praying with priests. One traveller left an exciting descripiton of this ancient shrine in darkness, with the contours outlined solely by the candlelight of the faithful.

Epilogue

In the long course of its existance, Serbian art, in the Kosovo region, reached its peak in the first half of the 14th century. A limited selection of buildings has been made here, most of which date to that period, with the aim of representing the chief stylistic currents and outlining the complexity of ideas on which their sophisticated sculptural decoration and painting rely. These shrines especially exemplify the character of artwork in surroundings exposed to simultaneous influences of Byzantium and the West. In political life, this ancient duality was displayed in the existence of two Serbian lands, Raška and Dioclea (Zeta), which from the second half of the 12th century onwards permanently united their destiny into one state. In art, these dual concepts became clearly manifested as early as the era of the state founder, the Grand *župan* Stefan Nemanja. The churches he raised articulated, on the one hand, characteristic features of Byzantine architectural skill, even of Constantinople masters (in all probability, St. Nicholas in Toplica), while, on the other, of Romanesque style, notable in the articulation of the marble façades and the outstanding sculpted ornamentation on the church of the Virgin in Studenica, a level of artistic achievement which was never to be attained in later years.

During the 13th century, the Raška school of architecture produced churches of monumental dimensions and harmonious proportions, but, in terms of sculptural decoration, the simple features of their outward appearances were modestly executed in the western spirit. Elements of plastic ornamentation hardly appeared on them; the church of the Holy Apostles in Peć – for a long time the only surviving church in Kosovo invested with some importance, did not have them either. Hence, it certainly is no coincidence that no major sculptural works, typical of the towns in Dalmatia, came into existence along the southern Adriatic coast in this period.

The wife of Uroš I, Queen Helen, of French descent provided a powerful inspiration for architecture in the western spirit. When she supervised the building of the monastery of Gradac on the river Ibar around 1270, she engaged master-masons who were the first to make more extensive use of Gothic elements in construction. In the modulation of portals and windows on the main church they incorporated the appropriate sculptural repertoire. At a later time in the coastal region where she ruled after the death of her husband, Queen Helen had an Orthodox church built in the vicinity of Scutary and dedicated to St. Nicholas. She also aided the construction of a much greater number of Catholic places of worship, giving support to members of the order of St. Francis. Early sources reveal that in 1288 she consecrated Franciscan churches in monasteries in Kotor, Bar, Ulcinj and Scutary which echoed the characteristic appearance of religious buildings of the Umbrian-Tuscan type, with a simple, elongated space that could accommodate a large number of believers.

These ambitious ventures of Queen Helen were also aided by her sons. A well-preserved inscription from 1290 states that with kings Dragutin and Milutin she had the church of SS Sergios and Bakchos built near Scutary on the bank of the Bojana; this church was subsequently worn away by the river. With her sons dressed in royal robes and herself clad in monastic attire she is depicted praying to St. Nicholas who blesses her in the famous icon of SS Peter and Paul which she presented to their church in Rome.

Despite the fact that she had assumed the Orthodox monastic habit, the Dowager-Queen lav-

ishly aided monasteries of her earlier religious denomination. Milutin did the same at a later time: an inscription from 1318 relates to his merits, probably in the renewal of the Benedictine church near Scutary. By protecting his Catholic subjects, the king evidently adhered to the practice of religious tolerance cherished in his country.

PLATE 87

Of buildings erected by Catholic, not to speak of Orthodox, inhabitants of mining settlements for their religious needs, examples worthy of attention are the fragments still standing of a church dedicated to the Virgin in Novo Brdo, and of St. Peter's in Stari Trg in Trepča: the former, like Dečani and churches along the coastal region, was built of alternate layers of red and white stone, while the base of the latter church, three-aisled with semi-circular apses on the east side, indicates that its central part was domed as were cathedrals in Kotor and Dubrovnik (before the great earthquake in 1667). Hence, each in its own way – i.e. in terms of construction method, dome design – was associated with Orthodox architecture in Kosovo.

99,100

Revived architectural activity in coastal towns was most certainly connected with their masters' engagement in building projects in Kosovo. Their role was especially conspicuous in the erection of sepulchral churches. It was perceivable, in some details at least, in other structures as well, even those which were typical specimens of the new, Byzantine style. Artists arrived here travelling along the valley of the Drim River, by the road linking Prizren directly with the region of Scutary and further on, by land and by sea, with other towns along the Adriatic coast.

Masters from Byzantine workshops came at invitation from rulers from the northern lands of the Empire, and with local artists they fostered a style which was to become typical for Serbian surroundings, particularly in terms of fresco-painting. Painting belonged to the inviolable sphere of Orthodox art, within which no concessions were made in Serbia. The complete and absolute acceptance of its iconographic expression, connected with growing religious needs, rendered it possible for masters from local workshops, skillful and experienced, to respond to the high requirements posed by the court. Before becoming king, Stefan Dečanski had ruled over Zeta for some time, and there he had become acquainted with the Mediterranean ambience and the spirit of Western art. After that, under the Byzantine Emperor's surveillance, he spent seven years in his capital whose edifices – erected in the course of its thousand-year history – must have impressed him deeply not only by their size and manner of construction, but also by the opulence of their interiors. His intimate knowledge of ancient places of worship and the ruler's court must have also had an impact on Dušan, who, as a boy, sharing the fate of banishment with his father, acquired his education in Constantinople.

It is not simple nowadays to assess the contribution of local artists working either alone in the same spirit, or with masters educated in centers where stylistic expression was constantly changing and representations were gradually becoming an increasingly complex manifestation of theological interpretation.

In medieval Serbia within its narrower borders – preceding Stefan Dušan's conquests – the character of painting displayed fewer differences in comparison to the leading stylistic currents in the Byzantine Empire than was the case in some of its other regions with their own local traditions. The reason for this is simple. Serbian rulers and the high clergy, in constant and close touch with larger cities, especially Thessalonica, invariably summoned from their workshops the best artists who represented the latest trends in art and, moreover, directly participated in its transformation. In this connection, it is but sufficient to examine the ascent of wall-painting in the last decade of King Milutin's rule (+1321): frescoes adorning the walls of all the ruler's endowments dating from this period are the creation of the renowned painters from Thessalonica, Michael Astrapas and Eutychios, or the masters from a very close artistic circle. The uncertainty of experts as to whether the frescoes bearing no surviving signatures should be attributed to these Thessalonian artists, known by names, confirms in the best possible manner the unity of spirit and the recognizable kinship of expression, which from the end of the 13th century could be followed from Mt Athos, through Ohrid, to Peć, Prizren and Gračanica.

Local artists who worked with famous foreign masters left no information about themselves, nor did the specific features of their creations distinguish them even at a later time when their participation was confirmed by signatures. A telling instance of this is the case of two great painters from the end of the 14th and the beginning of the 15th centuries, Metropolitan Jovan and his brother Makarije, famous for their works in Pelagonija, and in Serbia, in the Morava basin. Their creations, not only in terms of value, but also in style, closely resembled those produced by the most significant masters of that epoch, whose similar works are encountered even in faraway Cyprus.

In the epoch of Stefan Dečanski and Dušan, the painting heritage of the first decades of the 14th century was evolved by domestic artists, engaged in the construction of both large and small-sized churches in Serbia. This is best perceived in the painting of the spacious church of Christ Pantocrator in Dečani which took ten years to complete. Several groups of artists gathered there. They readily responded to the challenge posed by the complex and, in terms of volume, the richest subject-matter in the Byzantine world. The value of their work was in no way inferior to that of artists coming from other corners of the Empire. The remains of frescoes in the formerly grand Holy Archangels, only several years younger than Dečani, show the hand of the same or related painters; a similar manner of work has been discerned in other churches as well. Furthermore, direct analogies of the large fresco-sequences could not be found in Byzantium at that time; neither is it possible, as it is in the time of King Milutin, to determine their roots in the centers in which they had been previously noted. Financial wealth and increasing requirements obviously brought about the rise of local workshops. These workshops, like others all over the East-Christian world, were, understandably, always in touch with life in the capital and other towns of the Empire.

In large enterprises, apart from the participation of local artists, a significant role belonged to the leading personalities of the Serbian church, educated and widely cultured. Their involvement in the erection and adornment of monuments is revealed by documents, primarily endowment charters, as well as writings belonging to different literary genres. It was noticeable not only in the making of decisions concerning the appearance of a structure, the choice of artists and iconography, but also in the process of finding the most appropriate articulation for ecclessiastical and political ideas. The multitude of historical compositions and effigies of members of the ruling house, the nobility, high clergy and monks, most frequently in the role of founders, reflects the life and understanding of medieval Serbian society. The inscriptions accompanying them accurately record the historical moment and disclose the ambitions of the sovereign, sometimes of a short duration in a changing political reality. In that, painters, even those who came from other countries, displayed a developed sense of careful attention to the spirit of the artistic environment and the requests of those who commissioned the work. In that aspect, the shrines in Kosovo have

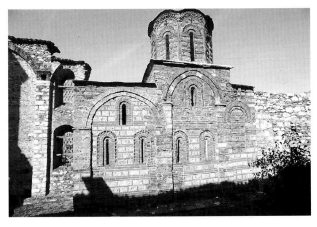

99. Prizren, Church of the Saviour, beginning of the 14th century.

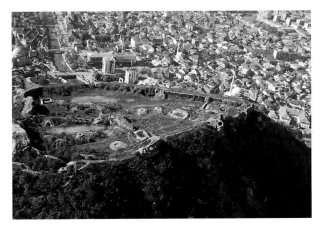

100. Višegrad fortress, remnants.

235

preserved the wealth of their uniqueness. In contrast to representations of saints whose images were entrenched in traditional Orthodox iconography, historical portraits, especially those of men, portrayed the person's original facial features in the majority of cases, meticulously registering the character of their clothes and attributes of their social status. St. Symeon and St. Sava, the founders of the autonomous state and church, were regular features on frescoes, as were expressions of complex state and legal ideas, the emphasis always being placed on the divine origin of rule.

The representations of founders took a special place in churches which they raised for their eternal rest. In Kosovo, however, such images have survived only in Dečani, in a number not registered elsewhere: the first ktetor, Stefan Dečanski, got four, and the second, Dušan, even five portraits, each in a different iconographic version, invested with a special message. The lost depictions of King Milutin in Banjska, and of Dušan in the Holy Archangels, were undoubtedly particular paraphrases of the same ideas. The latter, as it has been shown, had two – in Serbian art unique – ruling portraits carved in stone, above the entrance to the church and over the tomb itself.

Serbian kings of the first half of the 14th century entrusted the design and construction of their large shrines, the carving of stonework and the painting of frescoes in spacious interiors, to masters from provincial workshops, as well as to those from the coastal regions and Byzantine towns, depending on the character of the work and available artistic support. In the free selection of artistic forms, open to western concepts for the outer appearance of churches, they satisfied the requirements of the Orthodox rite in the disposition and function of spatial elements, preserving with consistency the appropriate character of wall-paintings and icons. The faithful in the Middle Ages admired such churches, but did not marvel at them: they were the expression of a specific and exciting – only for the present-day observer unexpected – synthesis that was the natural outcome of cultural circumstances and vital artistic practice. This vitality was felt in the works of the masters from other branches of art. Take, for instance, the handiwork of goldsmiths who fashioned "holy vessels" for the needs of the East-Christian cult, while decorating them with ornaments from the repertoire of western art, just as masters in that same period carve Byzantine and Romanesque (or Gothic) embellishments on the portals and windows of the churches before them.

A considerable number of feudal and town churches were erected in a more modest spirit within simpler forms. Only the rudimentary facts about them have been outlined in the appendix. Neither does this list offer a balanced testimony to their number and disposition. Those churches

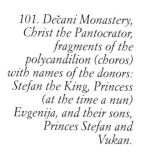

101. Dečani Monastery, Christ the Pantocrator, fragments of the polycandilion (choros) with names of the donors: Stefan the King, Princess (at the time a nun) Evgenija, and their sons, Princes Stefan and Vukan.

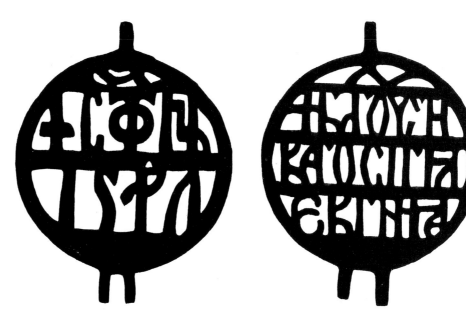

in towns whose remains have been insufficiently investigated, to a large extent have yet to be analyized. One need only to compare their number in towns like Ohrid, Kastoria or Verroia, which preserve their early nuclei throughout Turkish rule, or, at least, have surviving data about Christian structures in the *defters* (censuses), to project how many of them may have existed in the prosperous centers in Kosovo, with wealthy mine owners or lessees, master craftsmen, merchants and artisans. It has already been stated that, apart from the local population, these places were also inhabited by "foreigners," whose social and legal status was established by law, and implied, among other things, ownership rights, exemption from certain taxes, etc. There were many citizens from Dubrovnik, Venice and Genoa among them. In addition, the mines attracted Albanians whose arrival was prompted by the expansion of the medieval Serbian state into territory to the south of Scutary.

The growing exploitation of mineral riches in Serbia and Bosnia gathered momentum from the mid-14th century since mines in Europe were being exhausted. Thus, around Novo Brdo and Janjevo where silver mixed with gold was being excavated, as well as Trepča and elsewhere, tales spread about the rich deposits. The wealth was enormous. Archival data disclose that one fifth of the total European production of silver was exported from Serbia and Bosnia only via Dubrovnik.

PLATE 87

No churches have survived in medieval fortified towns with suburbs, or in marketplaces where, sometimes several times a year, fairs were held on particular feast-days when merchants from afar assembled offering commodities to the local population. In the last century of independence, however, no further monumental churches followed the completion of the Holy Archangels. With the revenues continually yielded by the mines, churches were built in the north, chiefly in the Morava River basin where the center of the state moved under the rule of Prince Lazar and his heirs. The monasteries on Mt. Athos were also lavishly furnished with gifts of silver. The quantities of this precious metal were expressed in characteristic liters or ounces, not in the currency unit in circulation at the time.

On the other hand, Peć, with "the throne of St. Sava," remained the heart of Kosovo spiritual life. The Church viewed Prince Lazar (1371-1389) as rightful heir to the Nemanjids and bearer of sovereignty over all Serbian lands, as expressed in his title and the manner in which he was addressed by state representatives and ecclesiastical dignitaries from other countries. The re-establishment of canonic relations with Constantinople, interrupted because of the conflict brought about by Stefan Dušan's proclamation as emperor and the elevation of the Serbian Archbishop to the rank of Patriarch, was of utmost importance both for the political position of the country and the peaceful existence of the Serbian church. These important issues were discussed at councils in Peć summoned at Prince Lazar's initiative. Through the mediation of Athonite

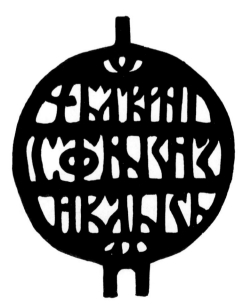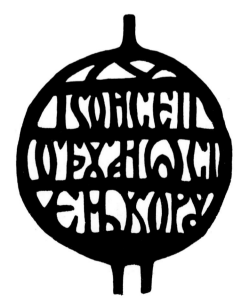

237

monks, an agreement acceptable to both churches was reached, and above the grave of the Emperor Dušan in the Holy Archangels in Prizren, in 1375, the decision of reconciliation was proclaimed in the presence of envoys from the Patriarchate of Constantinople. After that, the Prince commenced the construction of his large monastery of Ravanica, to which his body was transferred, first buried in Priština after his death, a year after the battle of Kosovo (1389). The disturbances and pressures that forced Lazar's widow and son, the young prince, to recognize the Sultan's authority as vassals, left traces on the grand endowments of the Nemanjids. In 1377, Princess Milica paid a visit to Dečani and, as stated in her granting charter, came across "a genuinely pitiful sight": the monastery was burned down and devastated by "the vile Ishmailite people." She restored to the monastery the estates that had been taken from it and conferred upon it several of her own; she also renovated the bronze polycandilion dating from the time of church construction, the largest surviving specimen of its kind in the Byzantine world. A wide, circular ring, held by twenty-meter-long "chains," suspended on the base of the dome, illuminated the interior during evening prayers with dozens of candles and hanging lights. Its parts – all together, there were around 600 – had perforated ornaments, and in the circles with decoratively linked letters, as was the custom, was the name of its founder: *Stefan the King*. The Princess, at that time the nun Evgenija, commissioned a similar piece to record the memory of

PLATE 79; 101 her sons, Stefan and Vukan and herself in the same manner. At a later time, popular tradition concocted the legend that the choros had been forged out of the weapons of the warriors fallen in the battle of Kosovo.

Until the final conquest by the Ottomans in 1455, modest-sized churches whose founders and time of construction are, in the main, unknown, continued to be built in towns, on feudal estates and monastic metochs. In the long centuries of Turkish rule, people gathered in these ecclesiastical buildings collecting contributions in order to restore them, protect them from demolition, and re-paint the frescoes, or, at least, replace damaged ones, adorn interiors with icons and furnish them with liturgical vessels. With the passage of time, however, as the religious and ethnic structure of the population has changed, these efforts have decreased.

The overall survey of hundreds of Christian places of worship – although itself incomplete – attests to lively religious life and the character of the environment over the course of centuries. Their density and disposition is shown on the map in the appendix. Several large structures that supplement this picture have, fortunately, survived. The most significant of them, as regards its

102. Relics of Prince Lazar, fallen at the Battle of Kosovo 1389.

influence and role in the organization of spiritual life and the preservation of national consciousness, was the Patriarchate of Peć – until the fortunes of war turned against the Austrian general Piccolomini whose campaign had won support of the Serbian people in Kosovo. Fearing retribution, they were compelled to move into regions across the Sava and the Danube (1690).

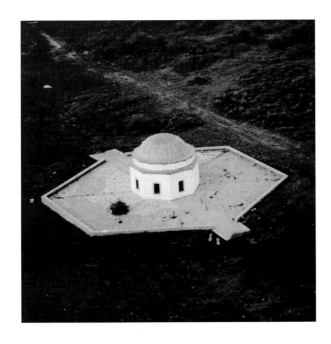

103. Tomb (türbeh) *of Sultan Murad I, fallen at the Battle of Kosovo.*

Shortened list of the shrines of the Kosovo and Metohija 13th to 20th Centuries

This List of Shrines is based on a study by Milan Ivanović, *Crkveni spomenici XIII-XX veka* (Church Monuments from 13th to 20th Century) from *Zadužbine Kosova* (Foundations of Kosovo), Prizren-Belgrade 1987, and other recent publications. Dragan Jovanović, researcher, compiled the major part of this List.

AJKOBILA (in the Mi?dle Ages Proždrikobila, Priština): demolished church in the vicinity of the present-day mosque.

AJNOVCE (in the Middle Ages Hainovċi, K. Kamenica): 1. ruins of the Tamnica monastery, with the church built and frescoed in the 14C on the foundations of an older Byzantine basilica; 2. remains of a church in the old cemetery on the site called Ravan.

ALAGINA RIJEKA (Peċ): 1. ruins of a Serbian church on Crkveno Brdo (Church Hill); 2. remains of a church near the place called Izvorski Laz.

ARILJAČA (in the Middle Ages Arhidijača, Priština): ancient ruins of a church and an old Serbian graveyard.

BABALOĊ (in the Middle Ages Babe, Dečane): according to legend, a mosque was erected on the site of an old church.

BABLJAK (Uroševac): old church (restored in 1966, dedicated to the Holy Trinity); a Serbian priest mentioned in the census of 1455.

BAČKA (Dragaš): church of St Barbara formerly occupied the site called Vakuf.

BADOVAC (Priština): 1. remains of an old church on the site called Crkvine (i.e. ruins of a church); 2. ruins of a former church above the Belograb site; 3. ruins of the monastery of Vojsilovica (14C) at Androvački Breg – its stone remains were used for the building of the Catholic church of St Nicholas in Janjevo, the Turkish mill on the Gračanka river and dwellings of the Albanians from nearby villages; 4. an old church, above the cemetery, on the site called Krstac.

BAJČINA (in the Middle Ages Bajčino, Podujevo): a Serbian church existed (village priest mentioned in the census of 1455).

BAJGORA (formerly Bela Gora K.Mitrovica): remains of a church on the site called Bačka.

BAKS (Srbica): microtoponyms "Crkva" (Church) and "Crkveni Do" (Church Valley) indicate that a church once existed in the village.

BALABANE (Priština): ruins of an ancient church next to the old graveyard on the site called Crkvena Livada (Church Meadow).

BALANCE (Vitina): 1. remains of the church of St Helena in the village; 2. ruins of the monastery of St Eliah, above the village.

BANOV DO (in the Middle Ages Banje Polje, K. Mitrovica): on the foundations of an old Serbian church, a new church was erected in 1950; next to it is an ancient Serbian cemetery.

BANJE (K. Mitrovica): 1. church erected in recent times on the site of an old one, surrounded by the old and present-day village cemetery; 2. remains of a monastery with a church and a bell-tower (13C or 14C), restored in 1492, in the Čpilje-Kuline hamlet; a large medieval graveyard situated on the plateau surrounding the church.

BANJE, BANJA RUDNIČKA (Srbica): 1. church of St Nicholas erected by the Serbian feudatory Rodop some time before 1432; restored in the 20C; 2. old cemetery on the St Paraskeve hill; 3. another old Serbian cemetery towards the village of Suho Grlo.

BANJICA (Glogovac): according to legend and some microtoponyms, the church of St Sava and an old Serbian graveyard were situated in the village.

BANJICA (Lipljan): a church existed once (suggested by the reference to a village priest in the census of 1455 and the toponym "Crkvena Njiva" (Church Field).

BANJSKA (K. Mitrovica): 1. monastery of Banjska (see p.); 2. remains of the church of St Elijah (mentioned in 1313) in the hamlet of Jeliċi; 3. remains of an old church in the hamlet of Stevoviċi; 4. traces of a structure, perhaps a church, in the hamlet of Kozareva Rijeka.

BANJSKA (Vučitrn): 1. old church of St Nicholas; 2. ruins of the church of St Stephen in the hamlet of Selište.

BARAINA (in the Middle Ages Barajino or Borajno, Podujevo): according to written sources, a Serbian church existed there in the 15C.

BARANE (in the Middle Ages Barani, Peċ): unascertained monastery of Barane (mentioned in 15th and 16th-century sources); 2. the site where an old graveyard was formerly situated.

BARDOSAN (Djakovica): 1. ruins of an old Serbian church and a graveyard (recorded in the 19C); 2. archaeological remains of early medieval Slavic culture.

BARE (Leposaviċ): old Serbian graveyard.

BARILJEVO (Priština): church of Samodreža (village priest mentioned as early as 1455); the Turks used its building material for the construction of the mill on the Lab river at the beginning of the 19C.

BATAIRE (in the Middle Ages Batahire, K. Mitrovica): the toponym "Crkva" (Church) points to the former presence of a Serbian church in the village.

BATUŠA (Djakovica): a written source from 1330 refers to the church of St Nicholas in the village (according to tradition, it occupied the site of the present-day mosque).

BEGOV LUKAVAC (in the Middle Ages Lukavac, Istok): remains of an old Serbian church and devastated graveyard on the hill of Vučur; a note from 1643 makes mention of the church of St George in the village.

BEGUNCE (Vitina): old church formerly existed.

BELA CRKVA (Orahovac): 1. remains of an early three-aisled Byzantine basilica and a necropolis; 2. church of St Elijah, mentioned in a source from 1330 (unascertained); 3. church of St Helena, formerly situated on the road to the Sopnič village; 4. church of the Holy Archangels, on the site called Listenol.

BELAJE (Dečane): rock-cut anchoritic dwellings of the Dečani monastery on Streočka Mt: 1. hermitage of King Stefan Dečanski; 2. hermitage of St Helena (built up); 3. central hermitage (between the former two); 4. hermitage of St Ephraim (14C); 5. Belajska hermitage (church of the Virgin), chief monastic anchoritic dwelling with 14th-century frescoes.

BELASICA, VRHLAB (Podujevo): according to folk legend, in the village and its surroundings there were seven sites with the ruins of former churches.

BELEG (Dečane): in the previous century, the ruins of a Serbian church and old graveyard still existed in the village.

BELICA (Istok): 1. Lazarica church, formerly venerating St George (probably from the 14C); repeatedly restored in the 16C, 17C and 18C); old and new graveyards are situated next to it; 2. remains of a church.

BELINCE (Uroševac): remains of a church on the site called Kiša (Crkva (Church)).

BELO BRDO (Leposaviċ): uninvestigated ruins of a former church and remains of a medieval mine.

BELOGRACE (in the Middle Ages Belogradice, Kačanik): ruins of a former church with a graveyard used to exist once.

BELO POLJE (Istok): remains of a church, dedicated, according to legend, to the Holy Saviour, and of an old graveyard on the site called Crkvenjak (Verger).

BELO POLJE (Peċ): the census of 1455 makes mention of two priests and a monk in the village. Today exist: 1. church of the Presentation of the Virgin (19C) erected on the foundations of an ancient church, surrounded by an old graveyard; 2. remains of a church on the hill called Krst (Cross); 3. the cave called Careva Stolica, or Razboj (the Emperor's Stool or the Loom) (according to legend, used to be a hermitage).

BELO POLJE (Podujevo): a church existed in the 15C.

BELUĊE (Leposaviċ): ruins of an old church and an old graveyard. BENČUK (in the Middle Ages Benčuj, Vučitrn): remains of the church and dormitory called Dušan's church.

BEREVCE (Uroševac): 1. church of St Paraskeve with a bell-tower (mentioned in a note from 1353); 2. ruins of the church of St Demetrios on the site called Crkvica (Small Church) (16C).

BERIVOJCE (Kriva Reka near Novo Brdo): church of Glo-

barica, dedicated to St John, with frescoes from the 16/17C (village priest mentioned in the census of 1455).

BERKOVAC or BERKOVICA: unascertained village (mentioned in the 15C in the Lapska nachye) somewhere in the environs of Podujevo, with "the church of "St Vasil" (Basil).

BERKOVO (Klina): church of the Holy Archangels, formerly situated on the site called Crkvište (i.e. ruins of a church), demolished by the Turks; above Crkvište, an old Serbian graveyard survives.

BESINJE (Priština): an old Serbian church stood once on the site called Crkveni Do (Church Valley); an old graveyard situated today on the site called Babino Groblje; the Pustinja-Leskovac monastery (mentioned in 1455) formerly located in the vicinity of the village.

BINAČ (Vitina): 1. ruins of an old settlement above the village; in the village and its environs there are the ruins of the churches of St Paraskeve, St Stephen and S. Nicholas (recently restored); 3. monastery of the Archang l Michael (Buzovik), south of the village, from the 14-16C, with the remains of two layers of frescoes (the younger dating from the 16C).

BISTRAŽIN (in the Middle Ages Bisažina, Djakovica): new church, erected on the foundations of an old one, demolished in 1941; the old and new graveyard formerly situated next to it.

BISTRICA (Leposaviċ): remains of a church and an old graveyard.

BISTRICA ŠALJSKA (Leposaviċ): remains of an old church on the site called Crkvište (ruins of a church).

BITINJA see GORNJA and DONJA BITINJA

BIVOLJAK (Vučitrn): old cemetery, known as the Wallachian cemetery.

BLAGAJE (Peċ): old Serbian cemetery.

BLJAČ (Dragaš): in the village with several old Serbian toponyms, the remains of a smaller church still existed in the mid-19C.

BOB (Kačanik): archaeological finds of two churches, Byzantine and medieval Serbian, with a graveyard, on the site called Crkva (Church).

BOBOVAC, BOBOVCE, BOBOJEVCE (Klina): ruins of a church with an old graveyard existed until 1870.

BOGOŠEVCI (Prizren): 1. church of St Nicholas in the graveyard (16C) frescoed in the 16/17C; 2. church of the Dormition of the Virgin in the hamlet of Peičići (18C).

BOJNOVICE, BOJINOVIĊE (in Kolašin upon the Ibar) 1. old cemetery, in the Bojnovačko field; 2. a church formerly situated on the site called Crkvine (i.e. ruins of a church), in the centre of the village; 3. old graveyard church, on the outskirts of the village, restored in 1950.

BOLJETIN (K.Mitrovica): Sokolica monastery with the church of the Intercession the Virgin (14-15C) at the foot of the Sokolica hill; the church contains damaged frescoes; especially valuable is the marble sculpture of the Virgin with Christ transferred from Banjska, the demolished mausoleum of King Milutin (1312-1316); a Serbian graveyard situated above the monastery.

BOLJEVCE (Kriva Reka near Novo Brdo): 1. ruins of the old church of St Panteleemon with the traces of the original fresco-painting.

BORČANE (in the Middle Ages Borčani, Leposaviċ): new church erected in the 19C on the foundations of the ruins of a former church, on the hill above the village.

BOSCE (Kriva Reka near Novo Brdo): several Serbian microtoponyms and an old cemetery have survived.

BOSTANE (Priština): 1. remains of the medieval Saxon (Latin) church venerating the Virgin; scarce fragments of frescoes with Cyrillic and Roman inscriptions; 2. church of the Virgin in the graveyard, erected in the 19C with the material of the old church of the Virgin in Novo Brdo beneath Mt Javor.

BRABONIĊ (K. Mitrovica): old ruins of a former church.

BRADAŠ (Podujevo): three churches formerly existed (who-

se stone remains were carried off in the 19C and 20C; the remains of one have survived.

BRAINA (Podujevo): according to historical sources, the village had: 1. church of the Virgin Amolyntos Brainassa – of Braina (14C); 2. church of St Nicholas (14C) 3. church of St Peter (14C). The remains of two churches and two old graveyards have been uncovered in the village area.

BRASALJCE (Gnjilane) 1. ruins of a former church in the hamlet of Barice; 2. ruins of a former church in the hamlet of Šašivar.

BRATILOVICE (Kriva Reka near Novo Brdo): 1. remains of an old church on the site called Crkvište (ruins of a church) in the location named Rupište; 2. demolished old church on the site called Prisoje in Rupište.

BRATOTIN (Orahovac): old church on the Glavica hill; old and present-day Serbian cemetery, north of the village.

BRECE (in the Middle Ages Brezovica, Podujevo): ruins of an old church in the Haimović (Halilović) mahala.

BRESJE (in the Middle Ages Brestije, Priština): church of St Cathrine; demolished in the 19C by Jašar-Pasha Džanić; restored in the 20C.

BRESNICA (K. Mitrovica): traces of the ruins of a church (village priest mentioned as early as the 15C); old graveyard on the hillock above the village; remains of another old graveyard in the hamlet of Alin Do.

BRESTOVAC (Orahovac): microtoponym relating to the old graveyard.

BRESTOVIK (Peć): old graveyard on the site also occupied by the remains of a church (village priest mentioned in the 15C).

BREZNA (Dragaš): according to legend, the church of St John occupied the site of the present-day mosque (confirmed by the toponym Crkveni Do – Church Valley).

BRNJAČA (in the Middle Ages Brnjašča, Orahovac): ruins of the church of St Kyriake (mentioned in a source from 1348), embellished with stone reliefs in the 16C and repeatedly restored.

BRNJAK: 1. foundations of several structures (probably belonging to Queen Helen of Anjou's palace, known only from written sources) discovered near the confluence of the Oklački stream into the Brnjička river; 2. medieval cemetery in the hamlet of Bašče; 3. remains of an old church near the graveyard in the hamlet of Dublje; 4. ruins of a church and an old graveyard on the site called Krnje; 5. remains of an old church called Crkvaš in the hamlet of Presjeke; 6. small, dilapidated church in the hamlet of Staro Guvno; 7. traces of a graveyard in the hamlet of Ušće on the site where, according to tradition, a church stood once.

BROĆNA (in the Middle Ages Brodna, Srbica): old Serbian graveyard and the site called Crkvište (i.e. ruins of a church) (village priest referred to in the 15C); according to legend, the village mosque was erected on the site formerly occupied by a church.

BROD (Dragaš): 1. church of St Demetrios (unascertained); 2. church of St Panteleemon and an old graveyard on the Pantelejci hill; 3. church of St Nicholas (completely destroyed in the 20C); 4. old Christian cemetery (situated on the site of the present-day burial ground for cattle).

BROD (Uroševac): remains of the church of St Peter, near the village, and of an old graveyard, in the village.

BRODOSAVCE Dragaš): 1. remains of a larger church stood above the village in the 19C; 2. remains of the small medieval fortress of Žinovo in the area of the same name.

BRUS (Lipljan): a church existed in the hamlet of Veliki Brus; very old Jewish cemetery located near the village.

BRUSNIK (Vučitrn): remains of an old church on the site called Marina Voda.

BRUT (Dragaš): old graveyard with a demolished church on the site called Vakuf.

BRVENIK (Podujevo): remains of the medieval fortress of Brvenik with the foundations of buildings and outer walls (a church situated in the centre).

BRZANCE (Leposavić): old cemetery.

BUBE (in Kolašin upon the Ibar): 1. remains of an old church in the village graveyard; 2. remains of two old, probably eccleciastical, buildings on the hill called Bupski Šiljak.

BUBLJE (Mališevo): Budisavci monastery with the church of the Transfiguration (14C); the church restored and frescoed in 1568, to the wish of the Patriarch Makarije Sokolović.

BURINCE (in the Middle Ages Bujince, Podujevo): a church existed (demolished so that Pasha's mill would be constructed with its stone remains).

BUSINJE (Priština): locality "Srpsko groblje" (Serbian Graveyard).

BUSOVATO, BUSOVATA (Kriva Reka near Novo Brdo): old cemetery (now called the Jewish cemetery).

BUŠAC: unascertained village (in the wide neighbourhood of Priština), in which, according to a written source from 1581, the church of St Nicholas was located.

BUŠNICE (in the Middle Ages Baošići, Kriva Reka near Novo Brdo): old cemetery called Jewish, on the site called Bara.

BUZEC (Dragaš): remains of an old church on the site called Crkvište (i.e. ruins of a church).

CAREVAJKA (Gnjilane): foundations of an old church on the site called Crkvena Bukva (Church Beech); by the stream near the village, next to the demolished church, was an old graveyard.

CAREVAC (Suva Reka): ruins of a modest-sized church.

CAREVCE (K. Kamenica): very old graveyard.

CECELIJA (Vučitrn): locality "Crkveni Do" (Church Valley).

CERANJA (Leposavić): remains of the church of St Paraskeve (with spolia from antiquity), in Ceranjska Reka, on the site called Mramor.

CERNICA (Gnjilane): village church referred to in a document from 1512. Three churches are known today: 1. ruins of the church of St Paraskeve, in the present-day village; 2. ruins of the church of the Holy Saviour, in the present-day village; 3. new church of St Elijah, erected in 1933.

CEROVIK (Klina): microtopnyms "Crkva" (Church) and "Srpsko Groblje" (Serbian Graveyard) attest to the existence of an old Serbian graveyard and church.

CHURCH OF ST NICHOLAS in the Lapska nachye: mentioned in the 15C, with three monks (which indicates that it was a monastery), but its site has not been precisely ascertained.

CREPULJA (in Kolašin upon the Ibar): church of St Nicholas, probably erected in the 14C, completely reconstructed in the 16/17C; painted with frescoes in the 18C.

CRKOLEZ (Istok): 1. church of St John in the old graveyard, built in the 14C, adorned with frescoes in 1672/73 (treasuring a collection of 17th-century icons); 2. another church might have existed near the village (grazing lands called "Saborna Crkva" ("Cathedral Church") and "Celije" (Cells).

CRKVENA VODICA (formerly Crvena Vodica, Priština): remains of an old church and an old graveyard.

CRMLJANE (in the Middle Ages Črmlje, Djakovica): a church formerly located on the Crmljanska peak (village priest mentioned in the 15C), converted by the Turks into a turbeh; an archaeological locality is also situated in that place (Iron Age).

CRNCE (in the Middle Ages Črnča, Istok): church at "Črnča in Hvosno" mentioned in 1264; until the mid-19C, remains of the church and the old graveyard stood on the slope above the village, on the site called Crkvište (ruins of a church).

CRNI LUG (Mališevo): in the 15C, there was a church with a priest (noted in a Turkish defter).

CRNI VRH (in the Middle Ages Črnii Vr'h, Peć): the 19C registered the ruins of the church of St John the Baptist; only an old graveyard exists today.

CRNOLJEVO (Uroševac): according to tradition, a Serbian church stood on the site of the present-day mosque.

CRNOVRAN (Mališevo): remains of the foundations of a church, on the hill outside the village, on the site called "Kod Crkvenog Cera" ("By the Church Oak").

CRVENI (Leposavić): remains of the medieval church called the Mining church.

ČABIĆ (Klina): 1. church of St Peter, mentioned in a charter from 1335, unascertained; 2. church of St Nicholas, with 17th-century frescoes; 3. remains of the "graveyard of the Lalićs", near the village intersection; 4. "the graveyard of the Mazićs" in the village.

ČABRA (in Kolašin upon the Ibar): old cemetery.

ČAGLAVICA (Priština): old graveyard with a modest building for memorial feasts.

ČAJDRAG (Suva Reka): locality "Srpsko Groblje" (Serbian Cemetery).

ČARAKOVCE (Kriva Reka near Novo Brdo): old cemetery.

ČEČEVO: church of St Paraskeve constructed in 1938 on the foundations of an older church (14C); remains of two buildings from the original complex situated next to it; several old graves west of the church.

ČELOPEK (Peć): old graveyard on the site called Glavičica.

ČESKOVO (Klina): locality "Crkvište" (ruins of a church) and an old graveyard.

ČIFLAK (Orahovac): graveyard in which the church of St Basil stood, on the eastern side of the village.

ČIKATOVO (in the Middle Ages Čigotovo, Glogovac): "Ježevica" church constructed after World War I; at present, only an old graveyard exists. The foundations of the church have been dug out by the Albanians, who also plowed the site.

ČITLUK (in Kolašin upon the Ibar): 1. old graveyard, on the site called Dublje; 2. old graveyard and remains of walls on the site called Čardačine (where, according to tradition, was a town); 3. the monastery of Duboki Potok, with the church of the Presentation of the Virgin, above the village.

ČUBELJ (Srbica): localities "Crkveni Izvor" (Church Well), "Crkvena Njiva" (Church Field) and "Srpsko Groblje" (Serbian Cemetary).

ĆEŠENOVIĆE, ČEŠANOVIĆE (in Kolašin upon the Ibar): remains of an ancient church in the old graveyard, on the hillock called Crkvina (ruins of a church).

ĆIREZ (Srbica): in a Turkish census of the 15C, the "Lozoriš (?) church" was noted on the village territory; today, the locality called "Groblje Srba" (Graveyard of the Serbs) exists.

ĆUŠKA (Peć): until recently, the old cemetery of the exiled Serbs stood completely preserved.

DABIŠEVCE (in the Middle Ages Dabiživovci, Priština): at the end of the 19C, the abandoned church with the founder's inscription above the entrance still existed.

DAJKOVCE (formerly Dojkovce, Kriva Reka near Novo Brdo): old church existed on the site called Prekobanjik.

DAMJANE, DAMNJANE (Djakovica) 1. church and an old graveyard formerly situated in the Trava mahala; 2. remains of a church near the site called Dva Bresta (Two Elms) (catholic church in the village of Smač built with its stone remains); 3. church in Šeh-mahala (with its stone remains, the Albanians constructed a bridge and a house in the village); 4. the fourth village church located on the site where in 1940 Mon Bajram erected his tower. Two microtoponyms and the name of the village also bear witness to the existence of Serbian churches.

DAVIDOVCE (Uroševac): traces of a Serbian graveyard in the part of the village called Staroselo where a church used to occupy the site called Crkva (Church). DAŽDINCE (Kriva Reka near Novo Brdo): part of the village still called Srpsko Groblje (Serbian Cemetary).

DEČANE (Dečani): 1. Dečani monastery (see p.); 2. hermitages in Dečani, see Belaje, Hermitages.

DEDINJE (K.Mitrovica): microtoponym "Kod Crkve" (By the Church).

DELOVCE (Suva Reka): ruins of the church of St Nicholas and an old graveyard.

DESIVOJCE (Krvia Reka on Novo Brdo): remains of a church in the old graveyard have been archaeologically established.

DEVAJE (Vitina): ruins of a church on the site called Bresje (village priest mentioned in the 15C) and traces of an old settlement in Selište.

DEVIČ, monastery, see LAUŠA.

DIKANCE (Dragaš): remains of an old settlement with the ruins of a church in the locality called Popove Rupe (Priest's Holes), near the village.

DIVLJAKA (in the Middle Ages Divjak, Lipljan): remains of an old village church and an old graveyard, as well as the localities "Crkva" (Church) and "Crkvena Livada" (Church Meadow).

DOBLIBARE (Djakovica): 1. archaeological remains of early medieval Slavic culture; 2. ruins of a church and a graveyard were present in the village in 1868; the 19C saw the construction of the turbeh called Djordje with the material from the church of St George.

DOBRAVA (in the Middle Ages Dobrhava, Leposavić): old ruins of a former church and a graveyard.

DOBRČANE (Gnjilane): 1. ruins of the so-called Latin Church, on the site named Baba-Andjin Most; 2. ruins of the church of St Basil, above the village; 3. church of St Paraskeve, constructed after 1918; 4. ruins of the old fortress of Kaljaja, near the village.

DOBRA VODA, UNJEMIR (Klina): 1. church (monastery?) of St Peter – Petrovica, with the remains of frescoes and stone decoration from the 14C and 16C; 2. the so-called Little Church, unresearched, on the site called Crkveni Lug (Church Grove).

DOBRI DO (Peć): 1. written sources from 1330 make mention of the church of St Kyriake (unascertained); 2. remains of the medieval church of St Demetrios; 3. ruins of a church (considered to be the remains of the church of the Virgin Amolyntos); 2. remains of an old settlement and graveyard, near the ruins.

DOBRI DOL (Klina): remains of the church of St Demetrios (village priest mentioned in 1455) and an old graveyard used to exist.

DOBRI DOL (Podujevo): small village cemetery.

DOBRODOLJANE (Suva Reka): church of St Stephen existed in the 16C; demolished by Mahmud-Pasha of Skadar in the first half of the 19C, when the village was forcebly Turkized.

DOBROŠEVAC (Glogovac): a written source from the 14C mentiones the remains of a church and "Dmitar's church" within the village bounds; two microtoponyms testify to the existence of churches in the village and its neighbourhood.

DOBROTIN (Lipljan): old church of St Demetrios.

DOBROTIN (Podujevo): surviving graveyard; a church existed in the 15C.

DOBRUŠA (Istok): remains of an old church on the hill of Vučar and two old graveyards (the Albanians from the village of Prekale made use of stone remains for the construction of their houses).

DOBRUŠTA (Prizren): monastic church of St Nicholas; restored around 1332 by King Dušan (there are several locations near the village on which it might have stood).

DOJNICE, DOJINICE (in the Middle Ages Doenci, Prizren): over the ruins of the church of the Virgin of the Passion, a new church was erected in 1940.

DOLAC (Klina): the Turkish census of 1455 makes mention of two village priests and a monastery with three monks near the village; today exist: 1. church of the Presentation of the Virgin, formerly in the monastic range (remains of two expansive walls), with frescoes dating from the 14C and from 1620; 2. traces of a church in one of three old graveyards.

DOLJ (Djakovica): a church existed on the site called Doljska Crkva (Doljska Church).

DOLJAK (Vučitrn): old graveyard; microtoponym "Crkvina" (ruins of a church) testisfies to the existence of a church.

DOMANEK (in the Middle Ages Domaneg, Mališevo): in the mid-19C, the remains of an old church, according to legend a monastery, were noted; as early as the 14C, the church of St Elies existed in the village or its environs.

DOMOROVCE (Izmornik): ruins of a large monastery on the hill of Popovac and three very old graveyards in the village and near the Končuljska gorge.

DONJA BITINJA (Uroševac): 1. church of St Theodore with 16th-century frescoes; 2. church of St Demetrios, the 16C.

DONJA DUBNICA (Vučitrn): an old church formerly existed (village priest mentioned as early as 1455), probably somewhere around today's Crkveni Do (Church Valley).

DONJA DUBNICA (Podujevo): a church existed in the 15C.

DONJA FUŠTICA (Glogovac): ruins of a medieval church (14C and 16C), near the site called Crkva (Church).

DONJA GADIMLJA (Lipljan): microtoponym "Crkva Jorgovanova" (Jorgovan's Church).

DONJA GUŠTERICA (Lipljan): church of the Holy Prince Lazar erected at the outset of the 20C, on the site of the old church of the Beheading of St John the Baptist.

DONJA KLINA (Srbica): as early as 1455, the village had a priest; today the microtoponym "Crkva" (Church) exists.

DONJA LAPAŠTICA (Podujevo): the village had a church in the 15C; its site is probably indicated by the present-day microtoponym "Crkva" (Church).

DONJA RAKOVICA: an unascertained village in the sanjak of Vučitrn and the Lapska nachye (the Turkish census of 1455 makes mention of the church of St Nicholas near the village).

DONJA SUDIMLJA (Vučitrn): old cemetery.

DONJE DOBREVO (in the Middle Ages Dobrijevo, Priština): at the time of the immigration of the Albanians in the 18C, a Serbian church stood on the site called Crkva (Church).

DONJE GODANCE (Uroševac): village church constructed after World War I.

DONJE ISEVO (Leposavić): ruins of an old church and an old graveyard.

DONJE KORMINJANE (Izmornik): church with 19th-century frescoes.

DONJE LJUPČE (Podujevo): a church existed in the 15C (the census of 1455 refers to two village priests), and a monastery was situated in the neighbourhood.

DONJE NERODIMLJE (Uroševac): according to the Turkish census of 1455, the village had two Serbian priests. At present, there are: 1. remains of the church of St Stephen; 2. restored church of the Virgin on the Glavica hill; 3. church of St Nicholas, erected on the foundations of an old church.

DONJE ŽABARE (K. Mitrovica): locality called "Crkva" (Church).

DONJI JASENOVIK (in Kolašin upon the Ibar): remains of churches on the hill of Janjevac and in the location called Staro Groblje (Old Graveyard).

DONJI LIVOČ (Gnjilane): ruins of a church at the top called Ilijina Glava.

DONJI MAKREŠ (Gnjilane): traces of an old settlement and the foundations of a Serbian church on the site called Selište; two old graveyards on the sites of Rudna Padina and Ljudje.

DONJI OBILIĆ (Srbica): microtoponyms "Crkva" (Church) and "Crkvena Glava" (Church Head).

DONJI SIBOVAC (Podujevo): a church existed once (the census of 1455 mentions a village priest).

DONJI STRMAC (Srbica): remains of an old church on the site called Crkvina (ruins of a church).

DONJO RAMNJANE (Vitina): ruins of an old church registered at the start of the 19C.

DRAGANAC (Gnjilane): monastic church of the Archangel Gabriel erected in the 19C over the ruins of an old church.

DRAGAŠ: remains of an old churh and a graveyard on the site called Čukare.

DRAGOBILJE (Mališevo): church of the Virgin mentioned in a 14th-century written source.

DRAGOBRATA: unascertained village in the sanjak of Vučitrn, a monk mentioned in the 15C, and the church of St John in the 16C.

DRAGOLJEVAC (Istok): remains of two churches (in the Petkovica field and on the site called Crkvine (ruins of a church)) and an old Serbian graveyard; as early as the 14C, the so-called Krstovo Crkvište (i.e. ruins of the Church of the Cross) stood near the vilage.

DRAGOVAC (Priština): old graveyard.

DRAINOVIĆE (K. Mitrovica): ruins of an ancient church with an old graveyard.

DRAJČIĆI (Prizren): church of St Nicholas (the end of the 16C), with frescoes and icons from the 16/17C.

DRAJKOVCE (Uroševac): church of the 40 martyrs of Sebasteia from the 16C (restored).

DRAMNJAK (in the Middle Ages Drobnjak, Uroševac): an old church occupied the site called Crkvene Jaruge (Church Gullies).

DREN (Leposavić): remains of a church.

DRENOVAC (Klina): remains of the church of St Nicholas registered in the 19C; at present, there is an old graveyard.

DRENOVAC (Orahovac): worship stone, above the village (in all probability, remnant of the old church of St Panteleemon).

DRENOVČIĆ (Klina): a church formerly existed on the hill above the village, on the site called Crkvište (ruins of a church); at present, two cemeteries are located near the village.

DRENOGLAVA (Kačanik): ruins of the so-called Mačićka church, not far from the village.

DROBNJAK (Kačanik): graveyard and the church of St George formerly existed (village priests mentioned in the censuses of 1452 and 1455).

DRSNIK (Klina): 1. remains of an old fortress, on the hill above the village; 2. church of St Paraskeve (St Nicholas), with 16th-century frescoes; 3. remains of a former church in the place called Ćelije (Cells).

DUBOKA (in the Middle Ages Globoko, Leposavić): a new church erected on the foundations of an old one, on Duplje hill.

DUBOKI POTOK (in Kolašin upon the Ibar): church of the Virgin in the monastery of the Presentation of the Virgin, erected in the 14C, restored in the 16C and 18C, and also in recent times.

DUBOVNIK (Dečane): ruins of an old church and an old graveyard.

DUBOVO (Peć): according to tradition, the present-day mosque was erected on the site of a former church; the remains of an old Serbian graveyard are situated at the foot of the Ozrim hill.

DUGA (Lipljan): microtoponym "Crkva" (Church) and a census from the 15C bear witness to the existence of a Serbian church.

DUJAK (Djakovica): ruins of an old church with a churchyard existed in the 19C.

DULJE (in the Middle Ages Duhlje, Suva Reka): 1. remains of the church of the Holy Saviour in the graveyard; 2. ruins of the church of St Paraskeve by the spring of the Lukara stream.

DUNAVO (Gnjilane): 1. ruins of an old church near the site called Velika Kosa; 2. ruins of a church near the site called Reka.

DUZ (formerly Dusje or Dušci, Podujevo): a Serbian church existed in the 15C; the ruins of three churches registered in the 19C.

DVORANE (Suva Reka): 1. modest village church of the Holy Saviour; 2. ruins of the church of the Archangel Michael; 3. Serbian cemetery demolished by the Albanians in 1984.

DJAKOVICA 1. unascertained church (in the 16C, metoch of the Dečani monastery, a village priest mentioned as early as the 15C); 2. church of the Dormition of the Virgin (with icons from the 17C, 18C and 19C) in Srpska Street; 3. large church, mausoleum of the Serbian warriors fallen in the wars of 1912-1918 (dynamited in 1949).

DJELEKARE (Vitina): ruins of a church probably existed in the vicinity of today's Crkveni Kladenac (Church Well) (village priest mentioned in the census of 1455).

DJOCAJ (Dečane): microtoponym "Grobac" (Small Grave) marks a Serbian grave or graveyard (perished).

DJONAJ (Prizren): 1. remains of the church of St Catherine, near an old mill; 2. remains of a church (Catholic?), on the site called Gedža.

DJURAKOVAC (Istok): 1. church of St Nicholas, with a sepulchar slab from the 14C and frescoes from the 16C; a stećak tombstone from the 14/15C in the Serbian graveyard in front of the church; 2. a Catholic church recently built over the remains of the church of the Holy Anargyroi; 3. ruins of a former church with an old graveyard, at the present-day trash dump.

DJURDJEV DOL (Kačanik): remains of an old church registered on the site called Crkva (Church).

DJURKOVCE (Uroševac): toponym "Crkvište" (ruins of a church) points to the existence of an old church.

ENCE (Priština): a microtoponym testifies to the existence of a church.

FIRAJA (Uroševac), see PAPRATNA

FIRIDJEJE (formerly Stanilovac, Kriva Reka near Novo Brdo): old graveyard.

GATANJE (Uroševac): the village had three churches: 1. on the site called Manastir (Monastery); 2. on the site called Kaludjere (of the Monks); 3. church of St Nicholas (recently reconstructed), east of Gornja Mahala.

GAZIVODE (K. Mitrovica): remains of a town-fortress stood on the hill above the village; an old graveyard located in the village.

GLADNO SELO (Glogovac): microtoponym "Crkveni Do" (Church Valley) points to the existence of a village church.

GLAVIČICA (Peć): old and present-day cemetery.

GLIVNIK (Dragaš): ancient graveyard and ruins of a church on the site of an old, abandoned village.

GLOBOČICA (Dragaš): present-day mosque constructed upon the foundations of a former church; the plateau above the village still called Crkva (Church).

GLOBOČICA (in the Middle Ages Dlbočica, Kačanik): at the end of the 19C, the church of St Nicholas (?) with an old graveyard, whose traces have been destroyed, stood in the centre of the village.

GLODJANE (Dečane): old cemetery (called Živko's Cemetery), in the Živkaj mahala.

GLOGOVAC: remains of the foundations of a medieval church, on Mt Kosmača, south of the village; a Serbian cemetery in the village.

GLOGOVCE, GLOGOVICA (Kriva Reka near Novo Brdo): ruins of an old church in the hamlet of Demovići.

GLOGOVCE (Lipljan): old cemetery (called Svatovsko, i.e. the Wedding Guests' Cemetery).

GMINCE (Kriva Reka near Novo Brdo): ruins of the old church of St Paraskeve on the site called Crkve (Churches).

GNJEŽDANE (in the Middle Ages Gnježdani, Leposavić): old cemetery.

GNJILANE (in the Middle Ages Gnivljani): church of St Paraskeve probably occupied the site called Petkovce (Petigovce); 2. monastery of St John, south of the town (demolished by the Turks in the 18C); 3. church of St Nicholas, erected in the 19C on the foundations of an older church.

GODANCE (in the Middle Ages Hudince, Glogovac): according to written sources from the 15C and 17C, the village had a church.

GOJBULJA (Vučitrn): old church of St Paraskeve in the village graveyard (recently restored); a Serbian graveyard from the 18C.

GORANCE (Kačanik): 1. church of St Atanas (Athanasios) in the centre of the village, demolished by the Albanians; 2. ruins of the church (monastery?) of St Elijah, above the village; 3. church of St Nicholas, formerly located in the west part of the village; 4. ruins of the church of St Paraskeve, in the west part of the village; 5. church of the Virgin, situated in the north-east of the village; 6. church of St George in the north of the village (demolished in the 19C); 7. church of the Holy Archangels, previously located in the north-east side of the village.

GORAŽDEVAC (in the Middle Ages Goražde Vas, Peć): 1. log-cabin church, dedicated to St Jerome, dating from the 16C (the oldest in Serbia), in the old graveyard; 2. church of the Intercession of the Virgin, erected in 1926.

GORNJA BITINA (Uroševac): new church constructed over the remains of the old church of St George (the apse with old frescoes); several stone slabs from the 14C have survived in the church and next to it (the Turkish census of 1455 makes mention of two village priests).

GORNJA BRNJICA (Priština): church of the Holy Apostles Peter and Paul, erected in 1975 on the foundations of the old church of St Nicholas.

GORNJA GUŠTERICA (Lipljan): 1. ruins of a former church, dedicated to St Elijah; 2. ruins of the church of the Virgin Amolyntos with an old graveyard.

GORNJA KLINA (Srbica): a 15th-century source makes mention of "the monastery of St Arhalije" (Achilleios) in the vicinity of the village; several microtoponyms testify to the existence of a church.

GORNJA KRUŠICA (Suva Reka): microtoponym "Srpsko Groblje" (Serbian Cemetery).

GORNJA LAPAŠTICA (Podujevo): a village church existed in the 15C (when mention is made of its priest), probably on the site of the present-day ruins.

GORNJA NERODIMLJA (Uroševac): in the 14C, the palaces of Serbian rulers were situated in Nerodimlja (Rodimlja, Porodimlja). Today exist: 1. monastery of the Holy Archangels from the 14C, restored in 1700; 2. church of the Dormition of the Virgin ("the Monastery of St Uroš"), in the hamlet of Šarenik, dating, according to legend, from the 14C; 3. remains of the church of St Nicholas, near the site called Kaludjerska Vodenica (Monks' Mill), where the ruins of several secular structures (as it seems, the palaces of rulers) are situated; 4. foundations of three churches in the village.

GORNJA SLATINA (Vitina): microtoponym "Crkvene Njive" (Church Fields) testifies that the village used to have a church.

GORNJA SRBICA (Prizren): church of St Basil, erected in 1863 over the ruins of an old church.

GORNJA SUDIMLJA (Vučitrn): remains of a church on the

site called Crkvište (ruins of a church) and two old Serbian graveyards.

GORNJA ŠIPAŠNICA (Kriva Reka near Novo Brdo): ruins of a church, in the village, and the church of St Pantaleemon, in a village field, towards Donja Šipašnica.

GORNJE GADIMLJE (Lipljan): ruins a former church and the significant archaeological site called Gradina (Lower Stone Age and Iron Age).

GORNJE GODANCE (Lipljan): ruins of an old church on the site called Žirovnica.

GORNJE KARAĆEVO (Kriva Reka near Novo Brdo): a priest mentioned in the village in the 15C, so that it must have had a church at that time; nowadays, the area of the old Serbian graveyard is used by the Albanians for grazing cattle.

GORNJE KORMINJANE (Izmornik): the demolished monastery of St George in the wood not far from the village; an old graveyard next to the village.

GORNJE KUSCE (Gnjilane): remains of the churches of St Paraskeve and St Kyriake.

GORNJE LJUBINJE (Prizren): remains of the churches of St Paraskeve and St Kyriake.

GORNJE LJUPČE (Podujevo): a church existed, and perhaps a monastery as well (the census of 1455 makes mention of a village priest and a monk).

GORNJE POTOČANE (Orahovac): old church and graveyard formerly existed.

GORNJE PREKAZE (Srbica): in the 16C, mention is made of the monastic church of the Dormition of the Virgin; the old and new cemeteries exist nowadays.

GORNJE SELO (Prizren): the graveyard church of St George with stone ornamentation and frescoes from the 16/17C.

GORNJE VINARCE (K. Mitrovica): medieval church, restored in the 16C; in 1972, demolished by a group of Albanians.

GORNJI and DONJI CRNOBREG (in the Middle Ages Črveni Breg, Dečane): a written source from 1330 refers to the churches of St Nicholas (still existed in the 19C) and St George in the environs of the village.

GORNJI and DONJI STREOC (Dečane): in the 14C, mention is made of the church of St Stephen (Stefanja church) and the monastery of the Holy Anargyroi; the old Serbian cemetery with one stećak situated in Nevestin Vrh (Bride's Peak).

GORNJI JASENOVIK (K. Mitrovica): remains of a church and an old graveyard on the Leskovača hillock and the site called Rovce.

GORNJI KRNJIN (in the Middle Ages Krnjino, Leposavić): ruins called the Latin church.

GORNJI LIVOČ (Gnjilane): the site of a former church, near the hamlet of Jabučani.

GORNJI MAKREŠ (Gnjilane): remains of an old settlement and old graveyard on the site called Grobljište.

GORNJI OBILIĆ (Srbica): acccording to a 17th-century travel account and folk tradition, the monastery of St George was situated in the vicinity of the village; next to the village, there is an old cemetery.

GORNJI PETRIČ (Klina): remains of an ancient church in the graveyard (where, according to tradition, was the monastery of St John the Baptist) and the ruins of the medieval town of Petrič, on the hill above the village.

GORNJI STRMAC (between Kolašin upon the Ibar and Drenica): old graveyard church (restored in recent times) in the hamlet of Perkovac, and the old Serbian cemetery in the hamlet of Rusce.

GORNJI STRMAC (Srbica): restored old church and an old graveyard.

GORNJI SUVI DO (K. Mitrovica): small church and an old graveyard.

GOROŽUP (Prizren): until recent times, the microtoponym of the old Serbian cemetery was preserved.

GOTOVUŠA (Uroševac): 1. church of St Nicholas with 16th-century frescoes; 2. old church of the Dormition of the Virgin (restored in 1886); 3. traces of an old church in the vicinity of the ancient fortress of Zidovica.

GRABAC (Klina): remains of the church of the Holy Trinity and an old graveyard.

GRABANICA (Klina): the surviving name of the old Serbian cemetery.

GRABOVAC (K. Mitrovica): old graveyard and the ruins of a former church.

GRACE (Vučitrn): old graveyard and the ruins of a former church were situated in Ljigate, near the river Lab.

GRAČANICA (Priština): 1. Gračanica monastery (see p.); 2. medieval hermitage of St Luke near the Kižnički stream; 3. monument to the Serbian soldiers fallen in the wars of 1912-1918; 4. Gladnice, an early Slavic necropolis from the 6-7C.

GRADICA (Glogovac): according to 15th-century Turkish censuses, a church existed there.

GRADJENIK (Kriva Reka near Novo Brdo): remains of demolished churches on the site called Selište and in the Kaludjerica mahala.

GRAMOČEL (in the Middle Ages Grmočel, Dečane): foundations of an old church with the remains of medieval bricks and frescoes (the census of 1455 makes mention of a village priest), in the present-day Catholic cemetery.

GRANIČANE (Leposavić): 1. remains of an old church in the village graveyard; 2. church erected around 1860 in the old graveyard, razed to the ground in 1876.

GRAŽDANIK (in the Middle Ages Ogradjenik, Prizren): in the 14C, the church of St Pantaleemon stood on the hill near the village; demolished in the 16C by Suzi Čelebija, a converted Turk from Prizren, who erected a palace on its site.

GRČINA, GRČIN (Djakovica): according to tradition, the village had five churches.

GREBNIK (Klina): 1. ruins of the Church of St Jerome and an old graveyard on the site called Kućine, where an old settlement was situated; 2. old cemetery, on the hill west of the village; 3. church erected in 1920 on the site of a former religious building (dedicated to St Athanasios?).

GREBNO (Uroševac): at the end of the 19C and the beginning of the 20C, the ruins of two churches stood in the village, and above the village was the church called Manastir (Monastery).

GREKOVCE (in the Middle Ages Grehovac, Suva Reka): ruins of an old church.

GRIZIME (in the Middle Ages Grizimjeh, Kriva Reka near Novo Brdo): traces of an old settlement; according to tradition, an old church was situated on the present-day locality called Crkvište (ruins of a church).

GRKAJE (Leposavić): uninvestigated remains of an old church.

GRMOVO (Vitina): a church existed in the village (priest mentioned in the Turkish census of 1455).

GRNČAR (Vitina): 1. village church of St Nicholas constructed on the foundations of an old, in all likelihood monastic, church; 2. ruins of the church of St Paraskeve, above the village; 3. ruins of an old fortress, called Staro Gradište or Kaleja, above the village; 4. shrine from the pagan epoch and late antiquity, and, as it appears, a Christian cell – hermitage, in the cave above the village.

GULIJE (Leposavić): small village church, south-east of the village.

GUMNIŠTE (Vučitrn): ruins of two churches, in the mahalas of Zekej and Memetej; an old cemetery situated on the site called Ulica.

GUNCATE (Mališevo): in the mid-19C, remains of a former church and of an old graveyard still existed.

GUŠICA (Vitina): old church with a graveyard formerly existed.

HOČA ZAGRADSKA (in the Middle Ages Hodča beneath Cviljen, Prizren): 1. remains of the church of St Nicholas (mentioned in notes from the 16C and 17C) recorded in the 19C.

HRTICA (in the Middle Ages Rtica, Podujevo): remains of the church of St Cyrill and Methodios, with an old graveyard, in Donja Hrtica.

IBARSKO POSTENJE (Leposavić): remains of a church on the hill called Crkvine (ruins of a church).

IGLAREVO (Klina): old church (a village priest mentioned in the 15C) and a graveyard existed.

ISTINIĆ (Dečane): 1. monastery of St Symeon, mentioned in 1485; 2. ruins of the church of St Elijah, registered in the 19C; 3. so-called "Obaljena" ("Pulled down") church, mentioned in the 19C; 4. in the first half of the 20C, old Serbian tombstones could still be seen in the present-day Albanian cemetery.

ISTOK: 1. remains of an ancient church, in the old graveyard, on the site called Crkvine (ruins of a church); 2. church of St Peter and Paul, erected in 1929; 3. Gorioč monastery with the old church of St Nicholas (according to tradition, dating from the 14C, repeatedly restored).

IVAJA (in the Middle Ages Ivanje, Kačanik): ruins of a church (of St Demetrios?), on the site called Crkva (Church).

IZBICE (Srbica): the church of the Ascension in "Isbinac", known from historical sources, probably located in the vicinity of the village.

JABLANICA (Djakovica): ruins of a church and a graveyard noted down in 1868.

JABUKA (in Kolašin upon the Ibar): remains of an ancient church and graveyard dating from the Late Middle Ages.

JANČIŠTE (Mališevo): in 1879, a graveyard with the remains of a former church still existed in the village.

JANJEVO (Lipljan): 1. church of the Holy Archangels Michael and Gabriel mentioned in the Plakaonička mahala in 1548; 2. church of the Annuciation mentioned in the Sopotska mahala in 1581; 3. on the foundations of the old church of St Nicholas (with frescoes and old inscriptions) a Catholic church was erected in the 19C.

JARINJE (Leposavić): remains of an old church and graveyard in the hamlet of Mijatovići; several specimens of old village houses typical of the area at the foot of Mt Kopaonik.

JASENOVIK (Priština): a church existed in the 15C; today there are two old graveyards and the ruins of two churches: in Beli Breg and near the hamlet of Filipovci (dedicated to the Virgin).

JAŽINCE (Uroševac): 1. church of St Paraskeve erected on the site of the former log-cabin church; 2. the site called Crkvine (ruins of a church) (near the present-day school), on which an old church formerly stood.

JELAKCE (in the Middle Ages Jelašci, Leposavić): remains of an old church near the hamlet of Stržin – perhaps the church of the Archangel Michael, erected by the Archbishop Danilo II (1324-1337).

JELOVAC (Klina): a church existed in the 15C; the remains of the church of St Paraskeve have survived in the graveyard and the ruins of another church on the hill called ĆĆelije (Cells).

JEŠKOVO (in the Middle Ages Elhovev or Elhovo, Prizren): in the 14C, the church of St Nicholas was situated in the neighbourhood of the village.

JEZERCE (Uroševac): 1. church of St Elijah, once situated on the site called Crkvena Livada (Church Meadow); 2. church of St Uroš, constructed in the 19C on the site of the large temple dedicated to the Dormition of the Virgin; 3. ruins of a church in the hamlet called Prorok, on the Rid ridge.

JOŠANICA (in the Middle Ages Jelšanica, Klina): remains of a church (of the Holy Saviour?) with whose material the mosque in the village of Lešan (Peć) was constructed in the 19C.

JOŠANICA (in the Middle Ages Jelšanica, Leposavić): remains of the old church of the Resurrection in the village graveyard and 4 roadside tombstones from the beginning of the 20C.

JUNIK (Dečane): old ruins of a church and a graveyrad in the Stepan-mahala. KABAŠ (formerly Grm, Vitina): demolished church, formerly situated near the village; the old graveyard has been plowed.

KABAŠ HAS (Prizren): remains of a medieval fortress with massive oval walls and a church in its centre, on the hill called Dubovi Sv Djordja (Oaks of St George).

KABAŠ KORIŠKI (formerly St Peter, Prizren): 1. hermitage and monastery of St Peter of Koriša with the remains of three layers of frescoes from the 13C and the 14C; 2. foundations of the church of the Virgin, next to the hermitage; 3. remains of a church with a crypt in the Luka-mahala; 4. unascertained remains of another church in the Luka-mahala, known from tradition; 5. ruins of the Graveyard church (remains of frescoes with Cyrillic inscriptions); next to the church was a cemetery with tombstones from the 15C and 16C, used for the construction of boundary lines between estates; 6. walls of a massive tower or a bell tower, on the hill of Čuklja.

KAČIKOL (Priština): remains of an old church and a graveyard in the mahala of Limonović.

KAJKOVO (in the Middle Ages Kaikovo, Leposavić): remains of an old graveyard church.

KALIČANE (Istok): an old church formerly existed; slabs from the church of Studenica Hvostanska were incorporated into the walls of the village mosque.

KALUDRA (in Kolašin upon the Ibar): 1. old graveyard and the ruins of a church in the hamlet of Velika Kaludra; 2. another old graveyard, in Mala Kaludra.

KAMENICA (Leposavić): remains of an old church with a dormitory, bell-tower and small graveyard.

KARAČE (Vučitrn): mycrotoponym "Crkva" (Church).

KARAČICA (Lipljan): a Serbian church existed in the 15C, as it appears, in the present-day locality called "Crkva" (Church).

KARAŠINDJERDJ (Prizren): old church of St George, after which the village was named, probably situated on the site called Crkvene Njive (Church Fields). Today this site is occupied by the memorial chapel of the Franciscan Stefan Dječovija.

KARMIL, KARMEL: unascertained monastery with the church of St Elijah from the 14C (built by the Serbian Patriarch Joanikije); registered in a 15th-century census as situated somewhere "in the nachye of Peć".

KAŠICA (Istok): 1. remains of an old church, in Brdo Mališića; 2. foundations of a church and an old graveyard (north of the village).

KIJEVČIĆE (in the Middle Ages also Doljani, Leposavić): ruins of a former church (above the confluence of the Crnilovica stream), an old water mill (on the stream), and an old graveyard.

KIJEVO (Klina): old church of St Nicholas from the 16C, perhaps even from the 14C; the narthex, added at a later date, was painted in 1602/3; the bell-tower dates from the 19C.

KISELA BANJA (Podujevo): remains of an old church on the site called Miloševa Crkva (Miloš's Church).

KIŠNA REKA (Glogovac): foundations of an old church, on the hill above the village.

KLADERNICA (Srbica): microtoponyms "Crkveni Do" (Church Valley) and "Srpsko Groblje" (Serbian Cemetery).

KLEČKA (Lipljan): a church existed in the 15C (the surviving toponym "Crkveni Do" (Church Valley)).

KLINA 1. remains of the church of the Presentation of the Virgin in the northern part of the village; the old and new cemetery located in proximity; 2. ruins of a former church were formerly situated in the village, in the clearing called Vakaf.

KLINAVAC (Klina): remains of the church of St Paraskeve in the village graveyard.

KLOBUKAR (Priština): ruins of an old church on the site called Crkvište (ruins of a church), and the remains of the slag ground of a medieval mine (Novo Brdo).

KLOKOT (Vitina): 1. demolished church of St Nicholas in the village; 2. Crkveni Lugovi (Church Groves) with the site called Lugovska Crkva (Grove Church) near the village; 3. traces of the old settlement called Vrban-grad; 4. old graveyard, formerly situated in the so-called Selište (remains of a village); 5. archaeological remains of a large Roman settlement.

KLOPOTNIK: ruins of the medieval fortress called Klopotnik, with the remains of a church and a suburb on the hill of the same name between the villages of Ugljar and Dobroševina.

KMETOVCE (Gnjilane): ruins of the monastery and church of St Demetrios (St Barbara) from the 14C, with the fragments of frescoes; next to the church is a very old cemetery.

KOBILJA GLAVA (in Kolašin upon the Ibar): old cemetery.

KOJLOVICA (Priština): an old graveyard in the village, and the remains of the old church of St Elijah, not far from the village.

KOLIĆ (Priština): a church existed once.

KOLO (Vučitrn): church of St Mark registered in the 15C (erected by Olivera Balšić in the 14C). The remains of two churches exist today: in the Raševački stream and in Klisura.

KOLOLEČ (Kriva Reka near Novo Brdo): old graveyard and an old church.

KOMORANE (Glogovac): locality "Crkveni Lugovi" (Church Groves); an old Serbian cemetery situated next to the village.

KONJUH (Lipljan): old graveyard.

KOPORICE (Leposavić): the village had churches as early as the 14C; nowadays their remains are found on the hill called Mali Krst (Small Cross) and in the hamlet of Zavrata (Modri Mel); an old graveyard stands on the site called Dub and the ruins of an ancient town are on the hill of Stražnik; remains of an old mining settlement have also survived.

KOPRIVNICA (Kriva Reka near Novo Brdo): a village church existed in the 15C; the remains of an old church and abandoned graveyard stand near the hill of Šitak, while the ruins of an old fortress are on the hill.

KORBULIĆ (Kačanik): an old church was situated in the wood, on the site called Crkva (Church), and an old graveyard on the site called Ključ.

KORENICA (Djakovica): old ruins, probably of a church.

KORETIN (Kriva Reka near Novo Brdo): a Slavic archaeological site (9-11C).

KORETIŠTE, KURETIŠTE (Gnjilane): remains of the church of the Virgin, in the part of the village called Selište (remains of a village); an old graveyard (Kana's graveyard) located near the village, and an abandoned medieval mine situated on the Glam hill.

KORIŠA (Prizren): 1. remains of the church of St Peter, erected before 1343 (with the fragments of 14th-century frescoes); restored several times, for it was demolished in 1885 (the mosque in Koriša built with its stone remains), then in 1915-1918 and in 1941; 2. remains of the church of St Nicholas, on the slopes of Gradište (demolished fortress); 3. ruins of the church of St George (14C) with the fragments of frescoes, in the village graveyard; 4. church of the Intercession of the Virgin with the fragments of murals from the 16-17C, riddled with bullets, in the hamlet of Vrelo; 5. remains of the fortified monastery of Mužljak (with the fragments of frescoes), abandoned in the 17C, above the hamlet of Mužljak; 6. monastery of St Mark of Koriša from 1467, restored in the 17C; in 1915, the Albanians devastated it and murdered the monks; the restored monastery was plundered in 1941; 7. hermitage of St Mark of Koriša, on the hill above the monastery.

KOSIN (Uroševac): remains of a church in the hamlet of Selište.

KOSMAČA (Glogovac): the mountain on which the ruins of a fortress are situated, as well as those of a church, or, according to tradition, the Ježevica monastery, King Milutin's foundation.

KOSORIĆ (in the Middle Ages Kosorići, Peć): remains of an old graveyard.

KOSOVCE, KOSOVCI (Dragaš): locality "Crkva" (Church) in the meadows testifies to the existence of an old church.

KOSOVO POLJE: church of St Nicholas, erected in 1940 on the foundations of an older ecclesiastical structure.

KOSOVSKA KAMENICA: 1. ruins of an ancient fortress, in all likelihood Prizrenac, on the Kuline hill; ruins of an old church are beneath it; 2. new church, erected at the beginning of the 20C on the foundations of an older one, in the town; surrounded by an old graveyard.

KOSOVSKA MITROVICA: 1. church of St Demetrios (14C) stood at the foot of Mali Zvečan; 2. church of St Sava (the end of the 19C); 3. traces of an old, small church in today's graveyard, on the road to Priština; 4. according to unconfirmed data, the church of St Elijah was situated in the southern part of the town.

KOSTADINCE (Kriva Reka near Novo Brdo): remains of an older Serbian village (devastated by the Turks in the mid-19C) and traces of an old cemetery on the site called Grobište.

KOSTIN POTOK (Leposavić): remains of an old church and an old graveyard.

KOSTRC (Srbica): traces of two small medieval churches and a medieval graveyard.

KOSTRCE (in the Middle Ages Kostrc, Suva Reka): the Byzantine and Serbian medieval fortress of Kostrc formerly overlooked the present-day village.

KOŠ (Istok): of two churches (according to tradition dedicated to the Virgin and St Nicholas), only the ruins have survived – one in the Obradović mahala, near the neglected "Sedlarević" graveyard, and the other in the village cemetery (a more recent church erected over it). The traces of foundations (according to tradition a monastery) can be found on the site called Devičak. The new church of the Holy Prince Lazar was constructed in the centre of the village in 1969.

KOŠARE (Uroševac): old necropolis called Srpsko Groblje (Serbian Graveyard).

KOŠTANJEVO (Uroševac): ruins of a church by the present-day mosque, on the site called Crkva (Church); in the 19C, the church of St Peter was situated near the village.

KOŠUTOVO (K. Mitrovica): ruins of a church existed in the locality called Crkva (Church).

KOŠUTOVO (Leposavić): according to unconfirmed data, the traces of the remains of a church and a graveyard exist there.

KOTLINA (Kačanik): foundations of a medieval church and several Orthodox tombs uncovered on the site of the present-day mosque.

KOTORE (Srbica): microtoponyms "Crkva" (Church) and "Crkveni Do" (Church Valley) have preserved the memory of the destroyed church.

KOVAČEVAC (Kačanik): ruins of an old church formerly existed.

KOVAČICA (K. Mitrovica): remains of a former church on the site called Crkvena Livada (Church Meadow).

KOZNIK (Orahovac): ruins of a modest-sized church surrounded by walls (probably a fortfied monastery in the past).

KPUZ (formerly Kupusce, Klina): 1. remains of an old church and an old graveyard on the hill of Dolinci; 2. ruins of a church (west of the village) whose stone fragments were used for marking boundaries between estates.

KRAJIŠTE (Lipljan): remains of the monastic church of the Holy Anargyroi in the Serbian cemetery (mentioned in 15th-century documents), demolished by Jašar-Pasha Džanić in the 19C.

KRAJNI DEL (formerly Kranidol, Kriva Reka near Novo Brdo): monastery of St Luke mentioned in the 15C and the 16C; today, there is the locality "Srpsko Groblje" (Serbian Graveyard); the traces of an old settlement exist on the site called Selište (remains of a village).

KRALJANE (Djakovica): remains of an old fortress and a church with a small graveyard situated on the hill near the village (according to tradition, it was a large king's town with the church of St John the Baptist).

KRASMIROVAC (Srbica): locality "Srbinov Grob" (the Serb's Grave), probably occupied by a graveyard once.

KRAVASARIJA, KRAVOSERIJA (Mališevo): ruins of a church upon which a primary school building was erected after 1945.

KREMENATA (Kriva Reka near Novo Brdo): remains of an old church and graveyard on the site of a former settlement (not far from the present-day Serbian cemetery); the remains of the medieval mine of Ce'ovi are located in the vicinity of the village.

KRILJEVO (Kriva Reka near Novo Brdo): ruins of an old church on the site called Crkva (Church).

KRNJINA (Istok): old graveyard, formerly with a church, on the hill above the village; the localities "Kod Crkve" (By the Church) and "Crkvište" (i.e. ruins of a church) exist in the village.

KRNJINCE (Klina): church of St George, with a graveyard, demolished in the second half of the 19C.

KRPIMEJ (Podujevo): 1. church of St Peter and Paul on the Kraljevica hill, erected upon the foundations of an older, according to tradition medieval, religious building; 2. remains of medieval walls unearthed in the village, probably belonging to an ecclesiastical structure.

KRSTAC (Dragaš) 1. ruins of the church of St Pantaleemon, on the Pantelevac hill in Veliki Krstac; 2. remains of a church on the Djula hill; 3. remains of a former church and an old graveyard in Mali Krstac, on the site called Rudina.

KRUŠEVAC (Srbica): in the 13C, the churches of St Bartholomew and St Elijah were situated near the village (unascertained).

KRUŠEVICA (Podujevo): a 15th-century written source indicates that a monastery may have existed in the village or its surroundings.

KUĆICA (Srbica): the mid-19C recorded the ruins of two churches; today a microtoponym survives indicating that a graveyard also existed once.

KUKULJANE, KUKOLJANE (Dragaš): microtoponym "Crkva" (Church) survives.

KUTNJE (Leposavić): ruins of the Kutna church, on the hill by the Ibar river.

KUZMIKAN, KUZMIĆANI, KOZMEKAN: an unscertained monastery in "the nachye of Peć" (mentioned in the Turkish censuses from the 15C and the 16C).

KUZMIN (in the Middle Ages Kuzmino, Priština): ruins of an old church and an old graveyard.

KRVENIK (in the Middle Ages Pokrivenik, Kačanik): ruins of the so-called Staro Selo, with the remains of a church (the village burned down by the Turks in 1690).

LABLJANE (Peć): not far from the village stands the ancient oak-tree next to which the Patriarch Arsenije III gathered the Serbs who escaped from the Turks in 1690 and started the Great Migration to the north. An old graveyard, and perhaps the old ruins of a former church, was situated next to the oak.

LABLJANE (Priština): old cemetery.

LABUČEVO (Orahovac): anchoritic cave-dwellings, the so-called Uljarice, north-east of the village, in the ravine above the cascades of the Miruš river – 1. the large rock-cut church from the 14C, restored in the 16C, with the fragments of medieval ceramics, glass and frescoes; 2. small rock-cut dwelling (the remains of frescoes completely destroyed by Albanian shepherds).

LAJČIĆ, LEJAČIĆ (in the Middle Ages Leočić, Kriva Reka near Novo Brdo): ruins of an old church and an old graveyard formerly existed.

LANDOVICA (in the Middle Ages Lutovica, Prizren): the 19C recorded the remains of the church of St Catherine and an old graveyard in Nemišlje.

LAPLJE SELO (in the Middle Ages Ljapov, Priština): church of St Paraskeve, recently erected upon the remains of an older church (village priests mentioned as early as the 15C).

LAUŠA (in the Middle Ages Loviša, Srbica): 1. medieval monastery of Devič, restored several times, with the complex of churches dedicated to the Presentation of the Virgin, St Ioannikios and St George. In 1941 dynamited by the Albanian nationalists. The monastery reconstruction, in whose ruins frescoes from the 15C, 16C and 19C were uncovered, commenced in 1950; 2. hermitage of St Ioannikios of Devič, on the hill north of the monastery, demolished in 1941; 3. medieval cemetery called Groblje Srba (Graveyard of the Serbs), in the village.

LEOČINA (in the Middle Ages Lel'čino, Srbiac): 1. church of St John from the 14C, completely reconstructed in the 16C, with the remains of frescoes (16C); next to it stretches a large graveyard with stone crosses from the 17C, the 18C and the 19C; 2. remains of the so-called Kaludjerska (Monks') church (of the Transfiguration) (14C).

LEPINA (Lipljan): church existed in the 15C; old ruins and an old graveyard survive.

LEPOSAVIĆ 1. remains of the church of the Dormition of the Virgin, by the graveyard; 2. remains of the church dedicated to the Palm Sunday, in the part of the settlement called Ulije; 3. church of the Crucifiction, constructed in 1935 on the foundations of an older church, on the Gradac hill.

LESKOVAC (in the Middle Ages Leskovec, Klina): an old church existed (the traces of which have perished).

LESKOVČIĆ (Priština): old graveyard.

LESKOVEC (Prizren): the site formerly occupied by an old graveyard.

LEŠAK (in the Middle Ages Lješ'k, Leposavić): 1. church of the Dormition of the Virgin, erected in recent times on the foundations of an older church; 2. "Borjani" church in the hamlet of Kamen; 3. old graveyard in the hamlet of Vrujci, on the Okruglica hill; 4. drinking fountain called Sulender in the hamlet of Vrujci; earthen pipes brought water to it even in the Middle Ages.

LEŠANE (Suva Reka): remains of the church dedicated to St Kyriake.

LEŠNICA (Podujevo): a church existed (a village priest mentioned as early as the 15C).

LEŠTANE (Dragaš): in 1861, the ruins of a church were recorded to have existed in the village.

LEŠTAR, LJEŠTAR (in the Middle Ages Leštije, Kriva Reka near Novo Brdo): remains of two demolished churches – on the site called Manastir (Monastery) and the present-day cemetery.

LETNICA (Vitina): new church of the Virgin erected in 1934 on the foundations of the Catholic church from 1584 (restored in the 19C), treasuring two wooden statues from the 16/17C.

LIPLJAN 1. church of the Presentation of the Virgin from the 14C (reconstructed and expanded in the 16C) with frescoes from the 14C and 16/17C; beneath the church foundations, the remains of two older basilicas have been uncovered; 2. church of SS Florus and Laurus, recently constructed.

LIPOVAC (Djakovica): a church probably existed on the site called Crkvena Stena (Church Rock), above the village.

LIPOVCI (Gnjilane): ruins of the old church of St Paraskeve

and an old graveyard, in the village; the remains of an older settlement near the village.

LIPOVICA (K. Mitrovica): the remains of an old, small church and an old cemetery.

LIPOVICA (in the Middle Ages Lipovci, Lipljan): a church formerly existed (suggested by a reference to a village priest in a 15th-century source and a microtoponym).

LISICA (K.Mitrovica): locality called "Staro Groblje" (Old Graveyard) and the ruins of an old church.

LISOCKA (Kriva Reka near Novo Brdo): traces of an old cemetery, on the site called Jovanovo Groblje (Jovan's graveyard); the ruins of an old Serbian church are situated next to it.

LIVAĆE (in the Middle Ages Livadije, Lipljan): church of St Gregory the Theologos erected in 1935 on the site of an old graveyard church, demolished to the order of the Turks.

LIZICA (Peć): according to historical sources, in this place (unascertained) the Archbishop Nikodim (1317-1324) constructed the church of St Sava, adorned by his successor Danilo II.

LOĆANE (Dečane): remains of a church existed until the end of the 19C; an old cemetery and a village log-cabin (one of the oldest in Serbia) have survived.

LOKVICE (Prizren): 1. remains of the church of the Holy Archangels (14C); 2. ruins of the church of St John or St George (16C); 3. church of St Elijah, erected in 1866 on the foundations of an older church; 4. old cemetery.

LOVAC (in the Middle Ages Lovač Potok, K. Mitrovica): old graveyard with the ruins of a former church.

LOVCE (Gnjilane): two demolished churches used to exist; at present, there is only the locality called Crkveno Brdo (Church Hill).

LUČKA RIJEKA (in Kolašin upon the Ibar): 1. church from more recent times built upon the foundations of an older religous building; 2. ruins of an old, small-sized church, in Prijeselo, in the old graveyard; 3. old graveyard in Prljevo.

LUKA (Dečane): remains of a church and an old graveyard noted in the 19C.

LUKARE (Priština): it is known where the sites of the ruins of a church and an old graveyard were located.

LUKINAJ, LUKINJE (Priština): ruins of a church (according to tradition, of St Luke) on the site called Crkveni Do (Church Valley).

LUŽANE (Podujevo): 1. medieval monastery of St Nicholas, known from sources (unascertained); 2. Pasha's mill, built with the stone remains of the Serbian churches in the villages of Burince and Bradaš.

LJEŠANE (Peć): after expelling the Serbs in the 19C, Hadži Zeka, an Albanian, erected a mosque in the village making use of the stone and marble columns taken from the vast church of the Holy Saviour in the village of Jošanica.

LJEVOŠA (Peć): 1. remains of the church of St Nicholas, on Tavor; 2. remains of the church of St George "in Ždrelnik" (before 1411); 3. remains of the church of St Demetrios (14C), with the traces of frescoes featuring Cyrillic letters, in Meta's meadow; 4. remains of the church of the Birth of St John the Baptist, on the site called Crkvine (Ruins of a Church); 5. remains of the church of the Holy Archangels in the village; 6. remains of the church of St Symeon the Myrrobletos; 7. monastic bell-tower on the Idvorac hill; 8. old graveyard above Savo's meadow; 9. remains of the medieval fortress of Ždrelo, at the entrance to the Rugovska ravine; 10. Kuzmića Peštera (the Kuzmićs' Caves), a rock-cut dwelling west of the village; 11. according to tradition, the residence of a Patriarch of Peć was formerly situated in the hamlet of Krstelan.

LJUBENIĆ (Peć): old and new cemetery.

LJUBIČEVO (Prizren): a written source from 1348 makes mention of the church of St Nicholas (unascertained).

LJUBIŽDA (in the Middle Ages Ljubižnja, Mališevo): 1. remains of a former church, in the centre of the village, in the locality called "Kod Crkve" (by the Church); 2. remains of a structure, probably religious, and several graves, on the Ljubiždanski peak.

LJUBIŽDA (in the Middle Ages Ljubižnja, Prizren): 1. church of St Nicholas from the 16C, restored and painted in 1867; 2. ruins of the church of the Holy Saviour (the survicing Royal Doors dating from the 16C), upon which apartment houses have been recently constructed; 3. ruins of the church of St Paraskeve, on the right bank of the Ljubiždanska river; 4. remains of the church of St John (the surviving Royal Doors from the 16C) on the hill above the village; 5. remains of the church of St Kyriake, near the village drinking fountain; 6. remains of the church of St Kyriake, in the hamlet of St John; 7. remains of the church of St Nicholas, in the hamlet of St John; 8. remains of the church of the Holy Anargyroi, in the hamlet of Todosići; 9. new church of St Elijah, in the Serbian cemetery, erected on the remains of an older church dedicated to the same saint; 10. remains of the church of the Holy Archangels, in the yard of the present-day mosque; 11. remains of the church of St George near the Co-operative centre.

LJUBIŽDA HAS (Prizren): a church existed, perhaps on the site called Grobovi (Tombs).

LJUBOVAC (in the Middle Ages Ljuboviće, Srbica): old and new cemetery of the expelled Serbs.

LJUBOVIŠTE (in the Middle Ages Ljubovići, Dragaš): according to tradition, the village had nine churches; the remains of only one, allegedly monastic, church have survived on the site called Dub.

LJUBOVO (Istok): 1. church of St Basil of Ostrog, built in 1939; 2. traces of an old graveyard, on the site called Markov Cer (Marko's Oak).

LJUBOŽDA (in the Middle Ages Ljubošta, Istok): 1. foundations of a church (with the fragments of frescoes) and a dormitory, in the village; 2. remains of a church and an old graveyard in the present-day graveyard; 3. remains of an old town-fortress, on the hill called Gradina.

LJUBUŠA (in the Middle Ages Streoce, Dečane): in 1854 the ruins of the church of St Elijah were seen by A. Boue in the village.

LJUMBARDA, LJUBARDA (Dečane): ruins of an old church and a modest-sized cemetery recorded in the 19C.

LJUŠTA (in the Middle Ages Ljuštica, K. Mitrovica): remains of a small, old church, below the hill in the village.

LJUTOGLAV (Prizren): old cemetery.

LJUTOGLAVA (Peć): 1. ruins of an old church formerly stood in the graveyard; 2. remains of an ancient town (mentioned in 1220), on the hill above the village.

MAČITEVO (Suva Reka): ruins of an old church in the centre of the village, and an old graveyard.

MADJERA (K. Mitrovica): a microtoponym testifies that a church existed in the village.

MAJANCE (in the Middle Ages Mojanovce, Podujevo): a church existed in the 15C.

MAJDEVO (Leposavić): walls of an old church in the village, and the remains of a fortified structure on the site called Kuline.

MAKOVAC (Priština): microtoponyms "Crkvene Njive" (Church Fields) and "Crkveni Do" (Church Valley) bear witness to the existence of a church before the Albanians settled here.

MALA SLATINA (Priština): microtoponym "Crkva" (Church) and the Serbian graveyard formerly existed in the village.

MALI DJURDJEVIK (Klina): old graveyard and the ruins of an old church.

MALI GODEN (Gnjilane): the Albanians that settled in 1780 found a dilapidated Serbian church and an old well which still exists today.

MALIŠEVO (formerly Maleševo, Gnjilane): a church and an abandoned old graveyard were situated by the Vlajkovac stream.

MALO KRUŠEVO (Klina): remains of the church of the Virgin Amolyntos and an old cemetery.

MALOPOLJCE (Uroševac): 1. three localities bearing the name "Crkva" (Church) exist today in the village whose priest is mentioned in the 15C; 2. walls of a demolished church, on the ridge called Pokvarena Crkva (Ruined Church) (Rid).

MALO ROPOTOVO (Kriva Reka near Novo Brdo): old and abandoned church of St Nicholas, on the hill outside the village.

MAMUŠA (in the Middle Ages Momuša, Prizren): clock-tower (1815) in the yard of the mosque; its bell was taken from a Smederevo church and brought as a booty by Mahmud-Pasha Rotul.

MANASTIRCE (Uroševac): a church (Drenkova Church) and a monastery existed in the 15C and 16C, the ruins of the latter have survived (on the site called Vrelo).

MANASTIRICA (Prizren): a church stood on the hill, northeast of the village (its traces have disappeared).

MANIŠINCE (Priština): 1. traces of an old settlement and a church in the part of the village called Selište (i.e. remains of a village); an old cemetery.

MAREVCE (in the Middle Ages Maroevci, Priština): 1. ruins of a church by the Kukavička river; 2. remains of a church by the Modri stream; 3. ruins of a church in Klokoč; 4. demolished church in the settlement called Nikšino Kolo (whose priest is mentioned in a note from the 16C); 5. remains of ore processing facilities from the Middle Ages.

MARINA (Srbica): written sources from the 15C and 16C testify to the former existence of a church.

MARMULE (Djakovica): ruins of a church and an old cemetery registered in the 19C; the remains of an old church and a graveyard can be discerned on the Rezina hillock, above the village; another old graveyard located at the entrance to the village.

MATICA (K. Mitrovica): traces of the old ruins of a church and a graveyard.

MATIČANE (Priština): 1. large 10th-century necropolis, belonging to the so-called Belobrdska Slavic culture; 2. old and abandoned graveyard.

MAZAP (in the Middle Ages Mihozub, Podujevo): old graveyard.

MAZGIT (Priština): 1. memorial turbeh to the Turkish Sultan Murad I on the site where he was murdered by a Serbian

nobleman (Miloš Obilić) during the battle of Kosovo in 1389; 2. Marble Column (destroyed), erected by the Despot Stefan Lazarević on the site of the battle of Kosovo; the text written on the column, dedicated to the Serbian warriors, has survived in copies; 3. monument to the legendary Serbian hero Miloš Obilić, destroyed by the Albanian nationalists in 1941.

MAZNIK (Dečane): ruins of a church and the remains of a graveyard recorded in the 19C.

MAŽIĆ (K. Mitrovica): 1. ruins of an old church in the village; 2. ruins of two churches formerly situated on the site called Stara Trepča, in the village area; 3. ruins of the oldest mosque in Kosovo (15-16C).

MEDREGOVAC (in the Middle Ages Milidrugovce, Podujevo): Serbian cemetery.

MEDVECE (Lipljan): old graveyard.

MEDJEDJI POTOK (in Kolašin upon the Ibar): 1. ruins of a former church and an old graveyard in the hamlet of Krivčevići; 2. old graveyard in the hamlet of Kopilovići; 3. old graveyard called Groblijšte, above the Čukića mahala.

MELJENICA (K. Mitrovica): microtoponym "Kod Crkve" (By the Church) points to the site of a former ecclesiastical structure.

MEŠINA (Kriva Reka near Novo Brdo): 1. ruins of a church on the site called Svilaš; 2. walls of a Serbian church in the graveyard, in the hamlet of Potok.

METOHIJA (Podujevo): remains of an old church on the site called "Crkva" (Church) in the village whose priests are mentioned in the 15C; another church was situated in the village cemetery, in the Donja Metohija mahala.

MIGANOVCE (Kriva Reka near Novo Brdo): old ruins of a church and an old graveyard.

MIJALIĆ (Vučitrn): ruins of two churches – in the hamlet of Topal-Mihalić and by the Church stream.

MILANOVIĆ (Mališevo): microtoponym "Crkvište" (Ruins of a Church).

MILJAJ, MILA (in the Middle Ages Milišta, Prizren): ruins of a church recorded on the Kulin hill near the village, in the 19C.

MIOKOVIĆE (Leposavić): old ruins of a church and a graveyard; two water-mills on the stream.

MIRUŠA (Mališevo): church treasuring a collection of medieval manuscripts formerly existed; the foundations of a church were situated in the vicinity of the village, on the site called "Kod Crkvenog Cera" (By the Church Oak).

MLEČANE (formerly Mlečani, Klina): church of St Nicholas (called St Paraskeve), with frescoes from 1601/2, in the graveyard on the hill above the village.

MLIKE (Dragaš): foundations of a church recorded in the 19C; the ruins of a former church and an old cemetery presently situated in the hamlet of Djurdjevica.

MOČARE (K. Kamenica): ruins of the monastery of Ubožac (Rdjavac) from the first half of the 14C, with the church dedicated to the Presentation of the Virgin (surviving fragments of frescoes).

MOGILA (Vitina): church of St Theodore on the hill in the centre of the village; the old cemetery near the village has been plowed.

MOGLICA (Djakovica): ruins of an old church in today's Catholic cemetery; microtoponym "Pusto" or "Svadbarsko Groblje" (Deserted or Wedding Guests' Graveyard).

MOJSTIR (Istok): two churches existed – in the present-day hamlet of Staro Selo, on the site called Crkvište (Ruins of a Church), and in the cemetery situated in the village.

MOKRI DOL: unascertained monastery, somewhere in the vicinity of Peć (mentioned in Turkish census from 1485 and the 16C).

MONASTERY OF ST PETER AND PAUL: unascertained monastery, formerly belonging to Vučitrn, mentioned in a 16th-century Turkish census.

MORINA (in the Middle Ages Homorje, Djakovica): historical sources indicate that a church might have existed there.

MOŠINCE (Leposavić): old ruins of a church and a graveyard.

MOVLJANE (in the Middle Ages Muhovljani, Suva Reka): ruins of an old church and an old cemetery.

MRAMOR (Priština): two churches existed – on the site called Ljog, and the site called Manastir (Monastery) (the latter probably monastic).

MUČIVORCE, MUČIVRCE (Kriva Reka near Novo Brdo): a priest mentioned in the village as early as the 15C; at present, the ruins of a Serbian church and an old Serbian graveyard are situated in it.

MURGA (Srbica): remains of an old church.

MURGULA (Podujevo): a church existed in the 15C.

MUŠNIKOVO (Prizren): 1. church of St Peter and Paul with frescoes from 1563/64 erected, according to tradition, upon the foundations of a 14th-century church; 2. church of St Nicholas in the graveyard, erected and painted in the second half of the 16C, with icons from the 17C.

MUŠUTIŠTE (Suva Reka): 1. church of the Virgin Hodeghetria, erected in 1315 and frescoed soon afterwards; apart

from the remains of frescoes, the church is embellished with two icons from 1603; 2. remains of the church of St Nicholas in the Upper mahala; 3. small church of the Holy Saviour in the Mecićeva mahala; 4. church of St Symeon (mentioned in 1326) which has perished; 5. remains of the church of the Holy Archangel Michael in Pasha's mahala; 6. ruins of the church of St Nicholas in Pasha's (Golema) mahala; 7. remains of the church of St Athanasios in Pasha's mahala; 8. remains of the church of St George in the Kovačevićeva mahala on the site called Mijovac; 9. church of St Paraskeve, west of the village; 10. ruins of a church beneath the Bolovan mountain ridge, on the site called Carevac; 11. monastery of the Holy Trinity – Rusinica (the 14C-16C); 12. Rusinica hermitage (in all probability, from the 14C), above the monastery; 13. Matoske hermitages, by the spring of the Matoski stream; 14. locality called "Gradac" with the remains of an old fortress upon which a hunting house has been recently erected (above the hermitages).

MUŽEVINE (Istok): remains of an old church (completely perished).

MUŽIČANE (Uroševac): small church and an old graveyard near the village, on the site called Staro Selo.

NABRDJE (Peć): ancient ruins of a church and an old graveyard.

NAGLAVCI (Klina): remains of an old church, dedicated, according to tradition, to St Arsenije of Serbia, formerly existed in the old village graveyard.

NAKLO, in the Middle Ages Nakla Vas (Peć): new church, erected in 1985, upon the remains of an old church (of St John the Baptist ?) in the old graveyard.

NAŠEC (Prizren): 1. remains of the summer residence ("Ribnik") of the Serbian emperors Dušan and Uroš, uncovered on the hill above the Drim river, on the site of today's motel; 2. remains of an old church situated in the village, flooded by an artificial lake.

NEBREGOŠTE (in the Middle Ages Nebregošta, Prizren): ruins of the church of St Elijah.

NEC (formerly Netic, Djakovica): foundations of a Serbian church erected in 1920; in 1941, it was demolished the Albanians, who also set the village ablaze.

NEČAVCE, NEĆAVCE (Kačanik): remains of an old church.

NEGROVAC (Glogovac): mention of a village priest in the 15C and the microtoponym "Crkva" (Church) testify to the existence of a church.

NEKODIM, NIKODIM (Uroševac): residence of the Serbian Archbishop Nikodim (1317-1324) and a church were situated in the village; the locality called "Stara Crkva" (Old Church) and the church of St Elijah, restored in 1975, exist today.

NEPOLJE (in the Middle Ages Dnepolje, Peć): old graveyard on the site called Camov Do.

NEVOLJANE (Vučitrn): remains of an old church on the site called Crkvište (Ruins of a Church), and an old graveyard.

NIKA (Kačanik): remains of an old church on the site called Kamenica.

NOSALJE (Gnjilane): ruins of the church of the Holy Saviour on the Glavica hill and the locality called "Crkvište" (Ruins of a Church).

NOVA ŠUMADIJA (Prizren): remains of the cemetery of the expelled Serbs.

NOVI MIRAŠ (Uroševac): traces of a church on the site called Crkveni Laz (Church Lane) (a village priest mentioned in the 15C).

NOVO BRDO (Priština): 1. ruins of the cathedral church erected in the second half of the 14C, with the fragments of frescoes and stonework featuring Serbian inscriptions (converted into a mosque in 1466); 2. remains of a modest-sized and somewhat older town church, next to which a large place of worship was constructed; 3. remains of the medieval Jovča church, in Jovan's mahala; 4-5. two churches, the so-called Čifte Kilise (Paired Churches) – 4. old graveyard with two churches, the so-called Čifte Kilise (Paired Churches); one of the two old town cemeteries lies next to them; 6. church of St Stephen, situated in the vicinity of St Mark's churches; 7. church of the Virgin (subsequently called "Pod Javorom" (beneath Mt Javor)) located north-east to the fortress; demolished by the Turks on their seizure of Novo Brdo.

NOVO SELO (Kriva Reka near Novo Brdo): remains of an old church and an old cemetery near the village, on the site called Crkva (Church).

NOVO SELO (Peć): in the 15C, two villages bearing this name were mentioned to have existed in the vicinity of Peć; one of them had a church. Present-day Novo Selo had a graveyard at the beginning of the 20C.

NOVO SELO (in the Middle Ages Selce, Priština): remains of the church of the Holy Archangels and an old graveyard became flooded when an aritficial lake was constructed on the Gračanka river in 1965.

OBILIĆ (formerly Globoderica, Priština): old graveyard and a more recent church building in the graveyard.

OBJEDNIK (Dragaš): the site in the župa of Gora where the remains of a church and a graveyard are located.

OBRANČA, OBRANDŽA (Podujevo): locality "Kod Crkve" (By the Church), in the hamlet of Durići.

OBRINJE (Glogovac): a church existed in the 15C; according to tradition, it occupied the site of the present-day mosque.

ODANOVCE (Kriva Reka near Novo Brdo): a church formerly situated next to the present-day Serbian graveyard.

ODEVCE (Kriva Reka near Novo Brdo): 1. ruins of the church of St Paraskeve in the present-day cemetery; 2. old graveyard on the site called Dublje.

OGOŠTE (in the Middle Ages Holgošta, Kriva Reka near Novo Brdo): in the 14th century, mention is made of the church of the Virgin (located in the old cemetery in the hamlet of Bobovnik).

OKLANCE (in Kolašin upon the Ibar): 1. remains of an old church and a century-old graveyard in the hamlet of Trnjane; 2. remains of the foundations of a church in the hamlet of Crkvine (ruins of a church), on the site called Orah.

OKRAŠTICA (Vučitrn): a church formerly existed; its priest was mentioned in a census from the 15C.

OPRAŠKE, OPRAŠKA (Istok): remains of the church of St Jeremiah (whose priest was mentioned in the 15C) and an old graveyard.

OPTERUŠA (Orahovac): 1. ruins of the church of St George from the 16/17C with the remains of frescoes, on the hill in the old graveyard; 2. church erected in 1925 over the remains of the church of the Holy Saviour, south of the village; 3. church of St Nicholas, restored in 1934, upon old foundations.

ORAHOVAC: 1. church of the Dormition of the Virgin, reconstructed on its old foundations in 1859; 2. dormitory of the Monastery of the Patriarchate of Peć, erected in 1848 in the spirit of traditional architecture; 3. clock-tower erected in 1815 by Mahmud-Pasha Rotulović and furnished with a bell from the plundered churches in Smederevo; 4. until recently, the remains of a church stood on the site called Dubljane.

ORAHOVO, ORAOVO (in the Middle Ages Orjahovo, K. Mitrovica): locality called "Srpsko Groblje" (Serbian Graveyard).

ORAOVICA (Kriva Reka near Novo Brdo): old graveyard.

ORČUŠA (in the Middle Ages Orčuša, Dragaš): ruins of an old church formerly existed.

ORLANE (in the Middle Ages Orlani, Podujevo): according to a testimony from the 16C, the so-called Izborna church was located in the vicinity of the village. Nowadays, in the village (not far from the Brvenik fortress) there are the ruins of a church. The remains of another church (of St Constantine and Helena ?) stand on the hilltop where the present-day cemetery is situated; further to the east, an older Serbian necropolis has survived.

ORLATE, formerly Orlat (Glogovac): Orlate monastery, near the village, demolished in 1885 so that the village mosque would be constructed with its stone.

ORLOVIĆ (Priština): on the Gazimestan hill (near the village) there are: 1. monument to the Serbian warriors fallen in the battle of Kosovo in 1389, erected in 1953 on the site of the former, demolished in 1941; 2. turbeh with tombs of the Turkish warriors fallen in 1389.

ORNO BRDO, RUDNO BRDO (Istok): the site of an old graveyard is known.

OSEK HILJA (formerly Osak or Usak, Djakovica): remains of a medieval church, outside the village, by the Jagoila river, where the old graveyard was also situated in the 19C.

OSOJANE (Istok): 1. "Ivanja Crkva" (the church of St John), mentioned in sources from 1314 and 1485; appears to have been situated on the hill in the Serbian garveyard; 2. Nikoljača church (of St Nicholas), in the meadow on the hill; 3. ruins of a former church, beneath the site called Zvečan.

OSTRAĆE (Leposavić): 1. ruins of the old Borjanica church, in the hamlet of Žigolj; 2. medieval graveyard, on the Kula hill in Žigolj; 3. remains of medieval structures – of a town, according to tradition, and the ruins of the graveyard church on the site called Velika Livada; 4. old graveyard on the site called Tuturica; 5. remains of a Turkish watch-tower from the 19C, on the site called Merkez.

OSTROZUB (Mališevo): a written source from the 15C indicates that a church or a monastery may have existed here.

OŠLJANE (Vučitrn): old cemetery situated on the site called Bojlija; in the 15C, the village must have had a church (a census from that time makes mention of a village priest).

OVČAREVO (Srbica): 19th-century writers of travel accounts saw the ruins of three churches in the village, of which one certainly was the church of St Nicholas, mentioned in a notice from 1562.

PACAJ (Djakovica): a church erected after 1918 formerly existed. In 1941, the Albanians demolished it together with the entire village.

PADALIŠTE (Srbica): 1. foundations of an old church on the hill in the lower part of the village (50 years ago the church still had vaults); an old graveyard was next to it; 2. remains of a small church, in the southern part of the village, on the site called Vakuf.

PALATNA (in the Middle Ages Polatna, Podujevo): remains of church foundations, encircled by an old graveyard.

PALIVODENICE (Kačanik): traces of a larger place of worship, probably a church, oriented in the west-east direction.

PANČELO (Izmornik): abandoned old graveyard, further to the west of the present-day village.

PANTINA (Vučitrn): ruins of an old church in the old and new graveyards, in Glavica also called Verište.

PAPRAĆANE (Dečane): a church existed in the 15C (mention made of its priest). Today, a graveyard is located in the village.

PAPRATNA, PAPRADINA (now Firaja, Uroševac): the 19C recorded the existence of a half-demolished church with frescoes and icons, surrounded by a large graveyard.

PARALOVO (Gnjilane): 1. ruins of a church in the Perinska mahala; 2. remains of the church in the Petkovska mahala.

PARTEŠ (Gnjilane): ruined church of the Holy Saviour, on the hill of Glavičica above the village, and the old graveyard called Svatovsko (the Wedding Guests').

PAŠINO SELO (Peć): neglected old graveyard called Srpsko Groblje (Serbian Graveyard).

PAŠTRIK (in the Middle Ages P'str'c, Prizren): the mountain on whose summit two cult tombs are situated – that of St Elijah (formerly with a church) and of St Panteleemon.

PEĆ 1. monastery of the Patriarchate of Peć (see p.); 2. unascertained monastery of St Nicholas "on Tavor" from the 14C, situated in the vicinity of the Patriarchate; 3. unascertained church of St Sava of Serbia in Lizica, erected and painted owing to the efforts of the Serbian Archbishops Nikodim (1317-1324) and Danilo II (1324-1337); 4. Mark's cave-dwelling, a prehistoric residence and medieval hermitage, above the spring called Crne Vode; remains of a medieval church or a bell-tower are located above the cave; 5. Ružica church, according to tradition formerly standing on the site of the present-day Bajrakli-mosque; 6. Ivanovac church, unascertained (St Nicholas in Ivanac), mentioned in the 14C and the 16C, located near the Patriarchate; 7. Ivanica chapel, recently demolished, in the mahala of Kapištnica; 8. small church of St Paraskeve, constructed upon the remains of an older church, in Kargač park; 9. small church of St Gregory, in the yard of the Institute of Agriculture, converted into a Muslim turbeh; 10. chapel of St Basil, near the sugar refinery, converted into a turbeh; 11. Defterdar-mosque constructed with the material of the old town church called Djurdjevi Stupovi, on its former site; 12. Kenavija, Ćenavija, a convent with a school for girls and a small church, stood in the town centre in the 19C; 13. town church of St John erected in 1982 in the centre (Pesak), instead of the dilapidated old church; 14. Jerinka, the hillock on the northern side of Peć, formerly occupied by an old graveyard (destroyed by the Turks); 15. another old graveyard, for the most part destroyed during the construction of new buildings in recent times; 16. church of the Virgin of the Passion, the Tenderness, stood on the site of the present-day Djul-Fata's mosque; 17. church of St Paraskeve, once situated on the site of the Red Mosque; 18. rock-cut dwellings (Jerina's caves) in the rocks of Srednja Gora in the Rugovska gorge – a) the hermitage called Crne Makaze (Karamakaz) (Black Scissors), inhabited in prehistoric age; in the Middle Ages partitioned by walls and painted by frescoes; b) hermitages on the left bank of the Pećka Bistrica – a series of hermitages active from the 13C.

PEĆANE (Suva Reka): 1. remains of the church of the Presentation of the Virgin, constructed and painted in 1451/52 (part of frescoes in the National Museum, Belgrade); 2. rock-cut dwelling above the church; 3. remains of a small church below the village, to the south.

PERANE (Podujevo): old graveyard with the remains of a church, and the remains of another church building, on the hill near the village.

PESTOVO (Vučitrn): remains of an old church in the village graveyard.

PETIGOVAC, PETKOVAC (a suburb of Gnjilane): a medieval church, undoubtedly dedicated to St Paraskeve, formerly existed.

PETKOVIĆ (Orahovac): in the 19C, an old graveyard was recorded to have existed in the vicinity of the village.

PETRAKOVAC (Peć): hill with the remains of an uninvestigated place of worship.

PETRAŠICA (Lipljan): mention of a village priest in a census from the 15C and two microtoponyms testify that the village used to have a church.

PETROVCE (Izmornik): church of the recently expelled Serbs restored in the old graveyard.

PETROVO (in the Middle Ages Petrova Crkva, Uroševac): old ruins of a church in the locality "Crkveno Mesto" (Church Site); the remains of an old fortress situated above the village.

PETRUŠAN (Djakovica): remains of a church demolished by the Turks and an old graveyard.

PIDIĆ (Gnjilane): remains of the old fortress called Gradište – Kalaja, above the village.

PIRANE (Prizren): ruins of the church of St Geogre, near the village.

PIŠTANE (Peć): foundations of the church of St Paraskeve, in the centre of the village, east of the old graveyard.

PLAJNIK (Dragaš): remains of an old church, on the hill above the village.

PLAKAONICA (Leposavić): 1. traces of medieval mining facilities and settlements in the village and in the hamlet of Sta-

ro Selo; 2. remains of the old, according to tradition "mining", church, on the site called Crkvine (ruins of a church); 3. church erected in the graveyard on the hill of Dublje in 1926.

PLANEJA (in the Middle Ages Plano, Prizren): remains of the church of St Panteleemon, mentioned in a document from 1355, above the confluence of the Bistrica river into the Drim.

PLANJANE (in the Middle Ages Planjani, Prizren): church of the Nativity of the Virgin erected in 1868, upon the foundations of the old church of the Holy Trinity (icons from the 17-19C).

PLAVLJANE (Peć): old graveyard next to the Ljaovića mill.

PLEMETINA (Priština): remains of an old church with an old graveyard and the new, small village church erected in 1971.

PLEŠINA (Uroševac): in the 15C, the village had priests; the ruins of two former churches have survived – in the Lower mahala and Popov Do (Priest's Valley).

PLOČICA (Mališevo): the site of an old graveyard is known in the village.

PLUŽINE (Srbica): ruins of an old church called Crkva (Church) and the remains of the so-called Groblje (Graveyard) with Serbian crosses.

POČEŠĆE (Peć): remains of an old church (of St Nicholas) on the right bank of the Pećka Bistrica (a village priest mentioned as early as the 15C).

PODGORCE (Vitina): remains of the old church of St Paraskeve and an old graveyard, on the hill above the village.

PODGRADJE (Gnjilane): 1. remains of a town-fortress, with the ruins of a church, above the village; 2. remains of the old settlement called Mećava which had a church, in the Mećava mahala; 3. another two churches existed in the village; 4. remains of old structures in which materials from antiquity and late antiquity have been excavated, on the site called Goven.

PODUJEVO: a priest mentioned in the 15C; the church of St Elijah erected in 1930 (demolished in 1941-45, restored in 1971).

POGRADJE (Klina): the village had a priest as early as 1455. Today exist: 1. church of the Holy Anargyroi or the Lower church, formerly dedicated to St Nicholas or St Demetrios (16C), with badly damaged frescoes (second half of the 16C); 2. ruins of the Upper church, to the west above the village; the nartex built at a later date has 16th-century frescoes; 3. ruins of the medieval fortress – Gradište, in the south-east part of the village; 4. remains of a medieval fortress, on the Jernjak hill.

POLUŽA (Orahovac): old graveyard existed in the 19C.

POLUŽJE (in the Middle Ages Podlužje, Glogovac): mention of a village priest in the 15C and folk tradition point to the existence of a church.

POLJANCE (Srbica): old and new graveyard of the expelled Serbs.

POLJANE (Istok): two localities called Crkvište (ruins of a church) – in the area of Paljevo, where the old graveyard is located, and on the Glavica hill, where several tombstones are situated. On one of these sites, the remains of the church of the Visitation of the Virgin still stood in the 19C.

POMAZATIN (Priština): church of St Elijah, erected in 1937.

PONEŠ (in the Middle Ages Poniša, Gnjilane): 1. ruins of a church on the site called Letovac; 2. remains of a church in the present-day Orthodox cemetery; 3. old ruins of a fortress, above the village.

PONORAC (Mališevo): in the 14C, mention was made of "a church wood" and "Gradište" (ruins of a former fortress) in the village.

PONOŠEVAC (Djakovica): the newly-constructed church was demolished in 1941 by the Albanians, who burnt all Serbian houses in the village as well.

POPOVAC (Djakoovica): old ruins of a church formerly existed.

POPOVCE (Leposavić): a village priest mentioned in the 15C; remains of an old place of worship on the site called Mramorak.

POPOVLJANE (Suva Reka): church of St Nicholas erected and painted in 1626; surrounded by an old graveyard.

POPOVO (Podujevo): old church of the displaced Serbs was situated on the site called Crkveni Tesnac (Church Gorge).

POSLIŠTE (in the Middle Ages Ploskištino, Prizren): the site of an old graveyard is known.

POTKOMNJE (Leposavić): old cemetery.

POŽAR (Dečane): remains of a church and a small graveyard recorded in the 19C.

POŽARANJE (Vitina): two demolished churches are recorded to have stood next to each other: the so-called White church, dedicated to St Paraskeve, and the Black church; at present, an old graveyard exists.

PRČEVO (Klina): 1. at the beginning of the 14C, "the ruins of the old church of St Peter" were situated within the village boundaries; 2. the archaeological site of Boka, with the remains of the so-called Glasnička culture (Bronze and Iron

Age) and Slavic culture (10-12C); 3. old graveyard stood in the locality called "Srpsko Groblje" (Serbian Cemetery).

PRIDVORICA (in Kolašin upon the Ibar): ruins of the medieval fortified settlement called Zubodolački, above the village.

PRIDVORICA (Leposavić) 1. remains of the foundations of the church of the Holy Saviour, in the Lower mahala; 2. remains of a medieval mining settlement, on the site called Gradina. and an old cemetery.

PRESLO (Leposavić): old ruins of a church, in Borčansko Preslo.

PRIDVORICA (in Kolašin upon the Ibar): ruins of the medieval fortified settlement called Zubodolački, above the village.

PRIDVORICA (Leposavić) 1. remains of the foundations of the church of the Holy Saviour, in the Lower mahala; 2. remains of a medieval mining settlement, on the site called Gradina.

PRILEP (in the Middle Ages Hrastovice, Dečane): until 1898, the remains of an old church were preserved (village priest mentioned as early as the 15C).

PRILEPNICA (Gnjilane): 1. ruins of an old church; 2. small medieval town of Prilepac, several villages; 3. Draganac monastery, above the town of Prilepac.

PRILUŽJE (Vučitrn): church of St Kyriake, constructed in 1969 on the site called Sv Nedelja (St Kyriake); the traces of another two churches also exist.

PRIŠTINA: 1. church of the Holy Saviour in which the remains of the Serbian Prince Lazar were buried after his death in the battle of Kosovo; the Turks demolished it at a later date and erected a mosque on its site; 2. Turkish censuses from the 15C and the 16C recorded the existence of the monastery of "Bukovac" or "the Virgin"; 3. church of St Nicholas, erected on the foundations of the monastery of St Nicholas (mentioned in the 16C); 4. monastery of St George, mentioned in the 16C; a caravanserai was erected on its site; 5. old metropolitan building (mentioned in censuses from the 15C and the 16C) stood in the Christian mahala called Mitropolit (Metropolitan); with its stone, the Pirinač mosque was constructed; 6. church of St Paraskeve stood on the site of today's Kopt-mosque; 7. church of the Exaltation of the Holy Cross situated in the Panadjurište mahala; 8. data pointing to the existence of the churches of the Holy Archangels and St Kyriake have not been archaeologically confirmed; 9. according to the Turkish census of 1544, there was the Hagia Sophia mahala, so that in the Middle Ages Priština probably had the church of St Sophia; 10. monuments to Serbian and French soldiers fallen in World War I, situated in the town (Serbian) cemetery.

PRIZREN (occasionaly the Serbian capital in the Middle Ages): 1. church of the Virgin Ljeviška (see p.); 2. monastery of the Holy Archangels (see p.); 3. church of the Holy Saviour, erected and frescoed in the 3rd or 4th decade of the 14C (with the remains of wall-paintings); 4. church of St Demetrios (mentioned in the 13C and the 14C), demolished in the 19C so that the Catholic church of the Virgin would be erected on its site; 5. church of St Nicholas – Korač's, from the 14C, converted into a mosque at a later date; 6. cathedral church of St George, erected in 1887, with an icon of the Virgin from the 14C and an 18th-century iconostasis; 7. church of the Holy Anargyroi, built in the 19C on the foundations of an older church, with several icons from the 18-19C; 8. church of St Panteleemon in the Pantelija mahala, constructed in 1937 on the foundations of an older ecclesiastical sturcture; 9. foundations of the church of St Thomas beneath the Prizren fortress; 10. ruins of the church of St Prokopios, in the Pantelija mahala; 11. church of St Anna stood on the present-day site of Mustapha-Pasha's mosque; 12. church of St Athanasios, situated in the Prizren Fortress (Kaljaja); on its site Emin-Pasha Rot erected a mosque and clock-tower in 1805 (the mosque was demolished by the Bulgarians); 13. remains of the Church of St Peter, on the left bank of the Bistrica river; 14. church of St Elias formerly situated on the right bank of the Bistrica; until 1915, a graveyard was also located there; 15. church of the Epiphany, upon whose foundations a mosque was erected in the Maraš-mahala; 16. church of the Transfiguration, according to tradition part of the Emperor Dušan's court, on the present-day site of Mehmed-Pasha's mosque; 17. church of St Nicholas, the so-called Town church (mentioned in the 14C) in the ancient Višegrad fortress, above the monastery of the Holy Archangels; 18. "Gospodina Crkva" (church of the Virgin) mentioned in a charter of the Emperor Dušan in 1348; 19. monastery of St Barbara, in Prizren or its surroundings, mentioned in the Turkish defter of 1526-59; 20. remains of a rock-cut church and monastery (15C) in the locality called Golem Kamen near Prizren; 21. church of St Nicholas Rajkov from the 14C, restored in 1857 (treasuring a 16th-century icon); 22. church of St George Runović from the 15C (the Royal doors from the 16C), in the yard of the Cathedral church; 23. hermitage of St Nicholas, the most significant in the series of hermitages in the Bistrica gorge, adjusted to the form of a church (remains of 14th-century frescoes); 24. church of St Helena stood on the site of the mosque erected by Mustapha-Pasha of Prizren; 25. ruins of the building of the old Prizren Metropolitan with the Bishop's chapel, south-east to the Virgin Ljeviška; 26. church of St Blasios (mentioned in a charter of the Emperor Dušan in 1348) situated somewhere in Prizren or its vicinity; 27. church of St Nicholas – Tutić's, erected in 1331/32 and painted soon afterwards, with the remains of frescoes; 28. foundations of the church of the Presentation of the Virgin, the en-

dowment of the young Serbian King Marko from 1371 (the remains of frescoes from the 14C), discovered beneath a more recent church of St Kyriake; 29. church of St Stephen (unascertained), probably erected by the Serbian King Milutin; 30. monument to the Serbian warriors fallen in the wars 1912 and 1914-1918; 31. memorial charnel-house of Serbian soldiers fallen in the liberation of Prizren in 1912 and during World War I; 32. Studenac Kosovo, the memorial drinking-fountain to the officers and soldiers of the 3rd Serbian army fallen in the battle for the liberation of Prizren in 1912.

PROPAŠTICA (Priština): 1. foundations of a church near the present-day mosque; 2. ruins of an old church, south-west of the primary school building; 3. remains of a church and of foundations, probably belonging to monastic structures (the so-called Milica's church) in the Church valley.

PRUGOVAC (in the Middle Ages Prugovce, Priština): at the beginning of the 20C, the remains of a church were known to have existed (a village priest mentioned in the 15C).

PUSTENIK (Kačanik): ruins of a 14th-century church on the hill above the village.

PUSTINJA-LESKOVAC: an unascertained monastery on the Lab river (mentioned in the Turkish census of 1455).

RABOVCE (in the Middle Ages Robovci, Lipljan): new village church erected in 1984 on the foundations of the medieval church of St Kyriake, in the Crkvena (Church) mahala.

RAČA (Djakovica): remains of an old church still existed at the beginning of the 20C on the site called Račanska Crkva (Račanska Church).

RAČAK (Uroševac): remains of the foundations of a church (of the Holy Anargyroi?) from the 14C, with the fragments of frescoes and stone ornaments.

RADAVAC (Peć): 14th and 15th-century documents make mention of the monastery of the Holy Saviour; the church and subsidiary buildings whose remains stand above the present-day hydro-electric power plant probably belonged to it; a modest-sized church (on the site of today's sawmill) and an old graveyard also existed.

RADEŠA (Dragaš): in the 14C, the churches of St Nicholas and St Elias were situated in the village surroundings; the foundations of an old church have survived on the site called Zagrajce. The village also had two old graveyards – in the Lower mahala and in the Peterce mahala.

RADEVO (in the Middle Ages Radojevo, Lipljan): ruins of an old church and the medieval cemetery called "Čivutsko Groblje" (Jewish Cemetery).

RADIŠEVO (Srbica): a reference to a village priest in the 15C and folk tradition indicate that the village had a church; an old graveyard has survived.

RADIVOJCE (Vitina): censuses from the 15C and the 16C make mention of the monastery of the Holy Archangels; the locality called "Crkvište" (ruins of a church) is situated next to the village.

RADONJIĆ (Djakovica): ruins of Radonja's tower and the church of St Paraskeve noted down by 19th-century writers of travel accounts (according to tradition, the present-day village mosque was erected with their stone remains).

RADOŠEVAC (Priština): at the beginning of the 20C, the ruins of an old church still existed.

RADULOVAC (in the Middle Ages Radilovc, Klina): traces of the old graveyard existed until recent times.

RAHOVICA (in the Middle Ages Horavica, Uroševac): remains of an old church on the site called Crkvište (ruins of a church) (village priest mentioned as early as the 15C).

RAJANOVCE (in the Middle Ages Radanovce, Kriva Reka near Novo Brdo): traces of an older settlement on the site called Selište and the ruins of the church of St George on the site called Zli Do; an old graveyard.

RAKITNICA (Podujevo): church of St Archangel Michael (Lazar's church), erected in the 14-15C, restored in the 16C, with the remains of frescoes; formerly surrounded by an old graveyard.

RAKITNICA (Srbica): according to tradition, the site called Crkva (Church) was occupied by the church of St George and an old graveyard, called Serbian.

RAKOC (in the Middle Ages Rogat'c and Rakovac, Djakovica): ruins of a church and a small graveyard recorded in the 19C.

RAKOŠ (Istok): an old church formerly existed (its traces have perished); an old graveyard is situated on the hill above the village.

RANILUG (Izmornik): 1. ruins of the church of the Holy Saviour on the site called Reljan; 2. old graveyard, near the village.

RAPČA, RAPČE (Dragaš): there were two churches once – in Gornja Rapča on the site called Crkvine (ruins of a church) and the church of St Paraskeve, in the Marinac area (a mosque erected over its foundations); a charter of 1348 makes mention of the Mratinja church, south-east of the village.

RASKOVO (Priština): old graveyard with interesting tombstones.

RASTAVICA (in the Middle Ages Hrastovica, Dečane): ruins of a church and a graveyard were recorded in the 19C. The church built at a more recent date was devastated by the Albanians in 1941, and razed to the ground not so long ago.

248

RAŠINCE (Uroševac): microtoponym "Crkva" (Church) points to the site formerly occupied by an old church.

RATIŠ (in the Middle Ages Ratiševci, Dečane): church of the Holy Trinity erected in 1935 on the foundations of an older church; devastated in 1941, and not long ago completely destroyed; formerly surrounded by a graveyard.

RATKOVAC (Orahovac): a church formerly occupied the site called Crkvina (Ruins of a Church), next to the present-day Albanian burial-ground on the Bridje hill.

RAUŠIĆ (Peć): old graveyard (called Groblje Spasića, i.e. the Spasićs' Graveyard) in the Upper mahala; tombstones demolished in 1941-44.

REČICA (Podujevo): remains of the church of St Peter, behind the village, towards Mt Kopaonik (village priest mentioned in the 15C).

RESNIK (Klina): old church (monastery ?) of the Virgin formerly existed (village priest mentioned in the 15C); an old graveyard was situated next to the church.

RESNIK (Vučitrn): 1. ruins of a former church on the site called Crkveni Kladenac (Church Well); 2. old graveyard on the site called Srpsko Groblje (Serbian Graveyard).

RESTELICA (Dragaš): church (monastery ?) of St Barbara stood in the old graveyard, on the site called Krstine.

RETIMLJE (in the Middle Ages Retivlja, Orahovac): small church of the Presentation of the Virgin (a new mosque erected in its vicinity); an old graveyard on the hill north of the village.

REVUĆE (in the Middle Ages Ravuće, Podujevo): an old church existed (village priest mentioned in a Turkish census from the 15C).

REZALA (in Kolašin upon the Ibar): remains of an old church and graveyard (its stone and tombstones used for the construction of the Co-operative hall).

REZALO (Srbica): in the village in which 27 Serbian households and a village priests were mentioned in the 15C, only the toponym "Srpsko Groblje" (Serbian Graveyard) recalls today the former presence of the expelled Serbs.

REŽANCE (Kačanik): 1. church of St George, situated in the Rogač-mahala, on the site called Crkva (Church); 2. church in the south-east part of the village.

RIBNIK (Vitina): 15th-century census makes mention of a village priest; an old cemetery exists today.

ROBOVAC (Kriva Reka near Novo Brdo): ruins of a church on the site near Golem Kamen; next to the church was the graveyard desecrated and abandoned long ago.

RODELJ (Leposavić): small church and a very old cemetery.

ROGAČICA (in the Middle Ages Rogačić, Kriva Reka near Novo Brdo): an older and new cemetery formerly existed (devastated in 1985).

ROGOVO (Djakovica): elements of a Christian temple incorporated into the so-called "oldest house"; according to one opinion, the Old Mosque in the village was constructed on the site and with the material of a Serbian church.

ROMAJA (Prizren): 1. old cemetery above the village on the site called Crkva (Church); 2. "Crkveno Groblje" ("Churchyard") where, according to Albanian legend, "a Serbian church has been buried", on the left bank of the Daštica stream; 3. archaeological site of Romaja with cultural layers from the Neolithic period until the early Middle Ages.

ROMUNE (Peć): old and new graveyard.

RUDNIK (Srbica): church of St George, restored in the 16C, with several frescoes dating from the time of reconstruction; next to it is an old cemetery; the foundations of another church situated on the locality called Crkvine (Ruins of a Church).

RUGOVO, see ALAGINA RIJEKA and PEĆ

RUNJEVO (Kačanik): the site called Crkva (Church) (a village priest mentioned in the census of 1452).

RUSINOVCE (Lipljan): mention of a village priest in a 15th-century census and a microtoponym testify to the existence of a church in the village.

RVATSKA (Leposavić): remains of an old church and old graveyard on the site called Ostrvica.

RZNIĆ (in the Middle Ages Rzinići, Dečane): ruins of the church of SS Sergios and Bakchos were recorded to have existed in the 19C (the present-day mosque has been constructed with its building material).

SAMODRAŽA (in the Middle Ages Slamodraža, Suva Reka): foundations of the church of St Nicholas with a modest-sized graveyard were recorded in the 19C; according to tradition, the village also had three small churches.

SAMODREŽA (Vučitrn): on the remains of the church of St John Prodromos (where, according to tradition, the Serbian army took Communion before the battle of Kosovo) a new church was constructed and painted in 1932; next to the church there was an old graveyard with large stone crosses.

SANOVAC (Orahovac): ruins of an old church and the site formerly occupied by an old graveyard.

SEDLARE (Lipljan): reference to a village priest in a 15th-century census and a microtoponym point to the existence of the church.

SELOGRAŽDE (in the Middle Ages Črevogražde, Suva Reka): ruins of the old church of St Kyriake and an old graveyard.

SELJANCE (K. Mitrovica): an old graveyard and the site formerly occupied by the ruins of a church.

SEMANJA (Kačanik): remains of an old church (a village priest mentioned in the 15C) demolished in the 19C, and those of an old graveyard. SIBOVAC (Priština): 1. church of St Nicholas of Sibovac recorded in the 16C (a village priest mentioned as early as the 15C), was located on the site called St Nicholas (demolished in the 19C by Jašar-Pasha Džanić who used its stone to build a mill in the Mjekićska gorge); 2. traces of a church in the hamlet of Bregovine.

SEVCE (Uroševac): 1. church of St Nicholas with frescoes from 1861; 2. church of St Athanasios, built in 1921 on the foundations of an older religious building.

SIĆEVO (Klina): church of St Nicholas erected in the 15C, restored and painted in the second half of the 16C; the remains of an old cemetery are east of the church.

SIĆEVO (Priština): a church was formerly situated in the locality called Crkveni Do (Church Valley) (a village priest mentioned in 1455).

SIGA (Peć): church of St Demetrios, constructed in 1937 on the remains of an older religious building (demolished in 1941-45, restored in 1977), surrounded by an old graveyard (tombstones used for the construction of the Co-operative hall).

SILJEVICA (Podujevo): locality "Kod Crkve" (By the Church).

SINAJE (Istok): 1. ruins of the church called Kaludjerice (Nuns), below the hill of Ćelije (Cells); 2. remains of a church in the village; 3. foundations of a smaller church, in the Zuvića graveyard; 4. a church also existed in the old cemetery on the hill. According to folk tradition, two of these churches were dedicated to St Nicholas, and the third to St John the Baptist.

SKIVJANE (in the Middle Ages Ljivljani, Djakovica): tradition has it that the village church (a village priest mentioned in the 15C) was located on the site of the present-day mosque.

SKOČNA (Vučitrn): 1. an old church was previously situated in the locality called Crkveni Do (Church Valley); 2. remains of a medieval fortress on the Skočna peak, above the village.

SKROVNA (Vučitrn): old church formerly stood on the site called Crkvena Livada (Church Meadow).

SKULANOVO (Lipljan): old church ruins (a village priest mentioned in the 15C) and an old graveyard.

SLAKOVCE (Vučitrn): ruins of the old church of St Stephen in the old graveyard.

SLAPUŽANE (in the Middle Ages Zapl'žane, Suva Reka): according to tradition, a church existed once; the present-day mosque has been erected on its site.

SLATINA (Kačanik): ruins of a church (two village priests mentioned in 1455) and an old graveyard on the site called Crkva (Church).

SLATINA (Leposavić): 1. ruins of an old church next to the hamlet of Staro Selo (Staloga); 2. foundations of a church among the remains of an antique and medieval complex (called by the people "the monastery of SS Constantine and Helena"), upstream of the Sočanica, on the left bank of the Ibar.

SLATINA (Podujevo): 1. monastery of St Nicholas, unascertained (mentioned in the 15C); 2. church of St Peter (the parish church until 1878), stood on the site called Crkva (Church).

SLIVOVO (Uroševac): church dating from more recent times erected on the foundations of an older ecclesiastical structure (a priest mentioned as early as the 15C).

SLOVINJE (Lipljan): 1. ruins of the church of St John (the 14C and the 16C); the Albanians demolished it so as to construct the village mosque; 2. ruins of the church of St Nicholas (16C); the Albanians demolished it in order to sell its stone to the railway bridges construction company (1871-73); 3. monastery of St George (14C) in the mountain above the village; demolished in the 19C by Jašar-Pasha Džanić who used its material for the construction of bridges on the Sitnica river.

SMAČ (Djakovica): new Catholic church on the Glavica hillock, built with the stone of the church ruins situated on the site called Kod Dva Bresta (By Two Elms).

SMAČ (Prizren): old graveyard recorded in the 19C.

SMIRA (Vitina): 1. ruins of the church of the Holy Saviour (the Resurrection), erected in the 16C; 2. ruins of the so-called Upper Church dedicated to St Symeon Myrrobletos, next to the spring of the Smirnska river; 3. ruins of the so-called Mačićka church, on the road to the village of Drenoglava. Stone slabs from some of these churches were built in the village mosque. At the beginning of the 20C, an old cemetery still stood next to the village.

SMOLUŠA (Lipljan): ruins of an old church (a village priest mentioned in the 15C) and a desecrated graveyard of the expelled Serbs, near the village.

SMREKOVNICA (in the Middle Ages Smrekovica, Vučitrn): locality "Crkva" (Church).

SOČANICA (in the Middle Ages Selčanica, Leposavić): 1. church of the Beheading of St John Prodromos, erected in

1863 on the foundations of a medieval church, in the hamlet of Rakovac; 2. remains of the church of St Paraskeve, not far from the Žeratova meadow; 3. remains of the medieval church of the Presentation of the Virgin (the Virgin Amolyntos) opposite the Galič fortress; 4. medieval fortress of Galič, above the village; 5. remains of a Roman provincial centre (Municipium DD from the 2-4C AD).

SOJEVO (in the Middle Ages also Sivojevo, Uroševac): ruins of an old church formerly existed (the Albanians – immigrants found it in 1750).

SOPNIĆ, SOPINIĆ (Orahovac): ruins of the churches of St Helena (the Popovići mahala) and of the Holy Archangels.

SOPOT (Djakovica): a 14th-century source makes mention of the "Gradislaljska church", in the vicinity of the village.

SOPOTNICA (Kačanik): until recently, the ruins of a former church and the site of an old graveyard existed (a 15th-century census makes mention of a priest and a monk).

SRBICA: cemetery and the monument to the Yugoslav fighters fallen in the battles in 1944-45.

SRBOVAC (K. Mitrovica): old cemetery.

SREDSKA (Prizren): 1. remains of the church of St Paraskeve (mentioned in a charter from 1348); 2. church of St George with 16th-century frescoes; 3. church of the Virgin (17C) with frescoes from 1646/47; 4. church of St Nicholas, erected and painted in 1875.

SRPSKI BABUŠ (in the Middle Ages Bobuša, Uroševac): old graveyard.

STAGOVO (Kačanik): abandoned church, recorded in the 19C.

STANIŠOR (Gnjilane): Stanišor church, on an elevation in the village; the remains of a former village called Staro Selo situated in the plain near the village, while an old church occupied the site called Crkvište (Ruins of a Church); next to the village is an old graveyard. Recently, a Byzantine vault has been uncovered in the village.

STARI KAČANIK (Kačanik): remains of an old church (the Rečka church) in the Reč mahala.

STARI TRG (K. Mitrovica): remains of the large three-aisled basilica (of St Peter?), the so-called Latin or Saxon church, erected in the 13C in the spirit of Gothic, painted at the end of the 13C and the first half of the 14C in the Byzantine manner.

STARODVORANE, STARO DVORANE (Istok): large old cemetery, west of the village.

STARO RUJCE (Lipljan): remains of Byzantine walls and an old graveyard with the ruins of a former church.

STEPANICA (Klina): in the 14C, mention is made of the Stepanja church (unascertained) not far from the village.

STRANA (K. Mitrovica): microtoponym "Crkva" (Church).

STRAŽA (Gnjilane): 1. ruins of the church of St Nicholas, on the site called Manastir (Monastery); 2. village church erected on the foundations of an older church structure; 3. 20 medieval mining shafts on the Glama hill.

STRAŽA (Kačanik): ruins of a church by the destroyed Orthodox graveyard, on the road to the village of Kotlina.

STRELICA (Kriva Reka near Novo Brdo): the village probably had a church (a census from the 15C refers to a priest); remains of an old village, on the site called Selište.

STREOVCE, STROVCE (in the Middle Ages Strelac, Vučitrn): until recently, the remains of the church of St Nicholas occupied the site called Crkveni Do (Church Valley) (a church mentioned in a document from the start of the 15C).

STREZOVCE (Kriva Reka near Novo Brdo): ruins of an old church beneath the present-day cemetery (according to 15th-century documents, a monastery may have existed in the village at that time).

STRUŽIJE (Prizren): locality called "Grobište" (remains of a graveyard) where an old cemetery was formerly situated.

STUDENICA (Istok): stone slabs and cut stones from the ruins of Studenica Hvostanska incorporated into the village mosque (see p.).

STUDENIČANE (Suva Reka): locality "Srpsko Groblje" (Serbian Graveyard); according to tradition, a large church formerly existed (demolished in the 19C so that a mosque would be constructed on its site).

STUP (in the Middle Ages St'lpezi, Klina): remains of an old and new cemetery.

SURKIŠ (Podujevo): remains of an old church on the site called Crkvište (ruins of a church).

SUŠICA (Istok): according to tradition, the church of St George existed (a village priest mentioned in the census of 1485); demolished so that a mosque would be built with its material.

SUŠICA (Priština): church of St Demetrios in Sušica (a village priest mentioned as early as the 15C), demolished at the beginning of the 19C by Jašar-Pasha Džanić, who used the material for the construction of several bridges on the Sitnica river.

SUVA REKA 1. ruins of a church on the site called Crkvište (remains of a church) next to the Serbian graveyard, still existed in 1880; 2. in the 19C, a hermitage surrounded by cells stood on the hill near Suha Reka; 3. new church erected in

1938 in the east part of the settlement, near the present-day cemetery.

SUVI LUKAVAC (Istok): 1. traces of a church (of St Luke ?) on the site called Crkvine (ruins of a church); 2. ruins of a former church in the old graveyard; 3. a church considered to have been sitaued near the so-called Smrdel spring; 4. according to tradition, the church of the Holy Saviour once stood in the Spasavice fields.

SUVO GRLO (Istok): 1. church of "the Virgin on the Suhogrlska land" (unascertained) mentioned in King Milutin's charters (1282-1320); 2. remains of the church of the Presentation of the Virgin (mentioned in 1596) perhaps identical with the former; 3. ruins of the church of St Nicholas; 4. remains of the church of the Holy Archangels and the foundations of two ecclesiastical structures on the site called Brda; 5. foundations of the church by the site called Crkveni Kladenac (Church Well) (the Kamberoviča mahala); 6. ruins of the church of St John on the site called Crkvine (ruins of a church), below the Cutek hill; 7. remains of "Kaludjerski Grad" (Monks' Town) on the elevation called Gradina, above the village; 8. ruins of a former church on the estate of Seferaj Salija; 9. ruins of a former church in the barn of Hajzeraj Ramadan; 10. remains of an old town in the Šipovik wood, above the village.

SUVO GRLO II or GORNJE SUVO GRLO (Srbica): remains of several churches or the surviving names of the sites of former churches – 1. remains of the church of the Virgin; 2. the site of the former church of Epiphany; 3. the site of the former church "Kod Murike" (By the Mulberry Tree); 4. the site called Kaludjerska Gradina (Ruins of the Monks' Castle) with Kaludjerski Izvor (Monks' Spring); 5. Lupoglav with the remains of the church of the Holy Trinity and 6. Celije (Cells) with a spring and Celijski Krš above it.

SVETLJE (Podujevo): according to a 15th-century census, the monastery of St Menas was situated somewhere around the village, while the church was in the village itself.

SVINJARE (K. Mitrovica): church and the ruins of a church in the village; the ruins of another church situated on the site called Troja.

SVRČIN (Uroševac): in the 14C, the courts of Serbian rulers were located here, together with the church of St John in which King Dušan was coronated in 1331 (the palace stood on the Sarajište estate, and the church on the Glavica hill, on the site called Crkvine – i.e. ruins of a church); with the church's stone-remains, Jašar-Pasha built the bridge on the Sitnica river.

SVRKE (Peć): an old graveyard; the ruins called St Sava also existed.

SVRKE VOLUJAČKE (Klina): remains of an old church (mentioned in a notice from the 17C); its stone was taken away and used for the construction of village houses. An old Serbian graveyard is situated next to the church.

ŠAIĆ (Kriva Reka near Novo Brdo): old graveyard of the former settlement occupied the site called Grobljanska Ravan (Graveyard Plain).

ŠAJKOVAC (Podujevo): a church formerly existed (a village priest mentioned as early as 1455), while nowadays there is only a graveyard.

ŠALCE (Vučitrn): locality "Crkvena Kosa" (Church Slope) in the hamlet of Ugljare indicates that the village used to have a church; outside the village, another church stood on the site called Šalačka Crkva (Šalačka Church); the remains of an old Serbian graveyard in the village (on the site called Isenov Zabel).

ŠALJINOVICA (Istok): remains of a church (with the fragments of frescoes) and a bell-tower in the old graveyard, on the right bank of the Kujavča river (tradition associates the church with St Arsenije of Serbia).

ŠAPELJ, ŠAPTEJ (Dečane): locality "Srpsko Groblje" (Serbian Graveyard).

ŠARBAN (Priština): ruins of an old church existed until 1878.

ŠAŠARE (Vitina): ruins of the Catholic church of St Rocco.

ŠAŠKOVAC (Priština): remains of the medieval church of St Paraskeve and the Cells of Šaškovac (frequent abode of Serbian patriarchs in the 17C), above the village, at the foot of Veletina.

ŠILOVO (Gnjilane): 1. ruins of the church of St Mark, near the village; 2. foundations of an old, large edifice, in the locality called Slamnište.

ŠIPOLJE (K. Mitrovica): old cemetery, repeetdly desecrated in recent times.

ŠLJIVOVICA, SLIVOVICA (Vučitrn): ruins of a former church and an old graveyard on the site called Jesiće.

ŠPINADIJA (Prizren): remains of the church of the Virgin Amolyntos (probably from the 16C) near the village; several old tombstones are situated around the church.

ŠTIMLJE (Uroševac): one of the courts of Stefan Dečanski (1321-1331) was situated in the village; in 15th century, a village priest is referred to; the present-day church of the Holy Archangel Michael was erected in 1920-22 on the foundations of an older church; in the graveyard, in the east side of the settlement, the church of St Nicholas was constructed in 1926 on the foundations of the old graveyard church.

ŠTITARICA (Vučitrn): in the village which as early as 1455 had a priest a church existed once (confirmed by the ruins of an old church).

ŠTRPCE (Uroševac): 1. church of St Nicholas raised in the village and painted in 1576/77; 2. church of St John the Baptist, erected in 1911 on the site of a former church, east of the village; 3. old graveyard, in the village.

ŠTUPELJ (Klina): foundations of the church of the Presentations of the Virgin (also called St Paraskeve), in the Serbian graveyard, on the site called Vakuf (as early as 1485, the village had a priest).

ŠTUTICA (in the Middle Ages Štučanci, Glogovac): locality "Crkva" (Church), where a Serbian church used to stand.

ŠUMATI BOGOVAC: unascertained monastery in the nachye of Peć (mentioned in the Turkish census of 1485).

ŠUMNIK: unascertained monastery in the nachye of Peć (mentioned in Turkish censuses from the 15C and 16C).

ŠUMNJA LUKA, ŠAMALUK (Podujevo): locality "Kod Crkve" (By the Church).

TALINOVAC, JERLI TALINOVAC (Uroševac): 1. according to traditon, a church stood on the site of the present-day mosque before the Albanians settled in 1840 (a village priest mentioned in the 15C and the 17C); 2. Paun's field (near the village), where the unascertained summer residence of Serbian rulers, called Pauni, was situated, as well as a chruch where the Archbishop sojourned. The church of St John Prodromos also existed in that area (mentioned last in 1788).

TAMNICA, MONASTERY, see AJNOVCE

TARADŽA (Vučitan): 1. microtoponym "Crkveni Potok" (Church Stream) indicates that a church once stood in the village; 2. settlement from late antiquity and the early Middle Ages with a medieval necropolis, on the Čečan hill.

TENEŽ DO (in the Middle Ages Trndol, Priština): an old church formerly existed (a 15th-century census makes mention of a village priest).

TICA (in the Middle Ages Tip'c or Tipčinja Luka, Srbica): microtoponym "Crkvena Glavica" (Church Peak).

TIRINCE (Kriva Reka near Novo Brdo): ruins of two churches in the village territory (one devoted to SS Constantine and Helena); in the 15C, mention is made of a village priest and a monk.

TOMANCE (Istok): 15th and 16th-century documents refer to the Tumenica monastery near the village; the village had a church on the site called Gumourača (Gumurača).

TOPLIČANE (Lipljan): remains of a church by the Toplik spring (demolished in the 19C by Jašar-Pasha Džanić so as to build bridges with its stone), and a very old graveyard called Svatovsko (Wedding Guests').

TOPONICA, TOPOLNICA (Kriva Reka near Novo Brdo): old and new cemetery, desecrated and demolished in 1985.

TRBOVCE, TRBUVCE (Lipljan): remains of an old church ("the church of the Empress Milica), above the village.

TRBUHOVAC (in the Middle Ages Trbuhovci, Istok): until recently, the remains of the foundations of an old church still existed (according to tradition, demolished during Turkish rule).

TRDEVAC, TRDEVCE (Glogovac): a church formerly existed (a village priest mentioned in a 15th-century census), as well as the locality "Crkva" (Church).

TREPČA (K. Mitrovica): two Catholic churches existed – the so-called Latin or Saxon church in Stari Trg (of St Peter ?) and the unascertained church of St Mary; also, there were three Orthodox churches – the so-called Monks' church and two churches above the village of Mažić, on the site called Stara Trepča. In Stara Trepča, the remains of an old mosque (the mid-15C) are situated as well.

TRIKOSE (in the Middle Ages Tarkosi, Leposavić): walls of an ancient structure (in popular opinion, the remains of a church) and an old graveyard.

TRLABUĆ (Vučitrn): microtoponym "Popova Glavica" (Priest's Peak) points to the possible existence of a church.

TRNAVA (Podujevo): a church formerly existed (village priest mentioned as early as 1455).

TRNAVCE (Srbica): localities "Crkvište" (i.e. ruins of a church) and "Staro Groblje" (old graveyard) (a 15th-century census makes mention of two priests).

TRNAVICA, TRNOVICA (Podujevo): a church had existed until the Serbian population migrated in 1878.

TRNIĆEVCE (Priština): remains of medieval mining shafts and two old graveyards.

TRNJE (Suva Reka): the locality whose name indicates that an old graveyard used to exist there.

TRPEZA (Vitina): 1. remains of the monastery of the Holy Archangels Michael and Gabriel (mentioned in 17th-century notices), on the site called Gradište; with its stones, the Turks built the bridge on the Morava river near Klokot in the 19C; 2. remains of the monastery of St George by the spring of the Svintula river; 3. ruins of the church of St Nicholas, in the village.

TRSTENA (K. Mitrovica): large cemetery occupied the site called Srbinov Grob (the Serb's Grave).

TRSTENA (Kriva Reka near Novo Brdo): a church formerly existed (suggested by the microtoponyms "Ajdukova Crkva" (Brigand's Church) and "Popovo Brdo" (Priest's Hill)).

TRSTENIK (Glogovac): remains of the monastery of the Archangel Michael (mentioned in 1346 and 1365), subsequently in the 15C and the 16C); next to the walls, the old churchyard (called Srpsko Groblje i.e. Serbian Graveyard) occupies the site called Crkve (Churches).

TRSTENIK (Peć): a church existed (village priest mentioned in the 15C), probably in the old garveyard.

TRSTENIK (Vitina): ruins of a church and the remains of a graveyard (a 15th-century census makes mention of two priests and "the Trstenik monastery" with two monks).

TRUDNA (Priština): a church existed (suggested by the reference to a village priest in a 15th-century census and several microtoponyms).

TUČEP (Istok): locality "Crkvine" (ruins of a church), next to the graveyard, and the ruins of a former church in the fields above the village (a 15th-century census makes mention of two village priests).

TUDJEVCE (in the Middle Ages Todjovci, Kriva Reka near Novo Brdo): locality called "Srpsko Groblje" (Serbian Graveyard).

TUPEC (Prizren): an important archaeological site, situated north of the village, was flooded in the construction of a dam in Albania.

TURIĆEVAC (in the Middle Ages Tudoričevci, Srbica): the site of an old graveyard is known in the village.

TURJAKE (Mališevo): ruins of a town or a monastery, on the Gradina hill.

TURUČICA (Podujevo): in the village which in the 15C had an archpriest and a priest, the remains of four churches are located: 1. ruins of a former church in Donji Lugovi in the Simkovac valley, with the traces of an old graveyard; 2. remains of a church (of the Resurrection ?) and subsidiary church buildings, on the estate that formerly belonged to Sava Aleksić; 3. ruins of a church in the Sinkovac valley, on the estate of Dušan Radojević; 4. "Crkvište na sedlu brega" ("church ruins on the ridge of the hill"), on the other bank of the Turučička stream.

TUŠIĆE (in Kolašin upon the Ibar): two old cemeteries (one on the site called Repište, and the other on the site called Stare Kobile).

TUŠILJE (Srbica): in 1685/86, a reference is made to the monastery of the Holy Archangel Michael "called Tušimlja"; nowadays, the remains of a medieval fortress or monastery occupy the site called Gradevac.

TVRDJAN (Leposavić): remains of an old structure (considered to be the ruins of a church), on the hill by the Tvrdjanska river.

UGLJARE (in the Middle Ages Uliare, Priština): remains of an old church on the site called Crkvište (ruins of a church).

UJZ (Djakovica): old graveyard.

UKĆA (in the Middle Ages Ušče, Istok): a Turkish census from the 15C makes mention of a village priest and a monk; the traces of the old church have perished.

UROŠEVAC: the church dating from 1901 formerly existed; it was abandoned after the construction of the new church of the Holy King Uroš in 1933 (the new church treasures an interesting collection of 19th-century icons).

VAGANEŠ (K. Kamenica): church of the Virgin from 1354/55, with frescoes from the 14C and the 16C; the remains of a graveyard from medieval and more recent times surround the church.

VALAČ (K. Mitrovica): remains of a modest-sized church building and a significant prehistoric settlement.

VARAGE (in Kolašin upon the Ibar): two ancient churches, restored at a recent time, and an old graveyard.

VAROŠ SELO (Uroševac): a small church and an old graveyard.

VELEKINCE (Gnjilane): the old, demolished Serbian church on the site called Vakat.

VELETIN (Priština): ruins of the medieval fortress of Veletin, on the

VELEŽA (Prizren): remains of the old church of the Virgin Amolyntos with a graveyard (near the village); in the 14C, "the Berislavci church" was located in the vicinity. peak of the same name, with the remains of a church.

VELIKA DOBRANJA (Lipljan): remains of an old church were situated in the hamlet of Lešnica.

VELIKA HOČA (in the Middle Ages Hotča, Orahovac): 1. church of St Nicholas, in the graveyard (probably from the second half of the 14C, restored in the 16C), with the remains of frescoes from the 14C and the 16C; 2. church of St John, with 14th and 16th-century frescoes; 3. church of St Stephen from the 14C (subseqently restored), with the frescoes painted in the 16C and the 19C; 4. church of St Kyriake, erected in the 19C on the foundations of an older church; 5. church of St Paraskeve, constructed over the remains of an older church; 6. church of St Anna, erected in the 20C on the foundations of an older church; 7. ruins of the church of St Luke (recently reconstructed); 8. ruins of the church of the Holy Archangels from the 16C (the surviving iconostasis dating from 1601); 9. remains of the church of St Peter (16C) on the hill above the village; 10. remains of the church of the Virgin Amolyntos; 11. foundations of the church of St Elijah at the entrance to the village; 12. tradition has it that there was a

church in Dugi Rid; 13. a clock-tower formerly existed in the village (demolished after 1908).

VELIKA JABLANICA (Peć): 1. remains of a larger church or monastery above the village; 2. rock-cut hermitage – the so-called Popova Pećina (Priest's cave), in the gorge above the village; 3. the vast site of a former town, above the village called Grad; 4. tradition has it that the present-day mosque was erected on the site of an old church.

VELIKA KRUŠA (Orahovac): a graveyard in the northern part of the village.

VELIKA REKA (Vučitrn): remains of an old church in the wood above the village.

VELIKI ALAŠ (Lipljan): old graveyard.

VELIKI BELAĆEVAC (Priština): a stone church from more recent times, demolished in 1941/45.

VELIKI DJURDJEVIK (Klina): in the village in which a priest was mentioned as early as 1485, today exist: 1. ruins of the church of St Basil, in the graveyard; 2. remains of a church, above the site called Kaludjerska Česma (i.e Monks' drinking fountain).

VELIKI GODEN (Vitina): until recently, the ruins of a church could be seen in the village; outside the village, there are the remains of another church and the monastery of St Nicholas, above which the ruins of old Gradište stand.

VELIKI KIČIĆ (K. Mitrovica): old graveyard; four microtoponyms point to the existence of several churches.

VELIKO KRUŠEVO (Klina): remains of the church of the Presentation of the Virgin (recently reconstructed) with a tombstone from the 14C in the old graveyard.

VELIKO RIBARE (Lipljan): in the 16C, the monastery of the Holy Archangels was situated in the vicinity of the village; old church ruins and an old graveyard exist today.

VELIKO ROPOTOVO (Kriva Reka near Novo Brdo): a 16th-century source makes mention of the village church; the church of the Archangel Gabriel and the locality "Crkovište" (ruins of a church) exist today.

VELIKO RUDARE (in the Middle Ages Rudarije, K. Mitrovica): remains of a small church in the old graveyard.

VELJEGLAVA (Kriva Reka near Novo Brdo): the old village had a church.

VELJI BRIJEG (in Kolašin upon the Ibar): old graveyard with a small church; the remains of a small medieval town (Gradina) are situated on the hill above the village.

VERIĆ, VERIĆE (Istok): 1. remains of the church of the Holy Trinity on the site called Crkvina (ruins of a church); 2. old graveyard on the hill above the village.

VIDANJE: unascertained church (perhaps a monastery) in the Lapska nachye, mentioned in the defter of 1487.

VIDANJE, VIDENJE (Klina): remains of the church or monastery of Paskalica in the Vaganište plain (perhaps the monastery of St Symeon, mentioned in 1485 and in the 16C).

VIDOMIRIĆ (in the Middle Ages Vidomirići, K. Mitrovica): old graveyard.

VIDUŠIĆ (in the Middle Ages Vidoševci, K.Mitrovica): 1. remains of an old church on the site called Crkva (Church); 2. ruins of a medieval mining settlement and marketplace in the Zidovi valley.

VILANCE (Vučitrn): old and present-day Serbian cemetery.

VITAKOVO (in the Middle Ages Vitahovo, K. Mitrovica): two old graveyards – in the village, on the site called Njivčeta, and the so-called Rusalijsko graveyard outside the village, with monolithic tombstones.

VITINA KOSOVSKA: 1. large stone church from the 19C; 2. log-cabin church, devoted to St Paraskeve, dating from 1785.

VITOMIRICA (Peć): church of St Luke (erected after 1912) in the village graveyard.

VLADOVO (Gnjilane): a Serbian church and an old graveyard formerly existed.

VLAHINJA (K. Mitrovica): old church ruins with surviving walls and an old graveyard.

VLAŠTICA (Gnjilane): ruins of a church and an old graveyard, and the microtoponyms "Crkvište" (ruins of a church) and "Manastirče" (small monastery).

VOĆNJAK (Srbica): according to tradition, ruins of several churches formerly existed in the village; today there is only the site called Crkvište (ruins of a church), with an old graveyard in which a church stood once.

VOGOVO (Djakovica): ruins of a church in the old village graveyard; the Catholic church of St Mark erected in recent times.

VOJINOVCE, VOJNOVCE (Uroševac): according to tradition, an old church existed on the site called Crkvine (ruins of a church).

VOLUJAK (Klina): two rock-cut hermitages with the remains of frescoes and vessels from the 14C, in the ravine of the Miruša river.

VRAČEVO (Leposavić): church of St Kosmas and Damianos, appears to date from the 14C; since the 16C, thoroughly reconstructed for several times.

VRAGOLIJA (Priština): the bridge on the Sitnica river

(19C), erected by Jašar-Pasha Džanić, a Turk, with the material from demolished Serbian churches.

VRANIĆ (Djakovica): in the 19C, the ruins of a church and a modest-sized old graveyard could still be seen.

VRANIĆ (Suva Reka): microtoponym "Srpsko Groblje" (Serbian Graveyard) formerly existed in the village.

VRANI DO (in the Middle Ages Vranin Dol, Priština): 1. traces of an old church, in the village; 2. remains of a medieval fortress on the Kulan hill, near the village.

VRANIŠTE (Dragaš): remains of two old graveyards and the ruins of three churches situated in the village; not far from the village, another church occupied the site called Čukar.

VRANOVAC (Peć): on the south-west slope of the Vranovački hill, the old Ružica church was situated; tradition has it that the village mosque was constructed with its stone remains (19C); an old graveyard is located to the north of the ruins of this church.

VRBAN (Vitina): traces of the old settlement called Vrbangrad, in the vicinity of the locality called Selište.

VRBEŠTICA (Uroševac): 1. remains of the church of St Peter called Manastir (monastery); 2. ruins of a church on the site called Crkvište (ruins of a church); 3. church of St Elijah, erected on the foundations of an older church.

VRBICA (Gnjilane): remains of a demolished church on the site called Lojza.

VRBIČANE (in the Middle Ages Vrbičani, Prizren): ruins of an old church and a graveyard.

VRBNICA (Podujevo): a settlement that has perished; in a written source from 1455, the monastery of St Menas is mentioned to have existed in it.

VRBNICA (Prizren): an archaeological locality rich in the finds of the early Slavic culture, flooded in the construction of a hydro power-plant in Albania.

VRBOVAC (Glogovac): in the 14C, the ruins of a former church and the church of St Demetrios were situated in the vicinity of the village; the localities "Crkva" (Church), "Crkveni Izvor" (Church Spring) and "Crkvene Njive" (Church Fields) exist in the village.

VRBOVAC (Vitina): church of St Demetrios erected in the 19C on the remains of a medieval church (old apse with a part of frescoes). At the start of the 20C, the Albanians devastated the church treasury.

VRELA (Istok): 1. remains of the monastery of Studenica Hvostanska (see p.); 2. ruins of a fortress, above the monastery; 3. traces of rock-cut dwellings on Crveni Krš.

VRELO (Lipljan): small village church erected after World War I.

VRNICA (Vučitrn): church situated in the graveyard.

VRTOMICA (in the Middle Ages Vrtomirce, Kačanik): church of the Resurrection mentioned in 1434; probably located on the site called Crkva (Church) today.

VRŠEVCE (Lipljan): remains of an old cemetery on the site called Krst (Cross).

VUČA (in the Middle Ages V'lčija, Leposavić): 1. foundations of an old church (called Crkvina Kod Zapisa); 2. remains of an antique town (the locality called Anine, i.e. of Anna); 3. remains of an ancient church and graveyard (the Vučanska church), below the Vrabac hill.

VUČITRN: the centre of a medieval Serbian district, and subsequently of a Turkish sanjak. According to Turkish censuses, this sanjak had 42 monasteries and 11 churches. Today exist: 1. the Vojnović tower, the remains of the Brankovićs' court (14/15C); 2. according to tradition, the sites of the present-day Turkish bath and tekija in the Turkish cemetery were formerly occupied by churches; 3. church of St Elijah, erected in 1834.

ZABLAĆE (Istok): large stone bridge on the Istok river (constructed by the Turks with stone fragments from demolished Serbian churches).

ZABRDJE (Klina): a mosque erected on the site of the old church dedicated, according to tradition, to the Holy Saviour (the Resurrection).

ZABRDJE (K. Mitrovica): locality "Srpsko Groblje" (Serbian Graveyard).

ZAJČEVCE (Kriva Reka near Novo Brdo): ruins of an old church on the site called Vakaf and the locality "Stojanovo Groblje" (Stojan's Graveyard) where an old Serbian necropolis was situated.

ZAKUT (Podujevo): in the 14C and the 15C, mention was made of the churches of St Peter and St Nicholas; nowadays there are the ruins of two churches and a graveyard.

ZAPLUŽJE (in the Middle Ages Zaplužani, Dragaš): the legend that the village had a large church whose remains are situated in the vicinity of the village, was noted down in 1861.

ZASKOK (Uroševac): remains of a medieval church and a necropolis from the 10-14C (a stone icon from the 14C has been uncovered there).

ZATRIĆ (Orahovac): 1. yard boundary markers constructed over the foundations of an old church (in the vicinity of the village mosque); 2. remains of the medieval fortress of Zatrič, south of the village.

ZBORCE (Uroševac): the site formerly occupied by an old cemetery is known in the village.

ZEBINCE (Priština): old graveyard; in the 15C, the church of St Nicholas was located near the village.

ZEČEVIĆ (K. Mitrovica): 1. new church erected on the foundations of an older one; 2. remains of a church in the old graveyard, on the site called Kamenjača.

ZEMANICA (Leposavić): the site formerly occupied by old church ruins and an old Serbian graveyard.

ZJUM (formerly Subi or Zumbi, Prizren): 1. ruins of a former church above the Limež mahala, on the site called Crkva (Church); 2. ruins of the church of St George, above a small lake; 3. old graveyard in the Hurdi wood; 4. an old grave in the village, called the Priest's grave; 5. Catholic church of the Virgin.

ZLATARE (in Kolašin upon the Ibar): remains of an old church and several old graves in the village cemetery.

ZLATARE (Priština): old graveyard.

ZLATARE (Uroševac): abandoned church with an old graveyard existed in the past.

ZLAŠ (Priština): in the 15C, mention is made of a monastery with the church of St Luke.

ZLI POTOK (Dragaš): in the hamlet of Ogradje, the ruins of the church of the Transfiguration with a graveyard stood on the site called Zborište (a surviving tombstone in the form of a stećak with a Cyrillic inscription).

ZLOKUĆANE (Klina): 1. old cemetery; 2. large Catholic church erected at a recent time.

ZLOKUĆANE (Lipljan): in the census of 1487, mention is made of the monastery in the village surroundings; south of the village is an old graveyard; the microtoponym "Crkvena Livada" (Church Meadow) is recorded in the village.

ZLOPEK (Peć): remains of an old church, near the village, on the site called Crkvište (ruins of a church); an old graveyard situated to the south-west of it.

ZOČIŠTE (Orahovac): 1. Zočište monastery with the church of the Holy Anargyroi (remains of frescoes), mentioned in a charter from 1327; 2. ruins of the church of the Presentation of the Virgin, in the village; 3. ruins of the church of St John, in the monastic vineyard.

ZOJIĆ (Prizren): old graveyard.

ZRZE, ZERZEVO (Dragaš): in the 19C, the remains of an old graveyard still existed.

ZRZE (in the Middle Ages Zerzevo, Orahovac): a graveyard next to the hamlet of Orlović; the church of St Prokopios existed in the 14C.

ZUPČE (in Kolašin upon the Ibar): old walls in Zubačka Rijeka; a graveyard and a church (restored in 1938) situated in their vicinity.

ZVEČAN (K. Mitrovica): 1. the medieval fortress of Zvečan with the remains of the church of St George; 2. church of St Demetrios (mentioned as early as 1315), situated beneath Mali Zvečan, on the site where the Serbian, and subsequently Turkish, cemetery used to stand until the 19C.

ŽABELJ (Djakovica): ruins of a church and an old graveyard existed in the 19C.

ŽAČ (Istok): a new graveyard church, on the site called Kruglice, erected on the ruins of an older church (according to folk tradition, demolished by the Turks).

ŽAKOVO (Istok): 1. remains of the church of the Virgin Amolyntos, above the Vakav wood; 2. foundations of a church on the site called Crkvište (ruins of a church), in the village; 3. an old graveyard on the Glavača hill.

ŽAŽA (K. Mitrovica): locality "Kod Crkve" (By the Church).

ŽDRELO (Djakovica): the ruins of a church and a graveyard existed in the mid-19C.

ŽEGRA (Gnjilane): remains of two demolished churches and an abandoned graveyard; a new village church erected in 1931.

ŽEROVNICA (K. Mitrovica): ruins of a former church and an old graveyard.

ŽILIVODA (in the Middle Ages Zlivode, Vučitrn): at the beginning of the 19C, the ruins of three churches were recorded to have existed in the village and its surroundings.

ŽITINJE (Podujevo): a church existed in the 15C, probably on the site called Kod Crkve (By the Church); the surviving remains of a medieval mining shaft.

ŽITINJE (Vitina): 1. church of the Holy Trinity in the graveyard, recently erected over the ruins of the church of the Virgin; 2. ruins of the church of St Nicholas (St Theodore), by the river.

ŽITKOVAC (K. Mitrovica): 1. an old graveyard with the ruins of a former church; 2. archaeological remains of a Neolitic settlement.

ŽIVINJANE (Prizren): church of St Kyriake, erected in the 19C on the foundations of an old church from the 16-17C.

ŽUJA (formerly Cerka, Kriva Reka near Novo Brdo): a Turkish census from the 16C refers to "the monastery of the monk Symon".

251

Bibliography

BABIĆ G., *Les chapelles annexes des églises byzantines. Fonction liturgique et programmes iconographiques*, Paris 1969.

– *Les croix à cryptogrammes peintes dans les églises serbes des XIIIe et XIVe siècles,* Byzance et les Slaves: Etudes de civilisation. Mélanges Ivan Dujčev, Paris 1979, 1-13.

– *Ikonografski program živopisa u pripratama crkava kralja Milutina,* Vizantijska umetnost početkom XIV veka, Beograd 1978, 105-125.

– *Kraljeva crkva u Studenici*, Beograd 1987.

– *Liturgijski tekstovi ispisani na živopisu apside Svetih Apostola u Peći,* Zbornik zaštite spomenika kulture 18 (Beograd 1967) 75-83.

– *Liturgijske teme na freskama u Bogorodičinoj crkvi u Peći,* Arhiepiskop Danilo II i njegovo doba, Beograd 1991, 377-387.

– *Nizovi portreta srpskih episkopa, arhiepiskopa i patrijaraha u zidnom slikarstvu (XIII-XVI v.),* Sava Nemanjić – Sveti Sava. Istorija i predanje, Beograd 1979, 319-340.

– *O rekonstrukciji oštećenih epigrama i natpisa na portretu Sv. Save u južnoj pevnici Sv. Apostola u Peći,* Zbornik zaštite spomenika kulture 15 (Beograd 1964) 159-164.

– *Les portraits de Dečani représentant ensemble Dečanski et Dušan,* Dečani i vizantijska umetnost sredinom XIV veka, Beograd 1989, 273-284.

– *Les programmes absidaux entre le XIe et le XIIIe siècle,* L'arte georgiana dal IX al XIV secolo I, Galatina 1986, 120-136.

– *Simvolično značenje živopisa u protezisu Svetih Apostola u Peći,* Zbornik zaštite spomenika kulture 15 (Beograd 1964) 171-181.

BELTING H., MANGO C., MOURIKI D., *The Mosaics and Frescoes of St. Mary Pammakaristos (Fethiye Camii) at Istanbul*, Washington 1978.

BIRTAŠEVIĆ M., *Crkva Rečani kod Ajnovaca,* Glasnik Muzeja Kosova i Metohije 3 (Priština 1958) 209-218.

BLAGOJEVIĆ M., *Čelnici manastira Dečana,* Dečani i vizantijska umetnost sredinom XIV veka, Beograd 1989, 21-33.

BOGDANOVIĆ D., *Inventar ćirilskih rukopisa u Jugoslaviji (XI-XVII veka)* Beograd 1982.

– *Istorija stare srpske književnosti*, Beograd 1980.

– *Katalog ćirilskih rukopisa manastira Hilandara*, Beograd 1978.

– *Nove težnje u srpskoj književnosti prvih decenija XIV veka,* Vizantijaka umetnost početkom XIV veka, Beograd 1978, 85-96.

– *Povelje o zemljama i zadužbinama Kosova,* Zadužbine Kosova. Spomenici i znamenja srpskog naroda, Beograd – Prizren 1987, 311-360.

BOŠKOVIĆ Dj., *Crkva Sv. Spasa u Prizrenu,* Starinar 7 (Beograd 1932) 118-120.

– *O nekim našim graditeljima i slikarima iz prvih decenija XIV veka*, Starinar 9-10 (Beograd 1959) 125-131.

– *Osiguranje i restoracija crkve manastira Sv. Patrijaršije,* Starinar 8-9 (Beograd 1933-1934) 90-165.

– *O slikanoj dekoraciji na fasadama Pećke patrijaršije,* Starinar 18 (Beograd 1968) 91-102.

ČANAK MEDIĆ M., *Arhiepiskop Danilo II i arhitektura Pećke patrijaršije,* Arhiepiskop Danilo II i njegovo doba, Beograd 1991, 295-308.

– *Arhitektura prve polovine XIII veka,* II, Beograd 1995.

– *Prilog proučavanju crkve Sv. Apostola u Peći*, Zbornik zaštite spomenika kulture 15 (Beograd 1964) 165-172.

– *Uzori i projektantski postupak dečanskog neimara,* Dečani i vizantijska umetnost sredinom XIV veka, Beograd 1989, 159-165.

ĆIRKOVIĆ S., *Biografija kralja Milutina u Ulijarskoj povelji,* Arhiepiskop Danilo II i njegovo doba, Beograd 1991, 53-66.

– *Srbija uoči bitke na Kosovu,* Kosovsko-metohijski zbornik 1 (Beograd 1990), 3-20.

– *Srbija uoči Carstva,* Dečani i vizantijska umetnost sredinom XIV veka, Beograd 1989, 3-12.

– *Vladarski dvori oko jezera na Kosovu,* Zbornik za likovne umetnosti 20 (Novi Sad 1984) 67-82.

ĆOROVIĆ-LJUBINKOVIĆ M., *Istorijska kompozicija iz crkve Svetog Dimitrija u Peći*, Sveti knez Lazar, Beograd 1989, 89-95.

– *Nekoliko sačuvanih ikona starog gračaničkog ikonostasa XIV veka*, Zbornik Narodnog muzeja 2 (Beograd 1959) 135-150.

– *Prizrensko četvorojevanđelje – Ka problemu njegovog datovanja*, Starinar 19 (Beograd 1969) 191-201.

ĆURČIĆ S., *Arhitecture in the Byzantine Sphere of Influence around the Middle of the Fourteenth Century,* Dečani i vizantijska umetnost sredinom XIV veka, Beograd 1989, 55-68.

– *Articulation of Church Facades during the First Half of the Fourteenth Century,* Vizantijska umetnost početkom XIV veka, Beograd 1978, 17-28.

– *The Original Baptismal Font of Gračanica and its Iconographic Setting,* Zbornik Narodnog muzeja 9-10 (Beograd 1979) 313-323.

– *Two Examples of Local Building Workshops in Fourteenth Century Serbia,* Zograf 7 (Beograd 1977) 45-51.

ĆURČIĆ S., TODIĆ B., *Gračanica,* Beograd – Priština 1988.

DANILO II, ARHIEPISKOP, *Životi kraljeva i arhiepiskopa srpskih; Službe,* Stara srpska književnost, 6, Beograd 1988.

Danilovi nastavljači, Stara srpska književnost, 7, Beograd 1989.

DAVIDOVIĆ N., *Freske Vizije proroka Danila u crkvi Sv. Apostola u Pećkoj patrijaršiji,* Starine Kosova i Metohije 2-3 (Priština 1963) 117-122.

– *Predstava Bogorodice s Hristom "Krmiteljem" u Bogorodici Ljeviškoj u Prizrenu,* Starine Kosova i Metohije 1 (Priština 1961) 86-90.

DER NERSESSIAN S., *L'illustration du roman de Barlaam et Joassaph,* Paris 1937.

DEROKO A., *Monumentalna i dekorativna arhitektura u srednjovekovnoj Srbiji,* Beograd 1953.

DINIĆ M., *Nastanak dva naša srednjovekovna grada,* Prilozi za književnost, jezik, istoriju i folklor 31 (Beograd 1965) 195-205.

– *Za istoriju rudarstva u srednjovekovnoj Srbiji i Bosni,* I-II, Beograd 1955-1964.

DJORDJEVIĆ I., *Predstava Stefana Dečanskog uz oltarsku pregradu u Dečanima,* Saopštenja Republičkog zavoda za zaštitu spomenika kulture 15 (Beograd 1983) 35-43.

– *Prozne i pesničke slike Danila II i srpske freske prve polovine XIV veka,* Arhiepiskop Danilo II i njegovo doba, Beograd 1991, 481-491.

– *Stari i Novi zavet na ulazu u Bogorodicu Ljevišku*, Zbornik za likovne umetnosti 9 (Novi Sad 1973) 15-26.

– *Zidno slikarstvo srpske vlastele u doba Nemanjiča*, Beograd 1994.

DJURIĆ S., *Portret Danila II iznad ulaza u Bogorodičinu crkvu u Peći*, Arhiepiskop Danilo II i njegovo doba, Beograd 1991, 345-351.

– *The Representations of Sun and Moon at Dečani*, Dečani i vizantijska umetnost sredinom XIV veka, Beograd 1989, 339-344.

DJURIĆ V. J., *Ikona svetog kralja Stefana Dečanskog*, Beograd 1985.

– *Ikone iz Jugoslavije*, Beograd 1961.

– *Istorijske kompozicije u srpskom slikarstvu srednjeg veka i njihove književne paralele*, Zbornik radova Vizantološkog instituta 10 (Beograd 1967) 121-148; 11 (1968) 99-118.

– *Jedna slikarska radionica u Srbiji XIII veka*, Starinar 12 (Beograd 1961) 63-76.

– *Najstariji živopis isposnice pustino žitelja Petra Koriškog*, Zbornik radova Vizantološkog instituta 5 (Beograd 1958) 173-200.

– *Nastanak graditeljskog stila moravske škole – fasade, sistem dekoracije, plastika*, Zbornik za likovne umetnosti 1 (Novi Sad 1965) 35-65.

– *Nepoznati spomenici srpskog srednjovekovnog slikarstva u Metohiji*, Starine Kosova i Metohije 2-3 (Priština 1963) 61-86.

– *La peinture murale serbe du XIIIe siècle*, L'art byzantin du XIIIe siècle, Beograd 1967, 145-168.

– *Portreti na poveljama vizantijskih i srpskih vladara*, Zbornik Filozofskog fakulteta 7-1 (Beograd 1963) 251-269.

– *Presto Svetoga Save*, Spomenica u čast novoizabranih članova Srpske akademije nauka i umetnosti, Beograd 1972, 93-104.

– *Srpski državni sabori u Peći i crkveno graditeljstvo*, O knezu Lazaru, Beograd 1975, 105-121.

– *Sveti pokrovitelji arhiepiskopa Danila II i njegovih zadužbina*, Arhiepiskop Danilo II i njegovo doba, Beograd 1991, 281-291.

– *Sveti Sava i slikarstvo njegovog doba*, Sava Nemanjić – Sveti Sava. Istorija i predanje, Beograd 1979, 245-258.

– *Vizantijske freske u Jugoslaviji*, Beograd 1974.

DJURIĆ V. J., ĆIRKOVIĆ S., KORAĆ V., *Pećka Patrijaršija*, Beograd 1990.

DUFRENNE S., *Les programmes iconographiques des coupoles dans les églises du monde byzantin et postbyzantin*, L'Information d'Histoire de l'Art 10/5 (Paris 1965) 185-199.

– *Les programmes iconographiques des églises byzantines de Mistra*, Paris 1970.

FERJANČIĆ B., *Arhiepiskop Danilo II i Vizantija*, Arhiepiskop Danilo II i njegovo doba, Beograd 1991, 7-17.

FINDRIK R., *Gde se nalazila manastirska trpezarija u Pećkoj patrijaršiji?*, Saopštenja Republičkog zavoda za zaštitu spomenika kulture 22-23 (Beograd 1991) 131-156.

FISKOVIĆ I., *Dečani i arhitektura istočnojadranske obale u XIV vijeku*, Dečani i vizantijska umetnost sredinom XIV veka, Beograd 1989, 169-181.

GABELIĆ S., *Jedna lokalna slikarska radionica iz sredine XIV veka. Dečani – Lesnovo – Markov manastir – Čelopek*, Dečani i vizantijska umetnost sredinom XIV veka, Beograd 1989, 367-376.

GARIDIS M., *La peinture murale dans le monde orthodoxe après le chute de Byzance (1450-1600) et dans les pays sous domination etrangère*, Athènes 1989.

GAVRILOVIĆ Z., *Divine Wisdom as Part of Byzantine Imperial Ideology*, Zograf 11 (Beograd 1980) 44-53.

– *Kingship and Baptism in the Iconography of Dečani and Lesnovo*, Dečani i vizantijska umetnost sredinom XIV veka, Beograd 1989, 297-304.

– *Pogledi arhiepiskopa Danila II i teme kraljevstva i krštenja u srpskom slikarstvu XIV veka*, Arhiepiskop Danilo II i njegovo doba, Beograd 1991, 471-476.

GLIGORIJEVIĆ-MAKSIMOVIĆ M., *Skinija u Dečanima – poreklo i razvoj ikonografske teme*, Dečani i vizantijska umetnost sredinom XIV veka, Beograd 1989, 319-334.

GRIGORIJE CAMBLAK, *Književni rad u Srbiji*, Stara srpska književnost, 12, Beograd 1989.

GROZDANOV C., *Ćirilo i Metodije u umetnosti obnovljene Pećke patrijaršije*, Kosovsko-metohijski zbornik 1 (Beograd 1990) 143-153.

HAFNER S., *Danilo II kao srednjovekovni istoriograf*, Arhiepiskop Danilo II i njegovo doba, Beograd 1991, 131-136.

HALLENSLEBEN H., *Die Malerschule des Königs Milutin*, Giessen 1963.

HAMANN-MAC LEAN R., *Grundlegung zur eine Geschichte der mittelalterlichen monumental Malerei in Serbien und Makedonien*, Giessen 1976.

– *Zu den Malerinschriften der "Milutin-Schule"*, Byzantinische Zeitschrift 33 (Leipzig 1960) 112-117.

HAN V., *Intarzija na području Peļke patrijaršije, XVI-XVII vijek*, Novi Sad 1966.

– *Pevnica s koštanom intarzijom u crkvi manastira Gračanice*, Starine Kosova i Metohije 4-5 (Priština 1968-1971) 217-223.

HARISIJADIS M., *Beogradski psaltir*, Godišnjak grada Beograda 19 (Beograd 1972) 213-250.

– *Zastavica i inicijali šišatovačkog apostola*, Starine Kosova i Metohije 4-5 (Priština 1968-1971) 373-379.

HAUSTEIN E., *Die Nemanjidenstammbaum*, Bohn 1985.

Istorija Crne Gore, II/1-2, Titograd 1970.

Istorija srpskog naroda, I, II, III, Beograd 1981, 1982, 1993.

IVANOVIĆ M., *Crkva Bogorodice Odigitrije u Pećkoj patrijaršiji*, Starine Kosova i Metohije 2-3 (Priština 1963) 133-154.

– *Crkva Preobraženja u Budisavcima*, Starine Kosova i Metohije 1 (Priština 1961) 113-144.

– *Crkveni spomenici. XIII-XX vek*, Zadužbine Kosova. Spomenici i znamenja srpskog naroda, Beograd – Prizren 1987, 385-547.

– *Ikona Preobraženja u Budisavcima i ktitorski natpis u Vaganešu i Sv. Nikoli*, Saopštenja Republičkog zavoda za zaštitu spomenika kulture 16 (Beograd 1984) 187-198.

– *Ljubiždanska dvojna ikona sa predstavama susreta Joakima i Ane i Blagovesti*, Zograf 4 (Beograd 1972) 19-23.

– *Natpis mladog kralja Marka u crkvi sv. Nedelje u Prizrenu*, Zograf 2 (Beograd 1967) 20-22.

– *Natpis sa nadgrobne ploče monahinje Marine iz 1371*, Zbornik za likovne umetnosti 10 (Novi Sad 1974) 335-342.

– *Nekoliko srednjovekovnih spomenika Koriške gore kod Prizrena*, Starine Kosova i Metohije 4-5 (Priština 1971) 309-320.

– *Prilozi o spomenicima Metohije, Novobrdske Krive reke, Siriničke i Nikšićke župe*, Saopštenja Republičkog zavoda za zaļtitu spomenika kulture 15 (Beograd 1983) 195-220.

– *Sveti Petar Koriški*, Zadužbine Kosova. Spomenici i znamenja srpskog naroda, Beograd – Prizren 1987, 15-19.

IVANOVIĆ R., *Vlastelinstvo manastira Sv. Arhandjela kod Prizrena*, Istorijski časopis 7 (Beograd 1957) 345-360.

– *Zemljišni posedi gračaničkog vlastelinstva*, Istorijski časopis 11 (Beograd 1961) 253-264.

IVIĆ P., GRKOVIĆ M., *Dečanske hrisovulje*, Novi Sad 1976.

JANKOVIĆ M., *Danilo, banjski i humski episkop*, Arhiepiskop Danilo II i njegovo doba, Beograd 1991, 83-87.

– *Episkopije i mitropolije srpske crkve u srednjem veku*, Beograd 1985.

– *Lipljanska episkopija i gračanička mitropolija*, Istorijski časopis 29-30 (Beograd 1983) 27-36.

JIREČEK K., *Istorija Srba*, I-II, Beograd 1952[2].

JOVANOVIĆ V., *Crkva u Vaganešu*, Starinar 9-10 (Beograd 1959) 333-343.

– *Kosovski gradovi i dvorci*, Zadužbine Kosova. Spomenici i znamenja srpskog naroda, Beograd – Prizren 1987, 363-384.

KAJMAKOVIĆ Z., *Georgije Mitrofanović*, Sarajevo 1977.

KORAĆ D., *Kanonizacija Stefana Dečanskog i promene na vladarskim portretima u Dečanima*, Dečani i vizantijska umetnost sredinom XIV veka, Beograd 1989, 287-293.

253

KORAĆ V., *L'architecture de Dečani. Tradition et inovation,* Dečani i vizantijska umetnost sredinom XIV veka, Beograd 1989, 149-155.

– *Graditeljska škola Pomorja,* Beograd 1965.

– *Gračanica. Prostor i oblici,* Zbornik Svetozara Radojčića, Beograd 1969, 143-152.

– *Studenica Hvostanska,* Beograd 1976.

– *Sveti Arhandjeli u Prizrenu. Dušanov carski mauzolej,* Politika, 18. januar 1997, 23.

– *Sveti Sava i program raškog hrama,* Izmedu Vizantije i Zapada, Beograd 1987, 145-156.

Kosovska bitka, Istorija i predanje, Beograd 1996.

KOVAČEVIĆ LJ., *Svetostefanska hrisovulja,* Spomenik Srpske kraljevske akademije 4 (Beograd 1890) 1-11.

KRAUTHEIMER R., *Early Christian and Byzantine Architecture,* Tennessee 1979³.

LAFONTAINE-DOSOGNE J., *Les cycles de la Vierge dans l'église de Dečani: Enfance, Dormition et Akathiste,* Dečani i vizantijska umetnost sredinom XIV veka, Beograd 1989, 307-317.

– *Iconographie de l'Enfance de la Vierge dans l'Empire byzantin et en Occident,* I-II, Bruxelles 1964-1965.

LASKARIS M., *Vizantijske princeze u srednjovekovnoj Srbiji,* Beograd 1926.

LAZAREV V. N., *Storia della pittura bizantina,* Torino 1967.

LEMERLE P., *Les plus anciens recueils des miracles de saint Démétrius a Byzance et aux Balkans,* I-II, Paris 1979-1981.

LJUBINKOVIĆ R., *Crkva Sv. Apostola u Peći,* Beograd 1964.

– *Isposnica Petra Koriškog. Istorija i živopis,* Starinar 7-8 (Beograd 1958) 93-110.

LJUBINKOVIĆ R., DJOKIĆ D., VUČENOVIĆ S., TOMAŠEVIĆ A., *Istraživački i konzervatorski radovi na crkvi Vavedenja u Lipljanu,* Zbornik zaštite spomenika kulture 10 (Beograd 1959) 69-134.

MAGLOVSKI J., *Dečanska skulptura – program i smisao,* Dečani i vizantijska umetnost sredinom XIV veka, Beograd 1989, 193-217.

– *Skulptura Pećke patrijaršije. Motivi, značenja,* Arhiepiskop Danilo II i njegovo doba, Beograd 1991, 311-320.

MAK DANIEL G. L., *Genezis i sastavljanje Danilovog zbornika,* Arhiepiskop Danilo II i njegovo doba, Beograd 1991, 217-223.

MAKSIMOVIĆ J., *Kotorski ciborij iz XIV veka i kamena plastika susednih oblasti,* Beograd 1961.

– *Les miniatures byzantines et serbes vers le milieu du XIVe siècle,* Dečani i vizantijska umetnost sredinom XIV veka, Beograd 1989, 137-142.

– *Srpska srednjovekovna skulptura,* Novi Sad 1971.

– *Srpske srednjovekovne minijature,* Beograd 1983.

MAKSIMOVIĆ Lj., *Vizantinci u Srbiji Danilovog vremena,* Arhiepiskop Danilo II i njegovo doba, Beograd 1991, 19-27.

MANDIĆ S., *Vladarski lik u Bogorodici Ljeviškoj,* Zograf 1 (Beograd 1966) 24-27.

MANGO C., *Architettura byzantina,* Venezia 1974.

MARINKOVIĆ R., *Kako proučavati Danilov zbornik,* Arhiepiskop Danilo II i njegovo doba, Beograd 1991, 225-230.

MARKOVIĆ-KANDIĆ O., *Kule zvonici uz srpske crkve XII-XIV veka,* Zbornik za likovne umetnosti 14 (Novi Sad 1978) 3-71.

– *Ostaci manastira Petra Koriškog,* Starine Kosova i Metohije 4-5 (Priština 1968-1971) 409-420.

MARKOVIĆ V., *Pravoslavno monaštvo i manastiri u Srbiji,* Sremski Karlovci 1920.

MARK-WEINER T., *Narrative Cycles of the Life of St. George in Byzantine Art,* Ann Arbor 1990.

MEDAKOVIĆ D., *Grafika srpskih štampanih knjiga XV-XVII veka,* Beograd 1958.

– *Predstave antičkih filozofa i sivila u živopisu Bogorodice Ljevičke u Prizrenu,* Zbornik radova Vizantološkog instituta 6 (Beograd 1960) 43-55.

MIHALJČIĆ R., *Kraj Srpskog carstva,* Beograd 1975.

– *Lazar Hrebeljanović. Istorija, kult, predanje,* Beograd 1989.

– *Junaci kosovske legende,* Beograd 1989.

MIJOVIĆ P., *Menolog,* Beograd 1973.

– *O genezi Gračanice,* Vizantijska umetnost početkom XIV veka, Beograd 1978, 127-159.

– *O hronologiji gračaničkih fresaka,* Starine Kosova i Metohije 4-5 (Priština 1968-1971) 179-199.

– *Prilozi proučavanju Gračanice,* Zbornik Narodnog Muzeja 9-10 (Beograd 1979) 325-353.

MIKLOSICH F., *Monumenta serbica spectantia historiam Serbiae Bosnae Ragusii,* Vindobonnae 1858.

MILANOVIĆ V., *Proroci su te nagovestili u Peći,* Arhiepiskop Danilo II i njegovo doba, Beograd 1991, 409-422.

MILLET G., *L'ancien art serbe. Les églises,* Paris 1919.

– *Recherches sur l'iconographie de l'évangile aux XIVe, XVe et XVIe siècles d'après les monuments de Mistra, de la Macédoine et du Mont-Athos,* Paris 1960².

MILLET G., FROLOW A., *La peinture du Moyen âge en Yougoslavie,* I, II, III, IV, Paris 1954-1969.

MILJKOVIĆ-PEPEK P., *Deloto na zografite Mihailo i Eutihij,* Skopje 1967.

– *O poznatim i anonimnim slikarima koji su stvarali u prvim decenijama XIV veka na teritoriji Kosova i Metohije,* Kosovsko-metohijski zbornik 1 (Beograd 1990) 47-61.

– *Pišuvanite podatoci za zografite Mihail Astrapa i Eutihij i za nekoi nivni sorabotnici,* Glasnik na Institutot za nacionalna istorija (Skopje 1960) 141-156.

MIRKOVIĆ L., *Tipik arhiepiskopa Nikodima,* Bogoslovlje 16 (Beograd 1957) 12-19.

MOJSILOVIĆ-POPOVIĆ S., *Arhitektura manastirskog naselja Dečani,* Dečani i vizantijska umetnost sredinom XIV veka, Beograd 1989, 239-246.

MOŠIN V., *Rukopisi manastira Gračanice,* Starine Kosova i Metohije 1 (Priština 1961) 17-73.

– *Rukopisi Pećke patrijaršije,* Starine Kosova i Metohije 4-5 (Priština 1968-1971) 5-136.

NENADOVIĆ S., *Arhitektura u Jugoslaviji od IX-XVIII veka,* Beograd 1980.

– *Bogorodica Ljeviška,* Beograd 1963.

– *Dušanova zadužbina manastir Svetih Arhandjela kod Prizrena,* Beograd 1966.

– *Još jednom o prelomljenim lucima na Gračanici,* Starine Kosova i Metohije 6-7 (Priština 1972-1973) 13-19.

NIKOLAJEVIĆ I., *Portali u Dečanima,* Dečani i vizantijska umetnost sredinom XIV veka, Beograd 1989, 185-191.

NOVAKOVIĆ S., *Zakonski spomenici srpskih država srednjega veka,* Beograd 1912.

PAJKIĆ P., *Crkve u Velikoj Hoči,* Starine Kosova i Metohije 2-3 (Priština 1963) 157-196.

PAJSIJE, PATRIJARH, *Sabrani spisi,* Stara srpska književnost, 16, Beograd 1993.

PALLAS D., Ἡ Θεοτόκος Ζωοδόχος Πηγή, Ἀρχαιολογικὸν δελτίον 26 (1971) 201-224.

– *Die Passion und Bestattung Christi in Byzanz. Der Ritus – das Bild,* München 1965.

PANIĆ D., *O natpisu sa imenima protomajstora u eksonarteksu Bogorodice Ljeviške,* Zograf 1 (Beograd 1966) 21-23.

PANIĆ D., BABIĆ G., *Bogorodica Ljeviška,* Beograd 1975.

PÄTZOLD A., *Der Akathistos-Hymnos. Die Bilderzyklen in der byzantinischen Wandmalerei des 14. Jahrhunderts,* Stuttgart 1989.

PELEKANIDIS S., Καλλιέργης ὅλης Θετταλίας ἄριστο' ζωγράφος, Athänes 1973.

PETKOVIĆ S., *Bogorodica Hvostanska,* Zadužbine Kosova. Spomenici i znamenja srpskog naroda, Beograd – Prizren 1987, 21-28.

– *Gračanica,* Zadužbine Kosova. Spomenici i znamenja srpskog naroda, Beograd – Prizren 1987, 95-128.

– *Dečani,* Zadužbine Kosova. Spomenici i znamenja srpskog naroda, Beograd – Prizren 1987, 129-158.

– *Kult kneza Lazara i srpsko slikarstvo XVII veka,* Zbornik za likovne umetnosti 7 (Novi Sad 1971) 83-100.

254

– *Lik cara Uroša u srpskom slikarstvu XVI i XVII veka*, Zbornik Narodnog muzeja 9-10 (Beograd 1979) 513-526.

– *Nesačuvani portret novobrdskog mitropolita Nikanora iz 1538/1539*, Starine Kosova i Metohije 9 (Priština 1989-1990) 71-86.

– *O freskama XVI veka iz priprate Pećke patrijaršije i njihovim slikarima*, Saopštenja Republičkog zavoda za zaštitu spomenika kulture 16 (Beograd 1984) 57-66.

– *Pećka patrijaršija,* Zadužbine Kosova. Spomenici i znamenja srpskog naroda, Beograd – Prizren 1987, 29-68.

– *Srpska umetnost u XVI i XVII veku, Beograd 1995.*

– *Srpski patrijarsi XVI i XVII veka kao ktitori*, Zbornik u čast Vojislava Đurića, Beograd 1992, 129-139.

– *Zidno slikarstvo na području Pećke patrijaršije 1557-1614*, Novi Sad 1965.

– *Zograf Georgije Mitrofanović u Pećkoj patrijaršiji 1619-1620*, Glasnik Muzeja Kosova i Metohije 9 (Pri(tina 1965) 237-251.

PETKOVIĆ V., *Iz crkvenog kalendara u živopisu Gračanice*, Glasnik Skopskog naučnog društva 19 (Skoplje 1938) 79-86.

– *La peinture serbe du Moyen âge*, I-II, Beograd 1930-1934.

– *Portre jednog vlastelina u Dečanima*, Prilozi za književnost, jezik, istoriju i folklor 13 (Beograd 1933) 95-101.

– *Pregled crkvenih spomenika kroz povesnicu srpskog naroda*, Beograd 1950.

– *Živopis crkve Sv. Bogorodice u Patrijaršiji Pećskoj*, Izvestija na Blgarskija arheologičeski institut 4 (Sofija 1927) 145-170.

PETKOVIĆ V. R., BOŠKOVIĆ Dj., *Dečani*, I-II, Beograd 1941.

PETROVIĆ R., *Freske XIV veka iz crkve sv. Nikole u Velikoj Hoči*, Zbornik za likovne umetnosti 22 (Novi Sad 1986) 61-82.

– *Kameni nadgrobni natpis iz crkve sv. Nikole u selu Velika Hoča*, Zbornik za likovne umetnosti 16 (Novi Sad 1980) 211-222.

– *Konzervacija i restauracija živopisa crkve sv. Jovana Krstitelja u selu Crkolezu*, Starine Kosova i Metohije 6-7 (Priština 1972-3) 207-214.

POPOVIĆ D., *Grob arhiepiskopa Danila II*, Arhiepiskop Danilo II i njegovo doba, Beograd 1991, 329-341.

– *Nadgrobni spomenik arhiepiskopa Save II iz crkve Sv. Apostola u Pećkoj Patrijaršiji*, Zbornik za likovne umetnosti 21 (Novi Sad 1985) 71-90.

– *Sarkofag arhiepiskopa Nikodima u crkvi Sv. Dimitrija u Patrijaršiji*, Zbornik za likovne umetnosti 19 (Novi Sad 1983) 71-94.

– *Srednjovekovni nadgrobni spomenici u Dečanima,* Dečani i vizantijska umetnost sredinom XIV veka, Beograd 1989, 225-235.

– *Srpski vladarski grob u srednjem veku*, Beograd 1992.

POPOVIĆ Lj., *Figure proroka u kupoli Bogorodice Odigitrije u Peći: identifikacija i tumačenje tekstova*, Arhiepiskop Danilo II i njegovo doba, Beograd 1991, 443-464.

PURKOVIĆ M., *Srpski patrijarsi srednjeg veka*, Diseldorf 1976.

RADOJČIĆ S., *Arhiepiskop Danilo II i srpska arhitektura ranog XIV veka*, Uzori i dela starih srpskih umetnika, Beograd 1975, 195-210.

– *Gračaničke freske*, Vizantijska umetnost početkom XIV veka, Beograd 1978, 173-180.

– *Jedna scena iz romana o Varlaamu i Joasafu u crkvi Bogorodice Ljeviške*, Starinar 3-4 (Beograd 1955) 77-81.

– *Majstori starog srpskog slikarstva*, Beograd 1955.

– *Portreti srpskih vladara u srednjem veku*, Skoplje 1934.

– *Postanak slikarstva renesanse Paleologa*, Uzori i dela starih srpskih umetnika, Beograd 1975, 125-154

– *Die Reden des Johannes Damaskenos und die Koimesis-Fresken in den Kirchen des Königs Milutin,* Jahrbuch der österreichischen Byzantinistik 22 (Wien 1973) 301-312.

– *Stare srpske minijature*, Beograd 1950.

– *Staro srpsko slikarstvo*, Beograd 1966.

RADOJIČIĆ Dj. Sp., *Antologija stare srpske književnosti (XI-XVIII veka)*, Beograd 1960.

– *Književna zbivanja i stvaranja kod Srba u srednjem veku i u tursko doba*, Novi Sad 1967.

– *Tvorci i dela stare srpske književnosti*, Titograd 1963.

RADOJKOVIĆ B., *Srpsko zlatarstvo XVI i XVII veka*, Novi Sad 1966.

RADOVANOVIĆ J., *Ikonografija fresaka protezisa crkve Svetih Apostola u Peći*, Zbornik za likovne umetnosti 4 (Novi Sad 1968) 27-61.

– *Heilige? Demetrius – Die Ikonographie seines Lebens auf den Fresken des Klosters Dečani*, L'art de Thessalonique et des pays balkaniques et les courants spirituels au XIVe siècle, Belgrade 1987, 75-88.

– *Jedinstvene predstave Vaskrsenja*, Zograf 8 (Beograd 1977) 34-46.

– *Neveste Hristove u živopisu Bogorodice Ljeviške u Prizrenu*, Zbornik za likovne umetnosti 15 (Novi Sad 1979) 115-132.

– *Portreti Nemanjića u crkvi Bogorodice Ljeviške u Prizrenu*, Starine Kosova i Metohije 4-5 (Priština 1968-1971) 271-299.

– *Runo Gedeonovo u srpskom srednjovekovnom slikarstvu*, Zograf 5 (Beograd 1974) 38-42.

– *Sveti Nikola, žitije i čuda u srpskoj umetnosti*, Beograd 1987.

– *Tutičeva crkva sv. Nikole u Prizrenu*, Glasnik Srpske pravoslavne crkve 43 (Beograd 1962) 190-195.

RAHLFS A., *Die altestestamentliche Lektionen der griechischen Kirche*, Nachrichten der Königlichen Gesellschaft der Wissenschaften zu Göttingen, Philol.-hist. Klasse, 1915.

RASOLKOSKA-NIKOLOVSKA Z., *Fragmenti fresaka Dušanove zadužbine Svetih Arhandjela kod Prizrena,* Dečani i vizantijska umetnost sredinom XIV veka, Beograd 1989, 389-397.

SAVA, SVETI, *Sabrani spisi,* Stara srpska književnost, 2, Beograd 1986.

SKOVRAN A., *Freske XVII veka iz crkve sv. Dimitrija u Peći i portret patrijarha Jovana*, Starine Kosova i Metohije 4-5 (Priština 1968-1971) 331-347.

SLAVEVA L., MOŠIN V., *Srpski gramoti od Dušanovo vreme*, Prilep 1988.

SLIJEPČEVIĆ Đ., *Pajsije, arhiepiskop pećski i patrijarh srpski kao jerarh i književni radnik*, Bogoslovlje 8 (Beograd 1933) 123-144, 241-283.

SOLOVJEV A., *Odabrani spomenici srpskog prava*, Beograd 1926.

SOULIS G. Ch., *The Serbs and Byzantium during the Reign of Tsar Stephen Dušan (1331-1355) and his Successors*, Washington 1984.

Spisi Dimitrija Kantakuzina i Vladislava Gramatika, Stara srpska književnost, 14, Beograd 1989.

STANOJEVIĆ D., *Novi podaci o živopisu Danilove priprate u Pećkoj patrijaršiji*, Glasnik Društva konzervatora Srbije 13 (Beograd 1989) 58-61.

STEFAN PRVOVENČANI, *Sabrani spisi,* Stara srpska književnost, 3, Beograd 1988.

STOJAKOVIĆ A., *Arhitektonski prostor u slikarstvu srednjovekovne Srbije*, Novi Sad 1970.

– *Odnos arhitekture i slikarstva u Dečanima*, Dečani i vizantijska umetnost sredinom XIV veka, Beograd 1989, 379-387.

STOJANOVIĆ D., *Umetnički vez u Srbiji od XIV do XIX veka*, Beograd 1959.

STOJANOVIĆ LJ., *Stari srpski zapisi i natpisi*, I-VI, Beograd 1902-1926.

SUBOTIĆ G., *Crkva Svetog Dimitrija*, Beograd 1977.

– *Ikonografija Svetoga Save u vreme turske vlasti,* Sava Nemanjić – Sveti Sava. Istorija i predanje, Beograd 1979, 343-354.

– *Najstarije predstave svetog Georgija Kratovca*, Zbornik radova Vizantološkog instituta 32 (Beograd 1993) 167-202.

– *Prilog hronologiji dečanskog zidnog slikarstva*, Zbornik radova Vizantološkog instituta 20 (Beograd 1981) 111-135.

ŠAKOTA M., *Dečanska riznica*, Beograd 1984.

– *Nekoliko Longinovih crteža u Dečanima*, Starine Kosova i Metohije 4-5 (Priština 1968-1971) 303-307.

Šest pisaca XIV veka, Stara srpska književnost, 10, Beograd 1986.

ŠKRIVANIĆ G., *Vlastelinstvo Sv. Stefana u Banjskoj,* Istoriski časopis 6 (Beograd 1956) 177-198.

ŠUPUT M.: *Arhitektura Pećke priprate,* Zbornik za likovne umetnosti 13 (Novi Sad 1977) 45-69.

– *Plastična dekoracija Banjske,* Zbornik za likovne umetnosti 6 (Novi Sad 1977) 37-51.

– *Spomenici srpskog crkvenog graditeljstva. XVI-XVII vek,* Beograd 1984.

– *Vizantijska skulptura iz sredine XIV veka,* Dečani i vizantijska umetnost sredinom XIV veka, Beograd 1989, 69-73.

– *Vizantijski plastični ukras u graditeljskim delima kralja Milutina,* Zbornik za likovne umetnosti 12 (Novi Sad 1976) 41-54.

– *Vizantijski reljefi sa pastom iz XIII i XIV veka,* Zograf 7 (Beograd 1977) 36-44.

– *Manastir Banjska,* ed. Republički zavod za zaštitu spomenika kulture Srbije, Beograd 1989.

TAFT R., *The Great Entrance,* Roma 1978.

TASIĆ D., *Živopis pevničkih prostora crkve Sv. Apostola u Peći,* Starine Kosova i Metohije 4-5 (Pris¿tina 1968-1971) 233-267.

TATIĆ-DJURIĆ M., *Archanges gardiens de porte à Dečani,* Dečani i vizantijska umetnost sredinom XIV veka, Beograd 1989, 359-364.

– *Bogorodica u delu arhiepiskopa Danila II,* Arhiepiskop Danilo II i njegovo doba, Beograd 1991, 391-407.

– *L'inspiration littéraire dans l'iconographie mariale,* L'art de Thessalonique et des pays balkaniques et les courants spirituels au XIVe siècle, Belgrade 1987, 41-56.

– *La Vierge de la Vraie Espérance – symbole commun aux arts byzantin, géogrien et slave,* Zbornik za likovne umetnosti 15 (Novi Sad 1979) 71-89.

TEODOSIJE, *Žitija,* Stara srpska književnost, 5, Beograd 1988.

TIMOTIJEVIĆ R., *Crkva Sv. Spasa u Prizrenu,* Starine Kosova i Metohije 6-7 (Priština 1972-1973) 65-78.

TODIĆ B., *Ikonografski program fresaka iz XIV veka u Bogorodičinoj crkvi i priprati u Peći,* Arhiepiskop Danilo II i njegovo doba, Beograd 1991, 361-372.

– *Najstarije zidno slikarstvo u Sv. Apostolima u Peći,* Zbornik za likovne umetnosti 18 (Novi Sad 1982) 19-38.

– *Novootkrivene predstave grešnika na Strašnom sudu u Gračanici,* Zbornik za likovne umetnosti 14 (Novi Sad 1978) 193-204.

– *O nekim preslikanim portretima u Dečanima,* Zbornik Narodnog muzeja 11/2 (Beograd 1982) 55-67.

– *Patrijarh Joanikije – ktitor fresaka u crkvi Sv. Apostola u Peļi,* Zbornik za likovne umetnosti 16 (Novi Sad 1980) 85-101.

– *Tradition et innovations dans le programme et l'iconographie des fresques de Dečani,* Dečani i vizantijska umetnost sredinom XIV veka, Beograd 1989, 251-268.

TOMEKOVIĆ S., *Les évêques locaux dans la composition absidale des saints officiants,* Byzantinisch-neugriechische Jahrbücher 23 (Athen 1981) 65-88.

– *Monaška tradicija u zadužbinama i spisima arhiepiskopa Danila II,* Arhiepiskop Danilo II i njegovo doba, Beograd 1991, 425-437.

– *Place des saints ermites et moines dans le décor de l'église byzantine,* Liturgie, conversion et vie monastique, Roma 1989, 307-331.

– *Le "portrait" dans l'art byzantin: example d'effigies de moines du Ménologe de Basile II à Dečani,* Dečani i vizantijska umetnost sredinom XIV veka, Beograd 1989, 121-133.

TRIFUNOVIĆ L., *Banjska,* Zadužbine Kosova. Spomenici i znamenja srpskog naroda, Beograd – Prizren 1987, 89-94.

– *Bogorodica Ljeviška,* Zadužbine Kosova. Spomenici i znamenja srpskog naroda, Beograd – Prizren 1987, 69-88.

– *Sveti arhanđeli,* Zadužbine Kosova. Spomenici i znamenja srpskog naroda, Beograd – Prizren 1987, 159-164.

TOMOVIĆ G., *Morfologija ćiriličkih natpisa na Balkanu,* Beograd 1974.

– *Tomašev natpis o osnivanju crkve Blagoveštenja Gospodnjeg 1427. godine kod Orahovca u Metohiji,* Kosovsko-metohijski zbornik 1 (Beograd 1990) 63-78.

TSITOURIDOU A., Ή έντοιχία ζωγρφιὴ τοῦ Άγίου Νικολου στὴ Θεσσαλονίκη, Thessaloniki 1978.

UNDERWOOD P.A., *The Kariye Djami,* I-III, New York 1966; IV– *Studies in the Art of the Kariye Djami and its Intellectual Background,* Princeton 1975.

VASIĆ M., *Žiča i Lazarica,* Beograd 1928.

VELMANS T., *L'iconographie de la "Fontaine de vie" dans la tradition byzantine à la fin du Moyen âge,* Synthronon, Paris 1968, 119-134.

– *La peinture murale byzantine à la fin du Moyen âge,* Paris 1977.

– *La peinture murale byzantine d'inspiration constantinopolitaine du milieu du XIVe siècle (1330-1370). Son rayonnement en Géorgie,* Dečani i vizantijska umetnost sredinom XIV veka, Beograd 1989, 73-94.

– *Le portrait dans l'art des Paléologues,* Art et société à Byzance sous les Paléologues, Venise 1971, 93-148.

Vizantijski izvori za istoriju naroda Jugoslavije, VI, Beograd 1986.

VUČENOVIĆ S., *Arhitektura crkve sv. Djordja u Rečanima i konzervatorski radovi na njoj,* Glasnik Muzeja Kosova i Metohije 1 (Priština 1956) 347-353.

VULOVIĆ B., *Manastir Gračanica. Prilozi za istoriju, arhitekturu i slikarstvo,* Starine Kosova i Metohije 4-5 (Priština 1968-1971) 165-175.

– *Nova istraživanja arhitekture Gračanice,* Vizantijska umetnost početkom XIV veka, Beograd 1978, 165-170.

WALTER Ch., *Art and Ritual of the Byzantine Church,* London 1982.

– *The Cycle of Saint George in the Monastery of Dečani,* Dečani i vizantijska umetnost sredinom XIV veka, Beograd 1989, 347-353.

– *The Iconographical Sources for the Coronation of Milutin and Simonida at Gračanica,* Vizantijska umetnost početkom XIV veka, Beograd 1978, 183-200.

– *L'iconographie des Conciles dans la tradition byzantine,* Paris 1970.

– *Portraits of Local Bishops. A Note on Their Significance,* Zbornik radova Vizantološkog instituta 21 (Beograd 1982) 7-17.

– *Značenje portreta Danila II kao ktitora u Bogorodičinoj crkvi u Peći,* Arhiepiskop Danilo II i njegovo doba, Beograd 1991, 355-358.

VASILIĆ A., TEODOROVIĆ-ŠAKOTA M., *Katalog riznice manastira Pećke patrijaršije,* Priština 1957.

WRATISLAV-MITROVIĆ L., OKUNEV N., *La Dormition de la Sainte Vierge dans la peinture médiévale orthodoxe,* Byzantinoslavica 3/1 (Praha 1931) 134-174.

XYNOGOPOULOS A., Ὁ εἰκονογραφικὸς κύκλος τῆς ζωῆς τοῦ ἁγίου Δημητρίου, Thessalonique 1970.

Zadužbine Kosova. Spomenici i znamenja srpskog naroda, Beograd-Prizren 1987.

ZARIĆ R., *Freske u srednjem traveju crkve Svetih apostola u Peći,* Saopštenja Republičkog zavoda za zaštitu spomenika kulture 25 (Beograd 1993) 55-70.

Zidno slikarstvo manastira Dečana, Beograd 1995.

ZIROJEVIĆ O., *Crkve i manastiri na području Pećke patrijaršije do 1683. godine,* Beograd 1984.

– *Crkve i manastiri u prizrenskom sandžaku,* Kosovsko-metohijski zbornik 1 (Beograd 1990) 133-141.

ŽIVOJINOVIĆ M., *Hilandar i pirg u Hrusiji,* Hilandarski zbornik 6 (Beograd 1986) 59-82.

– *Ktitorska delatnost Svetoga Save,* Sava Nemanjić – Sveti Sava. Istorija i predanje, Beograd 1979, 15-25.

– *Svetogorske kelije i pirgovi u srednjem veku,* Beograd 1972.

(Compiled by Bojan MILJKOVIĆ)